THE ICONOGRAPHY OF
Malcolm X

CultureAmerica

Erika Doss
Philip J. Deloria
Series Editors

Karal Ann Marling
Editor Emerita

THE ICONOGRAPHY OF
Malcolm X

GRAEME ABERNETHY

UNIVERSITY PRESS OF KANSAS

Published by the University Press of Kansas (Lawrence, Kansas 66045), which was organized by the Kansas Board of Regents and is operated and funded by Emporia State University, Fort Hays State University, Kansas State University, Pittsburg State University, the University of Kansas, and Wichita State University

© 2013 by the University Press of Kansas

Library of Congress Cataloging-in-Publication Data

Abernethy, Graeme.

The iconography of Malcolm X / Graeme Abernethy.

 pages cm. — (CultureAmerica)

ISBN 978-0-7006-1920-7 (hardback)

 1. X, Malcolm, 1925-1965-In mass media.

2. Image (Philosophy) I. Title.

BP223.Z8L5713 2013

320.54'6092—dc23

2013018932

British Library Cataloguing-in-Publication Data is available.

Printed in the United States of America

10 9 8 7 6 5 4 3 2 1

The paper used in this publication is recycled and contains 30 percent postconsumer waste. It is acid free and meets the minimum requirements of the American National Standard for Permanence of Paper for Printed Library Materials Z39.48-1992.

CONTENTS

ACKNOWLEDGMENTS

I owe several debts, especially of gratitude, to supporters of this project, which had its inception a decade ago in a graduate seminar taught by Michael Zeitlin and Sandra Tomc at the University of British Columbia. Much of the research, undertaken at the Schomburg Center for Research in Black Culture and at the British Library, came together under the faultless guidance of Kasia Boddy, my doctoral supervisor at University College London; particular thanks in this regard are due also to Matthew Beaumont.

Eithne Quinn, John Howard, Erika Doss, Philip J. Deloria, Lori Rider, and James L. Conyers provided helpful comments on various sections or drafts of the manuscript. Ranjit Arab, Michael Briggs, and Kelly Chrisman Jacques supplied editorial support at the University Press of Kansas. Between 2009 and 2012, conference delegates, seminar attendees, and students at Universität Bremen, the University of Nottingham, the University of Birmingham, University College London, and Simon Fraser University contributed with their remarks to various issues informing this book. Lowell Pete Beveridge, Jr., former *Liberator* production editor, furnished information and encouragement at a late stage of the project.

Some artists and estates have been more forthcoming with responses to my permissions requests than others. I would like to extend my gratitude to those represented in these pages for their patience and professionalism. Representatives of the Richard Avedon Foundation and the Gordon Parks Foundation have been particularly generous with their time and resources. For their permission to reprint material adapted from my previously published article and chapter on Malcolm X, respectively, I wish to thank Taylor & Francis and Cambridge Scholars Press.

Friends and family have been instrumental in the realization of this process: thank you, all. Michael McCluskey provided me with countless opportunities to narrate and debate the book's contents. I am grateful to Dave Dhat, for his example of conviction and application; to Brett Taylor for a reliable correspondence; and to Myke Preuss, Wesley Cameron, Freddy Fredrickson, Ben Stoddard, Matthew Robertson, Gary Arnold,

Clayton Pierrot, and Jeff Nurcombe for their long-standing fellowship. I wish to express a large measure of appreciation to the Choi family, for their faithful support, and to Carol, Brent, and Joe Abernethy, for their love and patience—it is a long road, by way of an education in the humanities, to anything resembling independence. Finally, I thank Gina for shouldering much of the emotional burden of this, my first book, which is dedicated to Emile, our son.

THE ICONOGRAPHY OF
Malcolm X

INTRODUCTION

THE SCIENCE OF IMAGERY

How does Malcolm's icon work? And what does it say?
Joe Wood, "Malcolm X and the New Blackness,"
Malcolm X: In Our Own Image

This is skill. This skill is called—this is a science that's called image making. They hold you in check through this science of imagery.
Malcolm X, "Not Just an American Problem,"
February 1965: The Final Speeches

Malcolm X's life, like his death in 1965, was much documented and observed. Having left an abundance of photographic and filmic images, the textual material that would become the posthumous *The Autobiography of Malcolm X* (1965), and a number of interviews and speeches, Malcolm ensured his own cultural afterlife. He also inadvertently guaranteed that "we will never have access to an unmediated Malcolm."[1] The writer John Edgar Wideman has described the subsequent contestation of his meaning and legacy as "the bickering over the corpse of a dead man—who gets the head, the heart, the eyes, the penis, the gold teeth."[2] Other critics have lamented the cost in historical accuracy of the objectification of Malcolm X, invoking "the Malcolm that has often been lost in hero worship" and the images of Malcolm "all smoothed flat and stylized, like the holy men burning coolly in a Byzantine icon."[3] Black liberation theologian James H. Cone has cautioned that "the memory of Malcolm is likely to be both false and dim."[4] Indeed, the iconography of Malcolm X, at times discursively impoverished, resonates both with cultural remembrance and cultural forgetting.

The standardized narrative of Malcolm's life, primarily established by the *Autobiography,* can be identified above all with the myth of transformation. The book states that his "whole life had been a chronology of—*changes.*"[5] The three most commonly cited personae—Detroit Red, Malcolm X, and El-Hajj Malik El-Shabazz—are distinguished by their

Malcolm X, black nationalist leader, New York, March 27, 1963. Photograph by Richard Avedon.
© *The Richard Avedon Foundation.*

several ideologies and names. They are also identifiable in their singular images: Detroit Red in his 1944 mug shot; Malcolm X gesticulating at his podium, circa 1960–1963; El-Hajj Malik El-Shabazz kneeling in prayer in a Cairo mosque in 1964. Very few photographs are capable of evoking the collective personae of Malcolm X, but Richard Avedon's 1963 portrait manages to come close. The photograph is an example of how, as Alan Trachtenberg argues, images become "saturated with history" or dependent "on larger stories we tell (or hear) about the man and his history."[6] Cryptic in its purposeful haze, skull-like in its coloration and concealment of Malcolm's eyes in shadow, yet intimate in its perspective, the image seems to allude to the transubstantiation enabled by his death.

Avedon's haunting depiction is uniquely illustrative of the aura of instability—indeed, of ontological indeterminacy—that ultimately obtrudes on our perception of other images of this iconic figure.

Despite the suggestions above of stylization and the loss of meaning in his image, the key components of the narrative of Malcolm's life and death are familiar even to his casual observers. They bear repeating in condensed form for the sake of those new to his study, as knowledge of his biography is presumed in many of the documents discussed herein. In this narrative, Malcolm descends from childhood innocence to disillusion as Malcolm Little in Michigan; through moral corruption and the self-negating emulation of white values as Detroit Red in Roxbury and Harlem; to the extremity of godlessness as Satan in Charlestown State Prison. Beginning his moral reformation, he embraces Elijah Muhammad's black nationalist theology while incarcerated, becoming Malcolm X and, upon his release, the Nation of Islam's most fervent recruit. Finally, he ascends toward political and religious integrity as the Pan-Africanist and Sunni Muslim El-Hajj Malik El-Shabazz. In this final incarnation, on 21 February 1965, he is murdered while beginning a speech in the Audubon Ballroom in Washington Heights. The culprits are five Nation of Islam assassins aided by the indifference, if not the direct cooperation, of the FBI and NYPD.

This narrative has been invoked repeatedly since Malcolm's death—in books, photographs, paintings, films—often cast as a tale of powerful personal transformation culminating in a tragic, even biblically inflected, assassination. But Malcolm's image was not always so, as this study will show. The iconography of Malcolm X, from its inception in the late 1950s, has shifted as profoundly as the American racial landscape itself. Regarded at his emergence by many commentators as a preacher of hate, he was not, during his lifetime, perceptibly the figure of modern myth that he would, at his death, quite suddenly become. Much of this was attributable to his alienation from the mainstream of the civil rights movement, most notably articulated in his frequent verbal snipes at the politics of nonviolence and Christianity espoused by Martin Luther King, Jr. The murder of Malcolm X, always a figure of controversy, set in motion a series of tugs-of-war—between white and black journalists, biographers, artists, and his ideological champions—over the interpretation

of his cultural meaning. While some were invested in condemning his ostensibly violent rhetoric of African American self-defense, others perceived his death as a martyring conspired by a cabal of Judases.

This study considers the proliferation—and, frequently, the ideologically motivated separation into component parts—of the images and narratives that constitute the many different Malcolms available for consumption, not least the three central personae of the *Autobiography*: the teenage hustler Detroit Red; the Nation of Islam spokesman Malcolm X; and the Sunni convert El-Hajj Malik El-Shabazz. In the nearly fifty years since his death, many more Malcolms have appeared in increasingly diversified constellations of image, utterance, and text. My purpose is not to further eulogize, canonize, or update Malcolm X for current ideological consumption but to consider the production and circulation of his images since his initial appearances in print and on screen in the late 1950s and early 1960s. Although not exhaustive—American and British uses of Malcolm have been found to be far more abundant and accessible, for example, than African or Caribbean ones—my study will consider the global import of a figure who has been framed as both villain and hero, cast by mainstream media during his lifetime as "the most feared man in American history" and elevated at his death as a heroic emblem of African American identity.[7]

The evaluation of a figure of such cultural breadth is all the more vital at a time when traditional media, including the publishing industry, are beginning to adapt to the cultural implications of digital visual media. For Malcolm X the preeminence of the page was far from absolute. This is not to suggest that narrative or even literary traditions are alien to the iconography of Malcolm X but that they are typically integrated with, accompanied by, or subordinate to visual media, especially photography and film. Malcolm was well aware of the ideological efficacy of image making, frequently insisting upon the central role of the circulation of distorted images of Africa in fabricating the inhumanity of persons of African descent. His theoretical grasp of what he termed in a late speech "the science of imagery" enabled him both to analyze the role of representation in ideological (and, indeed, psychological) control and to exploit his own image in the interests of black empowerment.[8] His transformation of African American self-perception through representation rather

than the political process crucially informed the cultural nationalism of the Black Power and hip-hop eras.

Malcolm X is hardly alone in this visual proclivity. Sara Blair has indicated the influence of photography on postwar African American writers such as Langston Hughes, Richard Wright, Ralph Ellison, and James Baldwin, all of whom "engaged directly with the archives, practices, and effects of documentary photography."[9] None, however, can rival Malcolm for conspicuousness; his arrival as a public figure, like that of Martin Luther King, was associated not only with photography but also with the emergent medium of television. Through various visual means, Malcolm both critiqued and interacted with a tradition of African American iconography encompassing fictional stereotypes and folk heroes, film stars, athletes, musicians, and religious and political leaders. With such identifying elements of his images as the raised fist, the microphone, the rifle, the grin, and the glasses, Malcolm responded to figures "surrounded by [their own] obscuring legends"—Jack Johnson, Marcus Garvey, Joe Louis, Billie Holiday, and King, among others.[10]

Other scholars have explored Malcolm's unique cultural resonance. None, however, has responded fully to Joe Wood's questions, in this chapter's first epigraph, in a manner addressing Malcolm's complex presentation and circulation in image and text.[11] *The Iconography of Malcolm X* is the first systematic examination of the iconography of Malcolm X and its attendant narratives. I have stated that the iconography of Malcolm X continually evolves. Indeed, our notion of what constitutes an icon is itself evolving. As contemporary visual media present us with increasing numbers and kinds of images, we must continually reassess our criteria of evaluation. Which images are disposable? Which images or figures endure in light of the ceaseless news and celebrity cycles? Of these, which warrant the designation of "icon"? Iconic figures must be distinguished from mere stars in contemporary popular culture. To become iconic, a figure must attain a degree of recognition exceeding faddish celebrity. Additionally, he or she must be seen, within a finite number of images, to evoke a particular set of values or assumptions, and must do so over an extended period. Uniting principles of celebrity, heroism, rebellion, martyrdom, and worship, modern icons such as Malcolm X emerge from the visual detritus in our cultural landscapes. To remain iconic, they must do so repeatedly.

The Iconography of Malcolm X emerges at a time when an increasing number of critics and scholars are concerned with the intersection of cultural forms. The readings of images undertaken in this book are informed by a variety of approaches both to iconography and to visual rhetoric more generally, whether articulated in the service of art history, semiotics, cultural studies, or literary studies. Other analytical categories than iconography are inadequate to the task of assessing a cultural figure so comprehensively visualized; in addition to being extensively photographed and filmed, Malcolm X has been painted, figuratively and abstractly, and portrayed on stage and screen. Even his literary and journalistic treatments have been accompanied consistently by iconic images. Unlike "collective memory" or, simply, "cultural meaning," broader terms also implying a dynamic returning-to, iconography presupposes the visually oriented reinterpretation of the past.

Icons have been defined as "visual explanations of a larger symbolic order of time and space"—in other words, as distillations of our narratives, mythic or otherwise.[12] Iconography is understood to be concerned with "the transfer of meaning" rather than with the "aesthetic qualities" of images.[13] The useful notion that iconography is concerned more with meaning than form is attributable to German art historian Erwin Panofsky's *Studies in Iconology* (1939). This dispensing with questions of form in traditional iconography is enabled by the consistency of form of many Orthodox icons, which have long been reproduced mimetically; the photographic era has extended and secularized a tradition reliant upon the standardization of images. Indeed, "the vagaries of idiomatic expression" in visual style do not transform the ritual function predicated on a viewer's recognition of iconic meaning.[14] According to Panofsky, images must be situated in mythohistorical context if their "conventional subject matter" or conscious referents are to be thoroughly understood.[15] Without knowledge of an icon's narrative underpinnings, a viewer cannot unlock its function; the use of icons thus demands a distinctive synthesis of visual and scriptural literacy. Despite its visual bias, then, iconography traditionally demonstrates a powerful narrative imperative: stories are preserved largely through the shorthand repetition enabled by the circulation of a series of associated images. These images are not documents typically regarded in isolation, but as part of a cumulative iconography

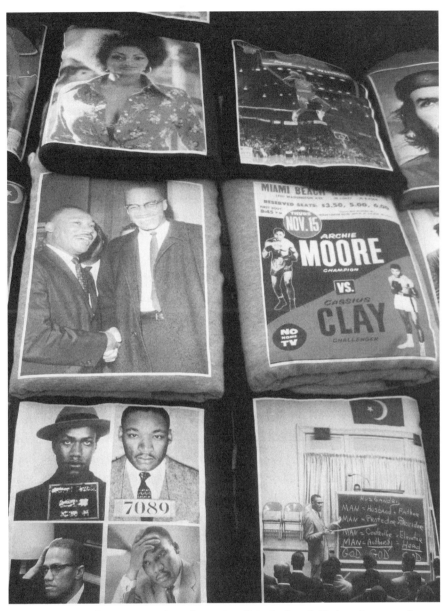

T-shirt stand on 125th Street near Adam Clayton Powell, Jr. Boulevard, Harlem, August 2008.
Photograph by Graeme Abernethy.

rendered familiar, in the contemporary context, by relentless media exposure of a figure such as Malcolm X.

As well as visual exposure, often it is the romantic consecration of death, especially youthful death, that confirms—and, in some cases, supplies—a figure's transcendent appeal. As iconography traditionally depends on the absence of the represented (the original subject) and the foregrounding of the representation (the icon), death often becomes its subject, stated or implied. Indeed, iconography's powerful interplay of mythic imperatives is only truly consecrated by the death of a portrayed individual. By many accounts, figures such as James Dean and Marilyn Monroe comfortably qualify as American icons through their respective visual examples of youthful beauty consumed by the tragedy of early death. In a more global pantheon, figures such as Mahatma Gandhi, Che Guevara, Martin Luther King, Jr., and Malcolm X, in their association with revolutionary politics as well as violent death, obtain meaning beyond the more straightforwardly consumerist nostalgia aroused by Dean and Monroe.

Their iconicity is not, however, anchored by the specifics of their politics but, finally, by a process whereby their politics are abstracted to an image of redemptive self-sacrifice for the sake of strongly held beliefs. Indeed, Malcolm's increasing (and increasingly broad) appeal is a consequence of the continuing cultural attraction to narratives of self-sacrifice and the implicitly Christian frame of reference that typically attends—and attenuates—our engagement with them.[16] A crucial aspect of Malcolm's iconography has been the occasionally overt Christianization of his image, undoubtedly intended to neutralize his alignment with Islamic martyrdom, that looming specter for contemporary Western civilization. Although contemporary mass media icons are not always "religious in the traditional sense," they are "imbued with sentiments held in common with religious devotion: mythification, exaltation, ritual, worship." Revered in objectified form, icons retain transfigurative associations, their subjects commonly being perceived to have "surpassed human limitations."[17] Wood argues that icons produce meaning through identification, inviting "communion" and "a sense of 'authorship'" within viewers.[18]

It is necessary to further articulate how the terms "iconography" and "icon" are to function in this study. As Robert Hariman and John Louis

Lucaites have indicated, the meaning of iconic images becomes "fully evident only in a history of both official and vernacular appropriations."[19] Iconography, throughout this book, thus refers to the totality of visual inscriptions of a given iconic figure and to their study. An icon, most simply, from the Greek *eikon,* is an image—a "visual or pictorial representation."[20] This primary definition belies, however, the specific cultural and semiotic traditions within which icons operate. Icons are symbols or signs with historically and culturally specific significations. This is not to suggest that the narratives with which icons share a mutually constitutive relationship are entirely stable. Indeed, they are ever shifting; the degree to which their encoded meanings shift is dependent on the extent to which the cultural values that inform these symbolic images themselves remain dynamic. In order to function, however, icons must remain relatively stable in terms of their visual form: their iconic capacity is a function of their recognizance. To maximize the likelihood of recognition, an iconic photograph such as Avedon's portrait of Malcolm is typically a close-up or medium close-up. Icons are images of illusory intimacy and, as in Avedon's case, of beguiling opacity.

Modern technologies have by no means disabled iconography's traditional ritual function. Photography and film have nevertheless revolutionized the transmission and reception of icons, simultaneously commodifying and domesticating their "monopoly of appearance."[21] Whereas the sacred associations of traditional religious icons emerge from the context of their placement, from the presumption of their origin in an unquestioned prototype, or from what Walter Benjamin called the "authority of the object," the utility of photography lies in the technology's exquisite naturalism and ease of reproduction and circulation.[22] For example, Avedon's portrait of Malcolm first appeared alongside an essay by James Baldwin in *Nothing Personal* (1964), a remarkable collection of Avedon's American photography. The portrait's prominence—and Malcolm's iconic familiarity—has since been reinforced by the image's reproduction for exhibitions at the Whitney Museum and the Museum of Modern Art and for a 1992 issue of the *New Yorker.*

Hariman and Lucaites have indicated the ideological consequences of photography's reassuring illusion of transparency: "once thought to be windows to the real, photographic images become the ideal medium for naturalizing a repressive structure of signs." Photography's lifelike ren-

derings, like those of film, in fact disguise their own fragmentation and manipulation: "the photographic medium is inherently paratactic: because photographic images operate meaningfully without a connecting syntax, these images denote only fragments of any coordinated action."[23] A photograph is the illusionary imprint of space delimited and time halted. As such, it is conducive to locating mythic or iconic meaning.

In our persistent and quasi-religious attachment to icons lies the suggestion of a profound distrust of the ability of language alone to effectively communicate or mediate the abstractions that anchor group identities. The central paradox of icons in both their Orthodox and modern variations is that, at least superficially, they depict the divine not at all: icons typically portray, whether in the person of Jesus Christ, various saints and martyrs, or celebrities, a given culture's vision of the sacred or the exceptional *always in the human form*. In other words, those aspects of divinity or quasi-divinity encoded in the representation of the human form give the icon its uniquely powerful social function. As Marshall Fishwick claims, even in their popular culture form, "icons do objectify the deep mythological structure of reality."[24]

Given traditional iconography's distinctly Christian orientation, the role of Islam in the popular iconography of Malcolm X is perhaps necessarily tenuous. Although Malcolm is less thoroughly decontextualized in his iconographic representation than someone such as Che Guevara—his constituency of urban African Americans remains a primary evocation of his image and, indeed, retains a proprietary interest in his legacy—it is arguably his religious rather than political views that suffer most at the hands of the posthumous inscriptions. This blindness is a systemic and genre-driven one, a function of Islam's outsider status in American culture and of iconography's Christian entrenchment. The popular consumption of Malcolm X does not often engage deeply with his religion; his iconography is, however, linked powerfully with his martyrdom and its evocation of the "sacredness" of extraordinary self-sacrifice.

In her discussion of motifs of martyrdom in modern culture, religious studies scholar Elizabeth A. Castelli identifies an element of compulsion in the exemplum of the martyr. Castelli argues that martyrs—there are a significant number among Orthodox icons—are creations not of history but of myth. They are "produced by the stories told about them."[25] Relative to the comparatively opaque early Christian era, such processes of ex-

altation now require less time to develop. As the iconography of Malcolm X demonstrates, however, the evolution has been rather slight. In another critic's view, we should regard "martyrdom as a reduction or, more appropriately, translation from individuality to symbol."[26] Martyrs, from Saint Sebastian to Malcolm X, are presented as idealized "models for emulation" representing some "unassailable truth, the seamless incarnation of the idea." The self-sacrificial model occasioned by the glorification of the martyr's death "simultaneously inspires awe and reverence, anxiety and suspicion."[27] As irreproachable figures whose lives and deaths we are encouraged to worship by way of their depiction, iconic martyrs can invite aspiration, idealism, or uplift. They are also capable of assigning their viewers or worshippers to positions of relative subordination. In this regard Malcolm's visual abstraction and commodification, like that of other iconic figures, can be seen to be associated simultaneously with resistance to and reinforcement of systems—such as patriarchy and capitalism—of tyranny and compulsion.

Several recent books have addressed the meaning and function of modern icons. Hariman and Lucaites's influential study *No Caption Needed: Iconic Photographs, Public Culture, and Liberal Democracy* (2007) identifies "the icons of U.S. public culture" as those photographs—such as Lange's *Migrant Mother* or Rosenthal's *Raising the Flag on Iwo Jima*—absorbed into the national narrative. Exceeding ordinary cycles of disposability, they become "sacred images for a secular society." Hariman and Lucaites's definition of the iconic image is at once broader and more specifically American than my own. It is also more narrowly photojournalistic and applies more often than not to civilians rather than to celebrities, political leaders, or other similarly mass-mediated figures. In its selection and analysis, *No Caption Needed* avowedly avoids images from "subcultures" such as sport or, disappointingly, the civil rights movement. The book identifies five crucial "vectors of influence" for photographic icons: "reproducing ideology, communicating social knowledge, shaping collective memory, modeling citizenship, and providing figural resources for communicative action."[28] Hariman and Lucaites's notions of identification and imitation are of general use in understanding the cultural function of the iconography of Malcolm X.

In *James Dean Transfigured: The Many Faces of Rebel Iconography* (2007), Claudia Springer explores the role of celebrity culture in icon for-

mation. Springer presents Dean as the prototypical "rebel icon," a figure uniting popular heroism and sex appeal with quasi-religious worship. In the model perfected by Dean's iconographers, the worshipper becomes consumer, purchasing and displaying proximity to the departed idol by way of films, posters, and T-shirts. Such expensive gazing affords a figure such as Dean unique power; he becomes an object both of desire and vicarious identification for the viewer. According to Springer, "the strategy of domesticating the rebel figure and subduing its disruptive connotations" is built into the modern iconographic process, in which the rebel icon peddles as it provokes. Indeed, Dean's association with rebellion emerged largely from the roles he played on screen and the fast cars he famously drove (and which killed him). While Springer demonstrates that Dean became a visual receptacle of fantasy or myth following his death, she does not sufficiently emphasize the role of celebrity death in modern iconography at large. Rather than identifying it as among the most significant aspects of iconicity, Springer focuses on rebel iconography's combination of "sexuality, image obsession, . . . and thrill seeking" as typified by Dean. Acknowledging that Dean's evident link with youth culture is typical of consumerist icons, Springer, perceiving a distinctive African American rebel tradition, claims that "the teen rebel is not a significant antecedent for rap and hip hop."[29] While Malcolm's teenage persona of Detroit Red was admittedly powerfully influenced by African American folk traditions associated with bad men and tricksters, the championing of Red, especially within hip-hop culture, at times resonates also with more conventionally consumerist iconography.

More than James Dean or Malcolm X, Che Guevara can be said to be associated with a single image: the photograph, titled "Guerrillero Heroico," taken by Alberto "Korda" Díaz on 5 March 1960. The collection *Che Guevara: Revolutionary and Icon* (2006) discusses the photograph's evocation of the "Christian ideas of inspiration, hope, serenity, timelessness," likening its portrayal to those of Christ.[30] The book also considers the Argentine revolutionary's popular iconography. Much like images of Dean, Monroe, and Elvis Presley, this particular portrait of Che has been abstracted "to a high-contrast outline," in the pop art style, amenable to inexpensive silkscreen reproduction.[31] According to Brian Wallis, the silhouette of Korda's photograph is attributable to Jim Fitzpatrick in 1967. As the book makes clear, however, the question of authorship or attribu-

tion has long been purposefully ignored or obscured; indeed, "Guerrillero Heroico" has been used—without the photographer's permission—to advertise products ranging from Jean Paul Gaultier, Smirnoff, Leica, and Magnum ice cream. Is the assumption that Che, as a kind of heroic-individualist self-author, is more responsible for his representation than any photographer? Does entry into the canon of popular icons democratize one's portrait, copyright be damned? Wallis asserts that "Che (or at least the graphic caricature of Che) has been translated into a distinctly American idiom and has become a cipher merely for the prototypical and declamatory revolutionary leader."[32]

While considering such dangers of decontextualization, this study argues that the iconography of Malcolm X does not fundamentally serve to neutralize dissent or political awareness as, for example, does the iconography of James Dean—or those associated with Michael Jordan, Tiger Woods, and LeBron James in their ostensibly apolitical pose for brands such as Nike. For the most part, Malcolm's (especially posthumous) depictions are a positive instance of an icon becoming "a condensation of public consciousness" rather than merely a mechanism of cooptation.[33] Mediated images may be pervasive in contemporary culture to the point of being almost blinding, but their role in expressive culture remains of central importance. As the semiotician Charles S. Peirce claimed, "We think only in signs. . . . So it is only out of symbols that a new symbol can grow."[34]

Despite his countless collaborations, especially with photographers and reporters, it must be emphasized that Malcolm X, as a practitioner of the science of imagery, achieved a remarkable degree of determination over his representation while living. Despite being murdered—the ultimate expression of a lack of control over his destiny—he has, in many respects, been successful in dictating the terms by which he was to be remembered in his cultural afterlife. Malcolm's notion of the science of imagery, partly inspired by Nation of Islam teachings on tricknology, or the dominant culture's practice of ideological inscription, has been, if anything, more salient in the ostensibly color-blind, yet persistently racially unequal, post–civil rights environment. His relentless, street-smart stage-managing in life has allowed him to resonate, in death, in the increasingly mediated, media-savvy, and racially charged period since the 1960s.

Even while allowing for a degree of continuity in his determination over his cultural images, there remains a paradoxical quality to Malcolm's posthumous representation, within which he appears alternately as an emblem of racial conflict and of potential racial reconciliation. He is recurrently invoked in support of the ethos, on the one hand, of black cultural autonomy and, on the other, of the redemptive possibilities inherent in narratives of American individualism. Much of this tension is attributable to the *Autobiography*'s narrative of perpetual personal transformation. The book dramatizes Malcolm's multiple conversions in such a way as to declare each subsequent incarnation of Malcolm more authentic and enlightened than those previous. In examining depictions of Malcolm prior to, within, and beyond the *Autobiography,* this book will argue that the several Malcolms are in fact only very thoroughly articulated facets of the same person that have, nevertheless, been isolated in numerous instances for particular ideological reasons.

Indeed, in his several radical incarnations, Malcolm has been vulnerable to ideological appropriation. An unmistakably oppositional figure, he remains implicated in a broad range of unresolved cultural tensions: conflicts of race, gender, and religion (not to speak of genre) have been refracted through him. Those occupying a variety of ideological positions—Trotskyist, black separatist, neoliberal—have claimed Malcolm as an ally. For similar reasons, artists in a variety of disciplines have perceived him as a kind of oppositional cultural conscience. Consequently, the iconography of Malcolm X has become, like the cultural landscape of his own lifetime, richly fraught cultural territory.

Unlike most books about Malcolm X, this one does not pursue further biographical revelation about his life and death. Rather, it provides a visually oriented cultural history providing entry to the nature and context of Malcolm's evolving meanings, not his meaning at a single fixed point in time. It is in the nature of icons to signify variously, and to endure beyond the cultural moment of their creation. Thus, this book will necessarily address the periods of Malcolm's iconic rise and canonization, and of the forging of his myth and commodification from his death to the present day. While the nearly fifty years since his death have not demonstrated a straightforward or irreversible decline in the understanding or championing of Malcolm X, new challenges continue to be mounted to his judicious assessment. In the dim past supposed by our gaudy and

accelerated cultural age, he is yet another receding figure increasingly filtered through contemporary biases toward visual, digital, and youth cultures.

The successive inscriptions of Malcolm X in fact began with his self-appellation. "Detroit Red," a jazz name, and "El-Hajj Malik El-Shabazz," an Afro-Islamic name, each marked transformative pilgrimages in Malcolm's life: to Boston (then New York), and to Mecca. Like these other names, "Malcolm X" repudiated both the diminutive denotation of his birth surname and the cultural legacy of enslavement. Much as nationalist rebels in rural India once used Gandhi's name in moral exhortation "to deal out justice to the landlords and the police," "Malcolm X" has demonstrated the political "power of a name."[35] Intended as a partial reclamation of a forcibly withheld African past, the X was given in the Nation of Islam not as a replacement but as a marker of the absence of one's divine or rightful name. Like Malcolm himself, the X signifies profusely: as an alternate cross, a crossing out (indicative of an acknowledged error)—a signal of obscurity, erasure, or the imperceptible. It is emblematic of an incomplete narrative, an uncertain origin and destination.

When the context demands it, I refer to the several personae by their separate names. However, in referring to the general or entire figure I have elected to use the more common and recognizable name "Malcolm X." Soon after claiming the name El-Shabazz, Malcolm told an interviewer that "I will remain Malcolm X as long as there is a need to protest and struggle and fight against the injustices that our people are involved in in this country."[36] Like nearly all of his authors, including scholarly ones, I will for the sake of variation often drop the X—not in favor of the familiarity of "Malcolm" but of its suggestion of a degree of continuity. Given the name Malcolm at birth, he continued to use it, if interchangeably, until his death.

One of the central assertions of this book is that, in his several incarnations, Malcolm in fact retained a continuity of consciousness. Despite the *Autobiography*'s advancement of an ethos of personal transformation, Malcolm Little was indeed the same person as Detroit Red; in the same way, Malcolm X can and must be reconciled with El-Hajj Malik El-Shabazz. Furthermore, within a history of conflictual, partial, and ideologically motivated interpretation, Malcolm has always been expressive of cultural complexity and political potency. In death, as in life, he sustains

an exemplary degree of determination over his public image. Rather than being a casualty of cultural constriction, Malcolm, in his embrace of and adaptability to multiple media, confirms the need for interdisciplinary critical inquiry in the twenty-first century.

In confronting notions of race and modern media, Malcolm X is an inimitable symbol. It is not only African American culture in the twentieth and twenty-first centuries that has been refracted through his images. He has been deployed in the articulation of evolving diasporic notions of black identity and a variety of international contexts; his representation also speaks to the changing relationship of written to visual culture since the mid-twentieth century and, indeed, of the interaction of religious, radical, and literary discourses with popular culture.[37] As such, a consideration of the shifting iconography of Malcolm X opens a door onto many of the most contested issues of our times.

The organization of material in this book, while more or less chronological, also reflects generic trends prevalent in the several periods in question. The first chapter, "Early Images of Malcolm X (1957–1965)," indicates that the evolving relationship of image and text in his iconography began in the mainstream journalistic milieu of the civil rights era. During the 1950s and 1960s, the explicit linking of politics and representation, long inseparable within African American culture, was intensified around the inverse figures of Malcolm and Martin Luther King. Malcolm's image was frequently paired, in print and on television, with words whose implications seemed, at least to white audiences, plainly villainous. His contribution to his representation, however, ensured that his meaning could not remain fixed by commentators and editors. Recognizing the need to make available an alternative to the orthodoxy of African American stereotyping, Malcolm dedicated himself to the production of images of a vocal and distinctly masculine defiance that could transform and radicalize African American self-images while drawing on a recognizable tradition of resistance in black culture. In so doing, he framed himself as folk hero, prophet, and revolutionary.

As national minister for the Nation of Islam from 1957, Malcolm emerged as an unprecedented African American media figure, a vehement and self-declared opponent of a racist America he rejected and figured explicitly as ideologically white. Malcolm, as a black nationalist and separatist, recognized the paradox that the white establishment that he

condemned nevertheless represented the means of transmitting his message. It also formed a significant part of his audience. Although much of his politics (and his credibility) rested upon his presumptive loyalty to a black constituency, Malcolm courted not only an African American but also "a national and, indeed, a global audience, and his only access to that audience was the mass media, and television, especially."[38]

Drawing on mainstream publications such as *Time* and the *Saturday Evening Post,* I also discuss print journalism's anxious reception and characterization of Malcolm X. In the early responses to the July 1959 telecast of the documentary *The Hate That Hate Produced,* the initial orthodox interpretation of Malcolm as a dangerous demagogue—described by James Baldwin as "the legend" of Malcolm X—was established.[39] Book-length accounts by such authors as C. Eric Lincoln and Louis Lomax were often indistinguishable in their sensationalism from the magazine journalism. Finally, numerous photographs by Henri Cartier-Bresson, Gordon Parks, Eve Arnold, and others will be examined, providing insight into the portrayal of Malcolm's oratory, his relationship to other radical or iconic figures of the period, and his violent death.

The late historian Manning Marable claimed that "the first phase of the remaking of Malcolm X occurred in late 1965 with the publication of *The Autobiography of Malcolm X.*"[40] In fact, most of the significant events narrated in the *Autobiography* had appeared in some form in mainstream media sources prior to 1965. What had changed by the time the *Autobiography* appeared in November of that year was that Malcolm's death had introduced the events of his life to memorializing discourses engaged in the process of cultural resurrection. Although it would only be among the first of many posthumous representations of Malcolm, the *Autobiography,* associated by most observers in its origin and depth with the truth of Malcolm's experience, asserted the structure, personalities, and images that would coalesce rapidly into a standardized narrative. Consequently, no document has been more influential on perceptions of Malcolm. The "overwhelming aura of authority" and authenticity, if not always of accuracy, associated with the *Autobiography,* has been almost unassailable.[41]

Nevertheless, my second chapter, *"The Autobiography of Malcolm X* (1965)," emphasizes that the *Autobiography* remains in many respects a problematical text. Since its first publication, the organization of the text, along with its manner of illustration, has been unstable. The source

At the intersection of Florence and Normandie, Los Angeles, 1992. Photograph by Paul Fusco/
Magnum Photos.

and reliability of many of its episodes and anecdotes have not been, and probably cannot be, verified. Our inability to identify, beyond the revelations of coauthor Alex Haley's epilogue, the seams of the collaborative authorship potentially casts the book into a purgatorial haze somewhere between fiction, biography, and memoir. Although Malcolm told Haley in 1963 that "a writer is what I want, not an interpreter," Haley inevitably interpreted as well as recorded.[42] This tension regarding the book's authorship is exacerbated by that attending the several personae narrated by Malcolm.

Begun in 1963, before the emotional and spiritual upheaval of Malcolm's separation from the Nation of Islam, the *Autobiography* contains, in the form of its unseen early drafts and revisions, much scar tissue. As Marable noted, it is in fact "three distinctly different books."[43] Had Malcolm lived and rewritten the *Autobiography* later in 1965, "the picture might have been steadier, but it would not be the fascinating multiple exposure it is."[44] Malcolm was aware of the difficulty—even dishonesty—of creating a stable, retrospective narrative perspective, and in his contribution to the book he sought "to defend himself against the fiction of the completed self."[45] He questioned, in a postscript to a letter to Haley, "How

is it possible to write one's autobiography in a world so fast-changing as this?"[46] With Haley's assistance, Malcolm would write this ontological skepticism into the book's structure. My discussion of Haley and Malcolm's collaboration begins with the first detailed scholarly examination of "I'm Talking to You, White Man," an impressively illustrated *Saturday Evening Post* article to which Malcolm objected after it was published. The chapter concludes with a detailed analysis of the *Autobiography*'s manner of illustration and the editorial and commercial presentation of various American and British editions of the book.

The third chapter, "Mainstream Culture and Cultural Revolution (1965–1980)," focuses, first, on the dramatic challenge to the orthodoxy of Malcolm's visual representation, undertaken initially, in response to Malcolm's death, in such radical African American magazines as *Liberator*. While providing the most comprehensive analysis to date of Malcolm's representation during this influential period, the chapter also addresses the circulation of the iconography by way of the *Autobiography* and Malcolm's other "almost sacred texts," including several posthumously published collections of speeches, interviews, and letters.[47]

Additionally, chapter 3 considers the Black Arts Movement and its unraveling, focusing on Malcolm's visual and vernacular currency in paintings, murals, poetry, plays, and an unlikely, if tellingly iconographical, format—unproduced screenplays about Malcolm by two distinctive African American writers: Amiri Baraka and James Baldwin. Baraka, like many others, was promptly radicalized by the assassination.[48] As well as invigorating a generation of radicals, Malcolm's death, by enabling his resurrection as an icon and martyr, even in Christian terms, helped bring him closer to conventional African American political thought. Malcolm, cast "in the role of father figure to be overcome by later generations," both daunts and haunts subsequent African American literature and culture as a kind of object lesson in blackness.[49]

The last thirty years have been a period of both renewed scrutiny and abstraction in the representation of Malcolm X, marked by further generic diversification, a pinnacle of popular interest, and the more distinct dispersal of the narrative of Malcolm's life and death into its discrete images: Malcolm as black nationalist; as Pan-Africanist; as socialist; as humanist; as Sunni Muslim; as martyr. It is a testament to the complexity of his contribution to history that "very different images of Malcolm X

can be drawn from words, phrases, and writings of various periods of his life."[50] The mutability of his ideology, however, has left him susceptible to decontextualization and oversimplification, especially within the mass consumer market that has accelerated his translation as "a hologram of social forces."[51] Nell Irvin Painter has suggested that emotional investment in Malcolm has demanded an evacuation or an avoidance of factual detail: "If Malcolm X is to work as a racial symbol, it is best not to look at him too closely."[52] More recently, Marable lamented that, in becoming an emblem of nostalgia, Malcolm "is presently being 'dispossessed' of the actual content of his words, ideas, and actual history."[53] In this selective remembrance, certain images, phrases, or moments have indeed come to dominate: Detroit Red; the man and the microphone; "by any means necessary"; the assassination. The memory of Malcolm is often indistinguishable from an album of his iconic poses. The fourth chapter, "From Hollywood to Hip-Hop (1980 to the present)," however, is concerned more with the retention than the evacuation of meaning.

In 1992 an improvised Malcolm X memorial appeared at the site of the beginning of the Los Angeles riots. The stark image, captured by photojournalist Paul Fusco, of a placard placed atop a burned and shattered Chevrolet festooned with Pan-Africanist ribbons in red, black, and green, appeared to incite African Americans to consciousness and further action during a period of civil unrest. Between April 29 and May 4, fifty-three were killed and dozens of businesses were ransacked or burned, partly in protest of the acquittal of four Los Angeles police officers who had been videotaped beating Rodney King in March 1991. An inscribed piece of wood in front of the placard demanding "Freedom!" further identifies the site as a shrine to the man who sought to make American democracy more accountable. Fusco's photograph, which both engages with and transcends the memorial's Los Angeles context, is suggestive of Malcolm's oracular legacy and continued association with the rhetoric of African American self-defense and rebellion, demonstrating his image's ability to signify powerfully some decades after his death.

Malcolm's continued currency has also been demonstrated by the maturation of a Malcolm X publishing industry, beginning in the early 1990s. Notable—and, in some cases, controversial—books by, among others, Bruce Perry, Joe Wood, Michael Eric Dyson, and Marable appeared at this time. Recent depictions of Malcolm in comic books, pulp

novels, and literary fiction further reveal his absorption into a broader cultural mythology, employing him as a figure representative of an often idealized revolutionary age. As well as interpreting Malcolm, these books (and their publishers) have had a stake in exploiting and perpetuating certain iconic images; trends in publishing, indeed, have affected the remembrance of the radical past.

The renewal of interest in Malcolm was also significantly advanced by the publicity generated in the buildup to the release of Spike Lee's *Malcolm X* (1992). My discussion of the film addresses the influence of Malcolm's iconic photographs on the film's visual design as well as the politics of the film's production and marketing, including Lee's decision to cite both the *Autobiography* and Baldwin's screenplay as sources while departing significantly from both in his own script. It is worth considering whether the Hollywood spectacle of *Malcolm X* has displaced other images of the radical minister through sheer capitalist force. The chapter concludes with a discussion of the role of hip-hop music—a mainstream genre informed by (and informing) Lee's cultural politics—in extending Malcolm's countercultural appeal to audiences black, white, and beyond since the 1980s.

Given the lack of consensus about his meaning in contemporary culture and politics, it is perhaps unsurprising that Malcolm is a common referent in the disparate rhetoric at either end of the current period's fundamental (or fundamentalist) ideological dispute—that of the so-called War on Terror. Following an account of Malcolm's cultural afterlife on the streets of New York and London, the book concludes, in a chapter titled "Continuing Signification," with a consideration of what recent invocations of Malcolm by American president Barack Obama and by Al-Qaeda's Ayman al-Zawahiri suggest about his continuing relevance as an iconic figure as we approach the fiftieth anniversary of his death.

As well as imploring us to vigilance in observing representations of racial difference throughout contemporary culture, the iconography of Malcolm X has a more elemental function. It demonstrates the consistent cultural practice of the production and retrieval of meaning through images: "The old process continues: history becomes mythology, mythology begets ritual, ritual demands icons."[54] The many images of Malcolm have served to contain and allude to the many narratives that have been produced by and about him. That images have appeared across so many

genres is attributable to his life and death's ascendance to the level of myth. It seems that a life and death so public and, finally, traumatic, must have—or must be given—a unifying meaning or purpose beyond the glib assessment of the man as a vicious demagogue. Wood has argued that "in figuring the Malcolm icon, we can suppose a Black people."[55] This has been Malcolm's primary use. With the aid of so observable and exemplary a figure, it is possible to suppose much more. Despite the competing claims for ownership of his meaning, Malcolm X's defining characteristic was, and in his cultural afterlife is, an ability to exceed any single form of ideological control.

CHAPTER ONE

EARLY IMAGES OF MALCOLM X
(1957–1965)

The symbols and images that for so long disfigured black minds had to be jettisoned.
Gordon Parks, *Voices in the Mirror*

There was a myth of the Negro that had to be destroyed at all costs.
Frantz Fanon, *Black Skin, White Masks*

In his preface to *Black Nationalism* (1962), Nigerian scholar E. U. Essien-Udom wrote that "Minister Malcolm X of the New York Temple, who has been described as the 'Nation's Ambassador at Large,' proved to be of great assistance concerning the ideological questions and administrative problems posed by the movement."[1] The observation was typical. For contemporary commentators on the Nation of Islam, the questions and perceived problems were many. All, however, met with a willing respondent in Malcolm X, the Nation's "most respected apologist and theologian"—and also, crucially, beginning in 1957, its photogenic spokesman.[2]

This chapter examines the cultivation and circulation of Malcolm's media image from 1957 to his assassination in 1965. Drawing on archival and textual research, it contains the most detailed discussion to date of two decisive components of the iconography of Malcolm X: Malcolm's theory of visual representation and his photographic depictions. The chapter addresses Malcolm's interest in the psychological consequences of the negative representation of Africans and black Americans, and it breaks new critical ground in arguing that he developed his theory of "the science of imagery" from Elijah Muhammad's teaching regarding "tricknology," the proliferation of a repressive system of racialized signs. This theory will be seen to have informed and motivated Malcolm to craft

his image as representative of a series of oppositions to a tradition of black stereotyping that he regarded, above all, as one of emasculation.

The relationship between Malcolm X and the Nation of Islam, visual and otherwise, was both constructive and destructive. As biographer Peter Goldman indicates, through Malcolm, "magazines and newspapers put the Nation on public view. So did the radio and TV talk shows, and, to Malcolm's enormous pleasure, the university lecture bureaus."[3] Whatever pleasure he took in public appearances, it must be acknowledged that Malcolm's increasing visibility contributed to the suspicion and, finally, vindictiveness with which he came to be regarded by the Nation's leadership. Malcolm's uneasy alliance with the cultural mainstream was evident in his earliest portrayals in literature and journalism, and on television, which typically framed his image, religion, and politics as in direct opposition to those of Martin Luther King and others associated with the civil rights movement's core values. The tendency of such scholars as James H. Cone to seek to reconcile Malcolm's and Martin's legacies represents a wishful misrepresentation of the two men's largely media-brokered and undeniably ambivalent relationship as it existed up to the point of Malcolm's death.

The chapter concludes with an analysis of several categories of photography, including Malcolm's visual associations with Harlem and other iconic figures, his use of photography in underlining his evolving style and ideology, and the photographic depiction of his death. Indeed, his visual prominence, once such an asset to the Nation of Islam, can be seen to have contributed to the injurious climate in which he died at the hands of Nation-affiliated assassins.

Early Images of Malcolm X

Malcolm's theory of visual representation emerged from the fabric of Nation of Islam culture and from his prominent role within the movement. Aware as a proselytizer and politician of the utility of mass media, Malcolm inadvertently exposed Elijah Muhammad's Nation to a critical gaze often hostile to its petty autocratic structure and unforgiving of its apocalyptic prophesying. He recognized also that he had pushed himself, as the Nation's primary representative, into a tenuous position: highly visible, yet marginal in his political and religious views in an era of mass

civil disobedience underwritten by Martin Luther King's twin Christian and American faiths. As C. Eric Lincoln indicated in *The Black Muslims in America* (1961), the first book-length discussion of the Nation, it became clear during his tenure with the organization that "Malcolm must abandon either the purity of Muslim dogma or his dream of respectability and massive expansion."[4] Malcolm himself struggled, personally and intellectually, to extricate himself from association with the Nation following his departure from the organization in early 1964. He also struggled during the last thirteen months of his life to distinguish himself representationally.

In the decade prior to Malcolm's death, the sensationalism of the news media led to the entrenchment of "Malcolm X" as his most clearly defined persona, a fact with which Malcolm and many others since would find it necessary to contend. The Malcolm most clearly delineated during his lifetime was that associated with the statement "the white man is the devil."[5] Thus, Malcolm was framed more as villain than hero by those publications and individuals through and to whom he spoke.

Profoundly suspicious of what he called "the shrewd white man with his control over the news media and propaganda," Malcolm nevertheless admired and understood mass media's ideological efficacy.[6] In 1957 he began writing a short-lived column syndicated in several African American newspapers, including the *New York Amsterdam News*. The column, titled "God's Angry Men," and its eventual replacement, "Mr. Muhammad's Messages," written by Elijah Muhammad, drew the condemnation of white journalists. The 1959 TV documentary *The Hate That Hate Produced* expressed concern that the Nation's "story of hatred is carried in many Negro newspapers"; the program went on to describe a photograph by Lloyd Yearwood of "Minister Malcolm X proudly displaying five of the biggest Negro papers in America—papers published in Los Angeles, New York, Pittsburgh, Detroit, and Newark."[7] Malcolm's column also drew the attention of the FBI; his increasing media profile was accompanied by the scrutiny of COINTELPRO (Counter Intelligence Program) surveillance. His words from a 13 February 1958 column appear in an FBI report in all their evangelical excess: "the greatest LIVING EMANCIPATOR and TRUTH BEARER that the world has ever known . . . is right here in America today in the person of ELIJAH MUHAMMAD," of whom "Moses, Jesus and Muhammad all spoke" and "who would be here in America in the 'last days'

of the 'white world' with a Divine Message of NAKED TRUTH" for "the long lost so-called Negroes." Alarmed by his preachments, both within the Nation's Temple Number Seven and abroad, and by his increasing visibility, the FBI's New York office presumed Malcolm's political menace, declaring him a "key figure" for observation in a July 1958 report.[8]

Despite Muhammad's warning to Malcolm that "you will grow to be hated when you become well known," Malcolm would be relentless in his pursuit of greater visibility for the Nation.[9] While supervising the establishment of a mosque in Los Angeles in 1957, he spent time in the offices of the *Herald-Dispatch*. Following this brief publishing experience and the acquisition of "a secondhand camera," he went on to found, with the help of journalist Louis Lomax, *Mr. Muhammad Speaks,* a precursor to the Nation of Islam's widely distributed *Muhammad Speaks* newspaper, claiming that the "initial editions were written entirely by me in my basement."[10]

As the Nation expanded, Malcolm would find it expedient to delegate and collaborate. Although writing for mainstream or white publications, the first significant interpreters of the Nation were necessarily black: as a matter of policy, white journalists and researchers were excluded from most of the Nation's functions. The tendency to conspiratorial fantasy on the part of the black, and eventually the white, authors of the Nation's infamy rapidly became apparent. Whether for reasons personal or professional, those journalists with access to the Nation—including Lomax and Alex Haley—did little to quell the rising terror at its aims. The journalism on the Nation from this period partakes of what Richard Hofstadter described in 1964 as "the paranoid style"—a kind of sensationalism that provokes and exploits the fear of catastrophe. According to Hofstadter, "the paranoid spokesman sees the fate of conspiracy in apocalyptic terms—he traffics in the birth and death of whole worlds, whole political orders, whole systems of human values. He is always manning the barricades of civilization."[11] The initial images of Malcolm X were informed by similar narratives of apprehension.

In *The Negro Revolt* (1962), Lomax wrote that the Nation's "withdrawal from America is almost complete" and that it presented "a threat for the future."[12] Haley and Alfred Balk, in their article "Black Merchants of Hate," alerted the reader to "the awesome discipline and power of this

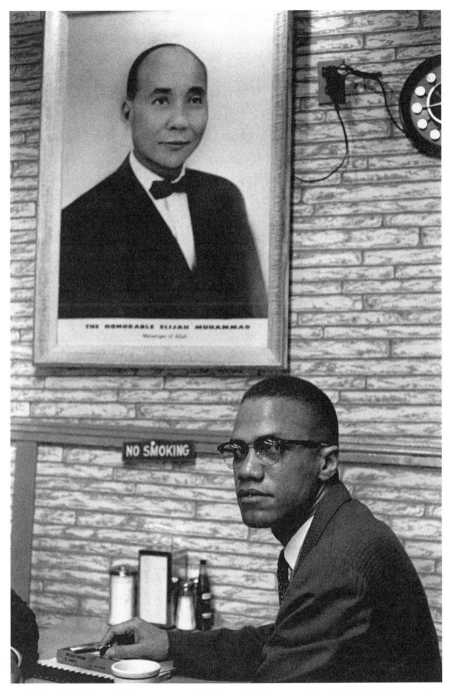

Malcolm X in Nation of Islam restaurant, Harlem, 1961. Photograph by Henri Cartier-Bresson/Magnum Photos.

militant, semisecret, anti-white, anti-Christian sect."[13] An article published in *Time* on 10 August 1959 typified the prevailing perception of the Nation as little more than a criminal cartel, characterizing Elijah Muhammad as a "purveyor of cold black hatred" and his "New York leader, Malcolm X, once Malcolm Little, [as] an ex-convict who has been arrested for larceny in two states." According to the article, titled "Races: The Black Supremacists," "the Moslems are of rising concern to respectable Negro civic leaders, to the National Association for the Advancement of Colored People [NAACP], to police departments in half a dozen cities, and to the FBI."[14]

In *Life* in May 1963, the African American journalist Gordon Parks provided a more sympathetic portrayal of Malcolm the spokesman, who, Parks indicated, "served as my guide through the intricacies of Islam." Parks's article, "The Black Muslims," allowed Malcolm to speak at length and with a degree of political nuance absent from other early journalistic accounts.[15] Rather than framing him as a mere upstart or rebel conspirator, Parks permitted Malcolm to contextualize his racial politics with a critique of conventional patriotism and American foreign policy in Vietnam. Although more tolerant in his early assessment of Malcolm than other journalists, Parks's first impression was illustrative of Malcolm's susceptibility to controversy. It was also prophetic of his violent death. Upon witnessing Malcolm railing at "a cordon of white policemen who stood to the rear" of a Harlem street rally, Parks told himself, "That's one crazy black man. . . . He'll be lucky to live out the winter."[16] Malcolm would not survive two more.

The psychologist and television host Kenneth B. Clark has suggested that Malcolm, ever conscious of projecting an image, was difficult for interviewers and authors to know privately: "He is conscious of the impression of power which he seeks to convey, and one suspects that he does not permit himself to become too casual in his relations with others."[17] Indeed, Malcolm tended toward the strategic rather than the sentimental in his regard for those journalists who shaped his early image. He remained wary, however, of their potential for purposeful misrepresentation. On one occasion, he openly accused the *Los Angeles Times* of colluding "with LAPD Chief William J. Parker in suppressing the facts" of the shooting of several Nation of Islam members in April 1962 by police.[18] Alex Haley recalled collecting "provocative material" for a *Reader's Digest*

article on the Nation in 1959. He sought out Malcolm at the Nation's restaurant in Harlem: "When my purpose was made known, he bristled, his eyes skewering me from behind the horn-rimmed glasses. 'You're another one of the white man's tools sent to spy!' he accused me sharply."[19] Despite this initial skepticism, Malcolm's collaboration with Haley would result in nothing less than a *Reader's Digest* article, a *Playboy* interview, two articles in the *Saturday Evening Post,* and, most importantly, *The Autobiography of Malcolm X.*

Clearly, negative publicity was no deterrent to Malcolm the spokesman. The *Autobiography* expresses his sense of anticipation for the controversial telecast of *The Hate That Hate Produced* and the publication of Lincoln's *Black Muslims in America:* "Every Muslim happily anticipated that now, through the white man's powerful communications media, our brainwashed black brothers and sisters across the United States, and devils, too, were going to see, hear and read Mr. Muhammad's teachings which cut back and forth like a two-edged sword."[20]

Lincoln, given access in 1959 to the Nation's "inner circle"—including "chief aide" "Minister Malcolm X Shabazz, minister of the powerful Temple No. 7 in Harlem"—made clear his lack of identification with Elijah Muhammad's teachings, which he described as "intellectually repugnant."[21] In spite of such censure, Malcolm understood the effectiveness of Lincoln's book as a promotional vehicle, crediting it, along with the 1963 *Playboy* interview with Haley, with launching his new career as a visiting speaker at American colleges and universities.[22]

A second study, Essien-Udom's *Black Nationalism,* appeared soon after Lincoln's. Essien-Udom, more transparent in his methodology than Lincoln, collected information by shadowing members of the Nation's Chicago and New York temples (including Malcolm) for two years. He was given access to religious literature authored by Elijah Muhammad and other restricted documents from the Nation's formative years. Unlike most other early authors, Essien-Udom presented in balanced terms the flaws inherent in the oppositional theories of race that contributed to the Nation's development, stating that its existence "reveals how deeply the cancer of American racism has infected all [of America's] parts, making the oppressed and oppressor mutually depraved."[23] Identified here is the rhetoric of racial opposition that Malcolm's early images were taken primarily to signify.

The Nation of Islam

Malcolm's affinity for public relations had perhaps first been demonstrated on 14 April 1957. His leading of a demonstration outside the Twenty-eighth Precinct in Harlem, following the beating and arrest of Hinton X Johnson by New York police, is generally considered as initiating his public profile in the eyes of Harlemites and the New York authorities. A policeman's comment following Malcolm's dispersal of the crowd with a wave of his hand, that this was "too much power for one man to have," is unfailingly related in biographical accounts.[24] The demonstration, perhaps more than any other single event prior to the airing of *The Hate That Hate Produced,* made Malcolm aware of the utility of publicized performance in recruitment for the Nation. The spectacle of peaceful protest in defiance of police brutality lifted Malcolm to a position of esteem as a community leader in Harlem.

The principles of the Nation itself were displayed to good effect on that day. Witnessing the military discipline of the Fruit of Islam, the disciplinary body of the Nation that bore no arms, onlookers were "impressed by the brothers' clean-cut appearance" and "their proud, soldierly bearing." Convert Benjamin Karim claimed that "the more I heard about the whole episode the more I wanted to be one of those men. I resolved to attend the services at the temple the next Sunday."[25] The Nation rose to prominence suddenly and, with its impressive military structure, as if fully formed. At the moment of their apparent emergence "the Muslims didn't appear to be seeking power; they seemed already to have it."[26] Precisely that which struck Karim was that which threatened Malcolm's earliest commentators: the organization of the African American urban "underclass" into an internally coherent unit founded upon values both reactive against and eerily reflective of dominant American ones.[27] It was with such contentious unions of the conservative and the apparently revolutionary that the Nation and Malcolm first made themselves visible.

The images of militancy and militarism projected by Malcolm X and the Fruit of Islam achieved their divisive aims. As well as arousing feelings of pride and purposefulness, the spectacle of disciplined congregation led to fears of conspiracy bearing all the marks of irrationality. *Time* reflected: "Thus far the Moslems have been strictly law-abiding—a fact that worries some cops more than minor outbreaks of violence."[28]

Lincoln described the Fruit of Islam in hyperbolic terms as "the secret army"—"the nucleus of [the] force" that was the Nation in its entirety: "The entire Movement is, in short, a kind of reserve fighting corps—a potential phalanx of Black Men ready to wage open war against the white community in case of white provocation."[29] The terms with which the Nation was introduced to a national audience were at once dismissive of and deeply concerned with its values. In 1963 Haley and Balk wrote of the Nation as "fanatic and well disciplined," warning that "Negro 'Muslims' threaten to turn resentment against racial discrimination into open rebellion."[30] Given Elijah Muhammad's apparently poor health, advanced age, and elfin appearance, the imputations of violence and false religion were typically directed at Malcolm, as spokesman and "first plenipotentiary" of "the Movement."[31] Balk and Haley went on to compare the Nation to the Nazi Party and the Ku Klux Klan; they would label Malcolm a violent crusader and "a worse threat to society than the criminal," describing him with subtle derision only as "Malcolm Little" and "Detroit Red."[32] With his criminal record, his advocacy of armed self-defense for African Americans, and his comprehensive rejection of Christianity, Malcolm may for a time have become "the most feared man in American history": an Adolf Hitler stirring up the black masses, a Nat Turner for the mass-media age.[33]

What most terrified Malcolm's early critics were the implications of the inevitability of African American violence, delivered with a cool grin, and inspired most frequently by references to the nonviolent demonstrations of the civil rights movement's mainstream, typically associated with Martin Luther King, who emerged as a leader of national significance during the Montgomery, Alabama, bus boycott of 1955. What Malcolm called for was not arms so much as the acknowledgment of the consequences of a history of violence toward African Americans—of the existence of "a racial powder keg" that the dominant culture must be held responsible to defuse: "All she's got to do is give the black man in this country everything that's due him. Everything."[34] His aim was, on one hand, for white Americans to confront the same fear of physical assault that had long distressed African Americans and, on the other, for African Americans to overcome it. Nevertheless, his statements on violence were generally rather prosaic iterations of the principles of readiness and self-defense. In 1963 Malcolm declared, "Islam is a religion that teaches us never to

attack, never to be the aggressor—but you can waste somebody if he attacks you."[35] Predictably, such statements were taken out of the context of Malcolm's fully articulated belief and conduct. That members of the Nation were expressly taught to be nonviolent save in situations necessitating self-defense was often represented as a dangerous, if latent, culture of vengeance. Few of his critics took comfort in his confidence, derived from Elijah Muhammad's teaching, in Allah's divine retribution for the abuses of the white race. Indeed, such beliefs and the statements they engendered were met with claims of black supremacy or reverse racism. That Malcolm confronted white America with its own acts of violence and a rhetoric alluding to African American revenge was for many both unthinkable and unforgivable.

The perception that Malcolm could succeed to leadership of the Nation, in particular, called forth concern. In *The Black Muslims in America*, Lincoln had anointed Malcolm the "Big X" and the likely successor of Elijah Muhammad. Lincoln captured the distinctive brand of deferential ambition that brought Malcolm so near to Muhammad's throne: "He is clearly superior to Muhammad in intellect, yet he credits Muhammad with 'everything I know that's worthwhile.'"[36] In his May 1963 *Playboy* interview with Haley, Malcolm addressed the assumption that he was "the real brains and power of the movement": "Sir, it's heresy to imply that I am in any way whatever even equal to Mr. Muhammad. No man on earth today is his equal. Whatever I am that is good, it is through what I have been taught by Mr. Muhammad."[37] Lincoln predicted that with the seemingly imminent death of Elijah Muhammad, "the now capped volcano of rivalry and dissension is likely to erupt."[38] The prospect of Malcolm becoming a messianic leader was alarming to complacent Nation of Islam officials, the FBI, and journalists such as Lomax, who had been introduced to the Nation of Islam by a street-corner speaker during a visit to Harlem in 1958.[39] According to Lomax, unlike the tall and athletically built Malcolm X, "Muhammad is a strikingly unimpressive man; he is small, five feet five, and speaks with a disturbing lisp. It is difficult to believe that he is the moving spirit behind a religion that is now being taught in fifty schools across the nation."[40] Malcolm, with his comparative youth, charisma, and articulacy, was regarded as an unheralded figure of potential messianic fanaticism.

In shedding light on the Nation, its early interpreters often found themselves providing a service of unwitting third-party recruitment. Lomax wrote of his regret that "it is impossible to conduct a public discussion of a group's activity without moving some people to go out and join that group." Coverage of the Nation also necessarily reinforced the visibility of Malcolm, its spokesman. Lomax's account illustrates the common, if ultimately inaccurate, perception of Malcolm as the groomed heir to the Nation's throne. Due to failing health, he reported, much of Elijah Muhammad's "work, and all his speaking engagements, [were] being carried on by Minister Malcolm X, whom many feel will one day be the leader of the movement." Lomax described the minister with cautious regard: "Malcolm X is a tall, lanky, light-brown-skinned man with an almost innate mastery of mass psychology. He served a prison term for robbery; now he is changed. He will not smoke, drink or even eat in a restaurant that houses a bar. He says the change came when he heard Mr. Muhammad speak and he lost his shame about being colored."[41]

This early rendering of Malcolm's biography is telling in its anxiousness, pointing as it does to several frequently mentioned traits: his imposing figure, mixed ancestry, potentially dangerous oratory, and equally (if more subtly) threatening asceticism. The mention of "mass psychology" suggests a preoccupation with the fascistic potential of Malcolm's leadership. In presenting an image of embittered and manipulative racialism cloaked in liberatory prophecy, Lomax's portrait of Malcolm displays suspicion of his particular brand of extremism.

Malcolm X was not the first prophetic African American leader regarded as a messianic figure. Like Marcus Garvey and Elijah Muhammad, he would come to be compared with Moses, the prophet and deliverer, extending an African American cultural preoccupation, originating during enslavement, with "the metaphor of Exodus."[42] Despite their genuine appeal as nonconformist heroes of humble origins "mirror[ing] the folk soul, promis[ing] power to the weak, and inspir[ing] revolt against the mighty"—and despite the fact that, according to Wilson Jeremiah Moses, "black messianism has always been reinforced by the messianic strains of American culture"—suspicion and persecution have typically stalked the prophetic leaders of black nationalist organizations.[43] Following a mail fraud conviction, Marcus Garvey, editor of *Negro World* and founder

of the Universal Negro Improvement Association (UNIA) and Black Star Line, was deported from America to Jamaica in 1927. After Nation of Islam founder W. D. Fard Muhammad's disappearance and possible deportation in June 1934, his most enthusiastic disciple, Elijah Muhammad (formerly Poole), would succeed him, consolidating his spiritual authority—as Malcolm would seek to do in turn—by circulating photographs and writing and distributing such texts as *The Supreme Wisdom* (1957) and *Message to the Blackman in America* (1965).[44] After his arrest in April 1934 by Detroit police following his establishment of an Islamic parochial school, Muhammad, under threat from various religious rivals, left Detroit and took on a number of aliases. He would be imprisoned in 1943—as Gulam Bogans—for inciting draft resistance. While serving his own sentence for burglary from 1946 to 1952, Malcolm would initiate his influential career as Muhammad's disciple.

Tricknology

Much as Malcolm's rhetoric of self-defense initially overshadowed his other views, the stridency of the Nation's "spiritual jihad against white supremacy" tended to obscure its underlying philosophy of racial uplift, which emphasized patriarchal gender roles and "collectivist capitalism," best exemplified by the Muslim restaurants often adjoining mosques.[45] Far from seeking specific legislative reforms—indeed, he discouraged both voting and participation in sit-ins—Elijah Muhammad aimed, with his moral reforms and plans for African American economic independence, at overturning the "perverted logic" that "turns to the past of the oppressed people, and distorts, disfigures and destroys it."[46] Muhammad looked to material means to rehabilitate the self-image of his followers; as Essien-Udom put it, "among the Muslims, hard work, thrift, and accumulation of wealth have a semi-religious sanction."[47] Despite the general perception that the Nation had withdrawn entirely from American society, parallels can be drawn between its puritanical reformism and those "Protestant values of cleanliness, thrift, and hard work" reflective of "conventional American morality." The Nation of Islam "attempted to withdraw from American society on a symbolic level, while accommodating bourgeois values on a practical level."[48] Malcolm X would later consolidate this image of defiant puritanism by way of his visual representation.

The Nation's model of racial uplift, like Malcolm's politics of represen-
tation, can be traced to Booker T. Washington's work with the Tuskegee
Institute from 1881, documented in his *Up from Slavery* (1901). Along
with education in industry, intended to reveal "the dignity of labour" to
black Southerners, and academic subjects, Tuskegee provided a swift in-
duction to the morality of personal cleanliness: "Over and over again the
students were reminded in those first years—and are reminded now—
that people would excuse us for our poverty, for our lack of comforts and
conveniences, but that they would not excuse us for dirt."[49] The Nation
inherited Washington's preoccupation with "inspiring self-respect and
promoting virtue" through cleanliness and professional appearance, per-
haps, in spite of Washington's protestations to the contrary, in the inter-
ests of dismantling the cultural nexus conflating black skin with poverty,
uncleanness, and sin—of "black skin as evidence of a dangerous vicious-
ness," invoking, consciously or unconsciously, a white assessment of
black bodies.[50]

In the Nation's temples—they would be called mosques only from
December 1961 following Elijah Muhammad's return from a trip to
Mecca—Malcolm taught the importance of purifying and thus liberating
the African American body through "the performance of ritualized du-
ties" including prayer, "hygiene, personal cleanliness, reading, writing,
and maintaining the proper body weight."[51] Avoidance of pork was also
central to his teaching, as indeed it was to his initial conversion to Nation
of Islam doctrine: "Carrying 999 poisonous germs and 'grafted' from the
rat, cat, and dog, hog meat came to represent enslavement, ignorance,
subjugation, impoverishment, and shame."[52] In religiously cleansing
oneself of such behavioral remnants of slave culture, the Nation's mem-
bers could begin to transform both their self-image and perception by
others. The dissociation from the vulgar here was motivated not only by
moral but also representational sensitivity: a distaste for the sensuality
associated with southern stereotype.

The dietary restriction on pork in fact represents one of few instances
in which Elijah Muhammad's teachings reflected those of Islamic ortho-
doxy; in other ways it can be argued that the rituals and rhetoric of the
Nation were as profoundly devoted to Christian reactionism as to the
Koran. Dissatisfaction, on the part of African Americans, with the hy-
pocrisy of American Christianity was long-standing. Typically, though,

critique was intended as a corrective for an institution whose values were regarded as infallible and renewable. In 1845 Frederick Douglass stated that "between the Christianity of this land, and the Christianity of Christ, I recognize the widest possible difference."[53] Douglass here provided a nineteenth-century precedent for Martin Luther King's sense of a "social gospel." In King's view the renewal of the church was prerequisite to the renewal of American society through faith.[54] Malcolm's position on the church was of course far more skeptical; he would state that "only the poor, brainwashed American Negro has been made to believe that Christ was white, to maneuver him into worshipping the white man." He went on to argue that "the world since Adam has been white—and corrupt."[55] His verdict encompassed representation as well as ideology. That images of Christ and the original man were apparently manipulated to uphold the dominion of the white race was a powerful illustration, for Malcolm, of Elijah Muhammad's teaching that all of "history had been 'whitened'" in the interests of the preservation of white privilege.[56]

Elijah Muhammad termed this practice of ideological inscription "tricknology" or, as Essien-Udom has it, "tricknowledgy."[57] Islamic historian Michael A. Gomez describes tricknology as a "process of falsification" that "is akin to a science"; its "schemes of fabrication cover a wide range of areas, but the principal canard concerns religion and the promulgation of the noumenal."[58] Nation of Islam teaching, with its logic of inversion, presented itself as an antidote to the false knowledge and images disseminated by the dominant culture. During his time with the Nation, Malcolm thus acknowledged the need to liberate the African American mind, as well as the body, by way of materialist racial and social analysis. He would characterize the self-destructive psychological dependency of black people as a corruption of nature: "No, there is plenty wrong with Negroes. They have no society. They're robots, automatons. No minds of their own. I hate to say that about us, but it's the truth. They are a black body with a white brain. Like the monster [of] Frankenstein."[59] Despite this reference to Frankenstein's monster, Malcolm's religion did not instill in him an anxiety regarding the hubristic ventures of modern science. On the contrary, Elijah Muhammad's philosophy embraced a metaphysical notion of science that aligned it with social dominance in its desirable (black) and undesirable (white) forms.

"Reinforcing the image of man as god while reifying his achievements as scientist," Gomez argues, the Nation taught that "trillions of years ago a council of twenty-four scientists-cum-elders was convened, who regulate human affairs by writing their history before it happens, and for spans of 25,000 years (a number that 'accords' with the approximate circumference of the earth in miles)."[60] The numerological myth points to the incontrovertible "scientific" authority of prophetic "history," thereby challenging the legitimacy of conventionally retrospective modern Eurocentric history—a rather mystical framing of the power of literacy. In addition to courses in Arabic for Koranic study, Nation of Islam temples gave lessons to members in advanced calculus, apparently in an attempt to return to the mastery of their forebears, those scientists who scripted history and extracted the white race from the black: according to Elijah Muhammad, the white race was grafted from the black race over a period of six hundred years by Yakub, the "big-head scientist" of the council of twenty-four.[61] The Nation's millenarian vision matched this creation story for technological fantasy; Muhammad anticipated the expiry of white dominion upon the arrival of an armed "mother plane" or ship in approximately 1970, whereafter the "Original People" would enjoy the installation by Allah of the "New World of Islam," a kind of heavenly dominion on earth. In keeping with the Nation's materialist analysis, there was to be no afterlife.[62]

As the Nation's spokesman, Malcolm X bore the responsibility for interpreting such beliefs to outsiders. Consequently, for sympathetic observers, it was Malcolm rather than Elijah Muhammad who became an emblematic iconoclast concerned with overthrowing a slave mentality. This latter process, later termed "psychic conversion" by Cornel West, entails "the decolonization of the mind, body, and soul that strips white supremacist lies of their authority, legitimacy, and efficacy." More simply, it is the "Black affirmation of self" enabled by an altered self-perception.[63] For Malcolm, this reaffirmation began with the banishment of white religious images and narratives and their replacement with black ones. The Martiniquan theorist Frantz Fanon argued for the psychological necessity of acts of cultural nationalism on the part of colonized groups: "This tearing away, painful and difficult though it may be, is however necessary. If it is not accomplished . . . the result will be individuals

without an anchor, without a horizon, colourless, stateless, rootless—a race of angels."[64] Himself a convert of Elijah Muhammad's "ego-restoring rhetoric," Malcolm remained aware that black audiences outside the mosques responded more warmly to this aspect of the Nation's teaching than to its theology and tailored his speeches accordingly.[65] Often wisely circumspect in his statements to the mainstream media about the Nation's more arcane teachings, Malcolm preferred to compare the Nation's essential teachings to those available in American schools. Employing the language of psychiatry, he described the curriculum of the Nation's parochial schools for Muslim children in Chicago and Detroit: "We teach them the same things that they would be taught ordinarily in school, minus the *Little Black Sambo* story, and things that were taught to you and me when we were coming up, to breed that inferiority complex in us."[66]

Although typically reticent about "Yakub's History," Malcolm retained, and after leaving the Nation in 1964 continued to evolve, a theory of ideological control through representation that he would come to call, in a speech given on 16 February 1965, the "science of imagery." In the speech, given in Rochester, New York, less than a week before his death, Malcolm revealed a continued insistence on the central role of the circulation of the distorted, "hateful image" of Africa in fabricating the inhumanity of persons of African descent.[67] Malcolm's interest in the relationship of image and self-image was here made clear. In the interests of strengthening the self-image of African Americans, Malcolm would develop, from the cultish teachings of Elijah Muhammad, and indeed the Garveyite influence of his parents, Earl and Louise Little, in his early childhood, a religious, political, and educational philosophy privileging pride in African origins and images. (Malcolm's parents were members of Garvey's UNIA; according to Malcolm's eldest brother Wilfred, "Garvey had visited their home on several occasions."[68]) However problematically, for the Nation's members, Islam represented the avenue to a spiritual connection with Africa disrupted by enslavement. In 1964–1965 Malcolm would move beyond Muhammad's synecdochic and racially suspect identification with Africa through Morocco or Egypt, rather than sub-Saharan West Africa, and come to embrace a more intellectually defensible position as a Pan-Africanist Sunni Muslim; he would retreat from the white devil theory, if not from his uncompromising critique of American racism, and denounce Elijah Muhammad as a "religious faker."[69]

Masculinity, Visual Culture, and Self-Representation

In a visual culture traditionally rife with stereotypical depictions of African Americans as servile and inarticulate beings, Malcolm X left an impressively nuanced record of self-representation. The writer Thulani Davis has noted Malcolm's assurance of our mediated access to him: "Were it not for the constant presence of reporters and electronic media around him we might not have been aware of the slight turns and changes as they came about."[70] The images he presented of himself were informed by his evolving theory of the science of imagery. As much as racial analysis, Malcolm's genius was for the contrivance of images of himself. His legendary transformations, marked by renaming, are also abundantly illustrated.

Although such clownish cinematic and televisual figures as the garishly attired Stepin Fetchit (the self-described "World's Laziest Man") and the bumbling Amos 'n' Andy did not specifically enter his analysis, Malcolm's self-representation enacted a resistance to their legacy.[71] Like many critics, he recognized that such images "were far better suited for the denigration than the elevation of black Americans."[72] James Baldwin insisted that, in the early 1960s, this cultural insight had become increasingly commonplace and that "even the most deluded black person" knew "more about his life than the image he [was] offered as the justification of it."[73] Criticism and protest of what Larry Neal would in 1969 call "a prison of distorted symbols and images" indeed occurred prior to the civil rights movement.[74] The NAACP lobbied for decades against the customary stereotypes, derived from early cinema's roots in vaudeville or "ethnic theatre" and American culture's general "infusion . . . with Southern lore"; it was not until 1942 that the organization received the assurance of studio executives that Hollywood was "to abandon pejorative racial roles, to place Negroes in positions as extras they could reasonably be expected to occupy in society, and to begin the slow task of integrating blacks into the ranks of studio technicians."[75]

In the late 1950s and early 1960s, subversion of stereotypes within mainstream visual media was still uncommon. The predominance of "racial mirages, clichés, and lies" arguably led to a disjunction between African American audiences and media figures that Malcolm X, who had a reputation for "telling it like it *is*," was well positioned to redress.[76] In

1962 Essien-Udom wrote that the "Negro 'greats' are, for the masses, brothers in skin but not in destiny," identifying a failure in the presumed equation of popular visual culture and African American leadership.[77] Malcolm would claim that "the black masses prefer the company of their own kind"; with his youthful Harlem residency and prison education, he often implied that his street credentials were well earned.[78] According to Malcolm, "the masses of black people [did]n't support Martin Luther King"—they supported him.[79]

Perhaps surprisingly, photographs of Malcolm reveal that his characteristic facial expression was not one of righteous anger but a smile of uncommon warmth. Just one aspect of his charismatic bearing, his smile must be situated in the context of a tradition of images of doltish grins that he sought to subvert. Much closer in kind to controversial heavyweight boxer Jack Johnson's "golden grin" than the grossly hyperbolic blackface images of Sambo and minstrel character Jim Crow, Malcolm's smile stood in bold defiance of the expectation of black male contented subservience, which had been "the basic mode of propaganda in defense of slavery."[80] According to jazz composer Miles Davis, whose rise to iconic status was contemporary with Malcolm's, "every little black child grew up seeing that getting along with white people meant grinning and acting [like] clowns." Indeed, Davis was roundly criticized for his sullen stage demeanor—his unwillingness to engage with or even face his audience. Davis claimed that "my troubles started when I learned to play the trumpet and hadn't learned to dance."[81] As Detroit Red, Malcolm, on the other hand, danced enthusiastically. According to biographer Bruce Perry, in July 1944 Malcolm, under the alias Jack Carlton, "got a job at a nightclub called the Lobster Pond, where he worked as a bar entertainer and used his dancing ability to good advantage."[82] Most images of Malcolm, however, can be seen as antithetical to the stereotype of the "childlike black male figure characterized by a constant grin; the ability and the desire to work for, to entertain, and to serve whites; and the absence of anything resembling wisdom or political potency."[83] With his latter-day sober suits, asceticism, and intellectualism—interesting also when considered in contrast to his zoot-suited, libertine, jive-talking teenage years—Malcolm distanced himself from what he considered a reprehensible past.

Malcolm most specifically directed his critique of visual culture at the images produced by the nonviolent protests of the mainstream of the

civil rights movement—images that, for him, represented not African American heroism but victimhood. Raised in a culture of limited integration and schooled in the countercultural ethos of the urban ghettos of the Northeast, Malcolm saw nothing sympathetic in images of protest suggestive of partial acquiescence to Jim Crow custom in the South. The *Autobiography* aligns the integrationist cause with the distortions of the science of imagery: "The truth is," Malcolm and Haley wrote, "'integration' is an image, it's a foxy Northern liberal's smokescreen that confuses the true wants of the American black man."[84] In his "The Ballot or the Bullet" speech, Malcolm more specifically critiqued restaurant sit-ins as emblematic of what he perceived as a culture of willing emasculation:

It's not so good to refer to what you're going to do as a sit-in. Then right there it castrates you. Right there it brings you down. What goes with it? Think of the image of someone sitting. An old woman can sit. An old man can sit. A chump can sit. A coward can sit. Anything can sit. For you and I have been sitting long enough and it's time today for you and I to be doing some standing. And some fighting to back that up.[85]

In embracing a rhetoric of physical violence in fundamental opposition to nonviolent protest, Malcolm's language equated his politics with an image of assertive masculinity. Rejecting King's notion, for African Americans, "that Christians should rejoice at being deemed worthy to suffer for what they believe," Malcolm demonstrated a misogynistic impulse in constructing nonviolence as merely feminine; his reference to castration positions nonviolence as a reiteration of the southern assault, associated by Malcolm with both slavery and lynching, on the African American male body and psyche.[86] Peaceful protest seemed to Malcolm little more than the conditioned response of the still enslaved.

In describing the 28 August 1963 March on Washington, which culminated in King's delivery of his "I Have a Dream" speech from the foot of the Lincoln Memorial, Malcolm extended his implied critique of nonviolent integrationism as unmanly: "Yes, I was there. I observed that circus. Who ever heard of angry revolutionists all harmonizing 'We Shall Overcome . . . Suum Day . . .' while tripping and swaying along arm-in-arm with the very people they were supposed to be angrily revolting against?"[87] It was the sublimation rather than absence of legitimate anger

that made the event, for Malcolm, an emasculating "Farce on Washington." He also underlined the event's function as spectacle: "Hollywood couldn't have topped it."[88]

Television

The civil rights movement was much televised, arising as it did soon after the emergence of TV as the dominant medium of mainstream culture. In 1952 Malcolm Little emerged from prison, as Malcolm X, to observe an entrenching televisual culture that altered and in some ways superseded the cinematic and musical milieu of his Detroit Red days in Boston and Harlem in the 1940s. As a technology of image making, TV resembled photography and cinema in function, but it differed from them in its degree of domestication. In the early 1950s TV became quite literally part of the furniture. As such, it was well positioned to relay an evolving political orthodoxy into American homes as a series of images. For media studies scholar Sasha Torres, "the civil rights movement staked the moral authority of Christian non-violence and the rhetoric of American democracy to make a new national culture; to succeed, it needed to have its picture taken and its stories told." Between 1955 and 1965 this "consensus" was most thoroughly embodied and engendered by Martin Luther King, leader of the Southern Christian Leadership Conference (SCLC). The elevation of King to the role of national savior was enabled by the emotional and moral appeal of "an emergent black political agency" conforming to the particular context and values of American network TV.[89]

The ideological pressures and limitations of early American network TV were of course significant. As black film historian Donald Bogle argues, conformity was endemic to a system dependent for financing upon corporate advertising. In the 1950s shows featuring stars Sammy Davis, Jr., and Nat "King" Cole had difficulty finding or retaining corporate sponsorship as a result of southern network affiliates' distaste for African American content.[90] The supposedly national culture of television was thus susceptible to censorship by way of sponsorship withheld. It is a testament to the irrepressibility of African American demands for justice, but also to the networks' interest in framing the perception of such political events, that "the nightly news recorded the boycotts, marches, and demonstrations of civil rights movement, shocking the nation with

images of fire hoses and billy clubs turned on African American protest-ers."[91] According to Torres, "coverage of the movement allowed network news not only to report, but also to intervene in, national culture and po-litical discourse," and not always in reprehensible ways.[92] Network news coverage helped recontextualize regional cultures of racism by situating them on television's newly national stage and exposing them to unprec-edented criticism. What was so momentous about these images were those unscripted or live elements that apparently placed them outside the customary strictures and stereotypes informing the representation of African American life. For the first time, TV presented southern race relations to American audiences without nostalgia or melodrama. In his general condemnation of southern African American values, Malcolm overlooked the moral import of these images he deemed emblematic of victimhood.

The TV images of the civil rights movement were of course always manipulated. As with photography and cinema, TV's inherent verisimil-itude belies its "illusionary nature," conferring a false transparency on its representations of human action and interaction.[93] The editorial and ideological apparatus, as with film, is here more nearly submerged by the seemingly unmediated realism of the image than in prior visual modes. As a result, "the deep connection, in African American cultural memory, of television to the civil rights movement" persists.[94] This mutually con-stitutive pairing introduced a powerful new way of seeing history: as a perpetual stream of live, ostensibly unfiltered, but largely unassimilable images.

Torres points to "the burden of liveness," or "a certain documentary or ethnographic impulse, an imperative to 'authenticity' in depictions of African Americans," as disguising TV's hegemonic function.[95] Present-ing images of African American activism to white viewers in the safety of their homes enabled a kind of vicarious identification with black rebel-lion that belied the social chasm necessitating that rebellion. This analy-sis indirectly questions the revolutionary substance of TV images of Mal-colm X, arguably reducing him to another in a long line of black images for white consumption, a mere instrument of "pseudo-realism" or the science of imagery.[96] Baldwin was similarly dubious of the relationship of viewer to image: "The distance between oneself—the audience—and a screen performer is an absolute: a paradoxical absolute, masquerading as

intimacy."[97] Yet the mythic distance created between performer and audience by mass mediation enables the retention of images as symbols of the exceptional in human form. The context in which modern icons most nearly approximate the ritual social function of religious icons is in their symbolic mediation of viewers and the abstraction—whether of God, race, or nation—to which those individuals belong or seek to belong.[98] Hariman and Lucaites term this mediative role "stranger relationality."[99] Despite the remote campaign of white domestic consumption, TV images of Malcolm, in their relentless verbal assault on racial oppression, had their insidious effect. Precluded by his racial theory from co-optation as a universal hero, Malcolm came to function very differently as an intermediary of collective identity than such decidedly American martyrs (and TV figures) as John F. Kennedy and Martin Luther King. His meaning was revealed to be utterly inseparable from the particularity of the blackness that he is given to signify.

A significant proportion of Malcolm's TV audience was of course African American—predominantly northern, urban, and poor. Both Malcolm and the televisual medium were well positioned to reach this demographic. Thomas Cripps discusses the vast audience of impoverished African Americans constituted by 1960s civil rights TV programming: "For many blacks TV provided their sole source of news because of the relatively low proportion of subscribers to other media, even black newspapers." Civil rights programming, with its orientation to the sound bite, interview, and panel debate, was rich in opportunities for Malcolm's proselytizing and political utterance. The unscripted or live quality of Malcolm's televised performances redoubled the perception of authenticity or sincerity that he projected as an advocate for African Americans. He may also have served indirectly as an advocate for TV itself. According to Cripps, "gradually, as a result of the daily broadcast of the visual reality of the streets, poor blacks themselves came to trust the medium."[100]

More than any other single factor, Malcolm's iconic emergence was accelerated by the 13–17 July 1959 television documentary *The Hate That Hate Produced,* which inspired journalistic discussion of the Nation in "articles that same year in *Time, The Reader's Digest, Cosmopolitan, U.S. News and World Report,* [and] the *New York Times*."[101] First shown on WDNT-TV in New York, *The Hate That Hate Produced* opened with presenter Mike Wallace delivering from a newsroom an alarmist editorial on the "gospel

of hate" preached by "a group of Negro dissenters" or black nationalists "while city officials, state agencies, white liberals, and sober-minded Negroes stand idly by." For Wallace, the Nation, "the most powerful of the black supremacist groups," represented a spectacle of "organized hate." As a precursor to 60 Minutes, the emblematic mainstream middle-class TV news magazine, the program included footage of Muslim assemblies being addressed by Louis X (later Farrakhan), Malcolm X, and Elijah Muhammad, as well as interviews with Elijah Muhammad and Malcolm X focusing on the Nation's demonology and its rejection of Christianity.[102]

The program's images of large congregations of soberly and uniformly attired "Black Muslims" were framed as the realizable inversion of King's contemporary demands for justice and equality for African Americans by nonviolent means.[103] The sizable African American minority appeared, as if more clearly than ever before, as a potentially murderous revolutionary mass. Malcolm did little to allay the anxieties of either the filmmakers or its white audience. In his interview, conducted by Lomax, Malcolm expounded the Nation's white devil theory, describing Elijah Muhammad's teaching that the biblical "serpent or snake is a symbol that's used to hide the real identity of the one whom that actually was": that is, the white man. Arguing that the white man "is other than divine . . . he is evil," Malcolm insisted that the Nation's philosophy was "not hate." Rather, it was motivated by a "love for your people . . . so intense, so great, that you must let them know what is wrong with them, what is the cause of their ills."[104] Malcolm's insular form of humanism self-consciously challenged the mutually debilitating psychological dependency of black on white in America; it also displayed the limitations of oppositional racial thinking.

The telecast of The Hate That Hate Produced initiated the mass media campaign that Malcolm would sustain until his death. As Karim claimed, "What Malcolm X said sold the news, and the news sold Malcolm X."[105] His alliance with mainstream media outlets was both effective and uneasy. William Strickland hints at the paradox of Malcolm, so vocal and visible in the mainstream, yet claiming a "Message to the Grass Roots" (the title of a November 1963 speech): from 1959, "Malcolm began to depend more and more on the press to do his organizing for him."[106] Malcolm was well aware of TV's propagandistic potential. At Cassius Clay's January 1964 training camp in Miami, Malcolm presented the Sonny Liston fight as both a holy war—a vindication of Islam as the true religion of

the black man in America—and a media event: "'This fight is the *truth*,' I told Cassius. 'It's the Cross and the Crescent fighting in a prize ring—for the first time. It's a modern Crusades—a Christian and a Muslim facing each other with television to beam it off Telstar for the whole world to see what happens!'"[107]

In recalling the fight, Malcolm revealed his interest in constructing his own image, claiming, "I folded my arms and tried to appear the coolest man in the place, because a television camera can show you looking like a fool yelling at a prizefight."[108] Among the first and most ubiquitous of media politicians, extricating himself from the ideological agendas of writers, interviewers, editors, and producers would become an ongoing project for Malcolm. Between Elijah Muhammad and the mainstream media, he came to understand that he was caught perilously within competing visions of catastrophe.

Much of Malcolm's notoriety followed from his Nation-derived separatist rhetoric, which echoed the Garveyite Back-to-Africa preachments to which he was exposed as a child. For a time, he demanded complete separation from America. This involved rather vague plans to negotiate a reparative land cession with the American government. Lincoln wrote in 1961 that "Malcolm X thinks 'nine or ten states would be enough.'"[109] In January 1965 Malcolm stated on CBC Television,

> Elijah Muhammad taught his followers that the only solution was a separate state for black people. And as long as I thought he genuinely believed that himself, I believed in him and believed in his solution. But when I began to doubt that he himself believed that that was feasible, and I saw no kind of action designed to bring it into existence or bring it about, then I turned in a different direction.[110]

The critic bell hooks has lamented, "[It] is often the case in racially biased media [that] the failing of an individual black male is not contextualized."[111] Early TV representations of Malcolm arguably set him up to fail. Contextualizing him as a demagogic threat to the social order, those who picked up his story intended it as a warning rather than an enticement. As Peter Bailey claimed, "The white media's portrayal of Brother Malcolm had one major goal, which was to turn the Black community away from him, if possible."[112] Malcolm's wider acceptance by African Americans, though not immediate, was inevitable. Ossie Davis recounted his

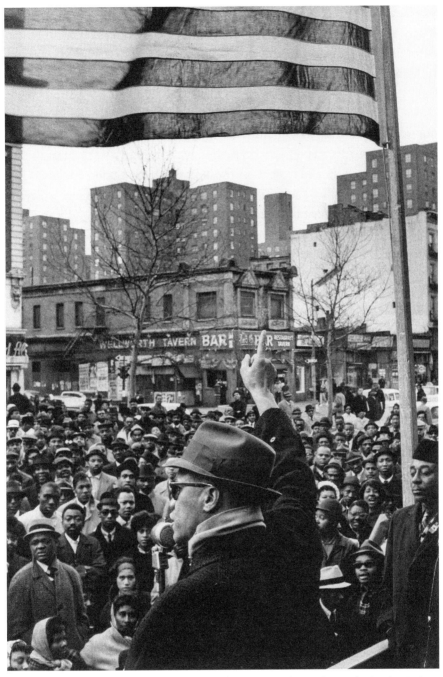

Malcolm X at rally, Harlem, 23 March 1963. Photograph by Gordon Parks. © The Gordon Parks Foundation.

mediated introduction to Malcolm: "When I saw him in *The Hate That Hate Produced,* I knew that I would never forget this man." Davis's initial response, however, was ambivalent: "He scared me. I'm sure he intended to." Reluctant to embrace, in 1959, a political philosophy so opposed to the integrationist mainstream of the burgeoning civil rights movement, Davis heeded the alarmist view of Malcolm: "Some of us, you know, had our jobs out in the white community. We didn't really want to get too close to Malcolm." Poet Sonia Sanchez was similarly wary, stating that when she "first saw Malcolm on the television, he scared me also. Immediately the family said, 'Turn off that television. That man is saying stuff you ain't supposed to hear.'"[113] Maya Angelou recalled, "When I first heard of Malcolm . . . he sounded so mean and so tough and so cruel. I thought the white people, they made him up."[114] That Malcolm was controversial was simply understood: his reputation, his bearing, and his words insisted on it.

The fact of Malcolm's visibility was in itself insignificant. What was striking was the degree to which he overturned the orthodoxy that sought to contain his cultural meaning. Although spectators such as Davis, Sanchez, and Angelou may initially have been disconcerted by their identification with Malcolm and his sentiments, the recognition that, unlike other media figures, Malcolm was "like them" allowed him to resonate incomparably with authenticity. Despite his fundamental misconception of Malcolm's philosophy as one of "hatred and violence," even Martin Luther King is reported to have experienced a pang of identification with Malcolm while watching him on television.[115]

In his journalistic convenience as a foil for King, as well as in his own uncompromising rhetoric, Malcolm was confined for much of his media career to a villainous reputation. Frequently cast in TV panel debates as a reliable controversialist, he appears in Saul Bellow's novel *Herzog* (1964) as a likely guest on a Chicago television panel show (along with the likes of Paul Tillich and Hedda Hopper) for which Valentine Gersbach acts as a fixer.[116] This reputation spoke as much to a cultural anxiety regarding his media-enabled viability as to the perception of his wickedness. In his nationally televised confrontation with white America, Malcolm established the most convincing cultural precedent yet for African American revolutionary mobilization—a fact that amounted to a declaration of war in the eyes of many Americans. His frequent invocations of American

racial violence also troublingly intimated that "live TV is always haunted by the possibility of death."[117] The death that he foretold, of course, was his own; with his inimitable grin, Malcolm told Mike Wallace during a television interview in early June 1964, "I probably am a dead man already."[118] Prior to his assassination, however, Malcolm would point to the mechanisms by which African Americans could forge a greater sense of collective purpose by controlling their own representation. By demonstrating the possibility of employing media venues for subversive ends on a sustained basis, his example radically altered the expectations African American audiences would have of the media and its icons.

Of course, Malcolm had his own televisual forerunners. Haley indicated that he modeled his rhetorical and televisual styles on the technique of one of America's most celebrated—and first televised—boxers: "He would turn a radio or television program to his advantage in a way he credited to the boxing ring's great Sugar Ray Robinson, who would dramatize a round's last thirty seconds. Similarly Malcolm would eye the big studio clock, and at the instant it showed thirty seconds to go, he'd pounce in and close the show with his own verbal barrage."[119]

Malcolm regarded his television appearances as opportunities to score blows against opponents in a context that pitted black against white, if in less bellicose terms than the boxing ring. For Malcolm, the superficial integration of multiracial panel debates "was such a big lie it made me sick in my stomach"; he believed that other debaters were present only to try to "beat out my brains."[120] With his proclivity for rhetorical upset, Malcolm did not often perform poorly. Goldman has described Malcolm's performance in televised debates in terms of wins and losses, indicating that "Malcolm nearly always won these encounters . . . partly because he was so brilliant at it, partly because he was unconstrained by the conventional niceties of debate, and partly because he pre-empted a kind of moral high ground for himself."[121] The *Autobiography* discusses Malcolm's unwillingness to be framed by television presenters in the familiar, dismissive terms: "The program hosts would start with some kind of dice-loading, non-religious introduction for me. It would be something like '–and we have with us today the fiery, angry chief Malcolm X of the New York Muslims . . .' I made up my own introduction. At home, or driving my car, I practiced until I could interrupt a radio or television host and introduce myself."[122] Exploiting the unscripted TV panel for-

mat, Malcolm reclaimed ownership of his representation. In doing so, he demonstrated a performative politics demanding of spectators a critical viewing of an insidiously politicized medium.

Harlem Photography

Appropriately, the most comprehensive collection of Malcolm X photography is housed in Harlem, in the archives of the Schomburg Center for Research in Black Culture. These collections—including important photographs of Malcolm X by Robert L. Haggins, Lloyd Yearwood, Klytus Smith, Richard Saunders, and Laurence Henry, among others—have been largely immobilized, however, for all but personal use as a consequence of a dispute among the six daughters of Malcolm and Betty Shabazz regarding the administration of their parents' estate.[123] The Schomburg archives also include several unsorted and widely unknown photographs taken by Malcolm himself in Miami and West Africa in 1964. Whether depicting Cassius Clay surrounded by a group of young African Americans (including Malcolm's two eldest daughters) or the staff of Air Afrique, a West African airline founded in 1961, Malcolm the photographer was evidently concerned with capturing images of exemplary black achievement. He also gravitated to congregations of black persons as a photographic subject, suggesting an investment in both the democratic and ethnographic utility of the photography he undertook on his travels. Malcolm also shot footage while abroad to aid in his teaching. Essien-Udom recalled that, for Muslim audiences, "X narrated the highlight[s] of his tour" of Africa in 1959 of Egypt and Sudan; "these pictures of Egypt, the Sudan, or 'Moslems' in general, were perhaps salutary in counteracting the deplorable extremes of Hollywood's image of Africa!"[124] Indeed, at the Audubon Ballroom in January 1965 he would share footage taken in West Africa in 1964.

Despite his significant interest in images of Africa, Malcolm's bond with his African American audience is typically depicted as being forged in Harlem as a street-corner orator. His immersion in radical black nationalist politics, as distinct from religion, was centered, in the early 1960s, at the corner at 125th Street and Seventh Avenue, where he socialized and debated over coffee with such orators as, among others, James Rupert Lawson, Edward Davis, and Carlos Cooks. According to reporter Booker

Johnson, "Chock Full O' Nuts Restaurant was their United Nations."[125] Inhabiting and politicizing local "black spaces" in this way, Malcolm contributed to the radicalization of Harlem.[126] Essien-Udom described Malcolm's nearby Saturday afternoon rallies as distinguishing him from his peers in the Nation: "Unlike the other ministers, he is used to 'street speaking,' a familiar sight in Harlem during the summer months."[127] Even when abroad, Malcolm remained rooted in what he regarded as his uptown constituency: "Whether he was in Cairo, London, Paris, Accra, Nairobi, or Dar es Salaam, he was always speaking to the world from a platform in Harlem."[128] Oratory was a means of circulating the communal knowledge that anchored black nationalist identity in Harlem. As an orator, Malcolm can also be seen to have rehearsed the performative politics informing his televisual persona, which enjoyed a national audience.

Benjamin Karim, assistant minister to Malcolm in both the Nation of Islam and the Muslim Mosque, Inc., described his mentor's public speeches with a solemnity suggestive of religious experience:

> At outdoor rallies in Harlem we would draw huge crowds by beating on drums you could hear, depending on the weather, ten, twelve, or twenty city blocks away. In droves the people would gather, and when Malcolm took the microphone they would all fall silent, thousands of them. I have seen Malcolm hold a crowd like that spellbound, even in the rain. . . . It seemed that nothing could dampen the fire in Malcolm's words. After a rally Malcolm would leave the public platform or stage and head for his waiting car. We'd drive him away. Sitting back, unwinding, he'd begin to slip back into his private self, and he would be very hungry.[129]

The account, resonant of Harlem's embrace of African musical heritage, also identifies Malcolm's transfigurative public persona, a figure identified as faultlessly sincere.

Unlike his childhood heroes—and fellow Harlemites—Marcus Garvey and heavyweight champion Joe Louis, Malcolm rose to prominence within a culture in which the technologies marrying "traditional heroism to mass-marketed celebrity" had been reduced, in their ubiquity, to the level of the mundane.[130] Nowhere is Malcolm's embrace of such technologies transmitted more clearly than in (and by) photography. Encircled by the audience and apparatus that in this context must be regarded as

mutually constitutive, the recurrent image of Malcolm behind a bank of microphones, with camera lenses trained upon him, is one whose Harlem-centered folk heroics were themselves elaborately constructed.

Between 1960 and his death, Malcolm cultivated collaborative partnerships with a select few photographers. His Harlem oratory is captured most notably in the photography of Robert L. Haggins and Gordon Parks. These photographers situated Malcolm within the traditions of Harlem oratory and street photography typified by the work of James Van Der Zee and Morgan and Marvin Smith, whose photographs illustrated the Harlem Renaissance and the Great Depression as they converged shortly before Malcolm's arrival in Harlem as Detroit Red. Haggins, referred to as "Malcolm's personal photographer" and "Malcolm's official photographer," was staff photographer and reporter for the *New York Citizen-Call* when he met Malcolm in 1960 at the temple restaurant. Malcolm would inform Haggins

> how ridiculous it was for me to carry the name of Haggins or any other English or Irish name when I was not ethnically either and how people were bought and slaved like cattle and their names changed to reflect who owned them. I had never had anybody awaken me like that before in my life. . . . Malcolm X was, I think, the realization of everything that was recessed in my mind.[131]

Haggins would remain Malcolm's secular devotee, their partnership lasting until Malcolm's death. Haggins's 1960 pictures of Malcolm speaking in front of Lewis Michaux's National African Memorial Bookstore in Harlem represent the beginnings of their collaborative campaign. The portrayal of Malcolm that would be most frequently circulated and thoroughly abstracted—"the balled fist or pointed finger, the raised arm; the indignation and the anger; the rhetoric; the fire, irony, and conviction; the grimace, the snarl: the image"—evolved from Haggins's (and Malcolm's) prototype of the man and the microphone.[132]

Parks, the first African American staff photographer for *Life* and, later, a novelist and filmmaker, brought to a mainstream audience portraits of Malcolm that were both intimate and, in their use of achromatic contrast and visual irony, highly symbolic. Typically more diversified and compositionally precise than Haggins's early photographs of Malcolm, Parks's images depicted Malcolm thinking, conferring, and teaching.[133] The com-

YBP Library Services

ABERNETHY, GRAEME.

ICONOGRAPHY OF MALCOLM X.

Cloth 293 P.

LAWRENCE: UNIV PR OF KANSAS, 2013
SER: CULTURE AMERICA.

REVISED DISSERTATION. INCL. B&W ILLUS.

LCCN 2013-18932
 ISBN 0700619208 **Library PO#** SLIP ORDERS

		List	34.95	USD
6207 UNIV OF TEXAS/SAN ANTONIO		**Disc**	17.0%	
App. Date 3/05/14 REL.APR 6108-09		**Net**	29.01	USD

SUBJ: 1. X, MALCOLM, 1925-1965--IN MASS MEDIA. 2.
IMAGE (PHILOSOPHY)

CLASS BP223 DEWEY# 320.546092 LEVEL GEN-AC

YBP Library Services

ABERNETHY, GRAEME.

ICONOGRAPHY OF MALCOLM X.

Cloth 293 P.

LAWRENCE: UNIV PR OF KANSAS, 2013
SER: CULTURE AMERICA.

REVISED DISSERTATION. INCL. B&W ILLUS.

LCCN 2013-18932
 ISBN 0700619208 **Library PO#** SLIP ORDERS

		List	34.95	USD
6207 UNIV OF TEXAS/SAN ANTONIO		**Disc**	17.0%	
App. Date 3/05/14 REL.APR 6108-09		**Net**	29.01	USD

SUBJ: 1. X, MALCOLM, 1925-1965--IN MASS MEDIA. 2.
IMAGE (PHILOSOPHY)

CLASS BP223 DEWEY# 320.546092 LEVEL GEN-AC

position of Parks's photograph of the 23 March 1963 Harlem rally is vertical, taken from a three-quarter rear angle, with Malcolm at the bottom of the frame in his elemental pose: speaking into a microphone and gesticulating with unmistakable force. The photograph's focal point, slightly off-center, is Malcolm's extended right hand. Imprecating but also imploring, his forefinger points upward at an American flag, whose lower stripes frame the upper fifth of the image. The flag covers much of the overcast sky, serving to contain the upward and slightly out-of-focus rise of Harlem housing projects in the distance that only Malcolm, and none of his audience, is positioned to see. Viewing the photograph, one shares Malcolm's point of view, something that is uncharacteristic of photos of Malcolm's oratory, which are typically straight-on or three-quarter angled from the front, below the podium, a perspective exaggerating Malcolm's commanding rhetoric and imposing height. The expressions of his facing audience, confined to the lower half of the frame, range from dispirited to meditative to exclamatory. All eyes are fixed on Malcolm X.[134]

Malcolm X and Other Icons

The pioneering photojournalist Henri Cartier-Bresson photographed many of the twentieth century's most prominent figures, including Pablo Picasso, Marilyn Monroe, and Martin Luther King, on the principle of "the decisive moment." In his first book, published in 1952, he would declare: "To me, photography is the simultaneous recognition, in a fraction of a second, of the significance of an event as well as of a precise organization of forms which give that event its proper expression."[135] Cartier-Bresson's 1961 portrait of Malcolm X in the Nation's Harlem restaurant is evocative of Malcolm's studied—and identifying—deference, at this time, to the superior authority of Elijah Muhammad, faintly abstracted in a painted portrait of his own above Malcolm's head. The insistent presence of the painting, from which the Messenger of Allah appears to both sanctify and survey the reverent space, indicates the formal use of iconography within the Nation; indeed, Cartier-Bresson's image is reminiscent of a photograph of Elijah Muhammad and his son Wallace Fard Muhammad beneath a portrait of the Nation's founder W. D. Fard Muhammad, reproduced in 1963 as part of the article "Black Merchants of Hate" in the *Saturday Evening Post*. Cartier-Bresson's portrait also al-

ludes to Malcolm's now legendary self-discipline, expressed not least in dietary terms, though he often joked that coffee was "the only thing I like integrated."[136] Malcolm's sideways glance toward the lens suggests, finally, an evident wariness of the motives of the journalists and photojournalists he typically received in the restaurant, demonstrably in his own sphere of influence in one of the Nation's Harlem properties.

Despite its black nationalist associations, Harlem was the site of Malcolm's incipient embrace of an internationalist perspective. Rosemari Mealy's *Fidel and Malcolm X: Memories of a Meeting* (1993) reveals that "sometime near midnight" on 19 September 1960, Malcolm arrived for a brief meeting with Fidel Castro, in New York for the United Nations General Assembly, at the Hotel Theresa. Mealy clearly regarded the meeting's symbolism as exceeding its substance: the two revolutionaries together, but most importantly, together in Harlem, proclaimed by Mealy the "Black Capital of the USA!" If it was a transformative experience for Malcolm, he continued to present "a class analysis in non-Marxist terms (that is, the *field* Negro versus the *house* Negro)," and black versus white. Indeed, his meeting with Castro was hardly substantive in content. One of its witnesses, James Booker of the *Amsterdam News,* claimed that it was "not a heavy conversation, lasting approximately 15 minutes. . . . It was an exchange of pleasantries—a greeting in terms of the struggle, briefly expressing what it meant to each one of them."[137]

A reporter from the leftist *New York Citizen-Call* recorded Malcolm and Fidel's exchange on the theme of the science of imagery: "In answer to Malcolm's statement that 'as long as Uncle Sam is against you, you know you're a good man,' Dr. Castro replied, 'Not Uncle Sam. But those here who control magazines, newspapers . . .'" The disparity between Malcolm's rhetoric and Fidel's analysis would remain telling, however: "Malcolm, rising to leave, explained his Muslim group for a Cuban reporter who had just come in. 'We are followers of Muhammad. He says that we can sit and beg for 400 more years but if we want our rights now, we will have to . . .' Here he paused and smiled enigmatically. 'Well . . .'"[138]

With his ellipses, Malcolm stopped short of disingenuously professing armed revolution before the revolutionary Fidel, yet he characteristically exploited the implication of violence. The reference to "Muhammad," rather than Elijah Muhammad, also hinted at an uncharacteristic, if sub-

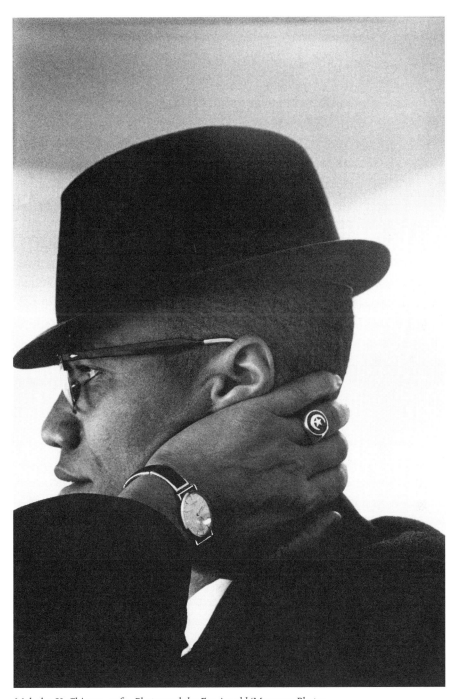

Malcolm X, Chicago, 1961. Photograph by Eve Arnold/Magnum Photos.

tle, abashment on Malcolm's part. He was perhaps already looking beyond the parochial Nation of Islam.

The meeting's only photographer was Carl Nesfield of the *Citizen-Call*. Nesfield stated that "for about a year of my photographic life, I was one of the photographers that Malcolm would use. He would have his people call me, and they would say, Malcolm is going to be at such and such a place, and he would like a picture, and could I make it."[139] Nesfield's account illustrates Malcolm's active role in his image making. In being documented, Malcolm was elevating both the significance of his presence and the event itself by exposing it to a mass audience. In the particular case of the photographs with Castro—Nesfield "just took a couple of shots"—the question of authorship (and its concomitant, ownership) is raised. Nesfield claimed never to have profited financially from the photograph, which has been reproduced dozens of times without his knowledge or permission. He "recently tried to get the picture copyrighted" with little success.[140] As with Alberto "Korda" Diaz's iconic photograph of Che Guevara, the photograph of Malcolm with Fidel has come to function as a kind of shorthand for the idealism of international revolution. By eliding context and authorship, however, the populist appropriation of such iconic images potentially enables them to signify vacuously in the service of revolutionary style before substance.

Due to Malcolm's ubiquity in American media prior to his death, his iconography has not been reducible to a single image. The nearest approximation of Korda's *Guerillero Heroico* in the catalog of Malcolm X images is precisely the kind of photograph that Malcolm instructed his appointed photographer Haggins to avoid taking: "I don't like those pictures. I am not a monster, and I want you to show me as a human being."[141] It is appropriate that a soon-to-be-ubiquitous photograph from a 15 May 1963 rally in Harlem was not taken by Haggins but by an unknown photographer on assignment for United Press International. The photograph—which would come to adorn book covers, T-shirts, posters, and placards—portrays a moment at which Malcolm gave voice to an indignant demand for accountability by the state. It has come to symbolize the cause of African American liberation more broadly. In his evident fury, the iconic Malcolm is not necessarily framed as articulate. Goldman observed that "the plain implication" of the "raging" image, with "the eyes burning, the finger pointing, the lower lip curling back

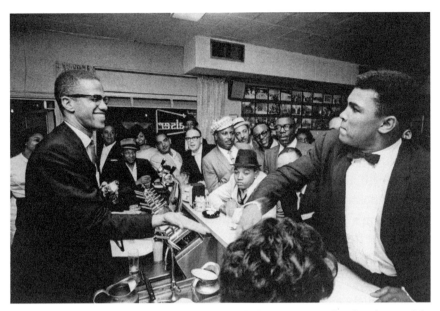

Malcolm X with Cassius Clay (soon to be Muhammad Ali), Miami, March 1964. Photograph by
Bob Gomel/Time & Life Pictures/Getty Images.

under the teeth beginning an 'f' . . . was *Fuck you*."[142] In becoming a
representative image, the photograph's righteous context is potentially
flattened; the rally at which it was taken was held in support of Project C
(for "confrontation"), led by Fred Shuttlesworth and Martin Luther King
in Birmingham, Alabama.[143] Malcolm's complexity is rendered divisible
to its superficial components: the glasses; the finger; the slogan; the X.

Roland Barthes has discussed photography's tendency toward hege-
monic circumscription, arguing that it enables "a new form of hallucina-
tion: false on the level of perception, true on the level of time." Photog-
raphy has the power to misrepresent by reproducing "to infinity [what]
has occurred only once: the Photograph mechanically repeats what could
never be repeated existentially."[144] In realistic yet unreal photographic
images, we see Malcolm only as we (or Malcolm, his photographers, or
his editors) would wish him to have been. In the iconic photograph, the
microphone situates Malcolm's vehemence within the context of pub-
lic culture. The photograph's ambivalence emerges from its angle: the
perspective places the viewer as if within the front row of Malcolm's au-
dience, close enough to register the flashbulbs reflected in his glasses,
the creases in his skin, the fixity in his eyes. Should one feel reverence,

shame, or fear before one so elevated above the masses he purports to represent? And what if one is apparently excluded from that constituency? The racial coding of American culture to which Malcolm was so attuned guarantees that the defiance portrayed in the photograph will be understood as *black* defiance. The image thus remains vulnerable to editorial deployment as a portrait of villainous demagoguery as well as of heroic advocacy.

The image's significance also emerges from what it anticipates: Malcolm's death and cultural resurrection as a kind of vernacular prophet. For those possessing the basic knowledge that Malcolm was assassinated while giving a speech, images of his oratory involve his death as a subtext. As Barthes argued, already inherent in photography is "a figuration of the motionless and made-up face beneath which we see the dead."[145] A photograph of a living person, now dead, speaks both of death to come and death that has been, provoking simultaneously in the viewer a refusal and acknowledgment of the reality of death. Barbie Zelizer has identified a genre of "about-to-die" photography whose tense is not the past but the subjunctive. The subjunctive voice of such images asks the viewer, then, not what happened but, illogically, "what could be," allowing for the projection of "altered ends on the screens through which we see."[146] Such irrational viewing is uniquely conducive to mythmaking; about-to-die photography thus "has something to do with resurrection"—a theme to which I will return.[147]

As fashion historian Carol Tulloch indicates, "Malcolm X was acutely aware of the powerful poetry of self-adornment"; following Foucault, she describes "dress as a technology of self-telling."[148] Having recognized, with Claude McKay, that there is "no getting away from the public value of clothes, even for you, my black friend," Malcolm's self-fashioning can be seen in this as in other aspects of his representation.[149] Karim claimed that "Malcolm wore any suit the way you would a uniform. The trousers would be perfectly creased, the jacket pressed, the white shirt fresh, his tie knotted neatly and right up to the neck—always."[150] The *Autobiography* also tells of the sartorial conservatism that would define his image as "Malcolm X" upon his being paroled from the Massachusetts prison system. Having ruined his eyesight reading by dim light in prison, upon his release he "bought a better-looking pair of eyeglasses than the pair the prison had issued to me; and I bought a suitcase and a

wrist watch," the latter because "you won't find anybody more time-conscious than I am."[151] These accessories were emblematic of Malcolm's rigorous moral and spiritual discipline; they represented also a self-conscious professionalism in opposition to the conspicuous dandyism of his Detroit Red days and the undifferentiated prison clothing he had just shed. Malcolm's dress, both at its most garish and conservative, enacted a resistance to cultural norms through the pursuit of "an authentic Black body aesthetic"; as his conception of blackness evolved, so did his style of dress.[152]

The photograph of Malcolm by Eve Arnold, commissioned by *Life* in 1961 but published in *Esquire* and "syndicated worldwide," captured the understated stylishness of his Nation of Islam period.[153] Arnold, famous for her photographs of Marilyn Monroe, was introduced to Malcolm in 1960 by Lomax, who served as "the fixer" for many journalists unaccustomed to traveling uptown. Arnold later recalled the harrowing experience of documenting Malcolm at a 125th Street rally as a downtown white female photographer: "As I walked about the crowd taking photographs, there were cries of 'White bitch!' and 'Kill the white bitch!' and I was spat upon." Her coat was used by spectators to extinguish their cigarettes. She refused to attribute the enmity to the rally's featured speaker, however. Indeed, it was Malcolm rather than Lomax whom she regarded as her informal chaperone in Harlem: "I felt that Malcolm wouldn't let anything happen to me."[154] Arnold regarded Malcolm as both a man of integrity and a worthy collaborator, describing him as "a really clever showman and apparently knowledgeable about how he could use pictures and the press to tell his story":

> He set up the shots while I clicked the camera. It was hilarious. I tried several times to get him in the act of framing a photo with his hands, but he was too quick for me. With the photos of himself, he was professional and imaginative. He obviously had an idea of how he wanted the public to see him and he maneuvered me into showing him that way. . . . Malcolm was brilliant at this silent collaboration.[155]

Apart from the identifying eyeglasses, the image could be of any African American actor or musician in New York City.[156] The glasses and wristwatch were shown in more emphatic detail than elsewhere; his trilby hat is ever so slightly cocked. The fact that Malcolm was pictured with

an imperturbable expression in profile hints at a more studied cool pose than the photographs of his oratory would have allowed: this is Malcolm pictured more purely than elsewhere as a star. His radicalism is hinted at only by his ring bearing the star and crescent of Islam.

More than any other contemporary icon, Malcolm's celebrity profile resembled that of jazz trumpeter Miles Davis. Canadian black studies scholar George Elliot Clarke recently bemoaned that "the cool images of X and Davis that circulate within African-American popular culture are mere reifications—all *beaucoup* style and denatured substance": "Both figures have suffered ironic iconizations into a kind of cool that reproduces them as true 'souls on ice,' as cultural heroes whose politics and social relevance are frozen in two-dimensional friezes or freeze-frames."[157]

Although accurate in his assessment of the susceptibility of such images to appropriation by "a patriarchal black masculinity" or "anarchic machismo," Clarke overlooked the significance of regarding Malcolm and Miles Davis within the cultural contexts that produced them.[158] Like Malcolm, Davis consciously emulated the "disciplined beauty of [Sugar Ray] Robinson's art" and found in the boxer "a black masculine analogue for his own life." For historian Gerald Early, music and sport shared a similar status among African American audiences: "Because there were so few black movie stars before the 1960s, black musicians and black athletes were the pop culture aristocracy of the national black community." From the 1920s, African American boxers and musicians shared a countercultural backdrop: "the netherworld of nightclubs, gambling, prostitutes, pimps, hustlers, the world of black entertainers. . . . It was a subversive setting, undermining all the assumptions of respectable society, including self-repression, false morality, and racism (though, unfortunately, not sexism), but it was a vicious, often criminal, almost Darwinian world as well that had little pity for losers."[159]

Described here of course is Detroit Red's Harlem. Although Malcolm would later reject the amorality of this culture shared in common with the likes of Davis, in formulating his media image he would retain its basic forms: the spirited defiance of traditional authority, the retention of patriarchy, the coterie. Part of Malcolm's appeal was (and continues to be) "a kind of swaggering hipness and unbridled audacity" reminiscent of Davis's persona of the rebel artist, which drew inspiration from "the

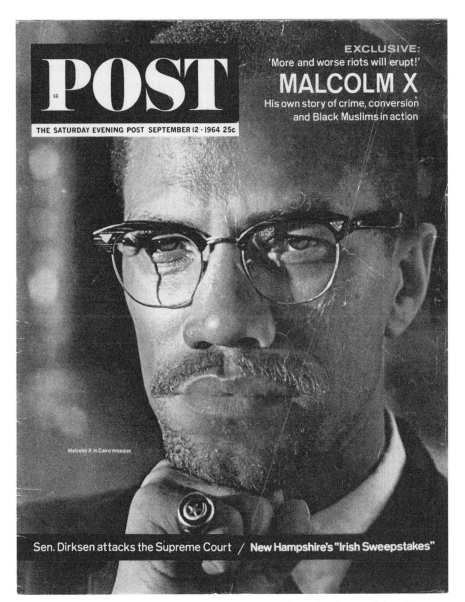

EXCLUSIVE:
'More and worse riots will erupt!'

MALCOLM X
His own story of crime, conversion
and Black Muslims in action

THE SATURDAY EVENING POST SEPTEMBER 12 · 1964 25c

Malcolm X in Cairo mosque

Sen. Dirksen attacks the Supreme Court / New Hampshire's "Irish Sweepstakes"

Malcolm X on Saturday Evening Post *cover, Cairo, 12 September 1964. Photograph by John Launois.*

masculine stylization" of the "outlaw: a dope addict, a pimp, a jazzman, a boxer."[160] Ingrid Monson's description of "Miles's style," encompassing his image as well as his playing, is useful also for Malcolm's image and oratory: "that confluence of sonic beauty, timing, introspection, sartorial elegance, masculine swagger, and utter contempt for racism."[161]

The images of Malcolm alongside Cassius Clay (or "Cassius X") in Miami and Harlem do little to foretell of his impending reinvention—religious, political, and sartorial—as El-Hajj Malik El-Shabazz.[162] The photographs depicted Malcolm at his most jubilant. Taken while Malcolm was serving a ninety-day silencing by Elijah Muhammad following his controversial comments about John F. Kennedy's assassination, the focus of the photos is in fact the more famous Clay: escorting the new heavyweight champion around Harlem, Malcolm introduces him to bookseller Lewis Michaux, peers over his shoulder, or appears as his interlocutor.[163] In the presence of the young boxer, the suspended Malcolm placed himself again in the media glare, though he made a show for the cameras of carrying a camera of his own. Photographs taken at Clay's prefight camp in Miami by Bob Gomel and Haggins show Malcolm, the fighter's "spiritual advisor," grinning while he photographs Clay, high-fives him, whispers something in his ear.[164] The scenes are expressive of a liberating resurgence of Malcolm's youthful admiration for Joe Louis and Sugar Ray Robinson. Despite his falling out with Malcolm soon after the photographs were taken, Muhammad Ali (as Clay soon became) would state in a 1998 interview that "his favourite photograph of himself was one with Malcolm X walking in Harlem. 'He was so controversial, so bold, so courageous.'"[165] The photographs of the two men in Harlem, one of which appeared on the cover of *Jet*'s 26 March 1964 issue, would inspire a brief scene in the Columbia Pictures film *Ali* in 2001.

The public friendship also had its political expediency for both men. For Clay, the fact of Malcolm's presence in his entourage signaled a rejection of conventional American values and narratives of good triumphing over evil. Prior to the championship fight, trainer Angelo Dundee exclaimed to Clay, "We've got to get him out of here! If the newspapers know you're associated with Muslims like Malcolm X, your career is over. Do you hear me?" Clay would not be billed, as fight promoter Bill McDonald would have it, as "the Johnny Appleseed of America" to Sonny Liston as the "thug, the menace, the monster."[166] For Malcolm, not just

any boxer would do. It was not insignificant that Clay was a charismatic young member of the Nation of Islam; after defeating Liston, he was very much in the favor of Elijah Muhammad.

If Malcolm did regard Clay as a bargaining chip for his reinstatement in the Nation, he was to be disappointed. As a publicity and recruitment tool for Elijah Muhammad, Clay proved not an ally but an admirable substitute for Malcolm. Clay "supplanted him as the NOI's chief attraction virtually overnight," thereby resolving any internal anxieties about Malcolm's religious and political ambitions and their consequences for his rivals in the Nation. With Clay's defeat of Liston on 25 February 1964, the Nation "quickly capitalized" on "the hero of the hour," "publicly embrac[ing] the champ, who had suddenly replaced Malcolm as the leading symbol of black masculinity."[167] Relishing the television cameras and microphones like Malcolm before him, the renamed Muhammad Ali would feature in numerous articles, photographs, and news reports in the national media.

Like those of Malcolm and Castro, the photographs of Malcolm's only meeting with Martin Luther King on 26 March 1964 have come to signify the possibility of a revolutionary unification—in this case, of contending religious, regional, class, and political positions within African American culture. Viewed from the vantage point of historical retrospect, these images allude, in a manner both wistful and chastening, to Malcolm and Martin's qualified but nevertheless profound commonality: their mutual demonstration of the utility—and, finally, the tragedy—of African American articulacy and self-discipline in the face of systemic injustice. Their meeting, however, was in fact little more or less than a very brief media event. Following the Senate debate of the bill that would become the Civil Rights Act, Malcolm headed off Martin in a corridor of the U.S. Capitol. As Malcolm would have anticipated, an Associated Press photographer documented their handshake and verbal exchange. The image has incurred a memorial function, presenting the two figures in a warmly smiling, if wishful, accord, more nearly reconciled in death than may have been possible in life. James Baldwin, for one, has insisted that "we, the blacks, must make certain that our children never forget them."[168] Later seeming to allude to the violence that disrupted the trajectory of each man's life, transforming them from actual to symbolic leaders in the African American struggle, the image suggests a fellowship

between two martyrs. Ultimately, though, the photograph lends itself to a false alignment of Malcolm's politics with those of King. More than unification, the photograph speaks of the thwarted potential of the civil rights movement to radically alter American society.

Although aware of the limitations of a career as "some marginal shadow-figure of wrath, always paralleling King's progress," Malcolm would persist in proclaiming the irreconcilability of black nationalism and integrationism, revolution and nonviolence.[169] As late as 5 January 1965, Malcolm referred dismissively to King as "Uncle Martin."[170] A month later, and only seventeen days before his death, Malcolm spoke in support of a voter registration drive in Selma, Alabama, where King was in jail for leading a protest march. Malcolm would proceed with his customary implication of King's unsuitability to lead the African American masses, reiterating that "I don't believe in any kind of non-violence" and telling an audience of activists that "today you still have house Negroes and field Negroes. . . . I'm a field Negro."[171] King, though insisting upon his "personal respect" for Malcolm, did not speak of the prospect of political partnership with him in positive terms: "I couldn't block his coming, but my philosophy was so antithetical to the philosophy of Malcolm X that I would never have invited Malcolm X to come to Selma when we were in the midst of a non-violent demonstration." King's response to Malcolm's assassination further illustrated the distance between them, both socially and philosophically. For King, "Malcolm was forced to die as an outsider, a victim of the violence that spawned him, and which he courted through his brief but promising life."[172] In thus mirroring the mainstream journalistic perception of Malcolm, it is perhaps only surprising that King stopped just short of the language of Malcolm's obituary in the *New York Times*, which labeled him "an extraordinary and twisted man, turning many true gifts to evil purpose."[173]

Another photographic alliance was with anti-imperialist hero and Ghanaian president Kwame Nkrumah. Although Nkrumah would not publicly endorse Malcolm following their meeting in May 1964, Malcolm made sure to exploit the symbolism of being photographed before a monument to one of his living idols. Like W. E. B. Du Bois, Malcolm, with his burgeoning internationalism and diasporic understanding of African American history and identity, felt a kinship with Ghana, sub-Saharan Africa's first independent nation, and with its Pan-Africanist so-

cialist leader. With the Nation of Islam in mind, Malcolm had declared that "the single worst mistake of the American black organizations, and their leaders, is that they have failed to establish direct brotherhood lines of communication between the independent nations of Africa and the American black people."[174] He intended to rectify this Pan-Africanist political failure with his founding of the Organization of Afro-American Unity (OAAU) on 28 June 1964, occasioned by his exposure to the Organization of African Unity (OAU), cofounded by Nkrumah, with Léopold Senghor and Haile Selassie, in 1963. Although his late political philosophy was never one of socialist internationalism, Malcolm sought to link himself, as an African American emissary, with global struggles against European and American imperialism. If he retreated from his earlier black nationalism, it was in his recognition of his newfound role "as a part of the non-white peoples of the world."[175]

El-Hajj Malik El-Shabazz

What was overlooked by those who suggested that Malcolm was the author of his own violent demise was that the man shot dead in the Audubon Ballroom on 21 February 1965 was not precisely Malcolm X but someone struggling to cast himself in a new mold as El-Hajj Malik El-Shabazz. In having so expertly constructed his media image as Minister Malcolm X of the Nation of Islam, he could not so thoroughly transform himself as to become unidentifiable as the Malcolm of old.[176]

The photographs of Malcolm in Africa and the Middle East in 1964 most dramatically announced the changes that marked the arrival of El-Shabazz. Of these, the images of Malcolm in Egypt most straightforwardly professed the centrality of Islamic legitimacy to his spiritual and leadership ambitions. Attached to a condensed version of his autobiography published in the *Saturday Evening Post* on 12 September 1964, the photographs by John Launois indicated that Malcolm's views had been internationalized and that the racially insular esotericism of the Nation of Islam was abandoned. Launois's portraits of Malcolm from this period are definitive.[177]

The *Post*'s cover pictured Malcolm, in a memorable close-up, performing the *salat* in Cairo's Mosque of Muhammad Ali. The portrait emphasized the image, associated with El-Shabazz, of renewed political and

religious conviction underlined, by way of the clenched fist, with masculine resoluteness. Appearing less jaunty than in Eve Arnold's portrait of 1961, but again displaying the ring bearing the Islamic star and crescent, Malcolm is portrayed here in the newly grown goatee associated with his final year. More significantly, this was a rare portrait of the man in color, highlighting Malcolm's much-remarked reddish complexion. His face and familiar glasses also reflect the spectacular lighting of the mosque's central chamber with a subtle suggestion of his inward illumination. The photograph also demonstrated the insistence of the present. The brilliance of Launois's image seems to have been intended to announce that other familiar photographs of Malcolm X in black and white were the products of a discarded past. Finally, the assorted references, framing the image, to the Supreme Court, a New Hampshire lottery, and the price of the magazine (twenty-five cents) demonstrate the relevance of Malcolm's particular brand of radicalism to the contemporary mainstream commercial and political context. The claim in the image's upper right-hand corner that "More and worse riots will erupt," and the identification of El-Shabazz in the caption as "Malcolm X," suggests a persistence of the former image or persona. Despite his self-conscious reinvention, Malcolm would still be positioned in the cultural mainstream as a harbinger of American racial volatility.

With cover images famously painted by Norman Rockwell, the *Post* had been established earlier in the century as a classic Americana brand. Despite their mainstream orientation, the *Post*'s images of Malcolm would find an audience among prominent African American radicals of the period. Closely following the media coverage of the hajj, Eldridge Cleaver indicated that, upon hearing of Malcolm's letter from Mecca that announced his experience of "a spirit of unity and brotherhood that my experiences in America had led me to believe could never exist between the white and the non-white," "many of us were shocked and outraged by these words from Malcolm X, who had been a major influence upon us all and the main factor in many of our conversions to the Black Muslims."[178] Soon following the example of Malcolm's second conversion, Cleaver would consecrate his photograph as a religious icon: "On the wall of my cell I had a large framed picture of Elijah Muhammad which I had had for years. I took it down, destroyed it, and in its place put up, in

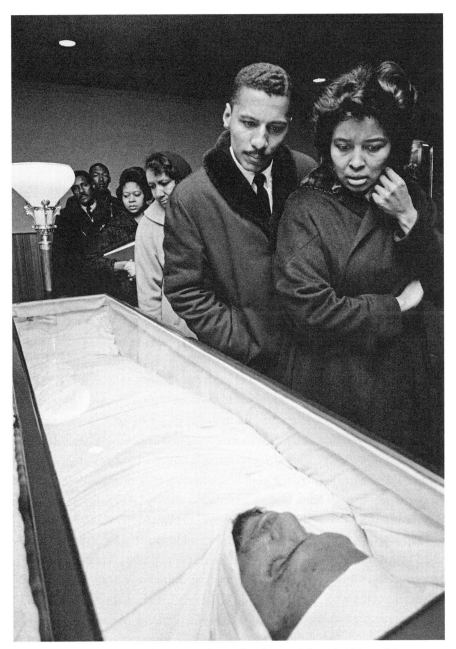

Malcolm X in the Unity Funeral Home, Harlem, 1965. Photograph by Bob Adelman/Magnum Photos.

the same frame, a beautiful picture of Malcolm X kneeling down in the Mohammed Ali Mosque in Cairo, which I clipped from the *Saturday Evening Post*."[179] The images cast Malcolm in a more ennobled light than was customary in the mainstream media: in silent meditation rather than vociferous denunciation.

Other notable photographs from this period show Malcolm holding a Koran and dressed in a blue robe and orange turban. The Nigerian high commissioner in Ghana, Alhadji Isa Wali, had presented Malcolm with the costume.[180] To the ministers and officials of the Nation of Islam, these photographs must have seemed another instance of Malcolm's dangerous influence on public perception of the organization. His declaration of Islamic legitimacy was a charge of fraudulence against them. Belying his apparent placidity of expression, with the photographs Malcolm identified himself as a target for violent reprisal.

Apparently on the orders of officials in Chicago who believed the national minister was receiving excessive publicity at the expense of the organization, the Nation's newspaper *Muhammad Speaks* omitted any reference to Malcolm in the final year of his tenure. Following Malcolm's departure from the Nation, *Muhammad Speaks* cartoonist Eugene Majied portrayed Malcolm as a severed head adorned with devil horns bouncing toward a pile of skulls identified as those of Judas Iscariot, Brutus, Benedict Arnold—and Malcolm "Little Red." Majied mockingly had Malcolm protesting that "I split because no man wants to be number 2 man in nothing! [*sic*] And—the officials at headquarters fear my public image! And . . . the Messenger's family was jealous of me! And—even the Messenger . . . Bla—bla—bla—bla . . ."[181]

It appeared for a time that Malcolm was determined to go down shooting. Announcing the establishment of the Muslim Mosque, Inc., on 12 March 1964, Malcolm initiated his post-Nation career with familiar controversy, advocating the formation of African American rifle clubs. He would soon afterward clarify that he intended such a policy as a deterrent to attacks on African Americans by "bigoted white supremists," but his apparent preference for a "bloodless revolution," the ballot before the bullet, was overshadowed in the media by his continued reliance on the rhetoric of violent prophecy.[182] In his movement toward the abandonment of Elijah Muhammad's millenarian vision, his accounts of violence were more expressly descriptive than prescriptive. But the implication of

African American armament under prophetic leadership was too much for the press to ignore. The terror of race war again reared its head, with Malcolm looming in the popular imagination as the scapegoat for the imagined conflagration. Malcolm aggravated the situation by posing for photographers at a hotel room window with an assault rifle. Although his media career revealed that he spoke loudly but "did not even carry a gun and was never known to have done physical harm to anyone," the new images, "like stills out of *The Battle of Algiers*," of Malcolm as "the prophet armed" ensured that his independence from the Nation was regarded by some with the same suspicion as his membership.[183] He was aware of the consequences for his reputation of such posturing. But, as Goldman claims, "he had no other way except our media to reach the great mass of black Americans, and so he paid the price of admission, which in most cases meant saying something scary."[184] This does not imply insincerity on Malcolm's part; nevertheless, it is difficult to argue that Malcolm's attitude to guns was other than naive. The Russian roulette scene in the *Autobiography*—a charade through which Malcolm established his dominance in his Boston burglary gang in the 1940s—reveals that he carried from his youth a pattern of conflating male power with guns, though he was clearly more comfortable exploiting the implication of violence than its actualization. For Malcolm, schooled as Detroit Red by "the tough guys" on New York City movie screens, gun violence was performative as well as political.[185]

Characteristic of his performances, Malcolm introduced multiple layers of meaning to the assault rifle image, which, among other places, appears in the 20 May 1971 issue of *Jet* and was turned into a popular poster after his death. The rifle, "an M-1 carbine with a thirty-round banana clip" provided by his assistant minister and Korean War veteran Karim as protection against mounting death threats, speaks to Malcolm's ambiguity as an iconic figure—his ability to appear all things to all people by means of "a multivalent discourse . . . targeting specific communities of interest."[186] In the photo Malcolm figures as, variously, terrorist and terrorized, hunter and quarry, soldier, protector, and irrational American. Like the images of his oratory, the rifle photo also seems to dramatize the inevitability of his martyrdom. In all of these, he is unavoidably masculine; again, as with images of his oratory, the picture is illustrative of photography's "gendering of the public sphere."[187] From this association

with masculine defiance and masculine violence emerge the qualities of the potential heroism and villainy that have been contested and explored in Malcolm's iconography since his death.

The Death of Malcolm X

Numerous failed attempts were made on Malcolm's life. Just prior to his family's eviction from their home in East Elmhurst, Queens (to which the Nation still held title), the most dramatic of these attempts, a fire-bombing, took place the morning of 14 February 1965. The photograph of Malcolm emerging from his Oldsmobile before the charred, scattered remains of his furniture might be taken to imply that he was reduced in his last days to a harried and paranoid existence; its inclusion in a 22 February front-page story in the *New York Times* seemed to infer that his days were always numbered.[188] Malcolm accepted and understood his role as a likely martyr, telling reporters, "I am a man who believed that I died twenty years ago, and I live like a man who is dead already. I have no fear whatsoever of anybody or anything."[189] Two days before his death, in conversation with Parks, he would lament "the sickness and madness of those days" with the Nation: "I'm glad to be free of them. It's a time for martyrs now. And if I'm to be one, it will be in the cause of brotherhood. That's the only thing that can save this country."[190]

The last known portrait of Malcolm, by Haggins, was taken on 18 February 1965. He appears wearing longer hair, exposing the grey signifying the wisdom accrued in his final year and his later, more professorial style. The mood of the picture is of sorrowful resignation, and again the tense is the subjunctive. Malcolm's downcast eyes seem to share in the viewer's consideration of what could have been. He appears to mourn the necessity of his dying to redeem the nation's—and the Nation's—sins. A central paradox of the iconography of Malcolm X is that, despite Malcolm's self-consciously defining himself in opposition to the images of Christian submissiveness he associated with such integrationists as King, his own image would obtain such Christian inflections. Although he would have resisted a Christian interpretation, his was a culture steeped in Christian iconography; as Wilson Jeremiah Moses indicates, "suffering-servanthood and the image of the man of sorrows are, of course, essential ingredients of the Christian messianic myth" appearing

so commonly in the African American religious tradition.[191] Civil rights photography frequently confronted audiences with grim depictions of death, and it would be no different with the images of Malcolm's corpse. The Haggins portrait, however, functions in Malcolm's iconography like representations of the Passion relative to the death of Christ. Zelizer has argued that, with the Passion, "the moment before [Christ's] death is positioned as the preferred way of depicting death itself, death's opposite being used as its stand-in."[192]

Consistent with the civil rights era's disruption of "one of photojournalism's strongest conventions, which is to present a clean image of death," Malcolm's would be another in a series of photographed corpses presented to the American public "as an image of its own systematic dehumanization."[193] Most shockingly, the images of a bloated and beaten Emmett Till appeared, at his mother Mamie Till Mobley's insistence, on the cover of the 15 September 1955 issue of *Jet*. The photographs of Till, a fourteen-year-old Chicagoan lynched in Money, Mississippi, distributed nationally, "literally *illustrat[ed]* southern atrocity with graphic images of black physical suffering."[194] Malcolm himself was familiar with the use of lynching photography as a political and pedagogical tool. Karim indicated that, at the first Nation of Islam meeting he attended, he placed below the blackboard a photograph of "a black man hanging from a tree by a rope around his neck"; Parks photographed Malcolm in 1963 displaying pictures of the dead body of murdered Nation member Ronald Stokes for reporters.[195] Challenging the mainstream journalistic perception of Malcolm's death, Thulani Davis likened Malcolm's death to a lynching. For Davis, the fates of Malcolm, King, Medgar Evers, and others are inseparable from the American racial violence they confronted: in death "they don't become Gandhis; they join a long line of lynching victims."[196]

Malcolm's death was, like his life, much illustrated. Eyewitness Herman Ferguson claimed, probably apocryphally, that at the moment of Malcolm's assassination he observed "lights going off and on. Yellow bright lights. And I said to myself they're not firecrackers, they're not gunshots, they're flashbulbs. They are taking pictures of this thing."[197] There are in fact no known photos from behind the stage or of the shooting itself. Earl Grant's photograph of Malcolm—for *Life*'s 5 March 1965 issue; it also appears in the first edition of the *Autobiography*—taken seconds later, with his wounds exposed and his head cradled in the hands of Yuri Kochi-

yama, captures the horror of the moment of death and its diminishment of Malcolm's imposing physical presence. The UPI images of Malcolm being carried on a gurney by policemen to Columbia Presbyterian Hospital show a more restful Malcolm amidst the moment's derangement, but they contain a sickening sense, as his head sags backward, of his falling into shadow.[198] The visual editorializing began soon after. *Life*'s March 5 issue would characterize Malcolm's legacy as one of destruction, picturing on its cover the shell of Mosque Number Seven, which was burned following his death.[199] Karim wrote that Malcolm's "death made news for days in the press, on the radio, on television. You couldn't escape it."[200] That his death became a spectacle seemed inevitable, following as it did from his career as a media icon in a culture marked by the consumption of images.

Photographs of Malcolm's body lying in state in the Unity Funeral Home, "wrapped in the seven white linen shrouds that a traditional Muslim burial requires," compose the final entries in this initial stage of his iconography.[201] As Hariman and Lucaites suggest, photography and mourning have long been entwined. Memorial images, like rituals of grieving—and, in this case, images of a grieving public—contribute to the "mutual readjustment of the community" by assuaging "the wounds of loss and grief and reconstruct[ing] a viable social order," contradicting Guy Debord's notion that the "spectacle aims at nothing other than itself."[202] Such images are in fact crucial in the consolidation of group identities. Hariman and Lucaites state that "common spectatorship" builds "a particular conception of civic identity" based on identification with, on the one hand, what one sees and, on the other, with what one presumes one sees in common with others.[203] Walter Benjamin has discussed photography's traditional role in mourning, suggesting that the nineteenth-century photographic "cult of remembrance of loved ones, absent or dead, offer[ed] a last refuge for the cult value of the picture," which he more typically associates with earlier periods of painting.[204] Benjamin argued that this value or function of the photograph as memento departed in the twentieth century. With the emergence of popular iconography in the mid-twentieth century, however, the cult of the picture can be seen to have reasserted itself powerfully, though in a context of increased disposability as regards individual images themselves.

As can be observed in the mourning phase of the iconography of Malcolm X, in being assigned to images, grief can begin to be externalized, thereby resolving death's disruption of the living. Barthes asserted that "we photograph things in order to drive them out of our minds."[205] In the case of Malcolm X, however, the photographs also reintroduce him to the contested process of memorial inscription as a figure constitutive of group identities. His photographs both document and distort his reality. Although it may be accurate that "no one who didn't see Malcolm in the flesh will ever know what he really looked like," his figuration as a site of memory allows for a degree of often wishful recognition to persist.[206] Even as he first became identifiable as an icon—of black America; of the African diaspora; of radicalism broadly speaking—Malcolm X remained uniquely resistant to the kind of single-minded interpretation associated with the science of imagery.

Conclusion

For most, inevitably, the images of Malcolm X infringe on the memory of Malcolm X. The Guyanese writer Jan Carew recalled avoiding acknowledgment of the mediation of Malcolm's death upon hearing news of it over the telephone: "I rushed downstairs to switch on the television. But standing before the charcoal-gray screen, I changed my mind. If Malcolm was indeed dead, then I'd defer facing that ugly reality for the moment. I wanted him to be alive, and if I ignored the TV news for a while I could pretend that he was."[207]

In constructing his identifying images and narratives, Malcolm exploited the technologies of mass media, consistently thwarting their intended ideological control. In doing so, he reached and reconstituted his intended audience, becoming in the process one of its most powerful symbols. At his death, however, the contestation of Malcolm's meaning had just begun. The next chapter examines the seminal role of his posthumous autobiography in extending Malcolm's iconicity and myth.

CHAPTER TWO

THE AUTOBIOGRAPHY OF MALCOLM X (1965)

But people are always speculating—why am I as I am? To understand that of any person, his whole life, from birth, must be reviewed. All of our experiences fuse into our personality. Everything that ever happened to us is an ingredient.

Malcolm X and Alex Haley, *The Autobiography of Malcolm X*

All we know of Malcolm is what he wanted us to know—and not one damn thing more. So . . . what if he lied?

David Bradley, "Malcolm's Mythmaking," *Transition*

The *Autobiography* insists that Malcolm's death was imminent. Indeed, the book leaves one with an impression of a series of selves cultivated under constant (if mutating) apprehension of death. Since his youth, Malcolm claimed, "It has always been my belief that I, too, will die by violence. I have done all that I can to be prepared."[1] It is unlikely, however, that Malcolm could have foreseen that even the image of his dead body would be absorbed into the narrative of evolving self introduced by the *Autobiography*. In his epilogue to the book, Alex Haley recounted his farewell to Malcolm's corpse in Harlem's Unity Funeral Home:

> Under the glass lid, I glimpsed the delicate white shrouding over the chest and up like a hood about the face on which I tried to concentrate for as long as I could. All that I could think was that it was he, all right—Malcolm X. "Move on"—the policeman's voice was soft. Malcolm looked to me—just waxy and dead. The policeman's hand was gesturing at his waist level. I thought, "Well—good-bye." I moved on.[2]

Some decades later, Haley's remembrance of this parting scene would be altered significantly. Prior to his death in 1992, Haley told an inter-

viewer not only that he directly addressed this memorial image of the departed Malcolm but also that it was not the name "Malcolm X" that accompanied his recognition of his body. (The restrained but implacable presence of state authority in the person of the policeman had also disappeared.) The name that crossed Haley's lips was one associated with an earlier incarnation of Malcolm's personality—that figure of rebellion and repentant nostalgia, Detroit Red. According to Haley,

> He was lying in state in a Harlem mortuary. I just got in line and went filing along with the other people. And there he was in the casket. I said to myself, but to him just barely audibly, "Bye, Red," 'cause he liked to be called Red by those who knew him very well. I never had called him Red to his face, but I felt now I was among those close to him, and so I just said "Bye, Red," and filed on past.[3]

The story that Haley told in this second account is of a late but final (and possibly apocryphal) recognition. In reconfiguring the record of his remembrance, Haley erected another layer of mediation through which we view, opaquely, his authorship and abstraction of Malcolm; he unintentionally charged the *Autobiography* with misremembering.

The image of Malcolm established by the *Autobiography* can be identified, above all, with the myth of transformation. The book states that his "whole life had been a chronology of—*changes*": from Malcolm Little to Detroit Red, and from Malcolm X to El-Hajj Malik El-Shabazz.[4] The emergent but unrealized narrative perspective of El-Shabazz aligns the most prominent of these identities, Detroit Red and Malcolm X, with Malcolm's "two careers as a black man in America."[5] These two personae are presented as fundamentally opposed; the authors saw fit to predicate Malcolm's transformations not only on photography, renaming, dress, and ideology but also on retrospective disavowal. The reversion, in Haley's memorial passage above, to an identification of the dead man as Detroit Red points to the tension between Malcolm's several personae that the book's structure and the process of its composition sought to resolve. Haley's (perhaps) false memory and Malcolm's retention of the nickname "Red" reveal the imperfect nature of Malcolm's alleged transformations—or, rather, they implicate Malcolm the narrator and author in an exaggerated separation of past from present self, with implications for our viewing of the iconic images that accompany the various personae.

This chapter reveals the extent to which the several images of Malcolm mythologized in the *Autobiography*, and so crucial to the formulation of his iconography, were constructions anchored by a fallacy of charismatic self-invention: a fallacy superficially refuting any notion of the continuity of consciousness among his various incarnations and designed defensively to exteriorize those readerly gazes trained upon a vulnerable interiority. Indeed, the Malcolm presented in the *Autobiography* will be shown to have struggled to articulate the private self underlying the public image. In addition to arguing that the book, in its initial conception, was intended to make Malcolm yet more visible as the likely successor of Elijah Muhammad, this chapter also demonstrates that, despite their overtly Islamic orientation, the images of Malcolm in the *Autobiography* corroborate my claims about his iconography's ambivalent relationship to Christianity. The genre of autobiography, like that of iconography, is rooted in the Christian tradition that Malcolm nevertheless so determinedly critiqued; as such, the book has contributed further to the paradoxical infusion of his images with elements of Christian lore. As well as exploring the strategic retention of some aspects of the image of Detroit Red in the subsequent persona of Malcolm X, this chapter considers the *Autobiography*'s explicit discussions of the cultural provenance and political utility of film and photography. It concludes with an analysis of the book's evolving manner of illustration from 1965 to the present. My treatment of Malcolm and Haley's contentious collaboration begins, however, with the first detailed scholarly examination of "I'm Talking to You, White Man," an article to which Malcolm objected after it was published.

The *Autobiography*'s Predecessors

On 12 September 1964, the *Saturday Evening Post* published across fourteen pages the first extended—and extensively illustrated—autobiography of Malcolm X. The *Autobiography* was at this time nearing completion under Haley's authorship as Malcolm undertook a brief residency in Egypt. Haley's name appeared, however, only in an authorial note below the magazine's table of contents reassuring readers that "Haley himself is a Methodist," and in fine print with the copyright information below the article's first page.[6] "I'm Talking to You, White Man" is attributed in

the table of contents's main entry and the article's byline exclusively to Malcolm X.

Malcolm did not read the piece until after its publication. From Malcolm's and Haley's correspondence, it is clear that he was in fact surprised and disappointed by its tone and by the weight given by Haley to his more declamatory Nation of Islam–era beliefs—an example of Malcolm contending with the science of imagery even in what was ostensibly his autobiography. As ever, Malcolm was no disinterested subject. He would seek to clarify his newfound religious and political views in a pair of letters to M. S. Handler of the *New York Times,* dated 22 and 23 September 1964.[7] After reading the *Post* piece in Cairo, he evidently sought to revise his presentation in the forthcoming *Autobiography* by way of indirect petition: he requested of Handler in a postscript that the first of these letters be copied and forwarded to Haley. Malcolm also informed Haley in "a stinging note" that he objected to the *Post*'s back-page editorial, which lamented that Malcolm was "self-made" in a different manner than the more forbearing Martin Luther King and, overlooking the account of the hajj entirely, cast him inaccurately as a continued follower of Elijah Muhammad.[8] The unsigned editorial concluded that "we shall be lucky if Malcolm X is not succeeded by even weirder and more virulent extremists." The *Post* editor did not suggest that Malcolm had reformed in becoming a Muslim but, rather, was possessed of "messianic delusions."[9]

The image of Malcolm as a former "burglar, dope pusher, addict, and jailbird" proposed by the article had already been established by many sources discussed in the previous chapter.[10] Reporters interested in discrediting the Nation often remarked upon Malcolm's criminal history. In "Black Merchants of Hate," Balk and Haley exaggerated the depravity of Malcolm's early environments, claiming that "he lived in crowded, crime-ridden racial ghettos in Omaha, Lansing, Michigan, Boston and New York."[11] As Essien-Udom noted, his hustling background was "frequently played up by the press. The impression given by this unfavourable publicity is that converts to the Nation come from extremely anti-social elements in Negro society."[12] Of course, it was Malcolm who pushed this history on anyone who cared to listen. Before finalizing it in literary form, Malcolm's conventionalized narrative of the reformed

criminal and sinner was sharpened in his street corner proselytizing and his pitching the Nation to reporters as a mechanism of social uplift. His narration of his experiences as Detroit Red and his subsequent moral reformation functioned as a vernacular legitimization of the Nation and of himself as an urban African American leader. Thus, despite being written by others, "the myth was mostly self-made, as Malcolm told his story again and again, in public speeches, magazine interviews, and finally the *Autobiography.*"[13]

The choice to publish in the *Saturday Evening Post,* and the title given to the essay, "I'm Talking to You, White Man," evocative, in its insistence, of Richard Wright's *White Man, Listen!* (1957), illustrated an important fact about Malcolm's audience: a significant proportion of it was white. Not unlike his eventual champion James Baldwin, whose "Letter from a Region in My Mind" implored a predominantly white, liberal audience in the 17 November 1962 issue of the *New Yorker,* Malcolm positioned himself with the article in a decidedly oracular posture. Malcolm and Haley's choice of the *Post* as a venue for the *Autobiography* is revealing of an interest in reaching a middle-class (if not exclusively white) readership through one of the era's most popular magazines. Despite the *Post*'s reputation for publishing good literature, the context was also a blatantly commercial one, with Malcolm and Haley's words and images juxtaposed with advertisements for Campbell's soup, *Jack & Jill* magazine, lawn fertilizer, the Yellow Pages, Shell, General Electric televisions, Contac, New York Life Insurance Company, RCA, Nationwide Insurance, Scripto pens, and LP Gas. The commercial viability conferred by the mass-market magazine did not imply editorial endorsement, however; the back-page editorial's political distancing from Malcolm is quite explicit. Thus, it is telling that Malcolm and Haley chose the *Post* to present Malcolm's narrative and portraiture of religious transformation. Although the article refuses to predicate the validity of his position by adopting a tone of supplication, a potentially (if conditionally) conciliatory impulse appears behind the bluster of the title.

"I'm Talking to You, White Man" began as the *Autobiography* would with "Nightmare": "When my mother was pregnant with me."[14] From these first words, comparison of the two texts provides evidence of considerable revision. In condensing the narrative, Haley omitted, or perhaps had not yet developed, elements integral to the *Autobiography* such

as the figure of Laura (emblematic of the social costs of Detroit Red's amorality) and the Russian roulette game (with which Red asserts his dominance in the Boston burglary gang). Present is Malcolm's bold and ultimately accurate prophecy of his death: "It has always stayed on my mind that I would die by violence. I have done all that I can to be prepared."[15]

Despite this preoccupation in the text, what distinguishes "I'm Talking to You, White Man" from the *Autobiography* most distinctly is that it was published during Malcolm's lifetime. In other words, it does not carry within the narrative or the editorial accompaniment the fact—or any images—of his assassination. The conclusion of the piece is fascinating in its comparative indeterminacy. The *Post* piece ultimately veers from topicality to defensiveness, gauging Malcolm's views on the presidential race ("It's just a question of Johnson, the fox, or Goldwater, the wolf") and issuing a rebuttal to his reputation as a reverse racist: "Once I was a racist—yes. But now I have turned my direction away from anything that's racist."[16] The image of Malcolm presented here seems not to have been redeemed, however, but sanitized: he appears purified of characteristic urgency and insistence.

The article does not address his black nationalism, anti-imperialism, or Sunni faith in any detail. Manning Marable insisted that the "individual most responsible for removing the radical and revolutionary context from the image of Malcolm X was Alex Haley," who, as a Republican and integrationist, was "politically a continent apart" from Malcolm, whose views he sought to absolve in humanist terms. Moreover, Haley, who "remained deeply hostile to Malcolm X's black nationalist politics," allowed his approach to Malcolm and the Nation to be (at least indirectly) shaped by the FBI. Alfred Balk, coauthor with Haley of "Black Merchants of Hate," had approached the FBI for information on the Nation. Marable argued: "The basic approach agreed upon by the FBI and Balk in late 1962—to give a reasonably accurate depiction of the Nation of Islam but to represent the black separatist group as a product of American society's failure to implement liberal integration—remained Haley's consistent, overriding ideological objective in the *Autobiography*."[17]

Like the Balk-Haley article, also published in the *Post*, "I'm Talking to You, White Man" advanced Malcolm's existing image as a perceived threat to white America. Although Malcolm can be seen to confront

white America with the piece, he does so in terms that do not always appear to be his own. In the conclusion of the article, Malcolm's message for America is presented in language surprisingly reminiscent of Martin Luther King's: "I dream that one day history will look upon me as having been one of the voices that perhaps helped to save America from a grave, even possibly fatal catastrophe."[18] This image of Malcolm as a prophet of avoidable doom, even hopeful of unity, speaks to the ambiguous and convoluted process of his authorship, a process that would continue with Haley for some months.

On 8 August 1964, Haley cabled Malcolm in Egypt requesting a portrait for the *Post*'s cover.[19] The photographer commissioned for the project was John Launois, a regular contributor to the *Post*, *Life*, and *National Geographic*. Launois was flown out from Paris by the *Post* to secure a rare color portrait of Malcolm; ultimately, he would provide three, including the cover photograph, and one in black and white. (Launois also captured an exceptional image of Malcolm X before the pyramids of Khufu and Khafre that did not appear with the original article.) Launois's series, including the images of Malcolm addressing a local imam and performing the *salat* in the Mosque of Muhammad Ali, documented the arrival of El-Hajj Malik El-Shabazz, the Sunni cleric and anti-imperialist—an image out of keeping with the content of the article.

Carl Nesfield's photograph of Malcolm with Castro was also reproduced with the article. Two other images depicted aspects of Malcolm's representation whose implications within the autobiographical mythology will be revisited at some length: first, a photograph of his wife and four daughters, seated beneath a map of Africa, with Malcolm the family man absent, and, second, a picture of a zoot-suited, unsmiling, teenage Malcolm standing incongruously in the suburban garden of a wood-paneled house.

The *Autobiography*'s Collaborative Authorship

Implicit in any autobiography is the author's declaration "that he is the person he says he is and that the author and the protagonist are the same."[20] In the *Autobiography*, this assumption is coupled with the problem of Haley's authorship. Subject to the dictates of commerce as well as genre, Malcolm has often been misrepresented as the book's sole

author. The myth of the *Autobiography* as a self-authored document has been conveyed through the title of the book, the absence of reference to Haley on the front cover of many editions, and the customary image of Malcolm on the dust jacket or cover. In packaging the text, publishers including Grove Press, Hutchinson, and Penguin have demonstrated an investment in presenting the book as providing direct access to Malcolm. Of the many posthumous books contributing to the spectralization of Malcolm X, only the *Autobiography* was substantively authorized by Malcolm himself. Carol Tulloch, for example, has asserted that "the storyteller, Malcolm X," is "always in control" of his representation, whereas Haley is merely "the guide."[21] Whatever Haley's intentions as an honest chronicler, his authorial and editorial contributions to the book—and thus to popular conceptions and images of Malcolm X—are significant and undeniable. Given their coauthorship of the *Autobiography*, the statement that "everything that ever happened to us is an ingredient" can and must be considered in a different light. Given Malcolm's heavy reliance on journalists and photographers in collaboratively transmitting his views and image, an examination of the persistence of the science of imagery in his relationship with Alex Haley, his most significant collaborator, will be instructive.[22]

In "Malcolm X and the Limits of Autobiography" (1976), Paul John Eakin provided an influential reading of the *Autobiography*'s unique revelation of "the temporal fiction" inherent to the genre: the false "notion that living one's life precedes writing about it." He urged readers not to be misled by "the fiction of the completed self" thrust upon Malcolm by the fact of the book's apparent completion and the "posthumous authority" conferred by his death. For Eakin, the book succeeds, paradoxically, "in its confession of failure as autobiography." Its logic resides not in a totalizing retrospection but in Malcolm's mutability and the narrative instability of the "voice from the grave," El-Hajj Malik El-Shabazz, merely "the last one in the series of roles that Malcolm X had variously assumed, lived out, and discarded." Eakin found precedent for the *Autobiography*'s provisional identities in the insistence, in the posthumously published *The Education of Henry Adams* (1918), that "uncompromising commitment to the truth of one's own nature . . . requires the elimination of false identities and careers one by one."[23] Eakin erred, however, in attributing the book's knowingness specifically to Malcolm. Malcolm's apparent res-

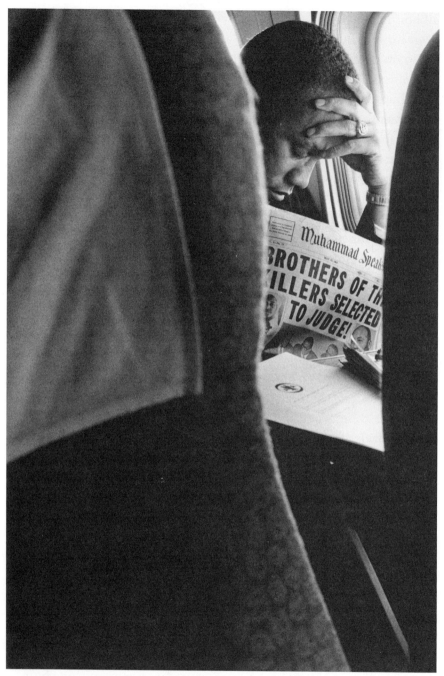

Malcolm X on airplane, 1963. Photograph by Gordon Parks. © The Gordon Parks Foundation.

ervation about the autobiographical form—"How is it possible to write one's autobiography in a world so fast-changing as this?"—is expressed not in the manuscript Malcolm approved but in Haley's posthumous epilogue; the image of Malcolm as distinctly self-aware is thus at least partly attributable to Haley.[24]

Haley, "a recently retired veteran from the Coast Guard and a feature stories writer" for *Reader's Digest,* composed most of the *Autobiography* in 1963–1964 from interviews undertaken with Malcolm during his tenure in the Nation of Islam.[25] The book was written—and Malcolm was killed—in the midst of a crucial period of personal, political, and religious evolution. At the outset of his collaboration with Haley, Malcolm was dogmatic in his devotion to Elijah Muhammad; indeed, within the autocratic context of the Nation it was necessary that the book be a devout one. But in early 1963, when Haley suggested to *Playboy* editor Murray Fisher an interview with the gregarious and dynamic Malcolm rather than the guarded and didactic Muhammad, Malcolm was already "firmly in command of the shape of his life, tracing his sense of this shape to the pivotal and structuring illumination of conversion itself."[26] Like St. Augustine, Malcolm saw divine intent in both his reformation and his sinful past. But "the very premises of the autobiography he had set out to write" with Haley were fractured upon his separation from the Nation.[27]

As Haley's epilogue revealed, Malcolm cancelled the book's original dedication to Elijah Muhammad, "who found me here in America in the muck and mire of the filthiest civilization and society on this earth . . . and made me the man I am today."[28] The published dedication would read, more modestly: "This book I dedicate to my beloved wife Betty and to our children whose understanding and whose sacrifices made it possible for me to do my work."[29] The image here is of Malcolm, the family man, abroad or sequestered in his study, demonstrating a gendered sense of public engagement. Although a letter of agreement signed by Malcolm and Haley on 1 June 1963 gave to the former editorial control of the manuscript, Malcolm spent much of his formative last year abroad. Haley considered his research complete and the book nearly finished in June 1964.[30] In taking time to write the book, Haley lost sight of Malcolm, "for even Haley and the book that was taking shape in his hands were out of phase with the reality of Malcolm X's life and identity."[31]

Haley's authorship was a necessary compromise for Malcolm. Practically speaking, he probably could not have attempted an autobiography. He rarely took a day off from his ministerial duties and speaking engagements, and he traveled incessantly, especially throughout the American Northeast. Malcolm was, in fact, anxious about Haley's motives during the early period of their collaboration, telling him, "You I trust about twenty-five percent." If Malcolm expected his words to be expurgated and his image to be distorted, however, it was not by Haley but his editors. Haley wrote: "He would end an attack upon the white man and, watching me take the notes, exclaim, 'That devil's not going to print that, I don't care what he says!'"[32] Haley reported that Malcolm, about two weeks before he was killed, told him, "Brother, I don't think I'm going to live to read this in print. So I'd like to read it again."[33] Malcolm apparently last read through the completed manuscript in a three-day stint at the New York Hilton. The draft was then sent, according to Haley, to the publisher. David L. Dudley concurs that "Malcolm had given his approval for the drafts of the latter chapters, so the book as it stands bears his imprimatur."[34] But the published version of the *Autobiography* is not the manuscript on which Malcolm signed off.

In late 1964 Malcolm proposed a wholesale revision of the text, asking Haley "gruffly, 'Whose book is this?'" Haley responded "yours, of course," indicating that he "only made the objection" to rewriting the account of Malcolm's "father-and-son relationship with Elijah Muhammad" from "my position as a writer"—a position from which he was determined to protect, out of a kind of misguided journalistic integrity, his account of what Malcolm "had originally said." Haley seems to have been as invested in preserving the former image of Malcolm X as Malcolm was invested in recasting himself as the reinvented El-Shabazz. Haley wrote of the faltering effort to update the chapters addressing Malcolm's evolving politics: "Malcolm X wanted to 'huddle' with me to fill me in on details from his trip that he wanted in the book. . . . 'What I want to stress is that I was trying to internationalize our problem,' he said to me, 'to make the Africans feel their kinship with us Afro-Americans.'" But within a few days, beset by "a host of problems" related to "discontent within his organization, the OAAU," he withdrew from Haley's time-consuming interviews.[35]

Like autobiographers Frederick Douglass, W. E. B. Du Bois, and Langston Hughes before him, Malcolm was coming to regard African American identity and struggle more clearly in the context of global politics—a shift revealed more explicitly by Malcolm's late speeches than by the *Autobiography*. According to Louis DeCaro, two chapters titled "The End of Christianity" and "Twenty Million Muslims" were deleted from the published version.[36] The titles suggest that the "missing" chapters described Malcolm's Nation of Islam–era philosophy, rather than his emergent internationalism, and were excised out of respect for his conversion to Sunni Islam. In *Living Black History* (2006), Marable presented a very different analysis. Given brief access to a section of the original manuscript including three unpublished chapters, which Marable dated to "sometime between October 1963 and January 1964," proposing "the construction of an unprecedented African-American united front of black political and civic organizations, including both the Nation of Islam and other civil rights groups," Marable claimed that Haley conspired, with the collusion of the FBI, to betray Malcolm's political vision.[37] Clearly Haley was not averse to altering the manuscript without Malcolm's approval and thus radically reshaping his image and legacy; Haley's correspondence with Kenneth McCormick reveals that he quietly wrote out of the manuscript some of Malcolm's "negative statements about Jews."[38]

The most evident departure from the final draft reviewed by Malcolm is a text appearing in some form with all versions of the published book: Haley's epilogue (or foreword, in British editions), written after Malcolm's death and covering sixty-three pages in the Grove Press first edition, making up nearly fourteen percent of the book's length. Haley wrote that he had preapproval from Malcolm for just such an epilogue: "I asked for—and he gave—his permission that at the end of the book I could write comments of my own about him which would not be subject to his review."[39] It bears mentioning, however, that the original letter of agreement contained no such provision. The *Autobiography* as we have it, then, is not quite Malcolm's. Following Malcolm's death, it "would be left to Haley to close the book; autobiography [gave] way to biography"; Haley became "Malcolm's biographer, or rather . . . his thanatographer."[40]

Despite Haley's declaration that Malcolm was "the most electric personality I have ever met," he insisted that "I tried to be a dispassionate

chronicler."[41] Irreducibly, Haley's interest in the book was, if not political, then personal, professional, and financial: the contract stipulated that 50 percent of the book's royalties were his—a lucrative share further appreciated by the tide of international interest aroused by Malcolm's murder. A decidedly sensationalist tone was struck by the reproduction, in the first edition, of Earl Grant's photograph of Malcolm dead or dying, with wounds to his chest fully exposed, in the Audubon Ballroom. Whether Haley approved its inclusion is unknown. Haley ultimately relinquished his financial interest in the *Autobiography* in the late 1970s—"when my book *Roots* made it possible, I signed over to Betty Shabazz my half of the royalties"—but not before he had profited considerably for more than a decade.[42]

The epilogue acknowledges Haley's authorial intervention and Malcolm's purposeful fictionalizations. The *Autobiography*'s self-consciousness is largely a product of the epilogue's ambiguous relationship to the nineteen chapters, being simultaneously internal and external to the text they make up. During extensive interviews, Haley audiotaped and took notes from Malcolm's discursive "freestyle."[43] Noticing "that while Malcolm was talking, he often simultaneously scribbled with his red-ink ball-point pen on any handy paper," Haley fixed upon Malcolm's "napkin scribblings," interpreting them as a partial revelation of his repressed or withheld thoughts and the path to a sort of psychoanalytical breakthrough to a more genuine subject. On this view, Malcolm was intimating what he dared not speak. Appropriately, Haley claimed that "talking about his mother triggered something," and Malcolm's memory of his painful past was unlocked.[44]

As many later memoirists would do, Haley fetishized the image of the private Malcolm, inscribing his elusiveness and presuming his distinctness from the public Malcolm. This account also served to valorize Haley's portrait of Malcolm by characterizing it as one possessed of intimate knowledge. As Malcolm had "rarely talked to anyone about [his] mother," Haley can be seen to provide privileged and hard-won access to an intensely private and, indeed, volatile subject. Malcolm is presented as having told Haley: "I believe that I am capable of killing a person, without hesitation, who happened to make the wrong kind of remark about my mother." Another passage speaks of an impolitic affinity for sympathetic white people. After being stopped at a traffic light by a white man who

told Malcolm, "If I were a Negro I'd follow you, too," Haley wrote, "Malcolm X said to the man very sincerely, 'I wish I could have a white chapter of the people I meet like you.' The light changed, and as both cars drove on, Malcolm X quickly said to me, firmly, 'Not only don't write that, never repeat it. Mr. Muhammad would have a fit.'"[45] Yet he did write it; this account is presented as an acknowledgment, by Haley, of his privileging of journalistic disclosure over personal loyalty. The Malcolm that Haley came to know, he tells the reader, is not the more superficial, public image Malcolm would have had us know—and it is Haley's Malcolm that is closer to the truth.

Despite Haley's interventions, Malcolm's role in shaping his image by way of the *Autobiography* was by no means negligible. Nor was it necessarily more truthful. "In public utterances and expressions," African American novelist David Bradley claims, "Malcolm consistently transformed his life":

> He turned a two-bit wife-beater of a father into a political and religious visionary who was killed because of his beliefs and defiance; he transformed his youthful self into a dangerous and hard-nosed criminal; he made the process of conversion seem sudden and powerful and inescapable. He made the bottom deeper so the top could be higher. He did just what a novelist or a scriptwriter would have done; tightened up the action, combined characters, gave the thing a better act structure and more dramatic impact—more punch.

Although Bradley, like so many commentators, overlooked Haley's authorial contributions, he was right to observe that "Malcolm did alter the facts."[46] Abdul Aziz Omar (formerly Philbert Little, then Minister Philbert X), remembered his younger brother Malcolm as a young fabulist: "He was a braggadocio. He would brag about what he had done and this and that, but it hadn't been that bad. He just knew how to tell it so it sounded as though he was a gang leader. But he didn't have no gang."[47]

With important implications for the *Autobiography*-inflected posthumous iconography, many have doubted the book's truthfulness, beginning with the opening scene. Nell Irvin Painter argued that Malcolm's "memory" of the Little family being terrorized in their home in Omaha, Nebraska, inaccurately employed the southern iconography of hooded Klansmen in a midwestern setting.[48] The episode has been taken up un-

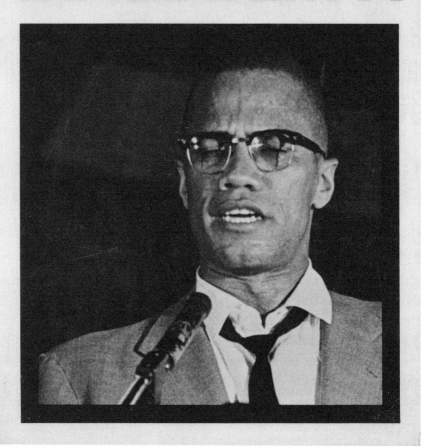

First edition of The Autobiography of Malcolm X, *Grove Press, 1965. Photograph by Leroy McLucas.*

critically in most retellings of the *Autobiography*, including Spike Lee's film. Several accounts also dispute the *Autobiography*'s framing of Malcolm's youth in Harlem as Detroit Red. Peter Goldman wrote of journalist Ted Poston's efforts to "reach some of Malcolm's old street crowd": "Poston, in an unpublished memorandum, reported that most of his contacts in the Harlem demimonde professed never to have heard of Malcolm—not the old Malcolm, anyway."[49] Bruce Perry claimed that Malcolm was himself intermittently a prostitute and, from 1944, worked as a dancer and drummer "at a nightclub called the Lobster Pond," using the stage name Jack Carlton.[50] Of all people, it was Harlemite James Baldwin who professed to recognize Malcolm, on first seeing him speak as a Muslim minister, as "the hustler I remembered from my pavements."[51]

DeCaro, having examined Massachusetts State Prison records, argued that the image of Malcolm "as an unyielding convict who preferred to pay for his aggressive acts of rebellion in solitary confinement is a fabrication."[52] Nor does the *Autobiography* mention what is revealed by Malcolm's prison correspondence: "that, even before [his brother] Reginald visited him, he had already become interested in religious ideas, and had even begun his own comparative religious studies" of Islam, Buddhism, Christianity, Hinduism, and even "the Watchtower Bible and Tract Society" of Jehovah's Witnesses. Media-savvy Malcolm even received some press attention, unremarked in the *Autobiography*, while in Charlestown State Prison. After he led a group of Muslims in requesting east-facing cells for purposes of prayer from prison authorities, "the local press picked up the story . . . describing Malcolm and his cobelievers as wearing beards and mustaches and declaring piously that Allah 'will help us and protect us from evil.'"[53] Through such elisions and alterations, the book can be seen to cast Elijah Muhammad more thoroughly in the light of the savior of hardened cases, and Malcolm in the light of the humble worshipper.

Haley acknowledged some of Malcolm's particular contradictions, misgivings, omissions, and demands, indicating that, "at intervals, Malcolm X would make a great point of stressing to me, 'Now, I don't want anything in this book to make it sound that I think I'm somebody important.'" Such expressions of modesty were tempered with bursts of braggadocio revealing of Malcolm's self-identification with prophets both sacred and secular:

Once when he said, "Aristotle shocked people. Charles Darwin outraged people. Aldous Huxley scandalized millions!" Malcolm X immediately followed the statement with "Don't print that, people would think I'm trying to link myself with them." Another time, when something provoked him to exclaim, "These Uncle Toms make me think about how the Prophet Jesus was criticized in his own country!" Malcolm X promptly got up and silently took my notebook, tore out that page and crumpled it and put it into his pocket, and he was considerably subdued during the remainder of that session.[54]

The passage presents a self-aware Malcolm calculating his reception. Clearly, humility was felt to be a necessary part of his projected image. That his frame of reference was white and Western hints at the global and, on some level, conventional character of his ambition. Malcolm's dramatic sense—his willingness to sacrifice truth to a good story—is also exposed in the epilogue. After confessing to Haley that "I palmed the bullet" in the Russian roulette game so central to the *Autobiography*'s characterization of the recklessness of his Detroit Red period, Malcolm is depicted as urging Haley to leave the passage alone. Otherwise, he said, "Too many people would be so quick to say that's what I'm doing today, bluffing."[55] In his authorial revelations, Haley suggested that Malcolm's public image was largely a construction—a clever manipulation of the science of imagery.

Unexplored in the epilogue is the *Autobiography*'s grandest scheme, at least in its initial conception: inscribing Malcolm's prophetic encounter with the divine in the interest of his succession to leadership of the Nation of Islam. Aspects of Malcolm's narrative are in fact self-consciously modeled on accounts of the life of Elijah Muhammad. Like Malcolm's father, who was rumored to have been murdered by intolerant whites in Lansing in 1931, Elijah Muhammad's father, Willie Poole, Sr., was reputed to have died violently in Georgia. Baldwin reported of Muhammad that "we owe his ministry, I am told, to the fact that when he was a child of six or so, his father was lynched before his eyes." In a kind of baptism in racial violence, "he saw his father's blood rush out—rush down, and splash, so the legend has it, down through the leaves of a tree, on him."[56] Narratives of imprisonment also connect the mythologies of both Elijah Muhammad and Malcolm X; Muhammad's popularity with prisoners

such as Malcolm was strengthened by informally circulated narratives of his persecution and imprisonment for inciting resistance to the draft in the 1940s.

Most important, however, was Malcolm's emulation, through Haley and the *Autobiography*, of Elijah Muhammad's visionary claim to religious authority—a studious application of the science of imagery linking the visual and spiritual planes. Although Marable charged Haley and the FBI with "pushing the erroneous thesis that Malcolm desired leadership over the organization" in order to paralyze the Nation, the perception of Malcolm's ambitions predated the *Autobiography* by some years.[57] In 1961 C. Eric Lincoln anointed Malcolm, the most visible figure in the Nation, as the likely successor of Elijah Muhammad. Lincoln also noted the tenuousness of Malcolm's claim to the throne: "But Malcolm has never seen Allah. . . . His revelation is second-hand." Unlike Muhammad, whose authority within the Nation was irrevocable, Malcolm had not been appointed by the Nation's supposedly divine founder, "The Mahdi," W. D. Fard Muhammad.[58] As such, according to Lincoln, Malcolm's supremacy within the Nation was not assured: "He will not be considered quasi-divine, and he will not reign unchallenged."[59]

The *Autobiography* responded aggressively, if implicitly, to this claim, establishing what the iconography would confirm: Malcolm's ambition to become a medium of worship. His quest for religious legitimacy is manifest in the book's image of him as a visionary figure. Malcolm is presented as having come by prophecy honestly—indeed, genetically. In the first chapter he is shown recalling "that my mother had this vision" of her husband dying before he set out on the day of his death. Malcolm's own vision appears to be more self-interested. In prison, the book claims, "as I lay on my bed, I suddenly, with a start, became aware of a man sitting beside me in my chair": "He had on a dark suit. I remember. I could see him as plainly as I see anyone I look at. He wasn't black, and he wasn't white. He was light-brown-skinned, an Asiatic cast of countenance, and he had oily black hair. I looked right into his face. . . . Then, suddenly as he had come, he was gone."[60]

Malcolm did not grasp the vision's import as suddenly. The *Autobiography* goes on to state that "I would later come to believe that my pre-vision was of Master W. D. Fard, the Messiah, the one whom Elijah Muhammad said had appointed him—Elijah Muhammad—as His Last Messenger to

the black people of North America."[61] As DeCaro has argued, the published version of the book fails to disavow or explain away the peculiar vision that Malcolm's later Sunni faith presumably could not have condoned. The vision is not, then, "the outstanding religious mystery" of the *Autobiography* but the boldest and clumsiest trace of Malcolm X's abandoned project to establish his claim as Elijah Muhammad's successor—an ambition rendered obsolete well before the book went to press. Still, "the Asiatic-looking man" sits in the narrative "gap between Malcolm's two conversion experiences," revealing, like Haley's conflation of Detroit Red and Malcolm's corpse discussed above, the persistence of past images in spite of the attractiveness of the *Autobiography*'s myth of transformation.[62]

Malcolm X's "Christian" Conversion Narrative

From *The Confessions of St. Augustine* (398–400 AD) to *Autobiography of Benjamin Franklin* (1771–1790); from *Narrative of the Life of Frederick Douglass* (1845) to Wright's *Black Boy* (1945) and Baldwin's essays, *The Autobiography of Malcolm X* demonstrates the influence of a variety of influential autobiographies and their memorable personalities, with the primary difference being the extent to which the various editions of the *Autobiography* have been illustrated, both advancing and exploiting Malcolm's visual currency. Before discussing the book's explicit treatment of film and photography and its manner of illustration, however, I will address three images of Malcolm irrevocably put forth in the *Autobiography*, with important consequences for his subsequent iconography: Malcolm X as a convert to Islam, but in Christian terms; Malcolm X as an elusively public and decidedly masculine figure; and Malcolm X as an emanation of the urban rebel Detroit Red.

Malcolm's autobiography can be viewed productively in comparison with the terms of both Augustinian conversion narratives and the biblical tradition. In the case of the latter, the scriptural authority of the text anchors an evangelism augmented, as with the *Autobiography*, by the use of iconic images. Autobiography scholar Eakin describes "the essential pattern" of Augustinian narratives: "In the moment of conversion a new identity is discovered; further, this turning point sharply defines a two-

part, before-after time scheme for the narrative; the movement of the self from 'lost' to 'found' constitutes the plot; and, finally, the very nature of the experience supplies an evangelical motive for autobiography."[63]

In *The Confessions of Saint Augustine*, the mechanism of conversion is not visual but literary: "the reading of the Gospel." Upon being urged by an unseen child's voice to "take up and read; take up and read," Augustine opens his Bible to a passage in Romans admonishing him in his sinfulness.[64] Augustine's account emerged from a tradition of Christian conversion narratives traceable to Saul's testimony of his salvation on the road to Damascus and his subsequent reinvention as Paul the Apostle.[65]

The *Autobiography* presents Malcolm's conversion in terms similar to Augustine's, indicating that Malcolm first came to religion through the written word, in the form of a cryptic letter from his brother Reginald encouraging him to stop smoking and eating pork, and promising to "show [him] how to get out of prison." He is described, further, as if reborn in the light of knowledge, claiming that "the very enormity of my previous life's guilt prepared me to accept the truth."[66] Despite such apparent religious sincerity, the *Autobiography* is imperfect in Augustinian terms. The intended narrative structure of the sinner saved by Elijah Muhammad is complicated by the second "more credible conversion story," unforeseen by the authors at the outset of their collaboration, which occurred in Mecca in 1964.[67] Nevertheless, the traces of the first narrative, including the cancelled dedication to Elijah Muhammad, necessitate the Augustinian comparison.

Augustine, who was born and educated in North Africa, is in fact referenced in the *Autobiography* as "the black African saint who saved Catholicism from heresy." He was not the only figure from antiquity reclaimed in this manner for a pantheon of iconic non-Europeans by Malcolm. The *Autobiography* suggests that Homer was a Moor and Aesop an Ethiopian; one of Malcolm's early triumphs as a Muslim was his extraction of the statement "Jesus was brown" from a Harvard seminary student visiting the Charlestown prison. Malcolm would recall a later conversation with an unnamed white reporter: "I remember we wound up agreeing that by the year 2000, every schoolchild will be taught the true color of the great men of antiquity."[68] The revisionism expressed here, concerned

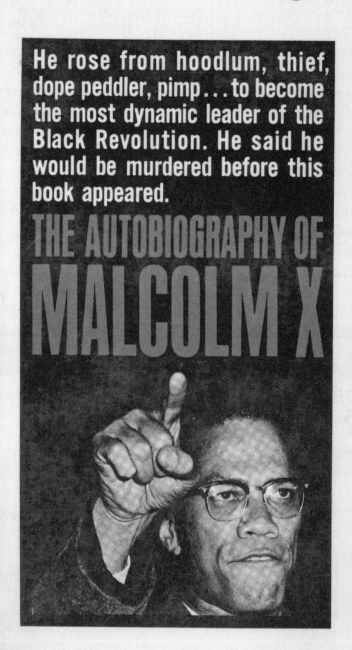

Paperback edition of The Autobiography of Malcolm X, *Grove Press, 1966. Photograph by United Press International.*

both with written history and visual culture's consequential distortions, is consistent with Malcolm's views expressed elsewhere on the science of imagery.

While Malcolm claimed Jesus as a fellow non-European, his resistance to the European-derived cultural influence of Christianity has been noted. The *Autobiography* states that, even as a child, "I just couldn't believe in the Christian concept of Jesus as someone divine," and, in later life, Malcolm could not look beyond the hypocrisy of "the so-called 'Christian trader' white man" plying "the seas in his lust for Asian and African empires, and plunder, and power." In a characteristic paradox, however, Malcolm would frame his critique of the "Faustian" white Christian in terms indigenous to the Christian cultural tradition. Neither was Malcolm averse to turning European literature (and frontispiece portraiture) on its political head for his own propagandistic ends, as in the rather unconventional reading of Milton's *Paradise Lost* offered in the *Autobiography*: "The devil, kicked out of Paradise, was trying to regain possession. He was using the forces of Europe, personified by the Popes, Charlemagne, Richard the Lionhearted, and other knights. I interpreted this to show that the Europeans were motivated and led by the devil, or the personification of the devil. So Milton and Mr. Elijah Muhammad were actually saying the same thing."[69] In a passage excised from Haley's *Playboy* interview with Malcolm, Malcolm went so far as to claim the lily-white Milton as a black poet, citing as evidence a portrait of Milton in a book confiscated from the Norfolk prison library.[70] Unfortunately, Malcolm had forgotten the book's title.

His insistence upon Christian complicity in racial oppression coexisted with an appropriation of a Christian frame of reference. Although Bashir M. El-Beshti was correct in noting that the *Autobiography* presents Malcolm's life as predestined or written, the book's debt is not exclusively to "Islamic providentialism," even, or especially, in its account of Malcolm's revelatory, prison-cell vision of Nation founder W. D. Fard Muhammad. Despite the overt Christian tenor of the book's form, El-Beshti has emphasized the Islamic content of the *Autobiography*, invoking such certainties as Malcolm's "true identity—El-Hajj Malik El-Shabazz."[71] Dwight F. Reynolds has written of a tradition of Arabic autobiography, traceable "at least as far as the ninth century" and concerned with exemplary lives often inspired by "the idea of the Prophet Muhammad as . . .

the ideal human being whose life and acts (*sunna*) are to be imitated by believers."[72] Malcolm and Haley's emphasis on illustrating his past life of sin places him nearer to the confessional than the exemplary mode, and nearer to the Christian than the Islamic autobiographical model.

Malcolm himself would not deny that the biblical narrative of Paul's conversion influenced the depiction of his own religious transformation, and, indeed, the Koran seems to have played little part in his coming to the Nation's unorthodox Islam: "I remember how, some time later, reading the Bible in the Norfolk Prison Colony library, I came upon, then I read, over and over, how Paul on the road to Damascus, upon hearing the voice of Christ, was so smitten that he was knocked off his horse, in a daze. I do not now, and I did not then, liken myself to Paul. But I do understand his experience."[73] Malcolm's hesitance to compare himself to Paul sounds suspiciously like false modesty. As the national minister of Elijah Muhammad, "that little humble lamb of a man," he seemed to have modeled his evangelical mission on that of Paul.[74] In this light, Malcolm's autobiography, as initially conceived, can be seen as evangelical in intent: this conversion narrative, like Paul's, sought to convert.

Private and Public Selves

Like the iconography it informs, the *Autobiography* expresses Malcolm's alignment with an unapologetically masculine, and necessarily public, defiance. While the photography discussed in my first chapter communicates such meanings by way of a raised fist or a microphone, the *Autobiography* discursively explores Malcolm's ambivalent relationship to violence, ultimately framing his preferred mode of combat as vocal. As an oratorical text positioning Malcolm as a fearless advocate of truth and racial justice, however, Malcolm comes to appear a largely public figure clinging to performativity—and patriarchy—even in his private life. Indeed, it may be a condition of iconicity that a figure appears sufficiently unfastened from conventional domesticity to become broadly emblematic in his or her self-sacrifice.

Autobiography, like much African American literature, has not only "been male dominated" in terms of output but also inordinately preoccupied with masculinity.[75] In America's violent and repressive climate, most commonly, and perhaps necessarily, figures of heroic resistance

have been male. The most iconic self-assertions of heroic black men have arguably been physical ones. As Fanon wrote, "The 'thing' which has been colonised becomes man during the same process by which it frees itself"; according to Gilroy, "the physical struggle is also the occasion on which a liberatory definition of masculinity is produced."[76]

Indeed, Malcolm was inspired in his youth by the physical mastery of boxing champions Joe Louis and Ray Robinson, whose victories seemed to exact a symbolic measure of revenge for wrongs inflicted upon African Americans. In his early years, Malcolm was convinced that "the ring was the only place a Negro could whip a white man and not be lynched."[77] But after consecutive clinical defeats at the hands of white boy and novice boxer Bill Peterson as a thirteen-year-old, Malcolm wisely confined himself to verbal sparring. The *Autobiography* suggests "that if he had been good at boxing he would not have become an exceptional leader": "I might have wound up punchy."[78]

Malcolm's assertion of selfhood—or, rather, *manhood*—through language, especially public speaking, is a matter of fundamental concern in the *Autobiography*, a book in which freedom is manifested as a condition of righteousness and articulacy. Indeed, with implications for the iconography of Malcolm X, African American speech is presented as an antidote to invisibility or conditional visibility within American culture more broadly. Even as a star pupil, basketball player, and seventh-grade class president, the young Malcolm is shown to have been made to feel—by an informal campaign of various offhand comments, slurs, "nigger jokes," social barriers, and popular images, in the face of which he remained silent or inarticulate—that he was little more than a "mascot," "a pet canary," or "a pink poodle." Thus, Malcolm believed, "they never did really see *me*"; his visibility, like that of African Americans generally, was nullified in its objectification by whites: "In their eyes we were just *things*, that was all."[79] Indeed, invisibility is recognizable as a trope well used by, even identifiable with, twentieth-century African American literature, many examples of which illustrate the encumbrance of the visual plane of American culture with unreconstructed racial iconography. Crispin Sartwell has described the process of dubious approbation within which "the oppressor seeks to constrain the oppressed to certain approved modes of visibility (those set out in the template of stereotype) and then gazes obsessively on the spectacle he has created."[80] By announcing so vehe-

mently the validity of his own presence in America, the mature Malcolm X can be seen to have sought to reconfigure visual perceptions of African Americans *even on the level of language.* The *Autobiography* recalls his fatalistic determination while in prison: "I made up my mind to devote the rest of my life to telling the white man about himself—or die."[81]

Malcolm's "baptism into public speaking" occurred when he entered Norfolk Prison Colony's debating program, although he had been introduced to oratory as a young child by way of his father's Garveyite, sermonlike exhortations of "the Negro masses to return to their African homeland"—a telling, if imperfectly remembered, immersion.[82] (In another incongruous yet characteristic Christian residue, the *Autobiography* characterizes Earl Little as a Baptist preacher. Malcolm's eldest brother, Wilfred, has claimed that this is inaccurate: the Little children were taught "never to give themselves to any religion."[83]) The portrait of Malcolm in the *Autobiography* suggests that he possessed an innate oral articulacy honed especially in his incarnation as Detroit Red.[84]

Oratory becomes formally central to the narrative of Malcolm's career in the Nation of Islam; it is tied to the self-fashioning that informs Malcolm's theory of representation as a whole. Beginning with its reconstruction of Malcolm's first speeches on "Christianity and the horrors of slavery" at Detroit's Temple Number One, the *Autobiography* is frequently propelled by lengthy quoted passages from, or resembling, speeches.[85] The speeches connect Malcolm to a tradition, associated with Douglass, in which the stereotype of inarticulacy associated with African American dialect is rejected, "the master's voice" is appropriated and subverted, a "dignity and manliness of tone" is asserted, and the mastery of language is shown to encompass literary and oral expression rather than being reduced to either.[86] These passages also project a public and performative Malcolm distinct from both narrator and author—a Malcolm recreated by Haley from private interviews with Malcolm. This is the Malcolm whose language, presented in paragraphs of direct speech, most closely resembles that of the public figure covered in my first chapter.

In his discussion of Haley's early interviews with Malcolm, Eakin argues: "Haley portrays two Malcolms: a loyal public Malcolm X describing a religious movement in which he casts himself in a distinctly subordinate and self-effacing role, and a subversive private Malcolm X scribbling a trenchant counter-commentary in telegraphic red-ink ball point on any

available scrap of paper."[87] The portrayal is not, however, entirely balanced or unambiguous. The facet of Malcolm's private self least clearly defined in the *Autobiography*—and consequently, in his iconography—is also its least subversive. One commentator has argued that, generically, "autobiography affords the greatest opportunities to combine the two perspectives [public and private] because it develops like a village on the crossroads between the author's subjective life and his socio-historical life."[88] But if there is a blind spot in the *Autobiography*'s confessional mode, it is in the depiction of the domestic personality of Malcolm X. In its guarded characterization of his home life, the book provides a glimpse of the moral subjectivity anchoring a very public life but ultimately asserts the separation of private and public selves along staunchly gendered lines.

M. S. Handler's introduction to the *Autobiography,* appearing with the critical apparatus of all American editions, represents the sole white voice in the text.[89] Handler, a reporter for the *New York Times,* was evidently a trusted—and well-connected—correspondent of Malcolm X who had written several sympathetic articles about his post–Nation of Islam views.[90] Handler wrote of first meeting Malcolm in March 1963 in the Muslim restaurant on Lenox Avenue. During this encounter, Malcolm enlightened him "about the Negro mentality," though Handler seemed unaware of the potential irony in Malcolm's words, spoken by a black man to a white: "He repeatedly cautioned me to beware of Negro affirmations of good will toward the white man. He said that the Negro had been trained to dissemble and conceal his real thoughts, as a matter of survival." Handler continued: "After this first encounter, I realized that there were two Malcolms—the private and the public person." Evidently, Handler was confident that he had observed the former and not the one who "frightened white television audiences [and] demolished his Negro opponents." Handler's sense of the private Malcolm was of "a man of mission" regarded by "impoverished Negroes" on the streets of Harlem with "a certain wonderment." His perception was of Malcolm's saintlike purity: "His personal life was impeccable—of a puritanism unattainable for the mass. Human redemption—Malcolm had achieved it in his own lifetime, and this was known to the Negro community." Yet Malcolm's meaning to Harlemites was also a function of his public life. Handler ultimately resorted to portraying Malcolm in the image of the classical warrior, rhapsodizing: "He was very tall, handsome, of impressive bearing. His skin had

a bronze hue." Following a meeting over tea at Handler's home, Malcolm is assessed strikingly by Handler's wife: "'You know, it was like having tea with a black panther.' The description startled [Handler]. The black panther is an aristocrat in the animal kingdom. He is beautiful. He is dangerous. As a man, Malcolm X had the physical bearing and the inner self-confidence of a born aristocrat. And he was potentially dangerous."[91] The private Malcolm here is not revealed but concealed by myth and racial presupposition. The Handlers' version of Malcolm remains irreconcilable with domesticity, with femininity, and with whiteness.

The domestic image of Malcolm can be sought more fruitfully elsewhere. His eldest daughter Attallah Shabazz's fond remembrances, in her foreword to Ballantine's 1999 edition of the *Autobiography*, invoke Malcolm the father figure: "Daddy was the jubilant energy in our world. He was not at all like the descriptions I grew up hearing. In addition to being determined, focused, honest, he was also greatly humorous, delightful, and boy-like, while at the same time a strong, firm male presence in a house filled with little women."[92] Malcolm, who died when his daughter was just six years old, is inevitably idealized. Haley's epilogue recalled Malcolm's regret at being "too *busy*" to buy a single gift for his daughters; he wrote of Malcolm's pleasure at receiving from Haley "two large dolls, with painted brown complexions" to give to his eldest daughters at Christmas. He also reported Malcolm's patriarchal torment following the Nation's efforts to repossess the Shabazz home in Elmhurst: "'A home is really the only thing I've ever provided Betty since we've been married,' he had told me, discussing the court's order, 'and they want to take that away. Man, I can't keep on putting her through changes, all she's put up with—man, I've *got* to love this woman!'"[93] The addition of these passages in Haley's epilogue seems designed to counter a tone of harshness or austerity characterizing Malcolm's Nation of Islam–era pronouncements about gender and romance that survived the final edits— part of Haley's authorial project of communicating the hidden sensitivity unmasked by their collaboration.

The view of gender expounded in the main text of the *Autobiography* is a catalog of archaism and ungenerosity; it reproduces the patriarchal masculinity that inscribes and orders social relations. Dyson has identified "Malcolm's lethal sexism," while Clarke has found fault with his "an-

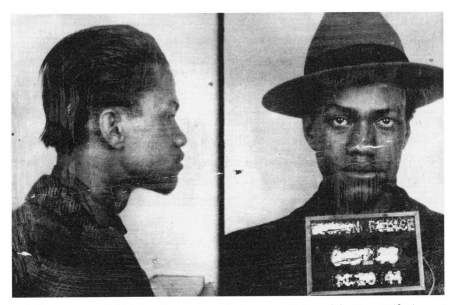

Malcolm "Detroit Red" Little in police mug shot, Boston, 1944. Photograph by Time & Life Pictures/ Getty Images.

archic machismo."[94] Although the account of Detroit Red's exploitative sexuality is accompanied by the retrospective narrator's regret, Malcolm's troubling Nation-era misogyny is not similarly recanted. In addition to adhering to the Nation's "very strict laws and teachings about women," which emphasized that "the true nature of a man is to be strong, and a woman's true nature is to be weak," and that a man's relationship with a woman must be characterized by both "respect" and "control," prior to marrying Betty X Sanders in January 1958, Malcolm is shown to have retained the hustler's attitude (whether or not a facade) of misogynist suspicion: "I wouldn't have considered it possible for me to love any woman. I'd had too much experience that women were only tricky, deceitful, untrustworthy flesh. . . . Even Samson, the world's strongest man, was destroyed by the woman who slept in his arms."[95] The moral mania of his preaching was such that "many Muslims accused [him] of being 'anti-woman.'" Illustrating Fanon's assertion that European cultural models, including patriarchy, were often uncritically reproduced under an Africanist aegis, Malcolm also seems to have guarded against temptation with this kind of rhetoric.[96] The book suggests that "from the time I entered prison until I

married, about twelve years later, because of Mr. Muhammad's influence upon me, I had never touched a woman."[97] In his involvement with the figures of Laura and Sophia, Detroit Red's sexuality receives a different treatment than that of Malcolm X. In the book's conversion narrative structure, the association of libido with Red renders its association with the puritanical Malcolm X problematic, hence banished.

Malcolm's courtship of Betty is presented as a strangely emotionless, rational undertaking. Malcolm told Haley that, after Betty joined the Harlem mosque, "I just noticed her, not with the slightest interest, you understand." As he pondered the eventuality of marriage, his thoughts settled upon Betty, who "just happen[ed] to be the right height for somebody my height, and also the right age." Although he would confess to a cautious regard partly inspired by his observation of Betty's teaching of Muslim Girls' Training and General Civilization classes ("where the women and girls of Islam are taught how to keep homes, how to rear children, how to care for husbands"), Malcolm's proposal of marriage is narrated as a unilateral decision, devoid of the conventional: "I wasn't about to say any of that romance stuff that Hollywood and television had filled women's heads with. . . . I was going to do [it] *my* way." His way, it turned out, was rather cursory. From a filling station pay phone in Detroit, Malcolm called Betty at the nurses' residence at which she lived and "just said it to her direct: 'Look, do you want to get married?'" They were married in haste by a justice of the peace, an "old hunchbacked white man. . . . And all of the witnesses were white"—hardly the wedding one might have imagined for Malcolm X.[98]

Domestic reticence is not uncommon in canonical African American male autobiographies. Douglass had little to say of his two wives in his books. Washington and Du Bois were similarly reserved, and *Black Boy* ends before Wright's first marriage.[99] This pattern is arguably evidence of an inordinate and reactionary reliance on traditional gender roles. According to Gilroy, "the conflictual representation of sexuality has vied with the discourse of racial emancipation to constitute the inner core of black expressive culture."[100] The *Autobiography* does suggest a degree of progression in Malcolm's attitude toward love, at least. Although he would dismiss the "Western 'love' concept" as merely lustful, he admitted to fond feelings for his wife: "I guess by now I will say I love Betty. She's the only woman I ever even thought about loving." He reserved doubts

about the general trustworthiness of women, however, stating that "she's one of the very few—four women—whom I have ever trusted."[101]

Masculine authority and the privileging of Malcolm's work over domestic life remained important to his image in the book. Betty is praised for understanding that Malcolm's role in "awakening this brainwashed black man and telling this arrogant, devilish white man the truth about himself" is a "full-time job" and allowing him, in "the little time I am at home," to work undisturbed. She is shown to meet his frequent absences with equanimity: "Once on the long-distance telephone, Betty told me in beautiful phrasing the way she thinks. She said, 'You are present when you are away.'"[102] The image of the patriarch's devoted helpmeet is apparent also in Malcolm's almost messianic post-hajj confidence that Betty would accept and follow his "new insight into the true religion of Islam": "Betty's faith in me was total." The *Autobiography* indicates, however, that Malcolm's excessive devotion to the Nation had in fact endangered their marriage. In a conflict over money, spurred by Malcolm's stringent unwillingness to "put away *something* for our family" and described as "the only domestic quarrel that I have ever had with my beloved wife Betty," the marriage nearly broke up.[103] Instead, the fracture occurred between Malcolm and Elijah Muhammad, after which Malcolm is described as feeling "like someone who for twelve years had had an inseparable, beautiful marriage—and then suddenly one morning at breakfast the marriage partner had thrust across the table some divorce papers." Only in February 1964, during Malcolm's period of silence imposed by Muhammad, did he and Betty enjoy their "first vacation" together, to Cassius Clay's training camp in Miami.[104] Robert L. Haggins would capture a striking portrait of the Shabazz family seated with Clay; the photograph, reproduced in the Grove Press first edition of the *Autobiography*, recently surfaced on the Internet with Betty unceremoniously cropped out at the left of the frame. Malcolm would spend much of the final eventful year of his life abroad—and alone.

The Problem of Detroit Red

As a consequence of Malcolm's death and Haley's authorship, the defining image of Malcolm in the *Autobiography* is that associated with the myth of transformation. If Malcolm's transformations were perpetual

rather than definitive—if "the completed self" is strictly an impossibility—it follows that his first narrative transformation is no less significant than those subsequent.[105] Malcolm Little's becoming Detroit Red presents the pattern from which followed his reinvention as Malcolm X and El-Hajj Malik El-Shabazz. In the narrative of Detroit Red, the self and its relationship to blackness are redefined by negations, sartorial transformation, photography, and mastery of language, including the act of self-appellation. The book takes pains to emphasize the moral distance between Detroit Red and Malcolm X. Not least in light of hip-hop's recent embrace of the image of Detroit Red, it is worth examining whether Malcolm changed so completely. Despite the superficial differences, is a photograph of Detroit Red also a portrait of Malcolm X (and vice versa)? For influential black studies scholar Robin D. G. Kelley, the Detroit Red years were "not a detour on the road to political consciousness but rather an essential element of his radicalization."[106] The interpretative problems regarding Detroit Red and his hustler mythology will be taken up in this section.

In the *Autobiography* it is Shorty, the Roxbury jazz musician who would become Malcolm's friend and partner in crime, who first refers to the teenage Malcolm as "Red"—hence the association of the name with his second, urban period. In Harlem "Detroit" was added to his name to distinguish Malcolm from fellow Harlem neophytes St. Louis Red, "a professional armed robber," and Chicago Red, later known as Red Foxx, the comedian. The nickname was, however, an early (if relatively minor) example of Malcolm fabricating his past. Detroit was not Malcolm's hometown, but, "since most New Yorkers had never heard of Lansing, I would name Detroit. Gradually, I began to be called 'Detroit Red'—and it stuck."[107]

The *Autobiography* suggests that, in prison, Detroit Red, in all his slang and artifice, fell away from Malcolm like a mask and came to seem "as another person."[108] After arriving to speak at Harvard Law School in 1961—also the site of Barack Obama's latter-day ascension—Malcolm is presented as looking from a window to the site of his "old burglary gang's hideout." The moment is revelatory:

Awareness came surging up in me—how deeply the religion of Islam had reached down into the mud to lift me up, to save me from being

what I inevitably would have been: a dead criminal in a grave, or, if still alive, a flint-hard, bitter, thirty-seven-year-old convict in some penitentiary, or insane asylum. Or, at best, I would have been an old, fading Detroit Red, hustling, stealing enough for food and narcotics, and myself being stalked as prey by cruelly ambitious younger hustlers such as Detroit Red had been.[109]

In projecting this alternate fate, the narrator explicitly condemns the judgments and cultural associations of Detroit Red, much as the figure of Detroit Red is shown to reject the naive, "gawking," and "countrified" Malcolm Little.[110] The transformations are less absolute and more superficial than they first appear; they may also be quite inaccurate. As indicated above, Malcolm X was still called Red by his friends in the 1960s. Clarence Atkins, who professed to know Malcolm well from their days working together at Jimmy's Chicken Shack in Harlem, claimed that Detroit Red was not the depoliticized, white-worshipping figure the book would have us imagine. Malcolm even "made time in their youthful discussions—which usually revolved around jazz music—to talk about his Garveyite background," which suggests an unexplored continuity of consciousness stretching all the way back to Malcolm Little.[111]

Detroit Red may initially appear as a kind of sacrificial figure in the book: "The conked and zoot-suited hipster is a type, as is the petty hustler; although each character comes to life in the *Autobiography*, we are meant to see how inauthentic, how unindividual each figure is" in light of Malcolm's progressive spiritual illuminations.[112] If Detroit Red is redeemable, his redemption is in the immediate cultural context that attracted him to Harlem in the early 1940s. Kelley has sought to recuperate the rebellious context of the "tragically dehistoricized" narrative of Detroit Red and its "signifiers of a culture of opposition among black, mostly male, youth": "the zoot suit, the conk, the lindy hop, and the language of the 'hep cat.'"[113] Despite the *Autobiography*'s insistence that Detroit Red "was deaf, dumb, and blind," Kelley regards Malcolm the devout Muslim as traitorous to a political past that nevertheless remains encoded in the text.[114] Politically unconvinced by the religious tenor of Malcolm's repentance, Kelley rejects the book's stated moral objective and extracts his own. Although acknowledging the *Autobiography*'s suggestion of the cost of Detroit Red's pernicious misogyny, Kelley counters Malcolm's claims

of "self-degradation," stating that the "language and culture of zoot suiters represented a subversive refusal to be subservient."[115] During World War II Malcolm cultivated a rebellious image that was opposed to "black petit bourgeois respectability and American patriotism" and differentiated him from southern migrants—political and cultural values also identifiable with his Nation of Islam period.

Well before his exposure to the Nation of Islam, Malcolm received a subversive education that Douglas Henry Daniels has described as being fundamentally vernacular or "musical"—evidence of the rebellious potential in American popular culture.[116] The musical idiom that informed Detroit Red's sensibility was jazz. Jazz is associated in the *Autobiography* with "a religious conversion experience" of sorts along pop-primitivist lines—while dancing in Boston's Roseland State Ballroom, Malcolm's "long-suppressed African instincts broke through, and loose"—and Malcolm retained a potent connection with jazz as an expressive form.[117]

In 1962 Malcolm declared, "I own nothing, except a record player."[118] Jazz standards were among the only songs permitted to members of the Nation. Devotion demanded a degree of self-denial in these musical enjoyments, however, as dancing was forbidden.[119] The mature Malcolm's ongoing (if repressed) sympathy toward jazz and his past as Detroit Red is glimpsed briefly and powerfully in Haley's epilogue:

> "Why, I'm telling you things I haven't thought about since then!" he would exclaim. Then it was during recalling the early Harlem days that Malcolm X really got carried away. One night, suddenly, wildly, he jumped up from his chair and, incredibly, the fearsome black demagogue was scat-singing and popping his fingers, "re-bop-de-bop-blap-blam—" and then grabbing a vertical pipe with one hand (as the girl partner) he went jubilantly lindy-hopping around, his coattail and the long legs and the big feet flying as they had in those Harlem days.[120]

The exuberance in what Haley casts as an almost involuntary response reveals the extent of Malcolm's self-willed repression. The images of Detroit Red and Malcolm X here merge.

The *Autobiography*'s interest in the jazz culture of Malcolm's youth is extensive. Detroit Red is, for all intents and purposes, a jazz name; in a rehearsal of his mature proximity to the media glare, the young Malcolm

cultivated public associations with jazz artists. Malcolm "Shorty" Jarvis "recalled that Malcolm always sought out the company of celebrities, and 'always wanted to be next to famous and notorious people'—especially singers, musicians and entertainers."[121] He shined their shoes, peddled marijuana, and lindy-hopped to their tunes. Musicians with whom the book claims a personal connection to Malcolm include Billie Holiday, Erskine Hawkins, Duke Ellington, Count Basie, Lionel Hampton, and Lester Young. As shoeshine boy Red, already awed by Roxbury's "neon lights, nightclubs, poolhalls, bars," cars, and jukeboxes blaring the latest hits, Malcolm hustled for tips in the Roseland State Ballroom, his shine rag "popping to the beat of all of their records, spinning in my head."[122] Harlem presented to Detroit Red the prospect of further transcending the humble provincialism of his upbringing through proximity to his jazz heroes.

The urban environment was integral to the forging of Detroit Red. Part of Malcolm Little's liberation from dependency on the institutions of family and state was enabled by his discovery, while a self-named but more-or-less anonymous city dweller, of a rebellious individualism. Amiri Baraka couched this urban experience of relative freedom in the language of jazz, claiming that such distance from "the paternalistic so-ciety"—the family, the church—while new to the city "enabled Negroes to *improvise* a little more in their approach to it."[123] Such freedom was predicated on its own exclusions, however. Malcolm's first black cultural immersion in Roxbury revealed to him not only the ecstasy of racial iden-tification but also the limits of acceptable blackness. Detroit Red estab-lished the beginnings of a class ideology alongside his racial theory; he was something of an extremist in both regards. The *Autobiography* makes clear Malcolm's disdain for the "self-delusion" of middle-class pretense among "the Hill Negroes of Roxbury" and his preference for the company of ghetto dwellers, musicians, and pool players. For Red, to be northern, black, and middle class was to be beholden to the South and its legacy. He equated professional or wage work with automatic exploitation, learning from his new associates that a "'slave' meant work, a job." The account of Malcolm's first experience of Harlem emphasizes its authenticity, its styl-ishness, by contrasting it with the artifice of midtown Manhattan, "which passed by like a movie set." Like a hyperreal version of Roxbury's ghetto

folk, the manners of Harlemites "seemed natural; they were not putting on airs. I was awed. Within the first five minutes in Small's, I had left Boston and Roxbury forever."[124]

Malcolm Little's self-conscious reinvention in the idiom of the urban North, visible in several early iconic poses, stands alongside the trope of migration in the *Autobiography*'s flight from the South. As for the Nation-era Malcolm, it was as a New Yorker that Detroit Red guarded against association with a South still associated by many with slave culture. He was not alone in his cultural phobia. In 1963 Baraka wrote of African Americans in the North that "their Utopia could have no slaves nor sons of slaves." Despite Red's outsider image, his hipster social trajectory resembled that of the bourgeois in being aggressively upward, the lowest rung of the ladder being reserved for newly transplanted southerners against whom such as Red defined their cool: "To the new city dwellers, the 'country boy' was someone who still bore the mark, continued the customs, of a presumably discarded Southern past. But the displaced persons made quick movements toward the accomplishment of the local sophistication and in a few months could even join in to taunt a new arrival with greetings like, 'Hey, Cornbread!'"[125] Harlemite Claude Brown echoed these sentiments in 1965, writing of "those old crazy-acting, funny-dressing, no-talking people from down South."[126] The *Autobiography* presents Malcolm Little, though a midwesterner, in the image of just such a country boy upon arrival in Boston: "I looked like Li'l Abner. Mason, Michigan written all over me. My kinky, reddish hair was cut hick style, and I didn't even use grease in it. My green suit's coat sleeves stopped above my wrists, the pants legs showed three inches of socks." Malcolm was comforted in his awkwardness by talk of "countrified members of the Little family come up from Georgia in even worse shape than I was."[127] He would not wait long to obtain his first conk and zoot suit, thereby commencing his career as Detroit Red.

Detroit Red's clothes, described in the *Autobiography* and captured in several early photographs, did not represent empty consumerism or abasement of his blackness but, rather, a form of political responsiveness to the culture of the 1940s. According to Tulloch, Detroit Red originated Malcolm's ongoing "adherence to a demarcation of ethnic divide based on an authentic Black body aesthetic." Like Kelley, she points to a continuity of consciousness, belied by the *Autobiography*'s moral declaiming,

made evident by the politics of Malcolm's style. Tulloch equates the zoot suit and the conk with a nascent Black Power, though they are more accurately seen as emanations of his earlier exposure to Garveyism. Detroit Red's early style, popularized by Cab Calloway and associated primarily with urban African Americans and Mexican Americans, can also be interpreted as expressing an objection to the values of the state: "An underlying agenda of the Zoot suit was to critique the Second World War. . . . To wear such an expanse of fabric as the knee-length, wide-shouldered jacket and voluminous trousers, was to flout the rationing regulations."[128] It is hardly surprising that the *Autobiography* tells of Malcolm orchestrating his 4-F classification (military ineligibility) by donning his "wild zoot suit," frizzing his "hair up into a reddish bush of conk," and "noising around that [he] was frantic to join . . . the Japanese Army."[129] In 1953 Malcolm X declared himself a conscientious objector to the Korean War on religious grounds. On a military questionnaire, he listed his citizenship as "Asian"—partly in faithfulness to Elijah Muhammad's teachings about the Asiatic race and partly, it would seem, as a gesture of solidarity with the Korean people against the American intervention.[130]

The *Autobiography* recalls the zoot suit period with amusement. In a prefiguring of his later facility for engaging the cameras, Malcolm is depicted as a particularly striking model and something of an attention-seeker, his clothes and his language literally stopping traffic: "My conk and whole costume were so wild that I might have been taken as a man from Mars. I caused a minor automobile collision; one driver stopped to gape at me, and the driver behind bumped into him."[131] Malcolm Jarvis corroborated Malcolm and Haley's account, comparing the flashy Red, in his Roxbury period, to Frank Sinatra, stating that he "used to change clothes once or twice a day—another thing that had all the girls in a tizzy. He couldn't walk down the street but to stop traffic with people all up and down Humboldt Avenue."[132] Later, the "green" Red, coming under the tutelage of some of "the ablest of New York's black hustlers," who "soon began in a paternal way to 'straighten Red out,'" would discard the zoot.[133] His visible transformation through clothes continued.

One of these criminal mentors had delivered to Malcolm "an expensive, dark blue suit, conservatively cut." Detroit Red was being schooled in fashion—and the business of discreet criminality. His latest cool pose demanded that he avoid drawing attention to himself. The book's descrip-

tion evokes the Nation-era style of Malcolm X as well: "I didn't lindy-hop any more now, I wouldn't even have thought of it now, just as I wouldn't have been caught in a zoot suit now. All of my suits were conservative. A banker might have worn my shoes." In his criminality Detroit Red was of course distinct from Malcolm X. As Red, he claimed, "I viewed narcotics as most people regard food. I wore my guns as today I wear my neckties." More troubling, perhaps, is the suggestion of continuity in Malcolm's attitude toward his inevitable death. His ready-to-die street credo may be seen as giving rise to his later Islamic providentialism: "Deep down, I actually believed that after living as fully as humanly possible, one should then die violently. I expected then, as I still expect today, to die at any time."[134]

The *Autobiography* insists that "the most dangerous black man in America was the ghetto hustler" and laments his "'glamor' image to the school-dropout youth in the ghetto." Undeniably, the devout Malcolm X rejected his nihilistic former image, stating, "The ghetto hustler is internally restrained by nothing. He has no religion, no concept of morality, no civic responsibility, no fear—nothing."[135] In presenting Malcolm's image of moral reformation as a response to his former degradation, however, the book indirectly insists upon the fact of their inverse relation, or a kind of equivalence. Malcolm himself deployed the Detroit Red image strategically throughout his ministry with the Nation. He spoke to reporters of Red in positioning himself as proof of the efficacy of Elijah Muhammad's teachings among black prisoners and the urban underclass. While "fishing" for potential recruits to the Nation on Detroit's streets, on the other hand, he spoke in the voice of Detroit Red himself: "My man, let me pull your coat to something—." The account of Malcolm's first "extemporaneous lecture" to a Muslim congregation also begins by invoking his criminal past: "If I told you the life I have lived, you would find it hard to believe me."[136] Detroit Red thus functions in the *Autobiography,* as he did in Malcolm's preaching, as an integral part of Malcolm's legitimacy. He is an expression, on some level, of moral one-upmanship: the greater the sinner, the greater the servant of Elijah Muhammad and Allah. Detroit Red also provided Malcolm with moral leverage to exert upon the middle-class African Americans pitted against him in debates: "Which of us, I wonder, knew more about that Harlem ghetto 'sub-culture'? I, who had hustled for years in those streets, or that black snob status-symbol-

educated social worker?" His experience as Detroit Red accounted for his adaptability as a speaker: "In the street, I had been the most articulate hustler out there—I had commanded attention when I said something." Thus, a significant part of Detroit Red's "ghetto instinct" and image was linguistic: "I could speak and understand the ghetto's language."[137]

The image of Malcolm as one possessed of undoubted street credibility served him well with his urban constituency. He cast himself as a man of the people—indeed, the chosen leader of a very discerning people: "The ghetto masses already had entrusted me with an image of leadership among them. I knew the ghetto instinctively extends that trust only to one who had demonstrated that he would never sell them out to the white man."[138] The image of Malcolm, as observed in my first chapter, is as the rightful king of Harlem.

Film

The Malcolm of the *Autobiography* is explicitly concerned with the technologies of image making. In framing his trip to Saudi Arabia in 1964, Malcolm regarded his life as through a lens, claiming that "in Mecca, too, I had played back for myself the twelve years I had spent with Elijah Muhammad as if it were a motion picture." Following the *Autobiography*'s account of the spiritual liberation enabled by the hajj, a sense of Malcolm's customary solicitousness would emerge:

> I saw that Islam's conversions around the world could double and triple if the colorfulness and the true spiritualness of the Hajj pilgrimage were properly advertised and communicated to the outside world. I saw that the Arabs are poor at understanding the psychology of non-Arabs and the importance of public relations. . . . I knew that with improved public relations methods the number of new converts turning to Allah could be turned into millions.[139]

Despite his evangelical enthusiasm, Malcolm inadvertently acknowledged an untranslatable quality of the hajj experience in suggesting that "I don't believe that motion picture cameras ever have filmed a human spectacle more colorful than my eyes took in."[140] This unorthodox project of religious marketing was halted by its impracticability and, more conclusively, by Malcolm's death.

Paperback edition of The Autobiography of Malcolm X, *Penguin Books, 1968. Illustration by* Michael Trevithick.

Although a film enthusiast from an early age, Malcolm anticipated Manthia Diawara's view that "Hollywood's Blacks exist primarily for White spectators."[141] Recently elected seventh-grade class president by his white peers, the young Malcolm of the *Autobiography* had his happiness "marred" by seeing the film *Gone with the Wind* (1939): "When it played in Mason, I was the only Negro in the theater, and when Butterfly McQueen went into her act, I felt like crawling under the rug." The performance magnified Malcolm's sense of being a black person abasing himself before whites, "because I was trying so hard, in every way I could, to be white"—in his mature assessment, both a futile effort and a betrayal of self.[142] As Detroit Red in Harlem, he "discovered the movies" with the help of his disposable income. Attending "as many as five in one day, both downtown and in Harlem," he partook, like Bigger Thomas in Wright's *Native Son* (1940), of sensual pleasure and studied the language and style of the screen's heroes and villains: "I loved the tough guys, the action, Humphrey Bogart in 'Casablanca,' and I loved all of that dancing and carrying on in such films as 'Stormy Weather' and 'Cabin in the Sky.'"[143] He would maintain an interest in the racial politics of cinema as a Muslim minister. Karim described the role of cinema in Malcolm's ministry in a passage revealing of his evolving artistic tastes: "On the occasional Saturday at the temple we might show a Hollywood historical film about the Crusades, and only very rarely, for the exceptional big film like *Lawrence of Arabia,* which was Malcolm's favorite movie, did we actually go to commercial movie theatres."[144] Claude Brown wrote of the Nation of Islam picketing the RKO Alhambra on Seventh Avenue circa 1955 for screening a film with a white actor playing Hannibal, the Carthaginian commander, whom the Nation claimed—like Augustine, Aesop, and Homer—to have been a black man misappropriated in the service of the science of imagery.[145]

Photography

The *Autobiography*'s account of Malcolm's childhood reveals an exposure to a Garveyite culture of image making that sought to reverse the erasure of black lives from American culture and to disabuse black people of their African misconceptions. Malcolm was shown to hail from a family undaunted by racist intimidation; his father embodied this lineage of

resistance. Although Malcolm and Haley would suggest that Malcolm Little's image of Africa "was of naked savages, cannibals, monkeys and tigers and steaming jungles," he clearly absorbed some of his father Earl Little's highly developed rhetoric of racial consciousness: "I can remember hearing of 'Adam driven out of the garden into the caves of Europe,' 'Africa for the Africans,' 'Ethiopians, Awake!'" The book claims that Malcolm was chosen from among his siblings for racial awareness: of the eight Little children, "it was only me that [Earl] sometimes took with him to the Garvey U.N.I.A. meetings which he held quietly in different people's homes." Retrospectively, "the image of [Earl] that made [Malcolm] proudest was his crusading and militant campaigning with the words of Marcus Garvey." With relish and a sense of identification, Malcolm would "remember an old lady, grinning and saying to my father, 'You're scaring these white folks to death!'"[146]

Along with such attitudinal instruction, Malcolm was early to discover photography's organizational and emotional utility. The circulation of photographs at UNIA meetings and in the homes of members served to document the movement's successes, glamorize its Pan-Africanist leader, and connect midwesterners with the hub of activity in Harlem. The *Autobiography* discusses the social function of photography:

> I remember seeing the big, shiny photographs of Marcus Garvey that were passed from hand to hand. My father had a big envelope of them that he always took to these meetings. The pictures showed what seemed to me millions of Negroes thronged in parade behind Garvey riding in a fine car, a big black man dressed in a dazzling uniform with gold braid on it, and he was wearing a thrilling hat with tall plumes.[147]

The account acknowledges Malcolm's awareness of the position of Harlem in the production of African American folk heroes; it describes James Van Der Zee's photograph of Garvey on parade in Harlem. Images of Garvey, in all their imperial pomp, were some of the most striking and memorable to emerge from the cultural abundance of Harlem in the 1920s. Garvey, described by Du Bois with reluctant admiration as "a master of propaganda," thus gave Malcolm his elementary lessons in image making.[148]

It is also worth recalling William L. Van Deburg's notion of a folk heroism that "inspire[s] revolt against the mighty."[149] Malcolm evidently

aspired to and was inspired by the spectacular scenes of African American folk heroism that so powerfully attracted him to Harlem in the early 1940s. He recalled the influence of his father's affirmations of black valor:

> My father had described Harlem with pride, and showed us pictures of the huge parades by the Harlem followers of Marcus Garvey. And every time Joe Louis won a fight against a white opponent, big front-page pictures in the Negro newspapers such as the Chicago Defender, the Pittsburgh Courier and the Afro-American showed a sea of Harlem Negroes cheering and waving and the Brown Bomber waving back at them from the balcony of Harlem's Theresa Hotel.[150]

This account of an early flush of racial pride foretells much of what would compose Malcolm's particular brand of heroism: it speaks of Harlem's predominantly African American community embracing black nationalism, interracial combat and black triumph, the role of the black press in circulating images and perspectives disregarded in the mainstream white press, and the solitary champion of the African American masses returning to his rightful audience.[151]

Malcolm's early sense of photography as a means to self-representation is illustrated in the *Autobiography*. In Roxbury, Massachusetts, he is initiated into his Detroit Red persona with his first hair-straightening procedure, or "conk," and the purchase of his first zoot suit, recalled enthusiastically in the text as punctuated with a gold chain, a personalized belt buckle, and a hat ornamented with a feather. Documenting his new style was as important as assembling it; he would certify his transformation by photographing it and distributing the images among his family and friends in Lansing and Roxbury:

> I took three of those twenty-five cent sepia-toned, while-you-wait pictures of myself, posed the way "hipsters" wearing their zoots would "cool it"—hat dangled, knees drawn close together, feet wide apart, both index figures jabbed toward the floor. The long coat and swinging chain and the Punjab pants were much more dramatic if you stood that way. One picture, I autographed and airmailed to my brothers and sisters in Lansing, to let them see how well I was doing. I gave another one to Ella, and the third to Shorty, who was really moved: I could tell by the way he said, "Thanks, homeboy."[152]

Paperback edition of The Autobiography of Malcolm X, *Penguin Books, 2007. Photograph by John Launois.*

He was Malcolm Little no longer—and here was the proof.

Leaving Roxbury for New York in 1943, Malcolm's arrival in Harlem was a homecoming of sorts: "Making the trip to Harlem was a kind of Garveyite pilgrimage, a way of reaffirming his belief in the black gospel that had been preached by his parents."[153] For the teenage Malcolm, Harlem was also a place of glamour and legend. The *Autobiography* situated Malcolm, as a waiter at Smalls' Paradise, jazz acolyte, and drug dealer to the stars, near Harlem's cultural center. Despite his hipster pretense, Malcolm appears to have been just another hanger-on eager to be pictured alongside the likes of Billie Holiday. Although Malcolm and Haley would place Malcolm at the Onyx Club (with friend Jean Parks) being serenaded by Billie Holiday with the song "she knew I always liked so: 'You Don't Know What Love Is,'" his sense of Holiday's importance was at least partly informed by her photographs: "We took a taxi on down to 52nd Street. '*Billie Holiday*' and those big photo blow-ups of her were under the lights outside." And Malcolm recalled memorializing the event with a more intimate pose: "We had a picture taken by the club photographer that night. The three of us were sitting close together."[154]

The *Autobiography* suggests that photography also had a more traditional iconographic function for Malcolm, who, as a prisoner, came to know Elijah Muhammad largely through pictures. In his cell, Malcolm "would sit for long periods and study his photographs," committing to memory the cast of the "small, sensitive, gentle, brown face . . . until I had dreamed about it." As Muhammad's national minister, Malcolm sought to counteract his own increasing visibility by disseminating photographs of Muhammad to the press: "My briefcase was stocked with Mr. Muhammad's photographs. I gave them to photographers who snapped my picture. I would telephone editors asking them, 'Please use Mr. Muhammad's picture instead of mine.'"[155] This pretense of unwilling visibility could not be sustained, however, in the very visual text and paratext of the various editions of *The Autobiography of Malcolm X*.

The Illustrated *Autobiography*

The *Autobiography*'s posthumous paraphernalia of publication—many editions' implicit attribution of authorship exclusively to Malcolm X, the critical apparatus, and the manner of illustration—are not part of the

book's authorship but, rather, its packaging of the narrative as the authoritative document of Malcolm's life. This section is concerned with paratext, or the editorial and commercial presentation of the *Autobiography*, particularly in terms of cover art and design. Given the *Autobiography*'s popularity and influence, the contribution of its accompanying images to the iconography of Malcolm X must be considered as among the most crucial.

Presumably for commercial reasons, many editions of the book misrepresent themselves as providing the kind of direct and factual access to Malcolm that is merely a wishful delusion. Among American and British editions of the book, only the Ballantine Books U.S. editions (1973–2007) and some of the Penguin U.K. editions (1968–2010) feature Haley's name on their covers. Ballantine has consistently presented the *Autobiography* "as told to Alex Haley," emphasizing the oral component of the content's transmission. The selective acknowledgment of Haley's involvement has been related to marketing strategy, especially since his *Roots* became the best-selling book of 1976 and a popular TV series in 1977. More recent Ballantine editions incorporated a blurb from Spike Lee, both a figure of presumed authority on the subject of Malcolm X and, in the 1990s, a bankable celebrity. The 2007 Penguin cover's retrieval of the claim that the book was written "with the assistance of Alex Haley," the designation common to the title pages of all editions, perhaps represents a reawakening of editorial concern with the complexity and derivation of the text of the *Autobiography*.

The organization of the text is notably different in American and British editions, further challenging any notion of pure or even uniform access to Malcolm X. What is given as Haley's epilogue, following the conventional nineteen chapters of the book, in all American editions is presented as a foreword in all British editions. The organization of the American text has the effect of deferring the revelation of the extent of Haley's involvement in authoring the book. Giving Haley the last word also reveals that, in shaping the text, he ultimately regarded the fact of Malcolm's assassination—and the book's prophesying of his death—as narrative considerations. As an epilogue, Haley's commentary aspires to preserve the illusion of a linear narrative progressing from birth to death. Haley's account of Malcolm's death imposes a kind of narrative resolution on the text, and his discussion of their collaboration provides what

the evolving and ultimately unresolved narrative perspective of the rest of the book cannot: a unifying retrospection, however ostensibly external to the narrative proper. The British structuring of the text, presumably intended to orient a general audience less familiar with Malcolm's media profile and the fact of his violent death, creates a different, more knowing (or perhaps more skeptical) reading experience. Haley's commentary as a foreword, in its length as well as its revelations, disrupts the narrative emphasis on the significance of Malcolm's childhood psychology yet honors the more tentative conclusion of the book on which Malcolm signed off, refusing to further editorialize.

The reproduction, in the first American and British editions of the book, of a series of thirty-one photographs that has not appeared with subsequent editions raises the question of editorial embellishment of an "autobiographical" text already encumbered with Haley's collaborative authorship. The most remarkable of these photographs—Earl Grant's image of Malcolm dead or dying in the Audubon Ballroom—has been discussed above. Its inclusion, while in glaringly poor taste relative to Malcolm's personal dignity and his family's sensitivities, does evince a certain logic relative to the death of so public a personality. Indeed, without the publicity that surrounded it, Malcolm's death would not have had such iconic resonance.

With the photographs of his assassination and funeral excepted, Malcolm himself may have selected and provided many of the images appearing in the earliest editions. Haley's correspondence with Malcolm contains at least one invitation to provide him with images of Malcolm in the act of giving a speech.[156] Two such familiar photographs appear, including the final image in the series depicting Malcolm in his public guise behind a microphone in Harlem—the only photograph in the first editions to be given a full page. Appropriately, given the book's at least limited exposure of Malcolm's public-private duality, the series of photographic plates partially resembles a family photo album: images of Malcolm's siblings are included with three pictures of Malcolm in his Detroit Red period and the photograph, mentioned above, of the Shabazz family with Cassius Clay. Like the account of Detroit Red's proximity to Harlem's jazz stars, the illustrations also catalog Malcolm's high-powered associations, picturing him alongside Elijah Muhammad, Martin Luther King, Ralph Bunche, Milton Galamison, Adam Clayton Powell, Ossie

Davis, Ruby Dee, Dick Gregory, Prince Faisal of Saudi Arabia, and Shirley Graham Du Bois. The first page of a letter he wrote in Mecca to Alex Haley, dated 25 April 1964, is also reproduced. Evidently, Malcolm saw in his newfound Islamic legitimacy an opportunity to discredit Elijah Muhammad: "Mr Muhammad and two of his sons made what is known as 'Omra' (the pilgrimage or 'visit' to Mecca outside of the *Hajj season*). I think I'm the first *American born Negro* to make the actual Hajj."[157] The partial letter may be the closest that *any* edition of the *Autobiography* has come to representing the output of Malcolm X's own pen.

Among the most widely circulated and least remarked images of Malcolm X are the cover illustrations of various editions of the *Autobiography*. Through them can be traced a partial history of Malcolm's evolving meaning and cultural significance. The *Autobiography*'s first publisher was the New York–based Grove Press, which had purchased the book's contract from the more stolidly mainstream house Doubleday for $10,000. Doubleday "had paid a then-hefty $15,000 advance for the *Autobiography* in June 1963, only to cancel the book contract just three weeks following Malcolm X's killing" and the controversy surrounding the firebombing of the Nation of Islam's Mosque Number Seven in Harlem.[158] Grove Press evidently was less wary of narratives of radicalism and race, also publishing by 1966 editions of *Malcolm X Speaks*, Fanon's *The Wretched of the Earth* and *Black Skin, White Masks*, and LeRoi Jones's *The System of Dante's Hell*.

Leroy McLucas's photograph on the dust jacket of the Grove Press first edition, designed by Roy Kuhlman, is uniquely unflattering, casting Malcolm as a sweat-browed orator distracted to the point of hypnosis. The sense here is of Malcolm as a fascinating, if possibly dangerous, aberration of an African American preacher. The image, taken during his Nation of Islam tenure, deemphasizes—like the content of "I'm Talking to You, White Man"—his attempted reinvention as El-Hajj Malik El-Shabazz. The field of white surrounding the portrait and title arguably alludes to Malcolm's perceived antipathy to the white establishment, while the microphone at the bottom of the portrait's frame again situates Malcolm's discourse and personality within the public sphere and alludes to his death in a hail of gunfire as he initiated his final speech in the Audubon Ballroom. The cover of the first edition makes no mention of Alex

Haley, eliding his authorial presence with only the name "Malcolm X" in bold type above McLucas's portrait.

By 1966 the cover of Grove Press's first Black Cat paperback edition spoke not to Malcolm's inscrutability but to the conventional perception of his militancy and thwarted revolutionary potential. The edition featured the following blurb above the book's title: "He rose from hoodlum, thief, dope peddler, pimp . . . to become the most dynamic leader of the Black Revolution. He said he would be murdered before this book appeared."[159] The blurb sensationalizes Malcolm's death and the wayward life preceding his moral reformation, inviting readers to indulge salaciously in the seven chapters Haley devoted to the figure of Detroit Red. The cover photograph, which may be *the* iconic image of Malcolm X, again situates Malcolm within his Nation of Islam tenure. Unlike in the image discussed above, the almost ever-present microphone is cropped out at the bottom of the frame. The choice of an image of Malcolm at his (seemingly) most confrontational, with fist raised and forefinger gesticulating, may have been intended as an allusion to the Black Power politics emerging at this time. The image, bordered in black, is framed again against a field of white, with the title given in a hue of red surely designed with the intent of evoking Malcolm's violent end. The cover follows the first edition in making no mention of Haley's authorial involvement.

Penguin's 1968 edition featured an original drawing by Michael Trevithick, portraying Malcolm, as El-Hajj Malik El-Shabazz, with weary and mistrustful eyes suggestive of his apprehension of approaching death. The figure looks directly back at the reader, both imploring and plaintive. Trevithick's memorable image of Malcolm is surrounded by words and phrases associated with urban tensions and the civil rights movement: "Like, Man, I'm Tired (of Waiting)," "There is No Quota on Freedom," "Brooklyn Congress of Racial Equality," and "Slum Lord Rich Miser." The portrait is further contextualized by a split Confederate flag flanked by a wide-eyed black child, twinned with what appears to be his mature, more defiant self, and a hooded Klansman. The drawing, like the text of the *Autobiography* itself, situates Malcolm in a mythic landscape of American racial discord. This cover is among the first to acknowledge the contribution of Haley's authorship, though it does so in rather small print. The 2001 Penguin Modern Classics edition reverted to the well-

used photograph taken on 15 May 1963 and removed Haley's name from the front cover.

Penguin's 2007 edition features John Launois's classic photographic portrait of a pensive and firmly masculine El-Shabazz, here fearlessly engaging the eyes of the viewer. Malcolm's eyes themselves, however, and the customary glasses that frame them, are largely concealed by a forbidding, broad-stroke X in red—a color appearing in most of the book cover designs in question—a design choice knowingly suggestive of the layers of mediation through which we regard Malcolm by way of the book. The obscuring X contains a more muted blurb than Grove Press's 1966 edition, describing the *Autobiography* as "Extraordinary . . . a brilliant, painful, important book." The cover attributes partial authorship to Haley, including his name in uncharacteristically bold type, though at less than half the font size of Malcolm X's (which, naturally, doubles as part of the title). More so than in other similar portraits, Malcolm's hand appears relaxed; although unclenched, it is decisively positioned to display his star and crescent ring and emphatic forefinger.

The Ballantine Books editions feature a painting of Malcolm by African American artist Charles Lilly, displaying a confident, meditative El-Hajj Malik El-Shabazz partially blended with an ethereal backdrop and looming above a New York cityscape. The painting portrays, from slightly different angles, three similar figures with varied expressions, the most compelling of which is the second: stony, dramatically shadowed, and apparently mid-declamation. Although the Ballantine covers hint at Malcolm's multiplicity, it is surprising that none of the covers in question depicts more than one of the *Autobiography*'s several personae, and that none depicts Detroit Red.

Conclusion

The Malcolm of the *Autobiography* is a construct necessarily straddling life and the grave, remembrance and prophecy, self-knowledge and ignorance, photography, memoir, biography, and fiction. At his death, he was known to some as El-Hajj Malik El-Shabazz. Although striking, this final transformation, as communicated by the *Autobiography*, was not entirely convincing or complete. The violence of his death did not help: his falling in a hail of gunfire conjured memories of the firebrand Malcolm

X of old. A funerary error served to compound this sense of thwarted permutation. As DeCaro and several photographs have indicated, the nameplate in Malcolm's casket mistakenly read "La Hajj Malik Shabazz," a fact that Haley did not mention in the epilogue, and another instance of the process of reinscription that continues to mediate our reception of the iconography of Malcolm X.[160] The myth of transformation—the cultivated open-endedness that formulates most narratives and images of his life and death—was indeed a myth, if a potent one whose resonance the following chapters will explore.

CHAPTER THREE

MAINSTREAM CULTURE AND
CULTURAL REVOLUTION (1965–1980)

So now comes the question: Who will uninvent the Negro?
John Oliver Killens, "The Black Writer Vis-à-vis His Country,"
The Black Aesthetic

*How can one, however, dream of power in any other terms than in
the symbols of power?*
James Baldwin, "Down at the Cross: Letter from a Region
in My Mind," *The Fire Next Time*

Malcolm X's assassination in 1965 was a trans-
figuring event. An omen of the conflagration in Watts later that same
year and of the eventual murder of Martin Luther King, the assassina-
tion has typically been framed as a transitional event in the civil rights
movement, a signal of its unraveling, even its failure. As a martyr to an
as-yet-unnamed revolutionary black cause, Malcolm's pronouncements
suddenly seemed more potent, his appeals to extremism more urgent,
than they had during his life. According to black cultural historian Wil-
liam L. Van Deburg, "Malcolm's influence expanded in dramatic, almost
logarithmic, fashion": "He became a Black Power paradigm—the arche-
type, reference point, and spiritual adviser in absentia for a generation of
Afro-American activists . . . [who] sought to change him into a totemic
being possessed of supernatural strength and wisdom: Malcolm, the Fire
Prophet, the ghetto-man in heroic proportions."[1] The mid- to late 1960s
were the most influential period in the formulation, if not the broader
distribution, of the iconography of Malcolm X. Not coincidentally, these
years were fertile ones for African American artistic and literary produc-
tion taking Malcolm as a subject; he came to be revered as the forebear
and fetish of Black Power politics and of the cultural nationalism associ-
ated with the Black Arts Movement.

This chapter discusses the abstraction of Malcolm X into an often idealized symbol of blackness and revolutionary commitment in the decade immediately following his death; it moves beyond the scholarly concern with Malcolm's function as a poetic muse during this period to show that his swift assimilation and quasi-deification—even in explicitly Christian terms—were accelerated by his visual representation. Leftist uses of Malcolm, especially by editor and author George Breitman, are addressed alongside a variety of mainstream and black nationalist responses, beginning with an examination of journalistic and photojournalistic renderings of Malcolm's death and legacy.

The chapter then addresses the circulation, and immediate influence upon the iconography of Malcolm X, of the *Autobiography* and other key texts, including his collected speeches. Often cast as an ancestral patriarch, Malcolm became a familiar figure within the Black Arts Movement's murals, paintings, magazines, anthologies, and visceral theatrical experiments. Shortly after his death, he would be regarded, by such as Eldridge Cleaver, Huey P. Newton, Amiri Baraka, Sonia Sanchez, and Robert Beck (better known as Iceberg Slim), as a near-divinity to be propitiated by the embrace of a revolutionism conceived at least partly in his honor. In a revealing paradox characteristic of the science of imagery, those invested in articulating the era's revolutionary aesthetics would contribute, through an often uncritical embrace of Malcolm's image and legacy, to his broader popularization. His influence soon trickled back toward the cultural mainstream. James Baldwin, certainly among the most widely read African American authors of the era, adapted *The Autobiography of Malcolm X* in a screenplay eventually shelved by Warner Brothers but published on its own merits in 1972. The chapter closes with a consideration of the extent to which Malcolm's ubiquitous commodification as a Black Power icon enabled the depoliticization of his legacy—and the abandonment of the "cultural revolution" he invited in a 1964 speech.[2]

Journalism

Images of Malcolm's death confirmed his iconic status and would quickly feature prominently in his iconography. Prior to the publication of the *Autobiography* later in 1965, mainstream and radical journalistic accounts established the early patterns of what became a prolific tradi-

tion of representation through which Malcolm's martyrdom and legacy were contested.

For several weeks after the assassination, mainstream publications deemed it worthy of prominent headlines and feature articles, typically presenting it as a fitting end to a uniquely "lurid" life marked by drug addiction, crime, imprisonment, and nominal reformation, or as the realization of a particularly virulent strain of blackness—"black supremacy"—opposed to racial reconciliation.[3] The story, in such publications as the *New York Post, Life, Time,* and mainstream black magazines *Jet* and *Ebony,* was of a potentially escalating blood feud between Malcolm's followers and the Nation of Islam. Malcolm's death, like his life, was interpreted as an incitement to indiscriminate violence. An unsigned piece in *Life,* "The Violent End of the Man Called Malcolm X," insinuated with its title that "Malcolm X" had been merely the false identity of an impostor—a kind of stage name. The article also implied that Malcolm's audience at the Audubon Ballroom had bayed for blood, waiting "expectantly" for a speech "flaying the hated white man" before "a scuffle broke out," Malcolm was murdered, and his killer "very likely would have been stomped to death if the police hadn't saved him." The forecast in *Life* was for "fratricidal war" within the "Negro community"; in *Time,* "a woman screamed: 'Oh, black folks, black folks, why you got to kill each other?'"[4] Malcolm's end itself was depicted in kinetic, almost cinematic, terms: his bodyguards "had been faked out"; two gunmen "rose from the audience and pumped bullets into the speaker"; another "cut loose at close range with both barrels of a sawed-off shotgun."[5] A witness described the felled orator, noting, "I looked at Malcolm, and there was blood running out of his goatee."

Although *Life* presented Earl Grant's photograph of Malcolm's "bullet-ripped body" in a cinematic layout and *Time* included his 1944 mug shots, mainstream accounts of the killing most often were illustrated—as on the front page of the *New York Times* on 22 February and in an *Ebony* photo editorial in April—with a photograph of Malcolm being carried on a stretcher by white policemen to Columbia-Presbyterian Medical Center.[6] The sense here was of a perfunctory effort at the rescue of a decidedly undignified corpse—and a warning that mob chaos would rapidly revert to the accustomed civil order. For some, "it was poetic justice that death came to him by violence."[7]

The counternarrative of Malcolm's death as a tragedy emerged as quickly but was largely confined to socialist and radical black publications such as *International Socialist Review, Monthly Review, The Militant, Liberator,* and *Negro Digest.* The image of Malcolm X as prophet and martyr—weary of eluding his pursuers, misunderstood, almost saintlike, but also mortal man and, especially, father and husband—would eventually overtake the initial journalistic orthodoxy of Malcolm's villainy.

The Militant, which deemed the "Murder of Malcolm X a Cruel Blow to the Cause of Black Emancipation," printed a 24 November 1964 photograph of Malcolm X with daughter Ilyasah and characterized Malcolm as a prophet of "unvarnished truth" who "won the admiration of the teeming black ghettos by his fearlessness and eloquence"—both a representative black man and a leader.[8] The *Bulletin of International Socialism* framed the murder as a symptom of systemic disease: it revealed, "as did the Kennedy assassination 15 months ago, the deep-rooted sickness beneath the surface of American capitalist society."[9] In the *Monthly Review,* Jigs Gardner admitted that "although we cannot call Malcolm X a socialist . . . he was developing in that direction"; thus, he died "a hero, *a martyr*" in an age of "hypocrisy, venality, stupidity, and brutality."[10]

International Socialist Review celebrated Malcolm's "powerful appeal to rebel youth, black and white," comparing him to Crispus Attucks and Frederick Douglass, and to "Fidel Castro and Hugo Blanco in Latin America."[11] For William F. Warde, Malcolm was representative of the "treasure of talents and creative capacities . . . hidden in the black ghettos which can be called forth by the unfolding revolt"—a kind of undiscovered revolutionary infantry.[12] Robert Vernon acknowledged Malcolm's "contradictions and limitations" while praising his "uncommon ability to think in unfettered, innately dialectical terms, free of fetishism and fixation on slogan-words." Vernon may have been prophetic in expressing regret for "the time-honored manner in which dead revolutionists are transformed into harmless, toothless icons," predicting that "reams of worthless literature will appear picturing Malcolm X as on the road to finding his place as a civil rights liberal when he met his tragic end."[13] Malcolm would be increasingly idealized with the passage of time. Addressing "The Impact of Malcolm X," George Breitman determined a year after the event that "the assassination removed the man who was best equipped to build and lead the kind of movement that will meet the immediate needs of black

people and the ultimate needs of all working people."[14] Malcolm was in Breitman's view a thwarted socialist messiah.

Malcolm's death also featured prominently in the "black little magazines" that flourished in the 1960s.[15] Among the most significant of these was *Liberator*, whose masthead unabashedly declared itself "The Voice of the Black Protest Movement." From 1961 to 1971 *Liberator* was the "information organ" of the Liberation Committee for Africa, a New York–based Pan-Africanist association inspired, in particular, by African independence movements.[16] Appropriately, then, *Liberator's* April 1965 issue depicted Malcolm on its cover in the guise of the late El-Hajj Malik El-Shabazz, only recently returned from his travels in North and West Africa. The photograph captured Malcolm wearing his distinctive goatee and an expression, both stoic and resigned, evocative of Robert L. Haggins's final portrait of Malcolm. Indeed, only Haggins and Leroy McLucas are listed as staff photographers for the issue in question, though *Liberator* assigned no credits to individual photographs. Rather than appearing, as was typical in the mainstream press, in a solitary pose, whether bloodied or behind a microphone, Malcolm was presented deliberately in an image recasting him as a tragically murdered father and husband, here again holding his daughter Ilyasah. The editorial evocation of the image selection is that Malcolm's death was that of a community leader—a loss to be felt keenly and collectively by African Americans. This speaks to the often simultaneous processes of elevation and domestication characteristic of the iconography of Malcolm X. Although Malcolm's eyes are closed in the photograph, he appears to confront a series of dramatic headlines addressing his death and the "Crisis" in Selma. At the bottom right of the cover, an epitaph gives his name as "El-Hajj Malik El-Shabazz" in a gesture of belated acceptance of his most recent reinvention.

Inside the issue, reporter and activist Ossie Sykes described the scene of the shooting in narrative terms reminiscent of the mass-media accounts. But he also told in detail of the ennobling ritual of Malcolm's funeral and burial. Malcolm's widow, Betty Shabazz, appeared "in her place, draped in black veil and dress, with tears streaming from her eyes"—a majestic and pathetic mourner, pregnant at the time of the funeral with twin daughters. An invitation to donate money "to help Malcolm X's family in their time of need" was included with the piece. Although it was perceived that "the police wanted this 'nigger' buried as quickly as

REC'D APR 2 1965

LIBERATOR

Vol. V, No. 4

APRIL 1965 35c

The Sellout
Editorial

Why Malcolm X
Was Assassinated
RAM

The Week That
Malcolm X Died
Ossie Sykes

Selma, Alabama:
Black People In Crisis
L. P. Neal

Watts, Los Angeles
Photo Essay

El Hajj Malik El Shabazz
MAY 1925 - FEB. 1965

Malcolm X and Ilyasah Shabazz on Liberator *cover, vol. 5, no. 4, April 1965. Photograph uncredited. General Research & Reference Division, Schomburg Center for Research in Black Culture, The New York Public Library, Astor, Lenox and Tilden Foundations.*

possible," Malcolm's death was understood to have mobilized and unified Harlem's "soul brothers" and, implicitly, the broader African American community. At the burial, "spontaneously, with controlled emotions, some of Malcolm's friends, ignoring the white grave diggers, began to fill the grave with their bare hands" in a communal expression of "love" for the fallen hero.[17] A second article claimed that the CIA likely killed Malcolm to stifle the OAAU, "the first organization officially recognized by an African government since the U.N.I.A. of Marcus Garvey," because of its "potential of becoming a Black Liberation Front with a government in exile."[18] *Liberator*'s June issue, which featured Paul Robeson on its cover, included inside a photograph of a placard in front of Lewis Michaux's National Memorial African Bookstore in Harlem stating, "IF YOU THINK BRO. MALCOLM X IS DEAD. YOU ARE OUT OF YOUR COTTON PICKING HEAD" and inviting the purchase of a record of Malcolm X's "Message to the Grass Roots" speech "for his children's sake."[19]

Negro Digest reprinted British novelist Colin MacInnes's evaluation of Malcolm's legacy, which concluded that "the death of a hero has a rightness, a perfection." For MacInnes, whose article originally appeared in the conservative London newspaper *The Times,* Malcolm's meaning for whites was remote but instructive: "There is no reassurance for whites in Malcolm's life. . . . But his example and influence are germinal. For the prime American problem—and perhaps world problem—is the racial one."[20] MacInnes's language echoed W. E. B. Du Bois's famous declaration that "the problem of the Twentieth Century is the problem of the color-line," a sentiment to which Malcolm, like Du Bois, had increasingly subscribed.[21]

For Milton R. Henry, a Yale-educated lawyer who changed his name to Brother Gaidi Obadele and cofounded in 1968 a black nationalist organization called the Republic of New Afrika, Malcolm was selfless, saintlike, killed "by blind unthinking assassins, as he was once more about to try to teach the blind to see." Writing in 1966, he likened Malcolm to prophets Moses, Jacob, David, Amos, Ezekiel, Daniel, Haggai, Zechariah, Peter, Paul, and Muhammad; he saw his martyrdom as "equal to the crucifixion of Christ himself," indicative of the Christian cultural lens through which Malcolm has often been perceived.[22] Henry regarded Malcolm as an oracular figure in an oral, prophetic tradition, claiming that "he did not write, as is the case with most traditional theologians. Yet, let us not

forget, that neither did Jesus or Muhammad write. It remained the task of their apostles and followers to reduce their work to written form."[23] Evidently the "Gospel" preserved in the *Autobiography* had not persuaded this reader as it had so many others.

The Influence of *The Autobiography of Malcolm X*

The *Autobiography* was popularly associated with an emergent ghetto aesthetic that would come to define the period with which this chapter is concerned; the book sold six million copies internationally by 1977.[24] Largely in response to urban uprisings between 1964 and 1967 in Harlem, Brooklyn, Philadelphia, Watts, Chicago, Cleveland, San Francisco, Tampa Bay, Cincinnati, Atlanta, Boston, Detroit, Newark, and Milwaukee, the U.S. government's Kerner Commission reported in 1968 that "our nation is moving toward two societies, one black, one white—separate and unequal."[25] The sociological study *Black Rage* (1968) sounded a similar note of alarm. Authors Grier and Cobbs wrote that "this troublesome tenth" of the population "have had all they can stand. They will be harried no more. Turning from their tormentors, they are filled with rage."[26] Literary scholar Carlo Rotella has argued that "a vast literature of delinquency" arose in the mid-1960s following *The Moynihan Report* (1965), including Kenneth B. Clark's study *Dark Ghetto* (1965) and Claude Brown's memoir *Manchild in the Promised Land* (1965). Neither book would rival the *Autobiography* as a formative document of the "ghetto-centered social and cultural upheaval."[27]

While publishers aimed many of these books at largely white or middle-class readerships, the *Autobiography* was taken up by numerous prominent black writers of the period. Indeed, the *Autobiography* has been depicted as a kind of holy book circulated everywhere from prisons to universities. It may also have come closest to creating the "organizational base" that "Malcolm was never able to re-establish" following his separation from the Nation of Islam.[28] The late historian Manning Marable wrote of the *Autobiography*'s role in radicalizing black university students and contributing to the rise of Black studies in the late 1960s. He recalled rereading the *Autobiography* "during the winter of 1969," in his late teens, this time in the context of the assassination of Martin Luther King: "The full relevance and revolutionary meaning of the man

suddenly became crystal clear to me. In short, the former 'King Man' (as I most assuredly had been) became almost overnight a confirmed and dedicated 'X Man.'"[29]

In his 1971 essay "Blackness Can: A Quest for Aesthetics," James A. Emanuel insisted that, for young African Americans, the assassination of Martin Luther King "symbolized the death of the black man's naïve Christianized faith."[30] The conversion experience Marable described, however, was not from Christian to Muslim but from faith in American democracy to faith in black cultural nationalism—what Van Deburg calls "the Negro-to-Black conversion process."[31] For Marable, Malcolm X, "the true fountainhead of Black Power," was to be accessed primarily by way of the books that sprang up in his absence. His autobiography, along with his collected speeches, "represented almost sacred texts of black identity" in which was contained the image and meaning of Malcolm X—and thus of blackness itself.[32] The influence of Malcolm's *style* (in the broadest sense), as depicted in the *Autobiography*, was far from negligible; Marable, for one, recalled quoting Malcolm X ad nauseam, even imitating his manner of speaking.

Partly through its invitation to imitation, the book's popularity invigorated the genre of radical black memoir. Malcolm was followed into autobiography by a variety of black men and women including Eldridge Cleaver, Michael Abdul Malik, H. Rap Brown, Maya Angelou, Julius Lester, George Jackson, Charles Mingus, Sonny Abubadika Carson, Hakim A. Jamal, Angela Davis, Muhammad Ali, and Chester Himes. Cleaver, who reverently distributed transcripts of Malcolm's speeches to inmates in Folsom State Prison, described Malcolm in *Soul on Ice* (1968) as a figure of ritual significance whose story and images exemplified personal transformation through repudiation of "the white man's burden" of "racial supremacy and hate." Writing in the immediate aftermath of the assassination, Cleaver declared, "I have, so to speak, washed my hands in the blood of the martyr, Malcolm X, whose retreat from the precipice of madness created new room for others to turn about in, and I am now caught up in that tiny space, attempting a maneuver of my own."[33] More pragmatically, George Jackson identified a nascent canon of iconic Black Power texts in *Soledad Brother* (1970), requesting of a friend in a 1970 letter, along with "the pocketbook edition of *A Dying Colonialism, The Wretched of the Earth, Black Face White Mask,* Malcolm's *Autobiography*

(the other was borrowed) and *Malcolm Speaks.*" Jackson claimed he needed the *Autobiography* "for my legal work"; at the time he was preparing his defense against charges of murdering a prison guard.[34]

Perhaps the book most self-consciously modeled on the *Autobiography* was *Revolutionary Suicide* (1973), the memoir of Black Panther Party cofounder and Minister of Defense Huey P. Newton, written with J. Herman Blake. Contracted by "Random House editor Toni Morrison in July 1971 for a $10,000 advance," the book was another narrative of African American radicalism packaged for the consumer market.[35] Like the *Autobiography,* Newton and Blake's book conveyed the failure of American education, resentment of white ancestry, imprisonment, autodidacticism, the rhetorical use of guns, and, as the title suggests, readiness to die out of political commitment. Malcolm, as one who successfully reconciled street knowledge with book knowledge, inhabits the text as a sort of supreme teacher. Newton and the Panthers also took their cue from Malcolm's self-fashioning through photography. The picture of Newton holding a rifle and spear and sitting on a wicker throne has enjoyed a Malcolm-like iconic afterlife. Contrived by Eldridge Cleaver, it "first appeared in the May 15, 1967 issue of the *Black Panther Black Community News Service.*"[36]

Newton's uncritical engagement with the *Autobiography* extended even to an embrace of its less-than-radical coauthor. In *Revolutionary Suicide*'s acknowledgments, he wrote that "Alex Haley provided valuable advice and encouragement in the early phases of this work."[37] The vision of Haley here is as a credible authority; for Newton, former intimacy with the absent Malcolm conferred a special status. This was reflected in the Black Panther Party's aggressive interest in providing a bodyguard for Betty Shabazz's visit to San Francisco on the anniversary of Malcolm X's death in 1967.[38] To be aligned with the iconic Malcolm in this era was to have access to a powerful currency. Stokely Carmichael famously compared Newton with Malcolm as a unifying figure for African Americans in a 1968 speech at a "Free Huey" rally held in Oakland in the imprisoned Newton's honor. At the rally, Carmichael invoked "Brother Malcolm," insisting that "we must examine history" and that "we reserve the right to self-defence—and maximum retaliation. . . . Understand this concept: when they offed Brother Malcolm, we did nothing. If they off Brother Huey, we *got* to retaliate!"[39]

Often situated in an international revolutionary pantheon alongside the likes of Fanon, "Lenin, Marx, Mao, Che, Giap, Uncle Ho, [and] Nkrumah," and a Pan-Africanist pantheon including such figures as Marcus Garvey and Patrice Lumumba, Malcolm also figured among the dominant literary influences of the period.[40] With Haley, Malcolm renewed popular interest in the traditional—some would say inherently conservative—literary mode of autobiography. The genre's individualist template reflected an uncomfortable allegiance of the black radicalism of the period to traditionalist and pecuniary considerations, a pairing also evident in Malcolm's reliance on mainstream media. Guarding, not always entirely honestly, against accusations of self-interest much as Malcolm had done in constructing his image with Haley as humble rather than ambitious, autobiographers such as Angela Davis made professions of modesty and political expediency in presenting their stories. Davis wrote, in the preface to her 1974 autobiography, "I was not anxious to write this book. Writing an autobiography at my age seemed presumptuous." The presumption broached here is also of the autobiographical form's popular association with Great Men and Women and establishment figures, despite its politicized role within the African American tradition. Her tone of modesty seems designed to counter the risk of being perceived as a mere self-publicist, an overture traceable to Benjamin Franklin and Frederick Douglass; it insists that the text in question is a narrative of a representative life with exceptional instructive and political application, rather than simply an exceptional life of genius, incident, or fame. As well as modesty, there is insistence in Davis's statement that "I had come to envision it as a *political* autobiography that emphasized the people, the events and the forces in my life that propelled me to my present commitment."[41]

In Davis's and most autobiographies of the era, the politics of black cultural nationalism, and in some cases revolutionary socialism, supplanted the religious emphasis of Malcolm and Haley's book, indicating a selective engagement with his ideology that would also infiltrate his iconography. The internationalization of Malcolm's politics is evident in his British influence. As a kind of revolutionary shorthand, the name and image of "Malcolm X" lent legitimacy to British Black Power organizations, including Obi Egbuna's Universal Coloured People's Association and Michael Abdul Malik's Racial Adjustment Action Society.[42] Malik, popularly

known as "Michael X" and Malcolm's follower or ally near the end of his life, was the first prominent black British figure to write at length about Malcolm.[43] Malik would insist that "Michael X" was a by-product of the science of imagery or, rather, an invention of the newspapers upon his accompanying Malcolm X to Birmingham as "Brother Michael" in early 1965. He was never a member of the Nation of Islam. The name Malik took when he converted to Islam in 1966, however, consciously echoed that adopted by Malcolm X following his pilgrimage to Mecca: El-Hajj Malik El-Shabazz. Malik was not without his detractors. Jan Carew described "Michael X" only as Malcolm X's "transatlantic imitator."[44]

Malcolm's political influence was of course also pronounced in African American autobiography. In *Revolutionary Suicide,* Newton told of finding inspiration (with Bobby Seale) for the Black Panther Party in Malcolm's OAAU. Although the Black Panthers likely overstated Malcolm's position "that Blacks ought to arm," and Newton himself admitted that "I do not claim that the Party has done what Malcolm *would have* done," he declared that "the Black Panther Party exists in the *spirit* of Malcolm"—an example of just how loosely Malcolm's name and image could be invoked.[45] I have asserted that his image has been Christianized. Indeed, Malcolm's Islamic faith was largely overlooked in this period. Newton assessed the Nation as follows: "I would have joined them, but I could not deal with their religion."[46] Chester Himes wrote of Malcolm that "I agreed with everything about his program except his religion."[47] Davis insisted that "although I experienced a kind of morbid satisfaction listening to Malcolm reduce white people to virtually nothing, not being a Muslim, it was impossible for me to identify with his religious perspective."[48]

Unlike so many others, Davis was not radicalized by Malcolm X. She would not follow her male contemporaries into self-conscious emulation of his style or observation of his martyrdom. Her autobiography neglects even to mention his assassination, arguing instead that it was "out of the ashes of Watts, Phoenix-like, [that] a new Black militancy was being born." Nor was she impressed with the posturing of such figures as Carmichael, who dismissed Marxism as "the white man's thing" and who confused "their political activity with an assertion of their maleness." Already exposed to socialist theory in high school, the political education narrated by Davis culminated not with her association with the Black Panther Party but in her turning over in July 1968 her "fifty cents—the

initial membership dues—to the chairman of the Che-Lumumba Club" in Los Angeles and becoming "a full-fledged member of the Communist Party, U.S.A."[49]

An exception to this movement away from spiritual autobiography is Muhammad Ali's *The Greatest* (1975), written with Richard Durham and edited at Random House by Toni Morrison (who also edited Davis's autobiography). Like much of the *Autobiography*, *The Greatest* emphasized an image of Ali as humbly devoted to Elijah Muhammad, seemingly in an effort to counteract the damage inflicted upon the Nation by Malcolm's widely publicized death. Kasia Boddy has written that the book "treats boxing as at best a suspect activity. . . . At the heart of the story is Ali's religious conversion and refusal of the draft."[50] According to Gerald Early, Ali "became a representative and symbolic political figure in the same way" as Malcolm X.[51] Although his autobiography and vernacular style were patterned in some respects after Malcolm's, Ali, as heavyweight champion, long before eclipsed Malcolm in the popular imagination—and certainly in the perception of the Nation of Islam, as his appearance on the cover of the 1966 paperback edition of Essien-Udom's *Black Nationalism* so soon after Malcolm's death attests. In my estimation, however, he does not rival Malcolm X as an icon.

Published in 1972, Hakim A. Jamal's *From the Dead Level: Malcolm X and Me* was the memoir most directly concerned with demonstrating a personal relationship with Malcolm X, not least in visual terms. Malcolm figures in the book as the cipher for Jamal's own spiritual and political evolution—a kind of cult messiah. Jamal wrote of his regret at not quite recognizing Malcolm's divinity before it was too late: "Had I known that one day I'd realize that Malcolm X was God, I know that I'd have cherished every word he uttered. Unfortunately my illness and stupidity allowed his words only to touch the surface of my brain." Despite this and other admissions that his recollection of Malcolm's words was severely limited, Jamal intended his book to be authoritative: "I began this book to put a halt to the runaway philosophies that have developed since his death."[52] *From the Dead Level* sought to preserve the memory of Malcolm not only in its narrative but in the form of holy relics, recalling a treasured postcard from London and reproducing a photograph of a broadly smiling Malcolm with the author's sons on the back of the book's dust jacket.

In some respects, Jamal's narrative reads as a painstaking corroboration of the *Autobiography*. It was Detroit Red's zoot-suiter style, recounted with an erotic attention to detail, that first intoxicated Jamal (then Allen Donaldson) in Boston and appealed to his Blaxploitation-era readers: "No one could help noticing that Malcolm's suit was pressed, its creases sharp, his pegged pants tight around his ankles, his hat snap-brimmed just right. . . . When he opened his coat, his pants were just high enough for the current style. When he took off his hat, we could all see that his hair was done up, 'fried,'—it was right." Jamal quickly determined that in Detroit Red "I had my model"; he stated that Red's "clothes were so nice that I settled for this vision" in first remaking himself in front of "the big mirror."[53]

The Nation-era Malcolm, encountered in Temple Twenty-seven in Los Angeles, "did not look all that neat" to Jamal, wearing "what looked like an Army raincoat" over a grey suit that "looked to be a little too big for him." Still, Jamal immediately recognized "that certain smile on his face" with which Malcolm carried a room.[54] Jamal also recognized that Malcolm was transformed. He was, decidedly, no longer the hustler of old: "Malcolm X was not Malcolm Little. He was not playing the role that I thought he was. He was not gaming me or the people like I thought he was." More than his new style, it was Malcolm's voice, redolent both of ghetto and church, that mesmerized Jamal, heretofore an unrepentant skeptic: "Malcolm used the words of street people, the delivery of a Baptist minister and the parables of Jesus Christ himself." Jamal would again confess to mimicry of Malcolm X, declaring that, in sharing with others the revelation of Malcolm's sermon, "I used the same emphasis, the same style and pretty much the same words as he did that day."[55] This paradigmatic perception of Malcolm is further reflected in the photograph of Jamal on the book's cover, in which the influence of the late style of El-Hajj Malik El-Shabazz—from goatee to astrakhan hat—is readily apparent.

Other "Sacred Texts": Speeches, Biographies, Manifestos

Books other than the *Autobiography* were catalogued amongst Malcolm's "almost sacred texts," including several posthumously published collections of speeches, interviews, and letters, and *Malcolm X: The Man and*

His Times (1969), an eclectic, hagiographical anthology edited by Pan-Africanist critic and historian John Henrik Clarke.[56]

Given the popular perception of oratory as "Malcolm's medium," the early recordings and transcripts of Malcolm's speeches and interviews may have borne for readers a myth of direct access.[57] The famous record versions of his "Message to the Grass Roots" and "The Ballot or the Bullet" speeches allowed a wide audience (and in particular a younger generation) to contemplate Malcolm's image, voice, and ideas. The Merit Publishers/Pathfinder Press editions of *Malcolm X Speaks* (1965), *Malcolm X on Afro-American History* (1967), *Malcolm X Talks to Young People* (1969), *Two Speeches by Malcolm X* (1969), and *By Any Means Necessary* (1970), all edited by Socialist Workers Party founding member George Breitman, were also a popular means of accessing Malcolm's political philosophy. Book titles, suggestive of Malcolm speaking and talking, next to photographs of El-Hajj Malik El-Shabazz in a corduroy sport coat, contributed to the wishful notion that he was "addressing us" in the vernacular.[58]

Although Malcolm apparently gave, in January 1965, his conditional approval for a book of his speeches to George Novack of Merit Publishers, the texts of his speeches leave the reader at as great a distance from Malcolm as the *Autobiography*.[59] Performative and social aspects of oratory are evacuated in translation to the page; unlike recordings, transcripts are unable to communicate tone, timing, and inflection, and they give even less sense of the composition and response of an audience. Marable argued, further, that an ideologically self-interested Breitman, in compiling and editing speeches for Merit/Pathfinder, altered and omitted lengthy passages from his transcripts, further distorting the reception and understanding of Malcolm that has anchored his iconography. Like the *Autobiography*, but with more direct political pronouncements, transcripts of Malcolm's oratory, dating mostly from late 1963 to early 1965, provide a vivid portrait of a man whose ideology was a work in progress. And, like the *Autobiography*, the speeches have been appropriated along with particular images of Malcolm to validate both socialist and black nationalist causes. Thus, through his speeches, Malcolm could appear at once reconciled and irreconcilable with whites, "non-revolutionary," "petty bourgeois," and even "one of the few men who could have been the Lenin of America before he was cut down by gunfire."[60]

Breitman also authored *Malcolm X: The Man and His Ideas* (1965) and *The Last Year of Malcolm X: The Evolution of a Revolutionary* (1967), and he coauthored *Myths about Malcolm X: Two Views* (1968, with Albert B. Cleage), and *The Assassination of Malcolm X* (1969, pamphlet with Herman Porter; 1976, book with Porter and Baxter Smith). *The Assassination of Malcolm X* reveled in conspiracy theory, questioning the role played in the murder by the New York Police Department, the CIA, and the FBI. The book also included Breitman's reviews of Lomax's *To Kill a Black Man* (1968) and Peter Goldman's *The Death and Life of Malcolm X* (1973), demonstrating his proprietary interest in Malcolm's legacy. In *The Last Year of Malcolm X,* Breitman argued that Malcolm "was on the way to a synthesis of black nationalism and socialism that would be fitting for the American scene and acceptable to the masses in the black ghetto."[61] Objections to Breitman's editorial and authorial treatment of Malcolm have been largely political in nature. From the start, "Breitman has been maligned as a latecomer seeking to foist his ideological bulwark onto Malcolm's last days."[62] Indeed, Breitman took sole editorship of *Malcolm X Speaks* only after encountering ideological differences with an unnamed "associate of Malcolm" from the Muslim Mosque, Inc., with whom he was compiling the material.[63] Marable argued that Breitman, a white Trotskyist, was ill suited to becoming one of Malcolm's most influential editors, particularly given that he *"never actually met Malcolm X himself,"* a fact that Breitman readily acknowledged.[64] Dyson certainly had Breitman in mind when characterizing a branch of the literature on Malcolm as "trajectory analysis . . . practiced by Trotskyist revisionists."[65]

Malcolm's legacy was also contested, and his image and speeches circulated, in leftist anthologies such as Tariq Ali's *New Revolutionaries* (1969), a book of essays and speeches by Ali, Regis Debray, Fidel Castro, and, among others, Eldridge Cleaver and Stokely Carmichael, who are positioned in the text as Malcolm's rightful heirs in an emergent black revolutionary tradition. The book, avowedly Trotskyist in tone, is dedicated "to the people of Vietnam"; its entries address social conditions and socialism in China, Britain, Poland, the United States, Czechoslovakia, Zimbabwe, France, Cuba, Indonesia, Italy, and Bolivia.[66] In this context, Malcolm X functions as an icon of global revolt.

Cleaver's entry, "Letter from Jail," presents Malcolm as the model for the Black Panther Party and other "revolutionary black youth of today,"

for whom "time starts moving with the coming of Malcolm X. Before Malcolm, time stands still, going down in frozen steps into the depths of the stagnation of slavery."[67] Cleaver eroticized the image of the gun-toting black male, reminiscent of Malcolm in his rifle pose of 1964. (The image had been turned into a celebrated poster.) Describing, appropriately enough, the Black Panther armed guard provided for Betty Shabazz upon her visit to San Francisco in 1967, Cleaver recalled

> the most beautiful sight I had ever seen: four black men wearing black berets, powder-blue shirts, black leather jackets, black trousers, shiny black shoes—and each with a gun! In front was Huey P. Newton with a riot pump shotgun in his right hand, barrel pointed down to the floor. Beside him was Bobby Seale, the handle of a .45-calibre automatic showing from its holster on his right hip, just below the hem of his jacket. A few steps behind was Bobby Hutton, the barrel of his shotgun at his feet. Next to him was Sherwin Forte, an M1 carbine with a banana clip cradled in his arms.[68]

The passage functions as a kind of conversion scene. This gun posturing provided for Cleaver a highly sexualized aesthetic of rebellion. Although he assigned the desire in his account to a woman observer—"there was a deep female gleam leaping out of one of the women's eyes"—it may be more accurate that a homoerotic recognition of the image of Malcolm in the Panthers led to his joining their ranks.[69] Carmichael invoked Malcolm more routinely, arguing that urban youths and alienated black students in America had superseded the civil rights movement and gained a "Third World" revolutionary perspective, becoming "the real revolutionary proletariat, ready to fight by any means necessary for the liberation of our people."[70] He would go on to characterize Malcolm's murder as a crime of the state.

A proprietary attitude toward Malcolm, in keeping with cultural nationalist ideals, is apparent in the anthology *Malcolm X: The Man and His Times* and a variety of memorial pamphlets and manifestos produced after his death. Black nationalists and Pan-Africanists responded forcefully to Bayard Rustin's assumption that "White America, not the Negro people, will determine Malcolm's role in history."[71] As a folk hero, the thinking went, Malcolm belonged to African Americans. *Malcolm X: The Man and His Times* is a collection of commentary, interviews, and other

primary documents. Ossie Davis's eulogy, here titled "Our Shining Black Prince," is featured even before John Henrik Clarke's introduction to the book. (The eulogy was reprinted in the poetry anthology, *For Malcolm* [1969], and recited in the documentary *Malcolm X* [1972].) One of the most prominent ancillaries to the iconography of Malcolm X, the eulogy emphasized Malcolm's image as an orator, ascribing to him a unique linguistic aptitude in declaring that "nobody knew better than he the power words have over the minds of men." In particular, Davis had in mind the power of the word and the image of the "Negro"; he argued that Malcolm "had stopped being a 'Negro' years ago." The eulogy celebrated Malcolm's smile as the symbol of his charismatic humanity, and it concluded, rapturously and influentially, with the invocation of his emblematic masculinity: "Malcolm was our manhood, our living, black manhood! That was his meaning to his people . . . our own black shining Prince!"[72]

Clarke, in his introduction, similarly aligned Malcolm's image with nobility, even when hailing him as a man of the people: "He had the greatest leadership potential of any person to emerge directly from the black proletariat in this century. In another time under different circumstances he might have been a king." Clarke did not interrogate Malcolm's myth as put forth by the *Autobiography* but instead summarized and reiterated its key elements as gospel. He went on to delineate Malcolm's iconic value as a founder of Black Pride, presented as rooted in masculine integrity, which became the model for a kind of psychic realignment of gender relations: "Certainly he didn't preach 'black supremacy.' Malcolm X preached black pride, black redemption, black reaffirmation, and he gave the black woman the image of a black man that she could respect." Clarke acknowledged Malcolm's advocacy of "a concomitant cultural and educational revolution" to accompany "the physical revolution," understood as an internationalist, anti-imperialist, nonwhite struggle. He concluded that Malcolm's death had resonance beyond the sordid infighting of rival Muslim factions, thereby investing it with the glamour of intrigue and identifying it as a rallying point for African Americans disillusioned with the political system: "Malcolm X threw himself into the cross fire of that invisible, international cartel of power and finance which deposes presidents and prime ministers, dissolves parliaments, if they refuse to do their bidding. It was this force, I believe, that killed Malcolm X, that killed Lumumba, that killed Hammarskjold." Specifi-

cally, Clarke claimed that Malcolm's plan to bring the African American struggle before the United Nations as a human rights case got him killed by "the American oppressors."[73]

Many smaller publications, issued by individuals and societies concerned with memorializing Malcolm as an African American icon, circulated regionally. Sara Mitchell's pamphlet *Brother Malcolm*, published in May 1965, reproduced much content from *Liberator*'s April issue, including Davis's eulogy. Although written prior to the publication of the *Autobiography*, Mitchell's commentary would touch on many of the familiar elements of Malcolm's myth: his father's death; his "pushing dope and 'hustling.'" Mitchell, who held the title of coordinating secretary of the OAAU and herself witnessed Malcolm's death, emphasized his ties to "the African and Asian world" as well as his image as an idealized, tragically murdered father.[74] Of the pamphlet's twelve photographs, four depict Malcolm's daughters. Balogun Moyenda Adom Jasiri's *Malcolm X Is Found Guilty* (circa 1978) included a one-act play of sorts, including a judgment of Malcolm by "Judge AmeriKKKan In-Justice," followed by a tribute by the author and quotations from Malcolm's speeches. In the first piece, Malcolm, "Charged with Telling the Truth," naturally pleads "Guilty Sir," and is sentenced to death "On the Podium of the Audubon—By Firing Squad." The suggestion of execution by the state is clear enough; Jasiri also indicated the complicity of "Fellow Niggers of Our Kind Who Wants [sic] You Out of the Way."[75] The pamphlet's cover features an uncredited photograph of Malcolm X in his casket. The author's tribute hailed Malcolm as "Greater Than Jesus, Greater Than Muhammad, Moses, and Others," and "The Greatest Prophet to Ever Walk This Planet Among MEN." Jasiri described Malcolm as "The Prophet of Our Age," laboring on "Four Continents to Free Us"—unlike the other prophets, according to the author, "Single-Handed[ly]. Without Any Miracles, or Help from God."[76] Malcolm, in this account, was ultimately a god.

Malcolm also inspired the formulation of political manifestos such as that contained in Brother Imari Abubakari Obadele's pamphlet *War in America: The Malcolm X Doctrine* (1968). Brother Imari, "whose slave name was Richard B. Henry," saw the urban uprisings of the mid- to late 1960s as "the opening of black guerrilla warfare" on American soil.[77] With his brother Gaidi Obadele (Milton R. Henry) and others, Imari cofounded the Republic of New Afrika (RNA), a territorial nationalist orga-

nization intending to militarize and liberate the Deep South. He stated that the founding of the RNA on 31 March 1968 was designed

> to remove the Malcolmites and the other black nationalist revolution-aries in America from a position where the United States might with impunity destroy them to a position where attacks upon us by the United States become international matters, threatening world peace, and thereby within reach of the United Nations, thereby within reach of our friends in Africa and Asia who would help us.[78]

The project extrapolated and synthesized a black Zionist program from Malcolm's Nation of Islam period and an internationalist one from his final months. The RNA, apparently with the blessing of Betty Shabazz, intended to establish a "prototype . . . settlement and future national cap-itol [in Mississippi]. It would be named El Malik in honor of Malcolm X."[79] Like George Washington, or Aeneas in Virgil's founding myth of Rome, Malcolm was to function as an icon and patriarch for the imag-ined nation-to-come.

After outlining his tenets, Brother Imari confessed that "it would be untrue to say that this is the plan which Malcolm X whispered whole into the author's ear." Yet Malcolm provided much of the inspiration and, im-portantly, legitimacy for the RNA's political philosophy. Although Brother Imari did meet Malcolm four times, he confessed that "I am sure he did not know me and certainly did not recall me from one meeting to the next." Like Jasiri, however, Brother Imari wrote that Malcolm "in the last 18 months of his life became God's surest prophet to this lost black tribe in America."[80] As the next section will show, African American critics and writers more commonly took to contesting Malcolm's legacy by cul-tural rather than territorial means: Malcolm X became a crucible through which a new Black Aesthetic was forged and consumed.

The Black Arts Movement

In his address at the founding rally of the OAAU on 28 June 1964 at the Audubon Ballroom, Malcolm X delivered a "Statement of Basic Aims and Objectives" that anticipated, and indeed formulated, many of the principles of cultural nationalism that would underwrite the Black Arts Movement, which began to coalesce in the summer of 1965 and would

extend into the early 1970s. Reading from the prepared statement, Malcolm echoed Fanon in declaring the need for a "cultural revolution" to "unbrainwash an entire people," to "recapture our heritage and our identity," and "to liberate ourselves from the bonds of white supremacy," all recurrent themes in his late speeches. This grassroots revolution was intended to bring "everyone in the Western Hemisphere of African descent into one united force" with "our African brothers and sisters." The program involved "the establishment of a cultural center in Harlem" to "conduct workshops in all of the arts, such as film, creative writing, painting, theater, music, and the entire spectrum of Afro-American history." Clarifying the latter point, Malcolm added: "When you have no knowledge of your history, you're just another animal; in fact, you're a Negro; something that's nothing."[81] The model of collective renewal that he imagined, and that his autobiography's myth of transformation sought to exemplify, began with shedding the confining designation "Negro" and substituting "Afro-American" or, as Malcolm's immediate heirs would have it, "Black." By way of a kind of elemental process of self-appellation, Malcolm argued, the psychology of self-perception was transformed and a state of nonbeing was annulled. The new state of being required proofs in the form of images that Malcolm, even in death, would readily provide.

The Black Arts Movement, partly inspired by Malcolm's invitation to cultural revolution, asserted "an aesthetics of separatism" calling for the abandonment of European models. Emphasizing the ritual and social functions of art, Amiri Baraka, Larry Neal, Nikki Giovanni, Haki Madhubuti (Don L. Lee), and others addressed their work to the psychic and spiritual needs of African Americans. These purveyors of the Black Aesthetic advocated and produced "art-for-people's sake," rejecting the universalist mode they associated with white art and the tradition of protest (or supplication before white morality) they associated with African American art, especially literature.[82]

The Umbra Workshop, Harlem Writers Guild, BLKARTSOUTH, Watts Writers' Workshop, Black Arts West, Spirit House, and the Black Arts Repertory Theater/School provided the institutional foundation for the movement. Small magazines also had a crucial role in the formulation and expression of the aesthetic. *Negro Digest, Liberator, Umbra, Soulbook, Black Dialogue, Journal of Black Poetry, Nommo,* and *Black Creation,* all founded between 1961 and 1970, circulated radical essays, short sto-

ries, poems, and plays. Black presses emerged in abundance during the 1960s, "including the Free Black Press of Chicago, Journal of Black Poetry Press of California, Black Dialogue Press of New York, Jihad Press of Newark, and especially Broadside Press of Detroit, established by Dudley Randall, and Third World Press of Chicago, developed by Don Lee."[83]

Within the Black Arts, Malcolm X became a foundational figure, "a symbol, a dream, a hope, a nostalgia for the past, a mystique, a shadow sometimes without substance, 'our shining black prince,' to whom we do obeisance, about whom we write heroic poems."[84] His apparently superior commitment to the new blackness was dramatized through the retelling of his martyrdom, often in the terms established by Ossie Davis's eulogy. Conversion narratives proliferated, depicting the reclamation of "'black manhood' . . . from 'Negro' emasculation," and the Black Arts from complicity in oppression.[85] The models for such redemption were Malcolm's myth of transformation and his "politics of transvaluation."[86] As much as Malcolm sought to redefine the "Negro" in America, however, it was the Black Arts postmortem that established a new orthodoxy by way of "the disciplining language of inside/outside."[87] The new blackness was to be underwritten by new, self-consciously "Black," cultural forms that, at least in theory, admitted or invited no white participants. The image of Malcolm X was often deployed as a sentinel on this racial frontier.

Visual and Monumental Art

The significance of social ritual to the Black Arts was readily apparent in the responses of visual artists to Malcolm X. By muralists, painters, and sculptors, "Malcolm X was beatified—elevated to the status of a martyred but soon-to-be-triumphant redeemer."[88] From the anonymous, the local, the found, the borrowed, and the disposable, to the beginnings of abstraction and commodification, images of and references to Malcolm were abundant in the era's art.

Posters advertising Malcolm X memorial meetings and tributes in New York City often subordinated artistry to social message, featuring borrowed or derivative images of a dignified El-Hajj Malik El-Shabazz. The meetings, usually held on the anniversary of Malcolm's death or on his birthday (19 May) and led by prominent educators, radicals, and

friends and relatives of Malcolm, including Betty Shabazz, Ossie Davis, James Baldwin, and John Henrik Clarke, were rituals of collective grieving. They were also fund-raisers and spectacles, featuring performances by the likes of Barbara Ann Teer's National Black Theatre, Marc Primus's Afro-American Folkloric Dance Troupe, and Louise Jeffers and the OAAU Singers. One poster indicated, in a gesture to Malcolm's late political and spiritual views, that representatives from African states and Islamic officials would be in attendance; another announced a pilgrimage from the Hotel Theresa in Harlem to Malcolm's burial place in Queens; another described him as a "Prophet of Black Power"; yet another depicted him, mid-declamation, flanked by a star and a crown of thorns alluding to the Passion.[89] Much like the mortuary display of his body and his funeral, these events both honored Malcolm and consolidated his mythic stature within black culture.

Community murals depicted Malcolm in the midst of other icons of African American identity. These murals, commonly known as "walls of respect," mythologized individuals involved in black cultural activity, "engag[ing] issues of black cultural accomplishment, radical protest against oppression, and contemporary heroism, rather than historical narratives."[90] They united contemplation of political endeavor with scenes of sporting triumph and the celebration of black music's transcendent performers. The walls transformed impoverished urban locations into catalogs of black achievement and even became backdrops for (often spontaneous) eruptions of public art, including drama, dance, speeches, and poetry readings by such as Gwendolyn Brooks. In this way, black artists newly invested in the ritual integration of art into local communities demonstrated their rejection of the secular commercialism of art in Western culture.

Chicago's *Wall of Respect,* at Forty-third Street and Langley Avenue, was among the first and most influential of these murals. The wall, a thirty-by-sixty-foot mural "that was completed in 1967 and destroyed in 1971," was organized by members of arts workshops AfriCobra and the Organization of Black American Culture; their collectivist goal dictated that no artists' names would appear on the wall. In addition to Baraka's poem "S.O.S.," the wall featured eight groups—"rhythm and blues, jazz, theater, statesmen, religion, literature, sports, and dance"— and included images of Billie Holiday, Muddy Waters, James Brown,

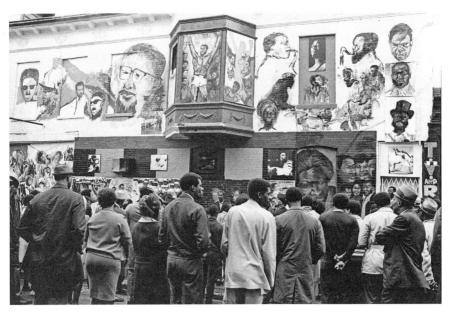

Neighborhood residents and artists gather at the dedication ceremony for the Wall of Respect, *Chicago, 1967. Photograph by Robert Abbott Sengstacke/Archive Photos/Getty Images.*

Charlie Parker, Ornette Coleman, Nina Simone, John Coltrane, Frederick Douglass, Malcolm X, Stokely Carmichael, W. E. B. Du Bois, Amiri Baraka, and Muhammad Ali.[91] However crudely painted, Malcolm was identifiable, in the Chicago mural and in others, by the invocation of his late style. The inclusion of the goatee, along with the customary glasses, suggested a preference for the Malcolm who sought political alliances in Africa to the combustible Nation of Islam minister or Detroit Red. Elsewhere, muralists juxtaposed Malcolm with the likes of Douglass, Garvey, Du Bois, King, and Tutankhamen, establishing a lineage and implying the conferral of a kind of nobility out of gratitude for historic contributions.

Malcolm's iconic reputation as the "maximum leader/teacher" of black consciousness was confirmed in the naming of community centers, schools, and colleges in his honor.[92] Crane Junior College in Chicago was renamed Malcolm X College in 1969; the same year, Malcolm X Liberation University was founded in Durham, North Carolina (it relocated to Greensboro the next year). Malcolm X College installed a distinctive monument on its urban campus: "The fallen Muslim leader's shiny black Oldsmobile [Ninety-Eight] was placed in the service of racial awareness

and pride"—exhibited like a treasured work of art within one glass-walled hallway."[93] The car was presented as symbolic of Malcolm's dedication to his work: it helped him persist in "a marathon schedule of press, radio, television, and public-speaking commitments." As one of his few acknowledged material indulgences ("every nickel and dime I ever got was used to promote the Nation of Islam"), it was emblematic also of his heroic self-denial. The car represented a triumph of sorts over his social environment—the *Autobiography* indicated that the Oldsmobile factory in Lansing refused to hire African Americans when Malcolm was a child.[94]

Artists working in more conventional visual arts genres addressed Malcolm's legacy, expressing anger and gratitude in both realist and neo-African styles. Vincent Smith, whose 1950s and 1960s genre paintings depicted "the bars, poolrooms, street-corners and small tenement rooms of the densely-populated neighbourhoods" of urban America, presented Malcolm as a folk prophet disregarded in his lifetime by many African Americans.[95] Identifiable by his goatee and exaggeratedly red hair in *For My People* (1965), Smith's Malcolm implores a crowd of a dozen from a street-corner podium. The orator gesticulates forcefully but is unheeded by many in the frame who turn instead toward the church (a nun in habit), a pawnshop (signaling economic exploitation), and a bar. The figures in Smith's painting, reminiscent of Romare Bearden's disproportioned figures from African American folklife, nevertheless contextualize Malcolm as an impassioned visionary seeking to unify the often contradictory elements of black culture into a coherent whole.

Elizabeth Catlett, a self-professed revolutionary artist best known for her sculptures, found inspiration in the mural tradition for her *Malcolm X Speaks for Us* (1969). Her starkly contrastive rendering of a photograph of El-Hajj Malik El-Shabazz, surrounded by representative sequences of apprehensive black youth, appeals to the perception of Malcolm as a visionary figure. The original photograph appeared, among other places, on the cover of Breitman's 1967 book *The Last Year of Malcolm X*.

Sculptor Barbara Chase-Riboud's four abstract monuments to Malcolm X (1969–1970), wall hangings described by one critic as "votive works of art," contrasted and synthesized bronze casts and braided fiber. The pieces dispensed with, or perhaps deconstructed, the conventional iconography of Malcolm's oratory. Less overtly polemical than other African American artists of the period, Chase-Riboud "regarded sculpture as

For My People, 1965. By Vincent Smith. Oil on masonite, 49 × 46 inches. Courtesy of Alexandre Gallery, New York. © Estate of Vincent Smith.

a reinterpretation of primitivist notions about magic and spirituality."[96] Overcoming the accustomed severity of the pedestal with braided skirts of silk and wool, Chase-Riboud explored with these pieces the convergence of contrasting forms, textures, and materials, from folk art to high modernist, African to European, masculine to feminine, bronze to silk. Selz and Janson interpret the pieces as being conceived in the spirit of "tribute and celebration, not in any sense as polemical interpretations or as icons of mourning."[97] This assessment flattens the context from which the Malcolm X sculptures emerged: Chase-Riboud traveled extensively in postcolonial Africa and Maoist China prior to producing the monuments.

Malcolm X Speaks for Us, 1969. By Elizabeth Catlett. The Museum of Modern Art, New York, N.Y., U.S.A. © Estate of Elizabeth Catlett, SODRAC, Montreal/VAGA, New York (2012). Digital Image © The Museum of Modern Art/Licensed by SCALA / Art Resource, NY.

The new generation of writers, described by Baraka as "the founding Fathers and Mothers, of our nation . . . the wizards, the bards, the *babalawo,* the *shaikhs,* of Weusi Mchoro," was further established with the publication of anthologies such as *Black Fire* (1968), *The Black Aesthetic* (1971), *New Black Voices* (1972) and *Understanding the New Black Poetry* (1972).[98] According to Larry Neal, *Black Fire* was intended as "a critical re-examination of Western political, social and artistic values." Like the celebratory poetry anthology *For Malcolm* (1969), it was also a re-examination of Malcolm X. Emphasizing in its critical selections the vernacular tradition in African American culture, the book proposed a "literature of Armageddon" inspired by Malcolm's incitement to "a revolution of the psyche." Neal positioned Malcolm as both "warrior" and prophet—as "the conscience of Black America," "it was both painful and beautiful to listen to him."[99] James Boggs echoed the Malcolm of early 1964 in writing of the importance of African American armament as a means of self-defense. He also complained of opportunistic appropriations of Malcolm by "every radical in the country and every group in the movement."[100]

In *The Black Aesthetic,* Gayle identified a tradition of resistance through folk expression recently exemplified by Malcolm X, stating that "anger in black art is as old as the first utterances by black men on American soil." (One unavoidably thinks of the iconic photograph of Malcolm X gesticulating behind his microphone.) Gayle posited a criticism, however, rooted in the desirability of transformation, arguing that "the problem of the de-Americanization of black people lies at the heart of the Black Aesthetic."[101] Neal claimed that Black Art, "the aesthetic and spiritual sister of the Black Power concept," "proposes a separate symbolism, mythology, critique, and iconology"—a cultural orientation he did not perceive in the Harlem Renaissance of the 1920s, an artistic movement he deemed "a failure."[102] Julian Mayfield, evidently invested in an image of Malcolm as sober and articulate, insistently distinguished his style, in terms of speech and dress, from that of Black Power. Expressing admiration for Malcolm's ability "to shape words into bullets," Mayfield, who met Malcolm in Ghana in 1964, was "struck by how often many of his most vociferous *post-assassination* advocates seem to think the word

'motherfucker' shouted at the top of the voice is a substitute for action and clarity of thought." He was similarly troubled by what he perceived as an overabundance of faddish commodities, ripe for co-optation, within the apparently revolutionary culture: "superficial appurtenances such as music, language, dress, and slogans, and other 'Black Is Beautiful' fads can so easily be chewed up, digested, and spat out by this vigorous, if sick, society, that no aesthetic is safe within its grinding teeth."[103] Finally, William Keorapetse Kgositsile warned of the cultural danger posed by hero worship, or "a tendency to put all our hopes in individual courageous men" who, in America, were too often killed or otherwise rendered unable to fulfill their potential as leaders.[104]

New Black Voices, a collection of contemporary fiction, poetry, and criticism, included work exclusively by living writers, with the exception of Malcolm X, whose "Statement of Basic Aims and Objectives of the Organization of Afro-American Unity" and "Basic Unity Program, Organization of Afro-American Unity" were included as formative texts of the period. The front-page teaser advertised "the voice of Malcolm X speak[ing] its living truths from beyond the grave."[105] Also included in the book was Baraka's essay "The Legacy of Malcolm X, and the Coming of the Black Nation," which stated that "Malcolm X's greatest contribution . . . was to preach Black Consciousness to the Black Man."[106]

Novelist John Oliver Killens presented a more thoughtful consideration of Malcolm's iconic resonance, alluding to visual culture's relationship to sexual desire. The Cotillion (1971) is a novel both satirizing and celebrating youthful radicalism and its self-conscious assertions of African American pride in contrast to bourgeois aspiration. Beginning with the testimony of self-named Ben Ali Lumumba, the novel is laden with contemporary cultural references to such figures as Lew Alcindor (Kareem Abdul-Jabbar), Sidney Poitier, Duke Ellington, and Malcolm X, who is presented as a figure of exemplary and desirable masculinity—a kind of Black Power heartthrob: "Tall and fire-haired, manhood oozing from every pore of him, fiery in his oratory, lightning fast of wit, uncompromising in his integrity, tough and tender with his people." The protagonist, Harlemite teen Yoruba Evelyn Lovejoy, is described as having long mourned Malcolm's death; she was "helplessly and hopelessly in love with him, like a thousand other girls her age who were of the Black persuasion."[107]

The articulation of the terms of Malcolm's iconicity can be traced in poetry more extensively than in other literary forms. Poetry's accommodation of the performative and sloganistic gave it a more direct political valence than the prose fiction of the period. In dozens of poems by Neal, Baraka, Madhubuti, Brooks, Robert Hayden, Etheridge Knight, Margaret Walker, Sonia Sanchez, and others, Malcolm was abstracted to a cultural symbol. Black Arts poets, like the urban muralists, eulogized and mythologized Malcolm alongside the likes of Nat Turner, Frederick Douglass, Paul Laurence Dunbar, Bessie Smith, Duke Ellington, Langston Hughes, Richard Wright, Martin Luther King, and, especially, John Coltrane. Malcolm would be variously interpreted within the movement's poetry as a prophet, martyr, ancestor, vengeful spirit, masculine fetish, and stylish rebel.

Despite Malcolm's frequent appearance in metaphysical guise, Marable suggested that the poets' interest in Malcolm was largely visual, attributable to his "magnetic physical figure." Viewed as "a kind of revolutionary Black Adonis . . . Malcolm X was mesmerizingly handsome, displaying a broad, boyish smile and was always spotlessly well-groomed. In photographs, he embodied strength and sensitivity. In death he would remain forever young."[108] Many invocations emphasized a particular alignment of blackness with Malcolm's manliness. Gwendolyn Brooks, for one, fixated upon the fulminating and revelatory "maleness" of Malcolm, a figure "devout and vertical" yet possessed of a primordial energy: "He had the hawk-man's eyes."[109] Marvin E. Jackmon (Marvin X), in "That Old Time Religion," presented Malcolm as "The Saint / behind our skulls"; the poem was perhaps unintentionally salacious in declaring that "Malcolm held our manhood."[110] Critics have argued that the ethos of cultural nationalism falsely "equated freedom with patriarchal authority and manhood" and "powerlessness . . . with femininity and homosexuality" and that "Malcolm X's inescapable identification as the quintessential model of black masculinity" served as a "kind of gendered barricade to any really objective appraisal of him or his legacy" during the Black Arts era.[111] The poetry remains a record of Malcolm as a figure of desire, emulation, and domination.

Although nearly all of the panegyrics written for Malcolm appeared after his death, he may have read at least one poem composed in his honor. Ishmael Reed has written of showing Malcolm the manuscript of an un-

published poetic tribute to him, "Fanfare for an Avenging Angel." Given this early evidence of his own beatification, Malcolm apparently told him, rather broadly, if generously, that "it reminded him of Dante and Virgil's poetry." Reed himself conceded that the poem "was terrible."[112]

Drama and Screenplays

The Black Arts Movement's emphasis on vernacular performance also favored the theatrical stage, a venue with an ephemeral but significant relationship to the visual representation of Malcolm X. Black Arts dramatists, like the poets, cultivated an aesthetic of opposition, confrontation, and transformation. Described variously as "a theater of warfare," "a special kind of chapel atmosphere for rituals and other procedures," and an alternative to the "contented fat white cow" of Broadway, the Black Arts theater was a self-consciously revolutionary theater intended to address itself directly to African American spectators and, according to critic Clayton Riley, to "force change; it should be change. (All their faces turned into the lights and you work on them black nigger magic, and cleanse them at having seen the ugliness. And if the beautiful see themselves, they will love themselves.)"[113] Whereas black audiences were expected to "witness the painful events" of their history so as not to "be destroyed by them," it was hoped that "white men will cower before this theatre because it hates them."[114] The revolutionary theater was, like much of the Black Arts iconography of Malcolm X, self-consciously theorized as a Black Power spectacle. In leading African American writers toward the commercial apparatus of filmmaking, however, these spectacles will be shown to have contributed to a once-unforeseeable exemplification of the science of imagery: Malcolm's latter-day arrival as a Hollywood icon.

Baraka, who, with Charles Patterson, William Patterson, Clarence Reed, Johnny Moore, and others, founded the Black Arts Repertory Theater/School (BARTS) in Harlem in March 1965, called for "a theatre of assault" that was "now peopled with victims" and must "soon begin to be peopled with new kinds of heroes—not the weak Hamlets debating whether or not they are ready to die for what's on their minds, but men and women (and minds) digging out from under a thousand years of 'high art' and weak-faced dalliance."[115] Woodie King, Jr., and Ronald Milner argued that "Black participants had to create their own Othellos, their

own Willy Lomans."[116] Malcolm X was of course one of the new theatrical icons, along with the likes of "Crazy Horse, Denmark Vesey, Patrice Lumumba," and figures drawn from "the so-called criminal element in Black America, the outlaws whose life-style and maintenance of confrontations with the terms of their existence make them the only true frontier personalities and thoroughly honest people in the nation."[117]

Drawing on Malcolm X's image and example of the rhetoric of physical confrontation, Black Arts dramatists often resorted to visceral scenes of deterministic violence suggestive of deep-seated anxieties regarding African American male identity. Baraka's *Experimental Death Unit #1* (1965) and *Junkies Are Full of (SHHH . . .)* (1970) end with scenes of ostensibly socially cleansing violence enacted upon white johns and an Italian American drug dealer by militant African American men. The marching, Swahili-speaking radicals also sacrifice the African American prostitute and addict who transact with the white predators, presumably for the collective good.[118] Such brutality, typical of Baraka's plays, primarily functions as a prophecy of violent outcomes in American race relations. Utilizing the theater as a venue for exploring an alternate racial universe in which African Americans could wield power as arbitrarily as whites were perceived to, Baraka sought to transform the psychology of American race relations in a distorted visualization of Malcolm X's rhetoric of self-defense.

A Black Mass (1966), a one-act play based on the Nation of Islam's myth of Yakub, was described by Neal as Baraka's "most important play mainly because it is informed by a mythology that is wholly the creation of the Afro-American sensibility."[119] Neal's perception of cultural independence as paramount in evaluating Black Arts theater outweighed the fact that Malcolm had thoroughly abandoned Elijah Muhammad's theology at the time of his death. (In another self-conscious echo of Malcolm's Nation of Islam–era theology, African American actors in whiteface typically played the devilish white characters in Baraka's plays.) First produced in Newark in May 1966 and published in the June *Liberator,* the play was "a version of *Frankenstein.*"[120] The play's alignment of black magic with the proper function of the Black Arts—in defending and mobilizing the community—was readily apparent. Reproducing the Nation's interpretation of religion as a racial property, the play's narrator addressed an audience understood to be African American, calling for the declaration of "Holy

War. The Jihad. Or we cannot deserve to live."[121] Violence was presented as a vindication of struggle and a matter of pride. Scored by Sun Ra and the Myth-Science Arkestra, *A Black Mass* featured African costumes and stage signs written in Arabic and Swahili; in keeping with the preoccupations of the period, women appeared only as shrieking harbingers of ill magic, objects of sexual desire, and interlopers in the male-dominated laboratory.

Baraka's *The Death of Malcolm X* (1969), a short, unproduced screenplay written between late 1965 and early 1966, dealt in racist clichés and explored the layers of mediation enshrouding the iconic Malcolm X.[122] The screenplay bore the marks of recent trauma. Baraka's Malcolm, inscrutable behind a pair of sunglasses, first appears on stage/screen surrounded by cameras, lecturing to a television panel on the nature of evil. The scene then shifts to a hotel room, where a monstrous Klansman, seemingly implicated by Malcolm's words, observes Malcolm on a television screen. The Klansman laughs as he watches but does not really see Malcolm, emboldened by his conspiratorial plan, code-named "Operation Sambo," to have him murdered. His fellow conspirators include a set of undifferentiated Uncle Sam–costumed white patriarchs, the "Hippy President," a "Banker," and, by implication, a misguided, grey-haired integrationist who collaborates with the plot in exchange for a gilded watermelon. The latter figure, who gradually overtakes Malcolm on the screenplay's pervasive television screen, is described as "a tall 'distinguished' looking Negro with graying temples" who parades a host of apparently brainwashed or brain-transplanted African Americans down a brutal gauntlet, singing "WE SHALL ALL BE WHITE."[123] Baraka clearly intended this as a cruel parody of the "We Shall Overcome" era and Martin Luther King—an instance of the Black Arts Movement's preference for Malcolm X as a figure of exemplary defiance, with King reduced to a champion of southern stereotype. Historical accuracy was evidently not Baraka's concern with the screenplay, an exercise in grotesque satire in which ancient Greeks, Vikings, and George Washington all make appearances. *The Death of Malcolm X* does communicate Baraka's deep pessimism about the adaptability of American government and media to the needs and demands of African Americans. Malcolm's murder at screenplay's end is an entertainment, a public execution carried live on television and radio for his many enemies to gape at in gleeful anticipa-

tion. Here Baraka rejected the notion that Malcolm had somehow invited his own death; he questioned the role of white spectatorship in willing the Black Arts icon's demise.

The drama of Malcolm's life and death appealed also to an older generation of African American writers, including James Baldwin, who had nevertheless explored the youthful radicalism in his play *Blues for Mister Charlie* (1964). Like Baraka's *The Death of Malcolm X*, Baldwin's *One Day, When I Was Lost* (1972) is an anomalous, unproduced screenplay about Malcolm. Described by Van Deburg as "a surreal and, at times, bawdy and soap-operish screenplay," it is a narrative filled with visual cues but no visuals.[124] Adapted from the *Autobiography*, Baldwin's screenplay was written after the violent images of the assassination had begun to recede from view. Ultimately discarded as a box-office risk, *One Day, When I Was Lost* was originally commissioned by producers who perceived the *Autobiography* as a fable of black pathology culminating in an apolitical exorcism in Mecca. Among the producers' concerns was beating *Ché!* (1969), another "controversial, courageous, revolutionary film . . . being packaged for the consumer society," to the box office.[125] This was not among Baldwin's concerns. Drawn to Hollywood in 1968 despite the skepticism of his family and friends about the project, Baldwin wished to bring a credible African American history and hero to the screen. Sharing with Malcolm and many other critics the sense that the cinema presented false images of African Americans, Baldwin argued that D. W. Griffith's *The Birth of a Nation* was "really an elaborate justification of mass murder." Of early screen comedians Lincoln Perry (Stepin Fetchit), Willie Best (Sleep 'n' Eat), and Mantan Moreland, he claimed that "it seemed to me that they lied about the world I knew, and debased it, and certainly I did not know anybody like them"; and of the emergent Blaxploitation films, Baldwin stated: "I suspect their intention to be lethal indeed." Upon being teamed with another, unnamed screenwriter who "translated" his scenes "into cinematic language, shot by shot, camera angle by camera angle," Baldwin began to despair "that all meaning was being siphoned out of them." Recognizing that collaborative compromise "in the interest of 'entertainment' values" was necessarily a loss of artistic control, Baldwin's own faith in the project collapsed.[126]

However unlikely a pairing—Baldwin was of a far more liberal strain than Malcolm, who apparently asked reporter Elombe Brath during a

lecture by Baldwin at Hunter College, "Is that guy a faggot?"—the two men shared a sense of the depth of America's racial animus and its role in shaping African American psychology.[127] Baldwin recalled that "I was a little afraid of him, as was everyone else." Although he confessed to being "sufficiently astute to distrust . . . the legend" of Malcolm X, when Baldwin first saw Malcolm in person, he "very nearly panicked." Malcolm was revelatory, however, in the racial particularity of his prophecy: "It was important, of course, for white people to hear it, if they were still able to hear; but it was of the utmost importance for black people to hear it, for the sake of their morale. It was important for them to know that there was someone like them in public life, telling the truth about their condition."[128] Baldwin would argue that "black men do not have the same reason to hate white men as white men to hate blacks. The root of the white man's hatred is terror. . . . But the root of the black man's hatred is rage."[129] As the most articulate and divisive instrument of this rage, Malcolm, especially upon his death, appealed to Baldwin as a representative figure and fellow Harlemite. Indeed, the screenplay was a kind of tribute to the Harlem of Baldwin's youth, addressing its religion, nightclubs, crime, and, in an extended montage, the Harlem riot of 1943. Malcolm was representative for Baldwin also in his ontological indeterminacy; a complex, unrealized figure revealing of America's unresolved racial destiny, his meaning was "as yet undetermined and, ultimately, undeterminable."[130]

One Day, When I Was Lost establishes very early the visual association of Malcolm with Africa, depicting him in the opening sequence addressing students in Senegal and Nigeria in 1964, where he was given the honorary name "Omowale," meaning "the son who has returned." The scene serves to underline Malcolm's claim that "I have had so many names," introducing to the story a trope of temporal simultaneity that dismantles the *Autobiography*'s linear narrative of transformation and its absolute separation of Malcolm's several personae.[131] Even the title of the screenplay speaks to this instability of Malcolm's "narrative location."[132] Ultimately, though, Baldwin reconciled the several Malcolms in a way that other texts do not. Brian Norman has argued that, unlike the *Autobiography* and Spike Lee's film, which "present models where earlier protest messages are discarded at each developmental stage," Baldwin combined "protest moments that do not dissipate or die when their speaker

(Malcolm X) leaves the stage."[133] Baldwin insisted upon the influence of Malcolm's past, with numerous flashbacks and voiceovers echoing his youthful experiences, including during the assassination scene at screenplay's end. Baldwin was the first and has been one of the only writers to disrupt the linear narrative of the *Autobiography*.

Some of this adaptation was of course demanded by the generic constraints imposed by the cinema, but, in largely dispensing with a totalizing narrator, Baldwin can be seen to have attempted a kind of psychological realism, placing the viewer "inside Malcolm's head bombarded by images or tropes from multiple times."[134] He portrayed Malcolm as a psychologically complex, traumatized individual. The screenplay begins not with images from Malcolm's childhood or youth but with Malcolm driving from the New York Hilton to the Audubon Ballroom—and to his death. In this, Baldwin's Malcolm resembles Rufus Scott, the catalyzing, suicidal New Yorker with "nowhere to go" at the outset of Baldwin's novel *Another Country* (1962).[135] A fruitful comparison can also be made with Richard Henry in *Blues for Mister Charlie*. Reprimanded by his grandmother for his unabashed criticism of whites, the defiant Richard is finally murdered by a white man.[136]

One Day, When I Was Lost's recurrent images and figures also provided a symbolic texture to the narrative. Baldwin's sense that America was haunted by historical crimes is evident in flashbacks to the image of Malcolm's burning childhood home, vandalized by Klansmen. Baldwin's Malcolm was not without his own past crimes. The ghostly figure of Laura, representative of Malcolm's failing of women—especially African American women—continues to haunt him in Baldwin's version, even appearing at Malcolm's graveside in the closing scene as a kind of Mary Magdalene figure.

The film that did make it to the screen during this period was the documentary *Malcolm X* (1972), directed by Arnold Perl. Perl had inherited from Baldwin the task of adapting the *Autobiography* for Warner Brothers. Although he would be credited as cowriter, with Spike Lee, of the *Malcolm X* that appeared in 1992, his own screenplay had long been confined to the studio's archives. In conducting the research for his screenplay, Perl came to understand that the truth of Malcolm X might forever have been submerged in Malcolm's own self-fashioning. A later screenwriter concurred, claiming of Malcolm's opacity that "if we didn't ignore it we'd

have to quit."[137] Perl found a more stable subject in the archival footage of Malcolm from which he constructed his documentary. *Malcolm X* also incorporated, as voice-over narration, passages from the *Autobiography* read by James Earl Jones; unusually, the promotional poster for the film featured an image of Grove Press's 1966 edition of the *Autobiography,* paying tribute to the book's iconic status. The opening sequence of the film featured The Last Poets' rendition of "Niggers Are Scared of Revolution," which echoed much of the poetry of the period in stating that "Niggers loved to hear Malcolm rap / But they didn't love Malcolm."[138] The film has been described by David Bradley as "a powerful, funny film that may be the only one we need about Malcolm X."[139] Bradley's view seems motivated by the desire for a definitive document of this distinctly elusive—and distinctively visualized—subject.

Pop Art

The arrival of Malcolm X as a rebel accessed and endorsed in the visual mainstream of American culture was announced as early as September 1965 in the men's magazine *Esquire.* The cover of the "Back to College" issue presented a conglomerate image of four figures, emblematic in their own ways of popular heroism and political controversy: Bob Dylan, Malcolm X, Fidel Castro, and John F. Kennedy. The four photographs were airbrushed by designer George Lois, who "produced 92 covers for *Esquire*" during the 1960s, including a memorable image of Muhammad Ali as the martyred Saint Sebastian in April 1968. Lois, who distanced his knowing practice of "graphic editorial" or "package design" from the pop art produced by the likes of Andy Warhol, would describe the four figures as "divided (and joined)" as heroic representatives of "that violent, revolting age." He concluded retrospectively that the cover image evoked a departed "time when we still embraced heroes": "Today, alas, without heroes, we must make do with celebrities."[140]

Identifiable on the cover in his browline glasses, Malcolm is listed as second among "28 who count most with the college rebels." The composite image, suggestive of a rifle's aiming mechanism, was dissonant in its pairing of Malcolm's stern gaze with the almost preening Kennedy grin. Given *Esquire*'s orientation to the cultural mainstream, the image and

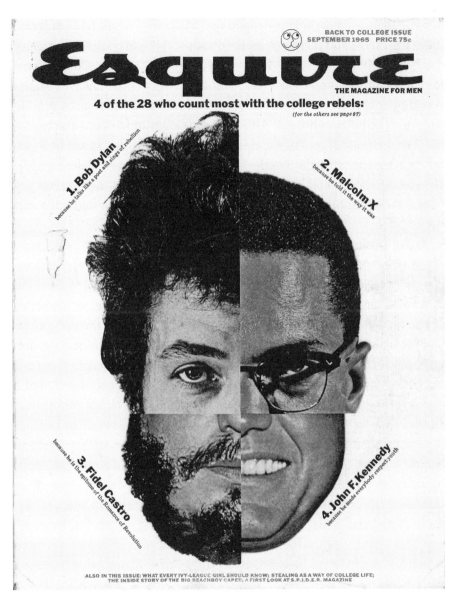

Esquire

THE MAGAZINE FOR MEN

4 of the 28 who count most with the college rebels:

(for the others see page 97)

1. Bob Dylan *because he talks like a poet and sings of rebellion*

2. Malcolm X *because he told it the way it was*

3. Fidel Castro *because he is the epitome of the Romance of Revolution*

4. John F. Kennedy *because he made everybody respect youth*

ALSO IN THIS ISSUE: WHAT EVERY IVY-LEAGUE GIRL SHOULD KNOW; STEALING AS A WAY OF COLLEGE LIFE; THE INSIDE STORY OF THE BIG BEACHBOY CAPER; A FIRST LOOK AT S.P.I.D.E.R. MAGAZINE

Malcolm X, John F. Kennedy, Fidel Castro, and Bob Dylan on Esquire *cover, September 1965. Design by George Lois.*

accompanying article acknowledged that Malcolm's death had conferred upon his image and legacy an assured status in popular media alongside the likes of Bob Moses, the Vietcong, Fannie Lou Hamer, Chuck Berry, James Bond, the Incredible Hulk, and Spiderman—the latter examples revealing a blurring of the lines between actual and fictional "rebels" in American popular culture.[141] Although ranking him in death among the most recognizable faces of the mid-1960s, what was not apparent in the article accompanying the *Esquire* cover was the content of Malcolm's life. He was deemed a notable rebel, a kind of pop prophet, not for his particular racial politics but simply because, sixties style, "he told it the way it was."

Exploring the persistence of the human figure in an era of abstract expressionism, pop artists were drawn to Malcolm's complexity as a media symbol. Extending Andy Warhol's project of the decontextualization of secular, commercial iconography, Robert Rauschenberg, in his prints from the 1960s and early 1970s, juxtaposed images of the ephemeral and the iconic, the organic and the mechanical, including film stars, athletes, astronauts, presidents, and animals. Compiling images from *Life* magazine, newspapers, and television, Rauschenberg communicated a social message that included an interest in the civil rights movement. *Dante's Inferno: Drawings for Dante's 700th Birthday,* a series of collages incorporating drawings and found images, appeared in *Life's* 17 December 1965 issue. The series presented both German and American racial brutality as a hellish, inchoate vision illustrative of the inhumanity of industrial civilization. Featuring images of Adolf Eichmann and a mushroom cloud, one panel depicts Martin Luther King, Elijah Muhammad, and Malcolm X (in his vociferous, iconic pose) as prophets of potential American doom. Also included is an image of a Klansman dangling a hangman's noose.

In a 1968 screen print, French artist Bernard Rancillac portrayed Malcolm as a solitary, Warholian figure of cool inscrutability while also imputing unnaturalness or inhumanity to American conceptions of race in strictly oppositional terms. Removing Malcolm from his accustomed portrayal in black and white, Rancillac rendered a UPI photograph in synthetic yellow and purple; the original photograph, taken 16 March 1964, had recently been given a full-page reproduction (alongside a typescript of "Malcolm X's own hand-corrected copy" of a December 1963 speech)

in the stylish New York–based arts review *Evergreen,* another indication of the breadth of Malcolm's posthumous resurgence. The editorial preface to the speech argued that, "at the time, the ideas expressed were considered harshly extremist, yet time has made Malcolm X's position the position of many American black men today."[142] The image of Malcolm here is as an unheeded prophet—as a man well ahead of his time.

Bad Men and Tricksters

Malcolm's representation during this period culminated in the privileging, in African American popular cultural forms, of the style of Detroit Red, an earthy and identifiable figure more easily and lucratively reconciled with an aesthetic of rebellion than El-Hajj Malik El-Shabazz. Although hardly a wholesale depoliticization, the shift in emphasis from sacred to secular, from communal to commercial, in invocations of Malcolm aligned him with icons of an urban mythology that was both old and new.

The iconography of Malcolm X is informed by those traditions of social banditry that have been described as forms of "revolutionary traditionalism."[143] Outlaws are of course well established in America's frontier mythology. Despite some evident parallels, especially in terms of posthumous canonization, between popular notions of Malcolm X and such American heroes as Jesse James and Billy the Kid, John W. Roberts has argued for a clear distinction between white outlaw heroes and black bad men, given that "the historical relationships of blacks and whites to the American legal system have been so radically different as to affect their views of how lawlessness in expressive traditions would be conceptualized as heroic."[144] While Roberts overstates the differences in white and black outlaw traditions, the figure of Detroit Red is clearly more indebted to the latter.

Studies of African American folk heroism (and villainy) by Roberts, Lawrence W. Levine, Robin D. G. Kelley, and William L. Van Deburg have outlined an expressive tradition, traceable to slavery, of rebellion and martyrdom that included contest heroes and "a host of legendary bad men figures": "Po' Lazarus, Billy Bob Russell, Dupree, Bolin Jones, Snow James, Roscoe Bill, Shootin' Bill, Slim Jim, Eddy Jones, Brady, Bad-Lan' Stone, Bill Martin, Bad Lee Brown, Devil Winston, Dolomite, the

Great MacDaddy, Toledo Slim," and Stagolee, "the legendary prototype for many of these figures, [and] the most important and longest-lived bad man in black lore."[145] Unapologetic and brutal in comparison with "the Robin Hood figure so familiar in the folklore of other Americans and other cultures," these individualistic (and often nihilistic) figures implicitly questioned the viability of the social order. According to Levine, "their badness was described without the excuse of socially redeeming qualities."[146] Van Deburg has claimed, however, that these men were "bad for a good reason."[147]

Bad men were celebrated for their ability to inflict violence unemotionally and for their impeccable style, usually purchased with the gains of gambling or crime. Symbolic champions of, or surrogates for, their admiring constituencies—not least in presenting an image of vicarious identification with their material ostentation—bad men were visual symbols of rebellious mastery. Prodigal sons returning home with their decadent spoils—such as Jack Johnson and Joe Louis, who were lauded for "defeat[ing] white society on *its* own territory and by *its* own rules"—inspired not only folk ballads and songs of triumphant "contest heroes" in the tradition of John Henry and Shine but also the flamboyant style of urban pimps and hustlers "antagonis[tic] toward the settled order."[148] According to black studies scholar Eithne Quinn, "the pimp became a totem of the antiaccommodationist, yet aspirational, desires of lower-class black men."[149]

The figure of the pimp inspired heroic tales in its own right, not least in *The Autobiography of Malcolm X*. Kelley has argued that the *Moynihan Report*'s forwarding of a thesis of matriarchal ascendancy in African American culture contributed to a masculine overcompensation that would include the pimp mythology of the late 1960s and early 1970s.[150] While the *Report* was likely just one contributing factor, certainly heroic pimps and hustlers, like the bad men celebrated in the African American folk tradition, were a misguided if inevitable manifestation of the prevailing ethos of hypermasculinity. In spite of the evident costs of his exploitative misogyny, the pimp's "attraction as a hero stems from the fact that he is a trickster" unbound by conventional morality, in keeping with the subversive trickster figures consistently present in African American folktale traditions.[151] In the *Autobiography* the hustler Detroit Red was not framed as emblematic of any conclusive social utility; in-

stead the narrative emphasized the paradox of rebellion against institutional authority while selling hard drugs and pimping women within the African American community. The seven chapters devoted to the Detroit Red narrative are nevertheless both absorbing and dynamic. Although entered as evidence of self-cannibalism, they instead illustrate Malcolm's nascent political rebellion.

Robert Beck, better known as Iceberg Slim, further popularized this motif of false glamour and repentance during the early 1970s. Despite his dismissal by much of the literary establishment, "at the time of his death [in 1992], Iceberg Slim was the best selling African American writer of all time, having sold six million copies of his seven books."[152] Leading Black Arts figure Larry Neal endorsed Beck, dedicating a poem to him in 1966, "Brother Pimp," which sought to politicize the pimp as a symbol of urban degradation.[153] According to Lee Bernstein, the "image of the pimp—alongside other criminals and convicts—provided a hyper-masculine, sexualized image that could be used (once transformed) to serve the revolution."[154] Not all of Beck's contemporaries agreed. For her part, Sonia Sanchez critiqued the exploitative and opportunistic sexual attitudes of "revolutionary" black men in her poem "rev pimps," appearing in *Home Coming* (1969).[155]

Beck's autobiographical novel *Pimp* (1969) showed the influence of the *Autobiography*. Like Malcolm and Haley's book, *Pimp* addressed itself largely to outsiders, providing readers with privileged access of a sort. In his preface Beck promised to "take you the reader with me into the secret inner world of the pimp." This writing style is characterized by abundant slang; *Pimp* includes a five-page glossary of urban diction to initiate literary tourists. Beck also expresses "my remorse for my ghastly life," presenting the book as a cautionary tale, though one with a decidedly less thoroughgoing moral and political reformation than that given in the *Autobiography*.[156] Full of graphic descriptions of sexual organs and activity, the novel conveyed an image of masculinity violently opposed to the feminine and, especially, the homosexual. Rather than with a political or religious awakening, the book concludes with the declaration that its narrator had become "an 'Iceberg' with a warm heart."[157]

Beck's political consciousness was explored in more detail in *The Naked Soul of Iceberg Slim* (1971), a collection of essays, letters, and vignettes dedicated "to the heroic memory of Malcolm X, Jack Johnson, Melvin

X, Jonathan Jackson; to Huey P. Newton, Bobby Seale, Ericka Huggins, George Jackson, Angela Davis; and to all street niggers and strugglers in and out of the joints."[158] Like *Pimp*, the book reveled in its moralistic nostalgia for "the cold-blooded academy of ghetto streets." Beck begins by declaring that he had become "ill, insane as an inmate of a torture chamber behind America's fake façade of justice and democracy." He was "getting better all the time," however, and his recovery was largely due to the arrival, "in sex-glutted, racist America, [of] a new gutsy black man inspired by the brilliantly bold wings of Malcolm X [and who] has arisen like a black phoenix from the flames of fear and the ashes of his crushed manhood to fuck over the white man as never before." Although he identified with the image of the new black man, exemplified here by the members of the Black Panther Party, Beck did not necessarily count himself among them. He belonged still "to that older generation of physical cowards"—Uncle Toms, in the at least partly Malcolm-inspired parlance of the era—which he regarded as a decidedly inferior breed.[159] For their part, the Black Panthers only tolerated Beck's visit to their Los Angeles headquarters because of his pimping fame.

In the 1970s the cinema, rather than literature, was the most significant purveyor of the image of the outlaw rebel, including the heroic pimp. Blaxploitation films such as *Sweet Sweetback's Baadasssss Song* (1971), *Super Fly* (1972), *The Mack* (1973), and *Dolemite* (1975) presented to a mass audience a series of African American pimp heroes more glamorous than repentant. Sublimating the radical politics of the 1960s as radical style, the plots of these films, motivated primarily by "wish fulfillment," "deified the black male, vilified the white male, and objectified women of all races."[160] The films, although they portrayed "unbought, unbossed helpmeet[s] of the oppressed" and "more abrasive, haughty natural men, noble savages, lone guns, and outsiders who chose the cool gains of militancy as against the old values of upward mobility and acceptance by white liberals," were blatantly consumerist in orientation.[161]

A notable exception was *The Spook Who Sat by the Door* (1973), directed by Ivan Dixon and adapted from Sam Greenlee's 1969 novel of the same name. The film's protagonist, Dan Freeman (Lawrence Cook), abandons a job with the CIA in Washington to train the Cobras, an African American gang of which he was a member as a child, as a guerrilla unit. The gang's Chicago pool hall is decorated with several photos of

El-Hajj Malik El-Shabazz and Black Power slogans. Freeman, codenamed "Uncle Tom," leads the urban rebels in a "war of liberation." Their aim, as "Black Freedom Fighters," is to "paralyze this country" through guerrilla warfare in major cities and to demand freedom from the American government. Ultimately, the National Guard is brought in to Chicago's South Side to fight them. In rallying his troops, Freeman declares: "What we got now is a colony. But what we want is a new nation." He continues, invoking Malcolm X: "This is not about 'hate white folks.' It's about loving freedom enough to die or kill for it if necessary."[162]

Conclusion

From his death through the 1970s, Malcolm X became increasingly visible. As Playthell Benjamin would claim, "Malcolm X is bigger in death than he was in life. Like Banquo's ghost, Malcolm's omnipresence haunts those who conspired his murder."[163] He haunted equally those who merely mourned him, becoming in the process a uniquely prismatic site of memory. In death Malcolm X could not resist absorption by the broader culture; he would continue to contend with the science of imagery. In a memorial essay the conservative white poet Robert Penn Warren wrote that "Malcolm X fulfills, it would seem, all the requirements—success against odds, the role of prophet, and martyrdom—for inclusion in the American pantheon" alongside the likes of John Brown, Abraham Lincoln, John and Robert Kennedy, and Martin Luther King.[164] The following chapters consider the ongoing negotiation of Malcolm's iconic meaning.

FROM HOLLYWOOD TO HIP-HOP
(1980 TO THE PRESENT)

*Malcolm's spirit blends—it is a vague notion, an idea that can
resonate everywhere, toothlessly. Malcolm's spirit has been and will
be used and misused for as many purposes as there are people; his
spirit will mix with many a community's ethos, good and bad. We
can consequently expect many cultural battles over Malcolm's "real"
spirit, and many resurrections, too.*
Joe Wood, "Malcolm X and the New Blackness,"
Malcolm X: In Our Own Image

Malcolm has become his admirers.
Arnold Rampersad, "The Color of His Eyes:
Bruce Perry's Malcolm and Malcolm's Malcolm,"
Malcolm X: In Our Own Image

The next major phase of the iconography of Malcolm
X, informed initially by the Reaganite context of diminishing state sup-
port and latterly by a fatuously "color-blind" neoliberalism, culminated
in the release by Warner Brothers of *Malcolm X* (1992), an epic-style film
starring Denzel Washington and directed by Spike Lee. The last three
decades have been marked, further, by the consolidation of a Malcolm X
industry encompassing a variety of cultural forms including hip-hop mu-
sic—the popular genre most concerned with commodifying images of
black male rebellion. Malcolm's visual and verbal rhetoric would figure
prominently within this period of populist and nationalist revival—very
often by way of the hustler persona of Detroit Red, that figure of stylish
menace; sometimes as a symbol of ongoing racial and class struggle.[1]

The context for this continued scrutiny was a period of decline in
black protest culture and political unrest and the cultural fixation with
African American male criminality. By the 1980s "higher unemploy-

ment rates, disease, bad housing, poor public schools, and inadequate social services" in American inner cities had exposed a new landscape of racial politics forged by neoconservative policies, withdrawal of state funds, and urban impoverishment on a mass scale. Crime was one of the consequences of this systemic dysfunction: drug use proliferated, and "by 1980, 50 percent of all American homicides were black males killing other black males."[2] In the early 1990s Cornel West detected "a lethal linkage of economic decline, cultural decay, and political lethargy in American life"; he warned of "the nihilistic threat" to African American identity: "the profound sense of psychological depression, personal worthlessness, and social despair so widespread in black America."[3] Another consequence of these social conditions was an escalation of black nationalist rhetoric in America's inner cities that invited often anxious comment.

The re-evaluation and popularization of Malcolm X have not been devoid of all substance, as this chapter will show. Citing Nelson George, Eithne Quinn discusses hip-hop, in particular, in the context of a "post-soul" aesthetic revealing "profound changes in black value frameworks" since the civil rights era. Quinn sees these shifts, characteristic of the period in question, as rooted in an ethos of "free-market survivalism" in an era in which "political empowerment became increasingly displaced by economic empowerment."[4] Indeed, the X functions increasingly as an overtly monetized symbol in the consumer economy. Malcolm's legacy as a variously interpreted cultural property has been illustrative, nevertheless, of continuity, change, and contestation in conceptions of nation and self; his representation has been revealing of fluctuations in American notions of race from the presidency of Ronald Reagan to that of Barack Obama. Malcolm's continued currency, and the persistent challenges posed by the science of imagery, have been demonstrated in the exploration of his meaning in biographies and studies, comic books, numerous films and exhibitions, and, finally, hip-hop songs, videos, and album covers, many displaying the influence of his iconic photographs. In addition to considering American and British interpretations, this chapter acknowledges the increasingly international interest in Malcolm, addressing depictions from as far afield as Canada, Guyana, and São Tomé and Príncipe; it brings up to date the evaluation of Malcolm's iconography, showing the need for an intertextual and interdisciplinary framework for

the study of Malcolm X that includes, but also moves beyond, a focus on Lee's imposing film.

Biographies and Critical Studies

Dozens of books about Malcolm, or making significant reference to him, have emerged in the era in question. These books have explored and contested the image of Malcolm as a figure of complexity, rare conviction, vicarious attraction, marketability, and nostalgia. He appears frequently in this period in the guise of a chastening moral authority, often utilized by an elder generation of critics interested in confronting the perceived nihilism, self-interest, or uncritical consumerism of a succession of irreverent youth cultures. Malcolm has often been deployed in this regard as a potentially unifying figure, capable of bridging a widening generation gap with his incisive social commentary, charismatic style, and street smarts. He is framed also, as he was in the 1960s and 1970s, as a tragically murdered patriarch or ancestor figure.

An abundance of biographical material has been produced, although, according to Manning Marable, "remarkably few books about Malcolm X . . . employed the traditional tools of historical investigation," such as archival research.[5] Indeed, many biographers have been too reverential of the *Autobiography* and speeches, perhaps because of their status as "the synoptic gospel of the Black Revolution" and "its Pauline epistles," respectively.[6] Books, both popular and scholarly—by the likes of Goldman and Evanzz—have been concerned primarily with the fragmentary details of Malcolm's assassination, piecing together an image of a knowing and increasingly paranoid Malcolm harried in his last days by the FBI's COINTELPRO surveillance and by those who wanted him dead. Other biographies have been eclectic or specialized. Carroll and Graf, a now-defunct press interested in American history and political scandal, published *Malcolm X: As They Knew Him* (1992) and *A Malcolm X Reader* (1994), both edited by David Gallen. The books offered access to Malcolm via transcripts of interviews and tributes from former associates, including Alex Haley. Rosemari Mealy's *Fidel and Malcolm X* (1993) demonstrated an interest in reanimating Carl Nesfield's photograph of the two men in Harlem's Hotel Theresa, thereby recalibrating the sense of Mal-

colm's contribution to the revolutionary politics of his lifetime. Other biographers were less reverent, pursuing a crude if inevitable iconoclasm.

Bruce Perry's biography *Malcolm: The Life of a Man Who Changed Black America* (1991) controversially alleged that, as Detroit Red, Malcolm worked intermittently as a prostitute and that shortly before his death he firebombed his own home as a publicity stunt. Although Perry claimed that his book "reveal[ed] the real Malcolm—the one nobody knew, perhaps not even Malcolm himself," his pseudo-Freudian framing of Malcolm's adult crises in the context of his childhood demons is simplistic.[7] In places, Perry rather indiscriminately employed the *Autobiography* as evidence while ignoring the four hundred interviews conducted between 1971 and 1990 with Malcolm's family members, friends, acquaintances, and colleagues. The book, described by Baraka as a "calumny" and "a barrage of psychopathic untruths," was nevertheless treated unfairly by some critics invested in a heteronormative image of Malcolm.[8] According to Arnold Rampersad, "homophobia undoubtedly lies behind much of the general supposition that Malcolm could not possibly have had homosexual experiences, the idea being that such experiences are at odds with his fierce teaching about manly race pride."[9] John Edgar Wideman, however, has argued that it was the irreverent Perry himself whose perspective depended upon "discredited assumptions about race, class, and gender."[10]

Due in large part to such persistent and proprietary investments in Malcolm's mythic status, it was not until 2011 that historian Manning Marable produced what has been hailed as the first comprehensive scholarly biography of Malcolm X, appraising and synthesizing the revelations of many earlier, occasionally indiscriminate, accounts of his life and death. That Marable's *Malcolm X: A Life of Reinvention* (2011) at last emerged, under the robust imprint of Viking Press, during the presidency of Barack Obama—who himself has cited or alluded to Malcolm X in several instances prior to and following his election—is significant. While not indicative of the arrival of an age of postracialism or of perfect understanding of this still-conflictual figure, the book's appearance, like Obama's cautious measuring of Malcolm's legacy, arguably marks an epochal distinction in the iconography of Malcolm X: only now has his association with racial volatility been sufficiently defused that Malcolm

may be openly, if conditionally, assimilated by those invested in mainstream values and institutions.

Like other books about Malcolm X, it purports to set the historical record straight, not least in honoring Malcolm's black nationalism as it was forged in his Nation of Islam phase; Marable rightly critiqued the *Autobiography* as having created an artificial distance between El-Shabazz and the Nation-era Malcolm X. The biography is susceptible to some familiar pitfalls. Marable, who synthesized the revelations of Goldman, Carson, Evanzz, DeCaro, and even Perry, among others, secured headlines by supplying a detailed hypothesis of Malcolm's assassination, including the identities of his supposed assassins. Marable acknowledged, however, that in doing so his book relied on "forensic probabilities, not certainties."[11] Despite its impressive scope and research, the book finally fails, like other biographies of Malcolm X, to match the charisma and immediacy of the flawed but enduring text it ultimately seeks to confront: *The Autobiography of Malcolm X*.

Malcolm's biographies have been both influential and disappointing in their contributions to the iconography. While *Malcolm X: A Life of Reinvention* addresses a number of Malcolm's television appearances, Marable says little about the distinctive photography. The book nevertheless contains a series of illustrations revealing in their emphases. Present are the 1944 mug shots and three images of Malcolm speaking into microphones; of the twenty-one photographs included in the first edition, six relate to Malcolm's death—the crucial event in his iconic translation—and its aftermath. Bob Adelman's portrait of Malcolm in his casket next to what appears to be an iconic image of the Madonna and child is a further illustration of the Christian content of the iconography of Malcolm X. Indeed, Malcolm's corpse was displayed for public viewing not in a mosque or neutral site but in West Harlem's Faith Temple Church of God in Christ.

Other books have been framed as visual biographies, helpfully reproducing many of Malcolm's iconic photographs, though in the absence of detailed analysis. *Malcolm X: The Great Photographs* (1993) features Eve Arnold's portrait of Malcolm in profile on its cover and provides a good representation of the work of Gordon Parks and Robert L. Haggins. *Malcolm X: Make It Plain* (1994) visually conveys Malcolm's life and cultural afterlife with a variety of images from the 1960s to the 1990s. The biog-

raphy of Malcolm X also appeared in simplified form in books for children within a few years of his death. Works such as James S. Haskins's *The Picture Life of Malcolm X* (1975) established a pattern of populist pedagogical appropriation of the iconography of Malcolm X, reproducing famous photographs by Robert L. Haggins and UPI, along with many others uncredited. Describing Malcolm as "a very famous black leader in America" and "the first Black Power leader," Haskins invited his readers to identify with Malcolm by including details of his family life and framing his resistance to authority in the relatable terms of schoolroom mischief: "he put a thumbtack on his teacher's chair."[12] Like many more recent children's narratives, the book presented Malcolm in conciliatory terms more typically associated with Martin Luther King: "One day he was killed by men who did not believe in his dream. But those who killed Malcolm X did not kill his memory. Many black and white people keep his memory alive. They share his dream that one day blacks and whites in America can live together as brothers."[13] The account unapologetically overlooks Malcolm's anticolonial Pan-Africanism to put forth an argument in favor of American equality.

Alkalimat's *Malcolm X for Beginners* (1990), addressed to budding African American activists, included brief sections on black history (including "The Glorious 1960s"), summaries of Malcolm's major personae, and passages from several speech collections and the *Autobiography,* which is described as "required reading" and "the most important book published in the 1960s."[14] Alkalimat regarded the *Autobiography* as both hallowed and pure; he claimed that "Malcolm X dictated this book to Alex Haley" who supplied only "editorial support."[15] The book's images of Malcolm are contextualized with images of African tribal warriors and big cats, slavery, and lynching. Pathfinder Press, apparently acting on behalf of Betty Shabazz but also evidently protecting its own Trotskyist stake in Malcolm, sued the African American–owned Writers and Readers Publishing in 1991 for including copyrighted material, forcing the book's withdrawal.

While no book before this one has analyzed Malcolm's visual representation in adequate detail, *Malcolm X: In Our Own Image* (1992), edited by Joe Wood, initiated the critical discussion of Malcolm's reification and iconicity. The book privileged African American commentary on Malcolm and was largely characterized by a tone "of myth and mourning."[16]

Michael Eric Dyson's *Making Malcolm* (1995) explored the cultural resonance of Malcolm's texts and images, and their usefulness as pedagogic tools, in the wake of Spike Lee's *Malcolm X*. Addressing literature, film, and hip-hop music, the book warned against a cultural tendency toward uncritical hero worship, arguing of Malcolm that "his complexity is our gift."[17] Robert E. Terrill's *Malcolm X: Inventing Radical Judgment* (2004) highlights Malcolm's understanding of the science of imagery but in the end demonstrates his skill with verbal rather than visual rhetoric. (The book also illustrated the need for further scholarly scrutiny, and accurate transcripts, of Malcolm's speeches.) Terrill recently edited *The Cambridge Companion to Malcolm X* (2010), which, while visually impoverished, contains a series of insightful essays on Malcolm's cultural afterlife in such subcultures as Hollywood and youth culture—conversations that this study extends and continues.

Comic Books

The story and image of Malcolm X have suited the distinctly American form of the comic book, concerned as it is with archetypal villains and "heroes engaged in a never-ending battle for Truth, Justice, and the American Way."[18] In his X-Men series, inaugurated by Marvel Comics in September 1963, Stan Lee cast in convoluted allegory "a race of mutants who are divided into two groups—the 'integrationists' led by Professor Xavier and the 'separatists' led by the charismatic hero Magneto."[19] Malcolm is diffusely present in both the X of the title and Magneto's decontextualized use of the phrase "by any means necessary."

More commonly, comic book artists have positioned Malcolm as a populist icon and freedom fighter. Michael Avon Oeming's *Malcolm X: An Unauthorized Biography* (1992) reframed several iconic images in drawings of plain black and white, including renderings of Haggins's last photograph of Malcolm, Malcolm with his two eldest daughters, Malcolm riding a camel in Egypt, and one of the few photographs of Detroit Red. Only the cover approached a conventional comic-book style, portraying Malcolm in several poses before a logo-esque X and a badgelike star and crescent. *By Any Means Necessary: The Life and Times of Malcolm X, An Unauthorized Biography* (1992), a comic book coinciding, like Oeming's, with the release of Spike Lee's film, adapted the *Autobiography*, show-

ing Malcolm's transformation from villain (Detroit Red) to heroic martyr (El-Hajj Malik El-Shabazz). The book's artist and cowriter Don Hillsman presented Malcolm as muscular and stylish, possessing a direct, commanding gaze. Hillsman's triadic portrait of Malcolm at his grimmest and most iconic before a subverted American flag immediately follows the lurid image of the assassination that concludes the narrative, implicating the reader with its blazing gun barrels and first-person point of view.

The most extensive of these comic-book versions of Malcolm's life and death has been Helfer and DuBurke's *Malcolm X: A Graphic Biography* (2006). Opening with an adaptation of the rifle pose and closing with Malcolm's assassination, the book attempts a balanced interpretation of his murder, quoting Elijah Muhammad ("Malcolm died according to his preaching. He seems to have taken weapons as his God") and Ossie Davis's eulogy ("He was and is—a prince—our own black shining prince!— who didn't hesitate to die, because he loved us so") and refusing to adopt the emerging orthodoxy of an FBI plot.[20] Helfer and DuBurke incorporated an awareness of Malcolm's representation in visual and narrative terms, depicting the telecast of *The Hate That Hate Produced* and the publication of magazine articles by Gordon Parks and Alex Haley, as well as that of the *Autobiography*. The closing pages acknowledge a few of the photographic sources for the biography, including the Detroit Red mug shot and the postassassination stretcher image.

Memoirs

Memoirists of the period were more emphatic than those of the late 1960s and the 1970s in demonstrating and idealizing their personal relationships with Malcolm X. Malcolm figured increasingly in these accounts as a symbol of departed integrity, whether in human or political terms. In reflecting on their past associations with Malcolm, Benjamin Karim, Maya Angelou, Gordon Parks, Yuri Kochiyama, Tariq Ali, Jan Carew, Malcolm "Shorty" Jarvis, and Ilyasah Shabazz expressed their grief (or disbelief) at his death and contended with the fragility and instability of memory.

Remembering Malcolm (1992) is the memoir of Malcolm's former assistant minister, Benjamin Karim. Contracted by Carroll and Graf's David

Gallen, one of the more prolific editors of biographical material on Malcolm X, and coauthored by Gallen and Peter Skutches based on a series of interviews with Karim, the book provided the testimony of a man twice converted by Malcolm. Converted to the Nation of Islam in 1957, Karim would follow Malcolm out of the organization in 1964; it was Karim who introduced his mentor at the rally at which he was killed. Alternating between first- and third-person recollections, the book confirms the *Autobiography*'s sense of Malcolm's fatalism. "Time hounded Malcolm's consciousness," Karim claimed, and Malcolm "knew that he was not going to die an old man." *Remembering Malcolm* also recalled the inescapable mediation of his death, which "made news for days in the press, on the radio, on television." In this reckoning, death was an absorption into a state of pure representation that threatened and polluted Karim's memory of the man he knew not as Malcolm or Malcolm X but as "Brother Minister or Brother Minister Malcolm," or just "the Minister."[21] Karim and Malcolm were pictured below a stark edifice on the book's cover in a photograph, a black-and-white shot by Haggins, hand-tinted to achieve an illusion of proximity to a bygone age.

Other memoirists presented stories of Malcolm in terms suggestive of a preoccupation with his visual representation. Angelou's *All God's Children Need Traveling Shoes* (1986), the fifth of her six autobiographies, reflected on Malcolm's Ghanaian visit in May 1964. The book, dedicated to Malcolm and Julian Mayfield (described as the "leader" of a group of African American émigrés in Ghana that included Angelou, Alice Windom, and Shirley Graham Du Bois), portrayed Malcolm as a quasi-divine orator met in Accra with "a trembling silence" of anticipation: "The golden man laughed, and lamplight entangled itself in his sandy beard." A witness to the unintentional meeting of Malcolm and Muhammad Ali in Accra just prior to Malcolm's departure for New York, Angelou recalled the event as momentous and melancholy, and already mediated: "The moment froze, as if caught on a daguerreotype, and the next minutes moved as a slow montage."[22] Angelou had Malcolm approaching Ali first with a gesture of Christlike forgiveness:

> "Brother, I still love you, and you are still the greatest." Malcolm smiled a sad little smile. Muhammad looked hard at Malcolm, and shook his head.

"You left the Honorable Elijah Muhammad. That was the wrong thing to do, Brother Malcolm." His face and voice were also sad. Malcolm had been his supporter and hero. Disappointment and hurt lay on Muhammad's face like dust. Abruptly, he turned and walked away.[23]

The scene, framed as a tragedy of broken fellowship between two of the twentieth century's most prominent and charismatic African Americans, implicitly endorsed Malcolm's late politics of black unification. Angelou would claim that, even during his lifetime, Malcolm had been taken by African Americans, "like a forbidden god, into their most secret hearts" with his courageous rhetoric of rebellion.[24]

Gordon Parks, in *Voices in the Mirror* (1990), sought to contrast an image of a more private, human Malcolm with his militant public persona. The figure that emerges from his account is one of undoubted sincerity, if also of careening obsession. Parks would provide a rare glimpse of Malcolm in a moment of vulnerability—sleeping on a flight out of Chicago following a rally: "Tired from his day of work, Malcolm slept most of the way to New York with his chin resting on his hand, mumbling incoherently now and then—and with anger on his face. He seemed to be a prisoner of his own strength, declaring war on the enemy even as he slept."[25] The passage speaks to the tendency of photographs to become conflated with memories. As Trachtenberg has argued, "more than we may want to admit," photographs "fashion and guide our most basic sense of reality."[26] Parks seems to have described a picture he took in 1963 capturing Malcolm without his identifying glasses.

Observing him the next day, "away momentarily from the wilderness of confrontation, and in the sanctity of his home," Parks saw Malcolm as unperturbed and "a far different man": "Munching an apple, he moved lazily about their small house, smiling easily, looking to be a young man whose heart was all future. His family was happy to have him home."[27] This domesticated version of Malcolm was swiftly consumed by the arrival on television of the fervent orator. Parks wrote:

Suddenly his own voice was booming from the television set, and all of us turned to watch as he fired up the crowd back in Chicago the day before. . . . As he watched himself the scowl had returned to his face for a few seconds, and I had wondered if he was unhappy with his performance, but I was careful to keep my silence. Even on this

peaceful evening with his family his thoughts were still in the world of confrontation.[28]

In Parks's view, the public mask seemed fused to Malcolm's face.

Memoirs of the period also reconsidered Malcolm's international cultural resonance. Japanese American activist Yuri Kochiyama wrote of Malcolm in her 2004 memoir, *Passing It On,* describing him as "a Revolutionary Internationalist" well versed in Asian history and politics. Kochiyama, present at Malcolm's assassination, recalled "cradling his head in my hands" on the ballroom stage—an image evocative of Earl Grant's photograph taken moments after the shooting. Her account is accompanied by her OAAU membership card, a postcard Malcolm sent to her family from Cairo, photographs taken of Malcolm during a 1964 visit to the Kochiyamas' Harlem home, and a family newsletter, compiled by the Kochiyama children, declaring Malcolm's visit "the most exciting thing that happened to us this year."[29]

Narratives of Malcolm's British visits have featured prominently in books by Tariq Ali and Jan Carew, who had come to Britain in the 1960s from Pakistan and Guyana, respectively. In *Street Fighting Years: An Autobiography of the Sixties* (1987), Ali presented Malcolm as an emergent revolutionary who confirmed and very briefly fostered his own radicalism. Carew's *Ghosts in Our Blood: With Malcolm X in Africa, England, and the Caribbean* (1994), the only book-length discussion of Malcolm's British visits and a kind of love letter, sought to reposition the discussion of Malcolm's life in an African diasporic, but especially a Caribbean, context by addressing the Grenadian roots and Garveyite activism of Malcolm's mother, Louise Little.[30] The book, like most biographies, focused on Malcolm's final fourteen months. The cover announced Carew's Pan-Africanist intent, picturing Malcolm wearing a dashiki in Ghana.

A pattern emerges in these accounts of exposure to the media-constructed image of Malcolm's villainy; the triumphant revelation of his sincerity by way of his oratory; the confirmation of his humanity and the prophecy of his death in a private audience with the author; and the invocation of the image of his death by the author. Ali recalled the influential media depictions of "Black Muslims . . . as a sinister outfit"; Carew anticipated Malcolm in particular as "a Black messianic nemesis figure."[31] The realization that Malcolm was no demon but, rather, "a smiling, su-

premely confident humanitarian" demonstrating "a total lack of dema-
gogy" seems to have emerged as much from the discovery of his personal
magnetism and vulnerability as from his rhetoric.[32] Carew claimed ac-
cess to a side of Malcolm that eluded the photographers. Watching him
getting dressed before giving a speech at the London School of Econom-
ics, he was "struck" that "no one had ever captured what he really looked
like." Carew portrayed Malcolm as deeply lonely and sensitive, with an
"aristocracy of the spirit"; "he reminded me of a greenheart tree in the
rainforest." Carew went on to imagine Malcolm's "secret nights of cry-
ing."[33] Ali was more prosaic in describing his enchantment: "I found
it very hard to sleep that night. The images and sounds of Malcolm X
refused to vacate my head."[34] In their efforts to penetrate Malcolm's pub-
lic image, these writers unavoidably imbued in their accounts a tragic
knowingness derived as much from Malcolm's death as his life. That
knowledge of Malcolm's subsequent death is inseparable from recollec-
tion in these memoirs renders them alternate histories, acts of mourning
as much as reportage.

Malcolm Jarvis and Ilyasah Shabazz claimed a familial privilege in their
reflections on Malcolm X. *The Other Malcolm—"Shorty" Jarvis* (2001) was
ghostwritten for Jarvis, who inspired the character Shorty in the *Autobi-
ography*. A product of an increasing scholarly appetite for appraisal of the
Autobiography, *The Other Malcolm* intended to "set the record straight"
relative to both Malcolms; Jarvis felt that Malcolm and Haley's book and
Spike Lee's film had both "portrayed him as an otiose 'buffoon'" and
reduced Malcolm X to an inhuman icon.[35] The first chapter itemized the
inaccuracies of the *Autobiography*, stating,

> I play trumpet, not saxophone; I was never ten years older than Mal-
> colm X; neither my mother nor any other part of my family lived in
> any part of Michigan at that time—or ever; playing pool was the only
> work I did in a pool hall; I was not into drugs—although I was a street
> tough, I was both a classy and a classic type of guy. . . . I never conked
> Malcolm X's hair (He always had his hair done at Fogey's Barber
> Shop). . . . I never dated any of the white girls in our "gang." . . . The
> list goes on.[36]

Demonstrating the belief, however unrealistic, that memoir should re-
flect historical truth rather than a blend of unreliable memory and fiction,

the book attributes blame for the *Autobiography*'s misrepresentations to Haley rather than Malcolm, and it makes no acknowledgment that the Shorty figure, like so many others in the book, was possibly a composite of more than one person associated with Detroit Red.

The book asserts Jarvis's claim to an even closer connection to Malcolm than that communicated by the *Autobiography*. Setting himself up as the supreme authority on all things Malcolm, Jarvis questioned his friend's willingness to disclose accurate details of his private life to Haley, criticized the motives of many of Malcolm's critics and commentators, and argued that he was better qualified than Betty Shabazz to have been hired as a consultant on Spike Lee's film. In addition to giving Jarvis credit for introducing Malcolm to Islam in Boston, the book describes a kind of "telepathic connection" between the two Malcolms, forged by what Jarvis calls "the mind transgression," which "gave birth to a mental compatibility between Malcolm and me. This harmonious mental relationship is what enabled me to see the death vision surrounding him the week before his death."[37] According to the bizarre account, a vision of Malcolm X's death came to Jarvis at his breakfast table on 14 February 1965. It was the third such vision that Jarvis had experienced in his life; apparently, the visions reliably foretold the imminent death of a loved one.

In *Growing Up X* (2003), Ilyasah Shabazz, the third daughter of Malcolm X and Betty Shabazz, followed her father into the genre of collaborative autobiography. Claiming that "it is not my intention to rehash my father's life," the book does retell his death in familiar terms. Although Shabazz admits that she cannot remember her father's death, which occurred when she was just two years old, she describes Malcolm, as he arguably appears in his late photographs, as "exhausted-looking" but "not about to run" from his certain fate—a fate finally evoked by "the thunderous shots, the terrified screams, the chaos and crashing of chairs." Shabazz echoes other memoirists in communicating a sense of haunting by a photographic image of her father. The book recalls her compulsive interest in the picture of Malcolm being carried on a stretcher after his shooting, an image that was "deeply disturbing and painful to me": "some part of me had to see it, to see his eyes, his mouth, his teeth, his chest, his arms, everything."[38] The photograph enabled the resurrection, however ephemeral, that Shabazz's memory could not afford.

Shabazz's childhood home in Mount Vernon was a kind of shrine to her departed father, containing an oil painting of Malcolm in four iconic poses, photographs in "nearly every room, his briefcase and suits in my mother's closet, his hat way up high on a shelf in the breakfast nook, [and] books about him in the library, especially the *Autobiography*," which is described as having been "a special presence in our house." Shabazz's book itself bears some trace of Malcolm's presence, frequently referring to him as "Daddy" and indicating that he called his wife in moments of tenderness "his Apple Brown Betty and Brown Sugar."[39]

Novels

No doubt someone will make a novel of Malcolm's life.
Alfred Kazin, *Bright Book of Life*

Fictional iterations reveal the absorption of Malcolm X into a broader cultural mythology, employing him as a figure providing vicarious access to an often idealized revolutionary age.

Pulp novelists retained a direct interest in Malcolm. Kent Smith's *Future X* (1990), a science fiction novel published by Holloway House (the publishers of Iceberg Slim) conjured an America in the year 2073 even more rigidly divided along racial lines. Following the election of the White Supremacist Party's John Welles Bryant III as president, and the Partition Act of 2067, the African American radical Ashford Henderson, a great-great-grandson of Malcolm X, travels back in time to 1964 with the aim of rescuing his ancestor from his assassins—another example of the desire to reanimate this iconic figure. Henderson obtains a number of banned books about Malcolm, including a first edition of the *Autobiography* described as "his Bible, his own genesis."[40] While unable to prevent the assassination of the man known as "the Great Martyr, the Great Preacher, the Great Orator," Henderson, a classically trained actor, comes to impersonate him instead, using the *Autobiography* as his script and encountering the likes of Alex Haley along the way.[41] Smith suggests with the novel that, while resurrection may be impossible, the iconic Malcolm can still be usefully internalized. The book's cover featured a poor likeness of Malcolm emerging from a landscape of the cosmic future—one of the more absurd entries in the iconography.

The X Press invoked Malcolm's symbolic X in branding itself as a dedicated black publishing house in London in the early 1990s. Early publications, including Jamaican-born Victor Headley's *Yardie* trilogy (*Yardie* [1992], *Excess* [1993], and *Yush* [1994]), reflected an ethos that was closer to that of Detroit Red than Malcolm X, expressing an interest in fashionable criminality in their content—"such topics as illegal radio stations, drug-trafficking, dancehall culture, ructions between the police and local communities"—and packaging: "The books sported striking covers—close-ups of gun barrels, gold-ringed fists being punched together in criminal solidarity—were promoted through flyers, and sold on tables outside nightclubs." According to cofounder Dotun Adebayo, the X Press cultivated an audience of working-class black readers who "don't read Ben Okri" but "will read stuff that seems to connect with their lives."[42] In 1995 the press published Peter Kalu's futuristic detective novel *Professor X*; the novel details black Detective Chief Inspector Ambrose Patterson's investigation of a plot to kill Professor Xango Al Hajj X, a controversial African American leader resembling Malcolm X, during his first visit to Britain in 2014.

Although hardly worshipful of Malcolm X, Paul Beatty's satirical novel *The White Boy Shuffle* (1996) acknowledges and explores Malcolm's absorption in contemporary African American culture. In the book's opening, Beatty implicitly ridicules the *Autobiography*'s mystification of Malcolm's birth with his narrator's disclaimer: "I am not the seventh son of a seventh son of a seventh son. I wish I were, but fate shorted me by six brothers and three uncles." The family tree of narrator and protagonist Gunnar Kaufman, a middle-class African American teenager whose family relocates to a Los Angeles ghetto, is a catalog of servility including a relative—an Uncle Tom's Uncle Tom—who betrayed Malcolm: "It was Cousin Ludwig who on February 21, 1965, stood up in the middle of the Audubon Ballroom moments before Malcolm X was to give his last speech and shouted, 'Hey man! Get your hands out of my pocket.'" Self-consciously aligning himself with stereotypical aspects of urban African American culture, including basketball and gangbanging, Kaufman sees a further opportunity to overcome his racially treasonous ancestry during the Los Angeles riots of 1992; he remakes himself in the image of a cultural nationalist, "a poet and a soon-to-be revolutionary." Kaufman's radicalization leads him to a kind of oratorical posture

inspired by the rhetoric and martyrdom of Malcolm X. Giving a speech at Boston University (to which his high school basketball stardom won him a scholarship), Kaufman denounces "today's black leadership" as an ineffectual assembly of "telegenic niggers not willing to die." He tells his audience: "What we need is some new leaders. Leaders who won't apostatize like cowards. Some niggers who are ready to die!" Kaufman is swiftly anointed by the ravening crowd: "'You! You! You!' they chanted, pointing their fingers in the air, proclaiming me king of the blacks."[43] Beatty's novel diagnoses and critiques a messianic cultural yearning; the messiah in The White Boy Shuffle is Malcolm X, and Gunnar Kaufman is his surrogate.

Malcolm also features in a range of historical novels revisiting him in his own cultural context, though with an anachronistic retrospection informed by his iconic martyrdom. Ted Pelton's Malcolm and Jack (and Other Famous American Criminals) (2006) follows Cone (Martin Luther King) and Mealy (Fidel Castro) in linking Malcolm to other icons of his era, though in this case the encounter evoked is merely a wishful fiction. The Jack of the novel's title is Jack Kerouac, presented as a young apostle of jazz whose appetites for marijuana and African American prostitutes bring him into the Harlem orbit of hustler Detroit Red. Insisting on the parallels in the two young men's cultural experience—"Malcolm and Jack both listen to, dance to, feel jazz"; like Kerouac, "Red was down, Red was BEAT–"; they cross paths again in Michigan, Malcolm's home state, during Kerouac's travels; neither undertook military service; both are destined for greatness—Pelton romanticizes what he calls "a surly, growing underground" extending from the 1940s to the 1960s.[44] In this, the novel echoes Esquire's September 1965 "Back to College Issue" in spuriously linking Malcolm with other iconic figures. Malcolm and Jack's partial bridging of white and black countercultures in America fantasizes a stylish and creative rebellion that the novel nevertheless confines to a receding history.

In Higher Ground (1989), black British novelist Caryl Phillips more effectively proposes an imaginative and political bridge, deploying Malcolm as a representative, diasporic figure who came to understand blackness as a condition of radical statelessness. The novel features three narratives: the first from the perspective of a West African in the slave-trading era; the second in the voice of an African American inmate in 1967–

1968; and the third in that of a Polish refugee in contemporary London. Rudi Williams, the narrator of the epistolary narrative "The Cargo Rap," was largely inspired by George Jackson, the Black Panther and author of *Soledad Brother*. Williams displays his prison education in the history of slavery and the black literary tradition, discussing with his family members and lawyer such figures as Crispus Attucks, Toussaint L'Ouverture, Phyllis Wheatley, Paul Laurence Dunbar, Joe Louis, Richard Wright, Frantz Fanon, and Muhammad Ali, and requesting from his correspondents such autobiographical works as Du Bois's *The Souls of Black Folk* (1903), McKay's *A Long Way from Home* (1937), and *The Autobiography of Malcolm X*. Williams's cultural allegiances are with those figures, like Malcolm, reconcilable with a militant image of blackness; he is contemptuous of the "eye-rolling" and "Uncle Thomas face" antics of jazz artist Louis Armstrong. Although his narrative encompasses the assassination of Martin Luther King, Williams asks his sister Laverne to name her baby "Malcolm Rudolf" if a boy. Rejecting identification with an imposed, coercive Americanness, Williams argues that "Malcolm was correct when he suggested that we did not land on Plymouth Rock, it landed on us."[45] Phillips here echoes an example of Malcolm's characteristic signifying quoted in the *Autobiography;* the line would also be repeated in Spike Lee's *Malcolm X.*[46]

Spike Lee's Films

No medium has been more revealing of the extent of the diffusion of the iconography of Malcolm X than film, the most influential example of which has been Spike Lee's *Malcolm X.* Lee's early independent features also represent a triumph of the African American cultural politics of the period, pairing black entrepreneurship and artistic endeavor, and uniting nationalist rhetoric and an escalating interest in the significance of Malcolm X with critical and popular appeal. Indeed, Lee's preference for hiring African American crew members earned him a reputation in the industry as "a baby Malcolm X."[47]

Lee's first feature, *She's Gotta Have It* (1986), established the rudiments of his style, with its interest in racial and sexual politics, its New York setting, its jazz score, and its characters who directly address the

audience. In presenting Nola Darling (Tracy Camilla Johns) as a collage artist, Lee also invoked a theme first explored in his 1980 short film, *The Answer* (concerned with the cultural resonance of Griffith's *The Birth of a Nation*): the effects of the manipulation of images of African Americans. Although only partially glimpsed on screen, the collage displayed on the wall of Nola's Brooklyn apartment includes a depiction of Malcolm X; presenting her artwork to Mars Blackmon (Spike Lee), Nola impresses upon him the importance of 19 May as Malcolm's—and her own—birthday. The association of Malcolm with Nola, a woman defined by an ethos of sexual independence, offers a movement away from the predominantly patriarchal, narrow concerns of 1960s African American cultural nationalism and toward a more inclusive sense of Malcolm's legacy. Yet *She's Gotta Have It* resorts to voyeurism and misogyny when Jamie Overstreet (Tommy Redmond Hicks) rapes Nola.

In Lee's *Do the Right Thing* (1989), the disabled itinerant Smiley (Roger Smith) attempts to circulate copies of the 26 March 1964 photograph of Malcolm X and Martin Luther King throughout the film's predominantly African American Brooklyn neighborhood. Continually rebuffed by the likes of Mookie (Spike Lee), who more profitably delivers pizza for popular, white-owned Sal's Famous Pizzeria, Smiley insists on the historical and social importance of the image, culminating in his hanging a copy on Sal's "wall of fame," consisting of pictures of Italian American celebrities, during a dispute over the racial character of the restaurant. The conflict results in the strangling of Radio Raheem (Bill Nunn) by white policemen and the burning of the pizzeria by incensed locals. As Sal's wall of fame suggests the blindness of white America to black achievement, Smiley's impaired speech seems meant to suggest the inability of the 1980s generation to articulate its social concerns as Malcolm and King had done. (Smiley privately listens to Malcolm's speeches on his Walkman.) Da Mayor, an elderly character played by Malcolm's eulogist Ossie Davis, is largely neutralized by alcohol dependency and is interpreted as a failure by many of his youthful observers, for whom shoes and basketball jerseys vie with—and threaten to overwhelm—the tradition of African American political engagement. Ultimately, it is Radio Raheem's boom box, repeatedly playing Public Enemy's "Fight the Power," that channels youthful style and substance for Lee. This sense of the animating quality

of the black musical tradition is also evident in the omnipresent voice of radio DJ Mister Señor Love Daddy (Samuel L. Jackson), which serves as a kind of Greek chorus in the film.

Do the Right Thing closes with quotations from King and then Malcolm, juxtaposing their views on the political viability of violence or self-defense. Unlike James H. Cone, whose *Martin and Malcolm and America* concluded that the two men are best regarded in dialectic or provisional equivalency, Lee gave Malcolm the last word, shifting from King's condemnation of indiscriminate violence to Malcolm's language of intelligently exercised self-defense. Lee wrote elsewhere of his sympathy with Malcolm: "Am I advocating violence? No, but goddamn, the days of twenty-five million Blacks being silent while our fellow brothers and sisters are exploited, oppressed, and murdered, have come to an end. . . . Yep, we have a choice, Malcolm or King. I know who I'm down with."[48] Although criticism of the film's ending, by such as Adolph Reed, Jr., as mere glib political and emotional posturing is ungenerous to the genuine moral dilemma posed by the film's violent conclusion, a strain of nostalgia and political anachronism is apparent.[49] The film is an exercise in the politics of racialized symbols—an exercise that served to prepare Lee for his work on *Malcolm X*.

The most controversial portrayal of Malcolm has been that of Denzel Washington in the title role of Lee's *Malcolm X*. Apart from the *Autobiography*, the film's major source, it has been the most influential text to date in shaping perceptions of Malcolm. Having owned the rights to the project since the 1960s, Warner Brothers finally released *Malcolm X* on 18 November 1992, a generation after Malcolm's death and in the wake of Nelson Mandela's release from prison and the Los Angeles riots. The film met with much criticism, particularly from an elder generation of black commentators, not least for a promotional campaign perceived by many to have married a rhetoric of black nationalism to unabashed capitalist practice, with the ubiquitous X functioning as a kind of dollar sign on posters, T-shirts, key chains, and baseball caps.

Lee's campaigning around the film in fact preceded his attachment to the project as director. Following the success of *Do the Right Thing*, he expressly sought to wrest the Denzel Washington vehicle from director Norman Jewison, who was developing a script by the novelist David Bradley. Arguing that "this was the picture I was born to make—this was

Malcolm X (Denzel Washington) steels himself for a final appearance in the Audubon Ballroom.
Malcolm X, *directed by Spike Lee (Warner Brothers, 1992).*

the reason I had become a filmmaker," Lee convinced producer Marvin Worth that the film "had to be done by an African-American director, and not just any African-American director, either, but one to whom the life of Malcolm spoke very directly. And Malcolm has always been my man."[50] Although his Malcolm X credentials extended only as far as having "read *The Autobiography of Malcolm X,* back in '69–'70, when I was at P.S. 294, Rothschild Junior High in Fort Greene," Lee's background in independent black filmmaking, rather than in the resurgent Blaxploitation-style films of the period, coupled with his command of youth culture, appealed to Warner Brothers. Lee has described the inception of his marketing strategy for *Malcolm X:* "While we were shooting *Jungle Fever* in late 1990, I made up an initial design for the 'X' cap. I'd already decided I had to do *Malcolm X,* and marketing is an integral part of my filmmaking. So the X was planned all the way out."[51] Acknowledging that he "didn't want hundreds of people to see my films. I want millions of people to see my films," Lee enlisted the help of one of the era's biggest stars, asking basketball player Michael Jordan to wear one of his baseball caps.[52] In the late 1980s and 1990s, Lee directed a series of basketball-themed commercials for Nike's Air Jordan shoes in which he starred alongside Michael Jordan, reprising his *She's Gotta Have It* character, Mars Blackmon. The humorous advertising campaign recalled

the 1964 photographs pairing a playful Muhammad Ali with Malcolm X. Like the Air Jordans that the character Buggin' Out (Giancarlo Esposito) had fetishized in *Do the Right Thing,* the X caps proved a popular trend— even, to the horror of Malcolm's black nationalist champions, with some white consumers.

Lee also made much of a kind of celebrity black nationalist fund-raising that supplied the final $5 million needed to finish *Malcolm X,* claiming a degree of African American ownership of the Warner Brothers film.[53] For Lee, the making of the film was both an artistic pilgrimage that allowed him to follow in Malcolm's footsteps by filming on location in Harlem, Cairo, and Mecca, and an exercise in Malcolm-inspired black entrepreneurship. He later wrote: "The BLACK MAN has to learn to stand on his own two feet. DO FOR SELF. I took a page out of the MALCOLM MANUAL. I know BLACK FOLKS with money. I would appeal directly to their BLACKNESS, to their sense of knowing how important this film is. How important MALCOLM X is to us. How important it is that this film succeed."[54] This sense of the film's historical significance was reflected in Lee's insistence on an epic structure inspired in part by David Lean's *The Bridge on the River Kwai* (1957) and *Lawrence of Arabia* (1962). Coproducer Preston Holmes claimed that "*Malcolm X* will be the first American Black man whose story has been told on this scale." Lee's production diaries, published in *By Any Means Necessary: The Trials and Tribulations of the Making of Malcolm X* (1992), also revealed his sense of the film's rivalry with Oliver Stone's *JFK* (1991) in a kind of cultural battle for the memory of the 1960s. Lee echoed the aims of the Black Arts dramatists in alluding to his cinematic ambition in the 1990s: "In film we haven't produced any Duke Ellingtons or John Coltranes or Michael Jordans or James Baldwins or Zora Neale Hurstons or Ella Fitzgeralds yet."[55] It seems clear that he meant for the film to consolidate his status as an African American pioneer. Produced at a cost of $33 million, the film eventually made $48 million. Although profitable, and despite its brilliant marketing, which reinvigorated discourses surrounding Malcolm's meaning and legacy, Lee's *Malcolm X* was only the thirty-second highest grossing film released in 1992, with box office figures significantly lower than those of such films as *Lethal Weapon 3, Sister Act, The Bodyguard, White Men Can't Jump,* and *Boomerang.*

As early as late 1987, Lee reflected on the cultural volatility of the War-
ner Brothers property, stating, "If that film is not done truthfully and
righteously, Black folks are gonna want to hang the guy behind it."[56] His
words proved to be prophetic. Amiri Baraka led the generational and
political contestation of the film's politics, claiming that "the script is
terrible" before the film had even been made.[57] Arguing that "black strug-
gle," for Lee, was "mainly commercial, economic as a pay raise," Baraka
objected to the filmmaker's concessions to the corporate structure of the
Hollywood studio system. These concessions were deemed narrative as
well as political. That "Detroit Red holds center stage in Spike's screen-
play"—Malcolm's childhood is confined to flashbacks while Red, the
guise in which we first observe Lee's Malcolm, dances the lindy-hop in
real time—was, for Baraka, representative of a flawed, sellout approach.[58]
It was also a betrayal of the neatly linear structure of the *Autobiography*'s
myth of transformation. Rather than undertaking a materialist analysis
of the conditions that produced Malcolm's consciousness, including his
childhood exposure to Garveyism, Baraka argued that Lee presented
Detroit Red at the opening of his story as if fully formed, a stylish and
charismatic figure complete with zoot suit and wide-brimmed hat, and,
unfortunately, as "a defining spine of the entire life" of Malcolm X.[59] In-
deed, for all his youthful appeal, little in the way of community activism
was likely to be inspired by the antisocial figure of Red. For his part, Lee
attributed Baraka's views to professional jealousy: "You know, we're *doing*
what these guys were just talking about in the sixties. . . . Because of film,
I have far greater access to the masses than he does, or ever will. And
with the access comes the influence, comes the power, and comes the
money."[60]

The newfound currency of Detroit Red and the unchecked expan-
sion of the commodity cultures of film and hip-hop aroused significant
hostility and anxiety within a black critical establishment informed by
the cultural politics of the 1960s and 1970s. Critics of the film such as
Baraka, Gilroy, and Marable positioned themselves as the heirs of Mal-
colm's critique of the dissemination of negative images of persons of Af-
rican descent. According to Gilroy, Lee bore much responsibility for the
cultural shift, having abandoned the previous generation's higher aims:
"Under the corporate tutelage of Spike Lee and company, consumerism,

hedonism, and gun play were no longer to be incompatible with the long-term goals of racial uplift."[61] Marable lamented "the highly commercialized promotion of the film, which shamelessly turned the black leader's likeness into merchandise"; for another critic, "the passing fashion for Malcolm X baseball caps, T-shirts and keyrings [preceding] the release of Spike Lee's film signified the growing romanticization of black power in a search for past heroes and leaders when charismatic, new black political leaders remain scarce."[62] What those who criticized Lee's marketing typically failed to acknowledge was that the publicity generated by the film enabled many of the materials with which this chapter is concerned to reach a much wider audience. Of more enduring interest are critiques directed at the content of the film itself. Given the increasing generic predominance of film relative to other cultural forms, Nell Irvin Painter's perception that the movie "glosses over the weirder themes in Elijah Muhammad's doctrine" is significant; in expurgating the *Autobiography* and in failing to interrogate some of its dubious assertions, the film sidesteps a great deal of history.[63]

The screenplay for *Malcolm X* was credited to Spike Lee and Arnold Perl, who had inherited the project from James Baldwin. Apparently adapting *Malcolm X* from Perl's adaptation of Baldwin's screenplay, *One Day, When I Was Lost*, Lee only credited Baldwin in the version of the screenplay reproduced in *By Any Means Necessary*. Although Baldwin may have provided Lee with artistic inspiration, a comparison of the screenplays reveals that, apart from the flashback structure, the Baldwin lineage is more wishful than actual. In preparing to write *Malcolm X*, Lee also read several other unproduced screenplay adaptations of the *Autobiography* in the Warner Brothers archive, including those by Calder Willingham, coscreenwriter of *Paths of Glory* (1957) and *The Graduate* (1967), and playwright and filmmaker David Mamet, whose script was to be directed by Sidney Lumet with comedian Richard Pryor playing Malcolm X.[64] Producers seeking an African American perspective considered hiring playwright August Wilson; they turned instead to novelist David Bradley, whose screenplay leaned heavily on Alex Haley as both a character and an interpreter of Malcolm, placing the composition of the *Autobiography* at the center of the narrative.[65] The playwright Charles Fuller had written another adaptation. In addition to these scripts, Lee benefited from an evolving historical narrative that had revealed facts about the

identity of Malcolm's assassins and the tensions between Malcolm and Elijah Muhammad. Unlike Baldwin and Perl, whose screenplay edged into indeterminacy in its final act, Lee could "go into the thing with Elijah and his secretaries; go into Malcolm being under heavy surveillance, being watched by the FBI." He also benefited from the availability of a greater variety of speech recordings and transcripts; Lee consulted with historian Paul Lee in writing more nuanced speeches for the character of Malcolm X.[66]

Few critics have questioned Lee's choice of Denzel Washington to play Malcolm X. It should be noted, however, given the political freight of skin color in African American culture historically, that the selection of "a richly brown-skinned actor" obviated the acknowledgment of the *Autobiography*'s discussion of Malcolm's ambivalence about his "reddish-brown 'mariny' color of skin."[67] Like many African Americans, Malcolm was embattled in a culture of unreconciled racial mixture in which "forms of dominance are also, covertly, forms of dependence"; his light skin likely contributed to the ambivalence with which he was received in mainstream media.[68] In fact, Washington was attached to the project prior to Lee taking it on, having first played the role of Malcolm in Laurence Holder's one-act play *When the Chickens Come Home to Roost* in 1981. The casting of Washington, now one of America's most recognizable and bankable film stars, may appear to have been the mere substitution of one iconic mask for another. But the role of Malcolm X was more than only one of the first in a long line of disposable, heroic guises animating Washington's ascent to Hollywood fame. Although he received an Academy Award for his supporting role as Private Silas Trip in *Glory* (1989), it was not until *Malcolm X* that Washington was firmly established as both a credible actor and a marketable male lead. His success in the lead role was one of the film's undeniable racial achievements.

The film's portrayal of Malcolm was rooted in a reconstruction of the apparatus of his iconic photography. Such period details as Malcolm's suits, hats, and glasses, his star-and-crescent ring, his microphones, and his reddish-hued hair were studied in photographs, such as those of Robert L. Haggins and John Launois, and carefully recreated in the interests of visual authenticity. Echoing the latter photographer's portrait for the *Saturday Evening Post*, Lee filmed Washington in a posture of prayer in the Mosque of Muhammad Ali in Cairo; he wrote that the production

team "even found the old brother who made Malcolm's original star and crescent gold ring . . . up in Harlem. The brother used the original ring molds and made up another gold one from the original and two others as backups."[69] The film's visually meticulous approach extended, of course, to set design, including the signage on Harlem storefronts, Malcolm's Oldsmobile, and the Coca-Cola billboard that establishes Lee's interest in the history of popular visual culture in the film's opening shot.

In preparing for a film demanding much from its lead actor—events spanning nearly a quarter century were condensed into three hours— Washington emulated the ascetic lifestyle of his subject in a recurrence of the pattern of mimicry marking the cultural response to the iconic Malcolm since the 1960s. Lee wrote of Washington's Method acting as the pursuit of inward realism:

> You might say he went through a personal hajj, a pilgrimage of his own, for himself. He went on a strict diet with periodic fasting, no alcohol, reading the Koran, going to bed early, going through a cleansing. He felt—and I felt along with him—that he had to come to this subject right. If you weren't righteous, if you weren't trying to reach a level of high spirituality—that might show up on the screen.[70]

Washington, aware of his powerful resemblance (at least when in costume) to Malcolm X, was also aware of its artifice. Filming in Rahway State Prison in New Jersey, he told prisoners "straight out I wasn't Malcolm X and could never be Malcolm X."[71] Lee, however, observed Washington's facility for improvising riffs of Malcolm-like oratory, claiming that "he could regurgitate Malcolm's speeches verbatim, and then change them around for effect. He had those looks and mannerisms down pat. He became Malcolm X." Lee would repeatedly conflate his film's pursuit of visual accuracy with historical accuracy, arguing that Washington "captured the complexity of Malcolm X. The real man. Not bullshit myth like throwing a dollar across the Potomac or chopping down a cherry tree."[72] Lee's aspiration for the authoritativeness of his epic suggests that he was unwilling to acknowledge that it was just one of many mythic representations comprising the iconography of Malcolm X.

The climax of the narrative is the assassination scene, which Lee intended to film in the former Audubon Ballroom in an artistic pilgrimage of his own. An asbestos problem and depleted finances necessitated that

the scenes be filmed in Midtown Manhattan's Diplomat Ballroom instead. Lee described the assassination shoot as the film's "most difficult, technically and emotionally," adding that "choreographing chaos is difficult."[73] The complexity of convincingly reenacting an event of mythic stature in modern African American history is evident in Lee's account of its visual and narrative requirements: "There are a lot of angles, maybe twelve set-ups. Re-cut, re-cut, re-cut. Some of the elements that have to come across are the cold-bloodedness of Malcolm's killers; you've got to see the devastation of his family—know that they are there; you have to see his awareness of what is happening; you have to see all this clearly in the middle of the chaos."[74] The film adopts the five-assassin theory set out in Goldman's second edition of *The Death and Life of Malcolm X*, depicting the Nation of Islam assassins cleaning and loading weapons in a basement hideout. In a gesture either misguided or self-sacrificial, Malcolm, who is presented as resigned to his fate, refuses armed protection, stating, "We don't want black people killing each other."[75] The film also implicates the FBI in the shooting. As Malcolm tells Betty over the phone that the Nation is not working alone in pursuing him, FBI agents listen in, one joking that, "compared to King, this guy's a monk."[76] A tracking shot memorably depicts Malcolm as if gliding mechanically and irrevocably along the sidewalk toward the Audubon. Prior to his speech, Malcolm sits before a dressing-room vanity in a scene suggestive of the distinctly performative context of his life and death. The setting is faintly tawdry, with burned-out bulbs visible around him as he declares, fatalistically: "It's a time for martyrs now."[77] The sequence represents Malcolm's final communion with his reflected image—both a farewell and a reminder of the degree of immortality his iconic images would afford. In its implication of a knowing resignation, the image is evocative of Haggins's last photographic portrait of Malcolm. While depicting a moment of private meditation, Lee here insisted upon the inevitable distance in our gazing at the public figure of Malcolm. His glance, reflected back at us as well as himself, withholds an enigma. Moments later, a hint of a smile crosses his lips as he observes his assassins approaching the stage.

The Earl Grant and stretcher photographs of Malcolm's corpse evidently influenced the framing of the sequence; the latter is alluded to with black-and-white mock-documentary footage of Malcolm being transported to the nearby hospital. Following the assassination scene is an ex-

tended montage of documentary footage and photographs accompanied by Ossie Davis reciting his eulogy in voice-over. The sequence is among the film's finest, acknowledging as it does the performances consigned to history by Malcolm himself and revealing a complex tradition of narrative interaction with his iconography. Sasha Torres has noted *Malcolm X*'s engagement with television as an aspect of Malcolm's layered mediation. In the film Malcolm watches nonviolent civil rights protests and appears on television himself. As Malcolm is observed on television by Baines, a Nation of Islam official, and Elijah Muhammad, "Baines broaches for the first time the possibility that Malcolm may be becoming too powerful, thus establishing definitively . . . the link between being powerful and being televised"—and, one might add, being televised and becoming a target of violence.[78]

Unlike the American editions of the *Autobiography, Malcolm X* did not conclude with the assassination, because, as Lee said, such an ending "would defeat the legacy of Malcolm X. Malcolm X lives today; the film will end in the present."[79] Lee thus situated his film in the epic rather than tragic tradition. *Malcolm X* concludes as it opens—with footage of the police beating of Rodney King in Los Angeles—with the invocation of conflicted contemporary race relations. Demonstrations in Malcolm's honor in Soweto and Harlem appear at the film's end. While the former sequence insists upon the diasporic currency of Malcolm's iconic radicalism, the latter sequence emphasizes his image's association with a particular urban space. Before a backdrop splashed with graffiti, the Harlem protestors—one of whom wears an X hat—hold aloft placards bearing the iconic 1963 photograph of Malcolm gesticulating behind a microphone. A number of the protestors suggest a further evolution of Malcolm's emphatic gesture in raising their fists in a Black Power salute. Lee's portrayal of an investment in Malcolm X by groups of ordinary citizens is, on the one hand, suggestive of the democratization of Malcolm's image. In plainly having been staged, however, the rally also speaks to Lee's polemical project with the film. The crowd chants "Malcolm X" in unison, arguably (and perhaps disingenuously) suggesting a singularity of understanding of the man of so many images and names. In presenting Malcolm as *the* representative or unifying figure for persons of African descent, Lee ultimately proposes a political model rooted as much in uncritical iconography as in dissenting democracy.

A Harlem rally for the remembrance of Malcolm X. Malcolm X, directed by Spike Lee (Warner Brothers, 1992).

Other Films and Television

While *Malcolm X* is the film most revealing of the relationship of cultural nationalism to commerce in the period in question, Lee was not the only filmmaker to stake his claim upon the Muslim minister. Indeed, the iconic Malcolm can be seen to have inspired a generation of visual storytellers working with both small and large budgets.

In their experimental documentaries of the 1980s and 1990s the Black Audio Film Collective, founded in London in 1982, examined the interplay of history and memory in the interpretation of Malcolm X. Director John Akomfrah's *Handsworth Songs* (1986) internationalized Malcolm, featuring him in archival footage alongside images of the Handsworth (Birmingham) and Broadwater Farm (London) riots, both sparked by police incidents in 1985. Akomfrah's interest in claiming Malcolm as a Pan-African icon is apparent also in *Who Needs a Heart* (1991), a fragmentary narrative contextualizing the emergence of black British leader Michael Abdul Malik with footage of Malcolm. *Seven Songs for Malcolm X* (1993), directed by Akomfrah and written by Akomfrah and Edward George, consisted of archival footage and interviews with Malcolm's family and friends, Spike Lee, and various writers and scholars. The film used an empty picture frame as a self-reflexive mechanism in its inter-

view segments, demonstrating the constructedness of the respondents' memories. The film opens with actor Darrick Harris posing next to John Launois's portrait of Malcolm with his finger on his temple; such iconic tableaux appear throughout, portraying, among other images, Malcolm on a mortuary slab and in a pose with a rifle. *Seven Songs for Malcolm X* circles around memories of Malcolm's death, incorporating stock footage of the aftermath of the shooting and the funeral. It interrogates Malcolm's cultural resonance in the early 1990s, acknowledging the cultural momentum generated by Spike Lee's *Malcolm X* with footage from its premiere. In a memorable scene, Harlemite Hassan El-Sayeed leads the filmmakers to African Square in Harlem, pointing out such vanished sites of Malcolm's Harlem as the Chock Full o' Nuts café and Lewis Michaux's National Memorial African Bookstore.

Death of a Prophet (1981), a television movie directed by Woodie King, Jr., and improbably starring Morgan Freeman as Malcolm X, dramatized the assassination scene, though evidently while laboring under severe financial constraint; the auditorium in which the scene takes place is scarcely occupied. The film's greatest interest is in its opening with commentary by Ossie Davis, Amiri Baraka, and Yuri Kochiyama. In another instance of peculiar casting, *Roots: The Next Generations* (1979), a sequel to the *Roots* (1977) miniseries that adapted Haley's best-selling novel, featured Al Freeman, Jr., as Malcolm X. In a bizarre illustration of the occasionally circular nature of iconography, Freeman would give a more memorable performance as Elijah Muhammad in Lee's *Malcolm X*.

Well before Katori Hall resurrected Martin Luther King, in *The Mountaintop* (2009), as a Broadway shill, Jeff Stetson dramatized a fictional meeting between Malcolm and King in Malcolm's suite at the Hotel Theresa on Valentine's Day 1965.[80] *The Meeting* (1987) was inspired by the March 1964 photograph of Malcolm and King shaking hands. A fable of brotherhood rooted in civil rights–era nostalgia and wish fulfillment, *The Meeting* plays fast and loose with the chronology of events in Malcolm's final week in order to bring the two heroic figures together following the crisis of the burning of the Shabazz family home in Queens. While engaging in a relatively nuanced discussion of their political differences, Malcolm and King arm wrestle twice, each winning once; the third and deciding round is a draw, with their clasped hands representing a truce or equivalence. Stetson clearly intended the play as an invitation to re-

gard the men not as adversaries but as comrades; Malcolm tells Martin of a nightmare he experienced in which both men were dead and the civil rights movement had never occurred.

Stetson's 1989 television adaptation of the play, directed by Bill Duke, was representative of the period in introducing two FBI agents undertaking the surveillance of Malcolm X and seeming to possess foreknowledge of his death. The death is nevertheless framed by Stetson as an arch betrayal arranged over the telephone by Malcolm's Judas-like bodyguard, Rashad. The play ends sentimentally with the two men discussing what might have been. With the verb tense suggesting he is already dead, a sort of ghost reflecting on an opportunity missed, Malcolm tells Martin, "You know, we could have made quite a team." Martin replies, "Malcolm, we do make quite a team. Most people just don't realize it, that's all." Malcolm apologizes for any hurt caused by his public comments about Martin, who is gratified by the apology, and Malcolm prays: "Allah, protect the dreamer."[81]

I have indicated that Malcolm X had a long-standing interest in popular cinema; the *Autobiography* tells of Detroit Red watching jazz singer Cab Calloway perform in his customary zoot suit in *Stormy Weather* (1943). In the musical comedy *The Blues Brothers* (1980), it is Malcolm who becomes a small part of the backstory of a character played by the septuagenarian Calloway himself. A narrative of redemption centering on the quasi-mystical appropriation of African American style and music by white principals Jake and Elwood Blues (John Belushi and Dan Aykroyd), the film stars Calloway as Curtis, the caretaker of an orphanage that the Blues Brothers intend to save from foreclosure. The wall of Curtis's basement residence displays a photographic portrait of Malcolm alongside photographs of John and Robert Kennedy and a painting of Martin Luther King. Toward the end of the film, Curtis reveals himself to be none other than the Cab Calloway of musical cinematic history—once observed in similar guise by Detroit Red—by performing his signature song "Minnie the Moocher" as an opening act for the Blues Brothers.

Another mainstream film with a plot involving an African American character's imparting of black style to a white apprentice is the basketball film *White Men Can't Jump*, which beat *Malcolm X* at the box office in 1992. With the help of a fellow street-ball hustler, the athletically superior Sidney Deane (Wesley Snipes), Billy Hoyle (Woody Harrelson) is finally

able to thwart racial expectations and dunk a basketball. Deane's status as proprietor of clichéd blackness is illustrated in the film by his easy access to an African American cultural milieu partly signified by images of Malcolm, whose face appears on T-shirts worn on the urban basketball courts heavily featured in the film. In yet another example of Malcolm's iconographic recirculation, in the comedy *Mo' Money* (1992), Seymour Stewart (Marlon Wayans) wears one of the X baseball caps used to promote Spike Lee's *Malcolm X*.

Many films of the 1990s underwrote Malcolm's currency in urban black culture. John Singleton's *Boyz N the Hood* (1991) represented "an advocacy for Black males" harassed by police and courted by gangs in South Central Los Angeles; the father of central character Tre Styles (Cuba Gooding, Jr.), played by Laurence Fishburne, inhabits the moral and political core of the narrative, displaying a nationalist rhetoric that inspires Tre's friends to compare him to Malcolm X and Louis Farrakhan.[82] *Panther* (1995) is a studio film whose Blaxploitation lineage helped sell its narrative of African American radicalism to a mainstream audience (and to its producers). A product of collaboration between Melvin Van Peebles, author of the 1995 novel on which his screenplay was based and, previously, the director, writer, and star of *Sweet Sweetback's Baadasssss Song* (1971), and his son Mario Van Peebles, who directed the film, *Panther* sought to emulate the commercial success of Lee's *Malcolm X*. Distinguished from such contemporary urban African American cinematic narratives as *New Jack City* (1991, also directed by Mario Van Peebles), *Straight out of Brooklyn* (1991), *Juice* (1992), and *Menace II Society* (1993) by its historical setting and its engagement with politics, *Panther's* opening credits established the film's appeal to and embellishment of historical truth with the use of documentary footage, including footage of Malcolm at the Oxford Union urging the use of "any means necessary to bring about justice." The footage is juxtaposed with images of Martin Luther King and John F. Kennedy; still images of the three assassinated men are punctuated with the sound of gunshots, suggesting that *Panther's* purview is that of a kind of Western involving 1960s racial politics.

Malcolm is continually invoked in *Panther*. After being arrested at a nonviolent demonstration, Black Panther Party cofounder Bobby Seale (Courtney B. Vance) alludes to the 1964 "The Ballot or the Bullet" speech ("Brother Malcolm says we need to stop singing and start swinging");

posters in the Oakland Black Panther Party headquarters depict a Black Power fist, a panther, Che Guevara, and El-Hajj Malik El-Shabazz; Malcolm's face also appears in a mural painted on the local church with the motto "All Power to the People." *Panther* dramatizes the Black Panthers' much-remarked provision of security for Betty Shabazz in San Francisco on the second anniversary of Malcolm's death. In an allusion to Lee's film, Betty Shabazz is again played by actress Angela Bassett. Finally, Eldridge Cleaver (Anthony Griffith) loads a revolver with the intention of shooting some Oakland policemen and declares, "This is for Brother Malcolm, this is for Brother Martin, and being a motherfucking pig." The avowedly antigovernment film, produced in the wake of the Los Angeles riots, contextualizes the eventual dismantling of the Black Panthers by proposing an FBI drug conspiracy in America's inner cities—a kind of "final solution" designed to "neutralize" African American radicalism.[83]

Michael Mann's *Ali* (2001), the most lavishly produced film concerned with Malcolm X (Mario Van Peebles), is preoccupied with the influence of his life, and particularly his death, on boxer Muhammad Ali (Will Smith). Broadly telegraphed in the narrative, the assassination is depicted in terms familiar from the *Autobiography*, the many biographies, and Lee's film: Malcolm greets the audience with "As-Salaam-Alaikum"; following a disturbance toward the rear of the auditorium, he tells the crowd to "Hold it my brothers. Just be cool"; and he is shot by a trio of gunmen. Contrary to the coroner's report, he is shown alive on the floor of the stage for a brief time during which he is unattended by witnesses.[84] The viewer shares Malcolm's largely unfocused perspective from the floor at the rear of the stage. Ali receives news of Malcolm's assassination while driving. Pulling over to listen with sadness and anger to a radio report, Ali is surrounded in the scene by African Americans grieving openly on the sidewalks. The scene echoes the assassination scene in Lee's film in being accompanied by Sam Cooke's 1964 single "A Change Is Gonna Come," here in Al Green's version; the song choice suggests the common perception of the period as one in which popular music and public figures such as Ali were more selflessly engaged in political struggle. Like the assassination, Malcolm and Ali's friendship is presented through the reinterpretation of received images; an early scene depicts the two men, as they appear in several iconic photographs, interacting with admirers on the streets of Harlem.

Recent television shows have demonstrated the extent to which, at least posthumously, Malcolm has been woven into the fabric of American visual storytelling. In HBO's acclaimed series *The Wire,* the surname and demeanor of the character of Omar Little (Michael K. Williams), a charismatic mercenary, are taken from the young Malcolm. Brother Mouzone (Michael Potts), a hit man from New York, appears in several episodes in Nation of Islam garb and Malcolm-style glasses, speaking to the popular postassassination perception of the organization as a ruthlessly vindictive one. AMC's *Mad Men,* a study in the commercial and artistic potency of 1960s nostalgia, makes passing reference to the death of Malcolm X in its fourth season: "Did you hear Malcolm X died? Did you know who Malcolm X was?"[85] What was framed elsewhere as Harlem's tragedy is shown here to have registered meekly with the downtown scions of corporate America.

Visual Art

Many visual artists have acknowledged Malcolm X's status as a heavily mediated figure within their work; a number of major exhibitions, especially since the early 1990s, have explored his evolving iconography. "Malcolm X: The Man, The Meaning" opened at New York's Jamaica Arts Center in December 1991 and included work by artists James Andrew Brown, Elizabeth Catlett, Sue Coe, Larry List, James Little, Isaac Robert Paris, Jr., Archie Rand, Tim Rollins + K.O.S., Daniel Tisdale, and Grace Williams. "Malcolm X: Man, Ideal, Icon," organized by Kellie Jones and originating at Minneapolis's Walker Art Center in December 1992, toured in Boston, Detroit, Washington, Atlanta, and San Francisco. The exhibition encompassed the work of Robert L. Haggins, Vincent Smith, Elizabeth Catlett, Barbara Chase-Riboud, Larry Rivers, Sue Coe, James Little, Tim Rollins + K.O.S., David Hammons, Glenn Ligon, Daniel Tisdale, and Clarissa Sligh and Carole Byard. In producing some of the most provocative images of Malcolm to date, these and other visual artists have confronted more directly than others the inducements and challenges encountered in a visual landscape already oversaturated with iconic images.

In the mid-1980s British-born artist Sue Coe produced a series of agitprop paintings and drawings dramatizing Malcolm's assassination and

decrying the American establishment by way of a grotesque symbolism of slaughterhouses, Klansmen, slavering wolves, sharks, Washington politicians, bishops, and moneybags. Coe, who relocated to New York in the 1970s to work as a commercial illustrator and became involved with the Communist Party USA, interpreted the X as symbolic of "all those who have been Xed out of the American Dream"; Malcolm is depicted as a witness and an emblem of the oppressed masses encountered in Coe's sordid American landscape.[86] The pictures, as reproduced in her 1986 book, X, are accompanied by quotations of Malcolm's language, captions, and snatches of poetry inviting readers to "open your eyes, / X out their lies" and to recognize Malcolm as a tragic hero: "At the Audubon ballroom a bird soared too high and was shot down."[87] Coe's paintings of the assassination, intended "as a visual complement to the *Autobiography*," paired the *noir* aesthetics of the graphic novel with a vision of hell, or perhaps the medieval dungeon. The paintings are characteristic of her polemical, expressionistic style illuminated by Goya-like "vignettes of horror."[88] In each, the figure of the orator is framed by the blood-red proscenium arch and an aura suggestive of ascension.[89]

In depicting Malcolm dying onstage, the paintings remind us that images of Malcolm's oratory often contain the implication of his death. *The Assassins*, the most evocative of these paintings, emphasizes his widow's grief and, in its portrayal of Malcolm, clearly echoes Earl Grant's photograph taken moments after the shooting. The backstage perspective reveals a shadowed group of hooded, horned figures resembling executioners. Their clasped hands feign innocence, while a rifle is visible behind the rearmost figure's back. Coe has since distanced herself from the work, claiming, "I made Malcolm into an icon when I should have dealt with him as an individual."[90] Engaging with Malcolm beyond the terms of his iconicity has, of course, become increasingly difficult. Although Coe's assassination paintings are on some level derivative of the photographs and narratives that have illustrated and evoked Malcolm's killing, they can also be seen to comment on (even while contributing to) the objectification of his martyrdom.

Some artists have demonstrated ambivalence about the circulation of African American culture in image and text. Jean-Michel Basquiat's *Toussaint L'Ouverture versus Savonarola* (1983), a work that "documents his stylistic range from expressive painting to conceptual collage and col-

or-field painting," placed black and white historical figures in dialectic.[91] A textual invocation of "Malcolm X versus Al Jolson" suggests the dramatic evolution of the representation of African Americans in twentieth-century mass media. Basquiat implicitly valorized Malcolm by contrasting and contextualizing him with Jolson, a Jewish jazz singer and, in *The Jazz Singer* (1927), America's most famous blackface performer. Glenn Ligon's *Deferred* (1991), a text painting with "Malcolm Martin" stenciled repeatedly in a gory murk of ink-black and luminous red, implicitly questioned the conventional narrative of the civil rights movement's advancement of American race relations by evoking both icons' violent deaths.

New York artists Tim Rollins and David Hammons engaged with existing representations of Malcolm X in transmitting their own commentaries on how art—and Malcolm—are contextualized and consumed. Tim Rollins founded Kids of Survival (K.O.S.) in 1981 while teaching art to underprivileged public school children in the South Bronx. His altered texts, including the *By Any Means Necessary* (1985–1986) series in which pages of the *Autobiography of Malcolm X*'s first chapter are marked with an "MX" reminiscent of a superhero's (or the New York Yankees') logo, are suggestive of the layering of mediation in our access to historical, literary, and celebrity figures; they also provide an irreverent commentary on the conventional authority delegated to texts in education.[92] The work of Harlem artist David Hammons, typically concerned with such American racial signifiers as spades, flags, and basketball, has employed in his work images of Marcus Garvey, Joe Louis, Charlie Parker, Bobby Seale, Nelson Mandela, and Jesse Jackson. In paintings, sculptures, installations, and performances that he has described as "somewhere between Marcel Duchamp, Outsider art and *Arte Povera*," Hammons demonstrates an interest in puns and the ironic juxtaposition of found objects.[93] His installation *The Fan* (1990) consisted of a library table, a mannequin head, a rattan fan, a funerary wreath, and a television playing a video, *Malcolm Speaks*. The piece presented an image of a stilted, mediated, domestic encounter with Malcolm—perhaps the prototypical encounter, for most, with a man whose life was much televised. That Malcolm's vociferous recording is necessarily met with such placidity by its bodiless white observer draws on Malcolm's reproach of complacent whiteness; Hammons's installation echoes Malcolm's exemplary defiance and ambivalent relationship to mainstream media.

The renewal of black nationalist identification with Malcolm in the early 1990s was further reflected in the visual arts. In 1992 Cincinnati artist Thom Shaw initiated *The Malcolm X Paradox*, a series of woodcut prints interested in the signification of the symbolic X in urban fashion and gang iconography. The prints identify a misapprehension inherent in sloganistic appraisals of Malcolm, suggesting that, in the dissociation of Malcolm to an X, a phrase ("by any means necessary"), or the Detroit Red persona, he was reduced to a rationalization of social ills and criminality—a retail icon emptied of social value and historical truth. The series is evidence of a widening generation gap exposed in the contestation of images of Malcolm X. In preparing for the series, Shaw (1947–2010) conducted a series of videotaped interviews with young gang members, interrogating their apparent self-destructiveness and sense of ownership of Malcolm. One gruesome image, suggestive of Malcolm's misappropriation in a culture of nihilism, depicts two figures in Malcolm X shirts angrily blowing their own brains out with pistols. Xs are scattered among the blood and tissue.

Anticipating the release of Lee's film in November and responding to the conflagration in Los Angeles, the *New Yorker*'s 12 October 1992 issue included a lengthy biographical commentary, Marshall Frady's "The Children of Malcolm," introduced by a reproduction of Richard Avedon's blurred, skull-like portrait from 1963. The cover, a painting and collage by New York–based multimedia artist Josh Gosfield, takes the form of a visual biography. Gosfield would depict a slender-faced Malcolm at a three-quarter angle, surrounded by signifiers of racial strife and his two Islamic conversions, including (clockwise from top left) a faint X, a mosque with domes and minaret, the much-reproduced and inhumanely overcrowded plan for the hold of an eighteenth-century slave ship, UPI's photograph of Malcolm and King in the U.S. Capitol reproduced in the 9 April 1964 issue of *Jet* and the first edition of the *Autobiography*, and a white devil. Two other images—a figure labeled "Rodney King" and a burning city—cast Malcolm in the light of an unheeded prophet of the Los Angeles uprising, emblematic in itself of the continued volatility of urban American race relations a generation after the Civil Rights Act. The cover is a selective, sensational, and powerful polemic of African American history centered upon the fiery rhetoric of the Nation of Islam–era Malcolm X.

Kerry James Marshall's prints and paintings have explored the fragmentary cultural memory of the 1960s preserved in commemorative kitsch and scraps of language. In his *Black Power* series of stenciled relief prints, Marshall made a study of the era's sloganistic residues. Illustrating the argument that "the revolution is over" and that "'Black Power' exists only as a historical reference," the series provided, in addition to an image of Malcolm's identifying *"By Any Means Necessary,"* a survey of African American cultural trends in the 1960s represented by the phrases *"We Shall Overcome," "Black Is Beautiful," "Black Power,"* and *"Burn Baby Burn."*[94] In his *Memento* series, Marshall depicted examples of the 1960s memorial banners that grouped and domesticated the likenesses of Martin Luther King and John and Robert Kennedy, elevating them to a kind of American holy trinity. He questioned this orthodoxy by proposing an extended or alternate pantheon of prominent 1960s deaths. Marshall's series invited remembrance of the cultural contributions of African American musicians, artists, and writers, depicting the "missing" figures as celestial observers. Among others, Marshall pictured Malcolm X, Zora Neale Hurston, Richard Wright, W. E. B. Du Bois, Langston Hughes, Lorraine Hansberry, Dorothy Dandridge, Otis Redding, Sam Cooke, Dinah Washington, John Coltrane, Billie Holiday, and Nat King Cole—a new Wall of Respect.

For artist Glenn Ligon, memorialization was not enough. In 2000 he produced a series of images that both invoked and sought to destabilize the conventional iconography. Inspired by workshops conducted at the Walker Art Center with children aged three to six years, Ligon's "Coloring" exhibition consisted of painted screen prints, adapted from 1970s coloring books, of such African American figures as Harriet Tubman, George Washington Carver, and Isaac Hayes. In Ligon's images of Malcolm X, available as individual canvases and in groupings with a sun, a boy blowing bubbles, and Frederick Douglass, a template is overlaid with childlike coloration in an irreverent gesture intended to trouble received narratives of American racial history and to explore their resonance with incompletely socialized children. Ligon has described his collaborators' approach: "I did give them some instruction, a little bit about the history of the images. But for kids, images are just images, so half the time they would forget what I told them and say, 'Oh, is that you?' and I'd say, 'No, that's Malcolm X.' Malcolm X was just an image to be colored

Malcolm X (small version I) #1, 2001. By Glenn Ligon. Paint and screen print on primed canvas; 48 in. × 36 in. (121.92 cm × 91.44 cm). Courtesy of San Francisco Museum of Modern Art. Gift of Anthony and Celeste Meier. © Glenn Ligon.

in."[95] Reminiscent of Andy Warhol's Mao Zedongs (1972–1973), Ligon's self-reflexive Malcolms draw attention to our reliance upon standardized images in accessing prominent living or historical figures and defamiliarize notions of race as "color." As such, Ligon's clown-colored Malcolm is among the most surprising and original representations of Malcolm to appear in the period in question.

Canadian artist Dan Starling's work examines the iconography at two extremes of the countercultural 1950s and 1960s, as circulated and reified by its influential images and texts, placing the representation of Malcolm X in conversation with that of American author J. D. Salinger. A deliberately incongruous pair, they are linked by Starling in both having "stopped speaking and publishing during the same historical moment in 1965."[96] Starling's 2007–2008 exhibition *Malcolm X / J. D. Salinger* consisted of wooden folk-art figurines, photographs, and a travelogue video from Starling's visits to the site of Malcolm's death (the former Audubon Ballroom) and Salinger's hermetic home in Cornish, New Hampshire. The exhibition also incorporated painted wooden likenesses of books by and about each man, illustrating the unavoidable mediation of our access to their distinctive consciousnesses. Starling's accompanying artist's book, *Malcolm X: An Introduction, by J. D. Salinger* (2007), extended his exploration of books as fetish objects. The book poses as a text authored by Salinger himself, with its cover a faithful imitation of Little, Brown and Company's unembellished design of Salinger's *Raise High the Roof Beam, Carpenters, and Seymour: An Introduction* (1963). The text of Starling's book is a slight adaptation of the novella *Seymour: An Introduction*, substituting "Malcolm X" or "Malcolm" or "M." for Seymour Glass in narrator Buddy Glass's reminiscence on the elder brother who, in the original, committed suicide in 1948. (Here, Malcolm is for Buddy a brother in spirit rather than in fact.) In Starling's version, Buddy echoes Shakespeare's Antony in his eulogizing of Julius Caesar:

> You may also have noticed—I know it hasn't entirely escaped my attention—that everything I've so far said about Malcolm (and about his blood type in general, as it were) has been graphically panegyric. It gives me pause, all right. Granted that I haven't come to bury but to exhume and, most likely, to praise, I nonetheless suspect that the honor of cool, dispassionate narrators everywhere is remotely at stake

Malcolm X / J. D. Salinger *folk figures, 2007. By Dan Starling. Photographs by Jody Rogac and Matthew Booth. Courtesy of Dan Starling.*

here. Had Malcolm no grievous faults, no vices, no meannesses, that can be listed, at least in a hurry? What was he, anyway? A saint?[97]

The passage questions whether historical truth is wholly sacrificed to myth in the narratives of iconic figures. The artist's book also includes pictures of Starling's folk-art figurines and ersatz books positioned as domestic ornaments, ephemera evocative of memorial practice and the performativity of politics and cultural connoisseurship. The books recreated (and questioned) by Starling include the Grove Press paperback of the *Autobiography* and Goldman's *The Death and Life of Malcolm X,* the first major biography.

Also worthy of note are photographs that demonstrate the enduring influence of Malcolm's portraits by recreating his poses with contemporary subjects. On 1 April 2008 *Giant* magazine published a series of photographs taken by Antonin Kratochvil in which Malcolm X's grandson, Malcolm Shabazz, stood in for his grandfather in mock-ups

of such memorable images as the portraits by John Launois and Eve Arnold, the rifle pose, and the Detroit Red mug shot. Revealing a desire to establish an iconographic as well as a genetic continuity with Malcolm X, the accompanying text described Shabazz as "the slain civil rights leader's first male heir" and recounted the tragedy of Betty Shabazz's death in 1997 in a fire set by her grandson.[98] As signs of Malcolm's distance (by two generations) from the present, the images invite viewers to ponder the passage of time. Photographer Samuel Fosso's *African Spirits* series similarly included a self-portrait in imitation of Eve Arnold's profile shot of Malcolm. Fosso, an Igbo born in Cameroon in 1962—he survived the Nigerian-Biafran War as a refugee in the Central African Republic—also featured in his autobiographical series poses inspired by a Pan-African pantheon including Angela Davis, Martin Luther King, Aimé Césaire, Nelson Mandela, Patrice Lumumba, Muhammad Ali, and Kwame Nkrumah.

The assembly of images of Malcolm X has extended to encompass such normalizing, tokenistic media as government-issued stamps and the tourist-and-entertainment culture of wax museums, forms that similarly assert their imperious iconographies of notable achievement. The dissemination of images on the Internet and in "the urban trinketry outposts of the mass consumer market" has threatened to confirm Adolph Reed's assertion that "only a dead Malcolm X is available to young people today."[99]

Marable stated that, with the issuance of a hundred million of the U.S. Postal Service's Malcolm X stamps in 1999, "the 'Americanization' of Malcolm X appeared to be complete." Arguably a dubious honor for "one of America's sharpest and most unrelenting critics" to be co-opted "by the same government that had once carried out illegal harassment and surveillance against him," the stamp's issuance was nevertheless marked on 20 January 1999 by "about 1,500 officials, celebrities, and guests crowded into Harlem's Apollo Theatre." The stamp was part of a Black Heritage Series honoring the contributions of, among others, Harriet Tubman, Frederick Douglass, and Martin Luther King. Surprisingly, given its iconic potential, the stamp featured a little-known photograph of Malcolm "taken during an interview in Cairo, Egypt, on July 14, 1964."[100] In 2007 a São Tomé and Príncipe stamp celebrated Malcolm as a hero to West Africans. Unlike in the more neutral Black Heritage stamp, his

message was interpreted here as one of "Black Power"; the stamp designer placed a bird of peace next to the figure of Malcolm as El-Shabazz.

The past decade has also seen what Abdul Alkalimat has called "the birth of CyberMalcolm."[101] Useful resources have emerged online, including Alkalimat's own *Malcolm X: A Research Site* (launched in 1999) and Columbia University's *Malcolm X Project* (launched in 2001). Digital artist James Ku's 2006 computer-generated images of Malcolm are also available on the Internet.[102] Inspired by Ku's reading of the *Autobiography*, by Malcolm's distinctive style, and by Ku's perception of a want of computer-generated images of African Americans, the impressively detailed images show the influence of Malcolm's iconic photographs and hint at the eventual possibility of a hologram of Malcolm X, or of an animated film or historical role-playing video game featuring his digital avatar.[103] Jailbreak Toys' inclusion of a gesticulating Malcolm figurine in their "Revolutionaries Collection" alongside Lenin, Gandhi, Che Guevara, and Mao Zedong may honor his international popularity as much as his politics. The most observed plastic figures of Malcolm are very likely the El-Hajj Malik El-Shabazz figures at Madame Tussaud's in New York and Washington, D.C.—locations suggesting a broad recognition of Malcolm's significance to New York history and to American politics; a new Nation of Islam–era Malcolm X waxwork was added to the New York Wax Museum's celebrity roll call on 15 January 2009 in honor of Black History Month.

Hip-Hop

Marable argued that "by the mid-1970s, the black nationalist impulse had been effectively splintered, repressed, and removed from political discourse."[104] Within this cultural fragmentation, black nationalist politics can in fact be seen to have migrated to alternative forms such as hip-hop music. Established in 1970s New York by such artists as DJ Kool Herc, Grandmaster Flash, Melle Mel, and Kurtis Blow, hip-hop music had, by the 1980s, become an international signifier of an African American urban aesthetic that was inevitably informed by the iconography of Malcolm X: the inception of Brooklyn's Malcolm X Boulevard was celebrated with a festival from 27 to 31 August 1985 featuring such performers as Grandmaster Flash. Equal parts popular music and vernacular ex-

pression, hip-hop, with its record scratching, sampling, drum machines, and rapping, expressed contemporary youthful attitudes to the African American musical tradition and social conditions in America's inner cities. Whether militant or sensationalist (or both), rappers typically have been concerned with narratives of poverty, violence, criminality, and policing; many have embraced Malcolm as a figure of nostalgia unsullied by the perceived self-interest of current mainstream politics, deploying his name, words, and image in presenting him "as the symbol of indomitable Blackness . . . so lacking in modern times."[105]

But critics have identified limitations in hip-hop uses of Malcolm X. One recurrent criticism is that politics are too eagerly reduced to posturing, and identity to consumer choice: "As used today, Malcolm the icon is principally a form of Black mask. Like dreadlocks and kente cloth."[106] Marable argued that, despite the "black nationalist cultural rhetoric" adopted by "hip-hop Malcolmologists," rappers have been too uncritical in their acceptance of "the main parameters of the black leader's tragic life story as presented in *The Autobiography of Malcolm X*."[107] The privileging of the image of Detroit Red, as in the mug shot reproduced as a figure of cool severity on the cover of the Roots' album *The Tipping Point* (2004), has been especially troubling to those wary of the teenage Malcolm's antisocial tendencies and invested in his more mature image. While simplifying Detroit Red to a prototypical hustler evacuates the complex cultural context from which Malcolm emerged, the figure of Red still functions in hip-hop as it once did in Malcolm's preaching, inviting identification, establishing credibility, and neutralizing skepticism about his religious and moral posture. Rappers also cite, through Red, the rhetorical "equivalencies between rap artist and pimp" identified by Eithne Quinn.[108] As a result, and despite the amorality of "Malcolm Little's teenage years, the youth today, particularly the hip-hop community, are reluctant to separate the hipster from the minister."[109]

While blues and jazz traditions are celebrated, by such critics as bell hooks, for their community values, hip-hop, with its interest in the hustler or gangsta as folk hero and in youthful death as evidence of a life well lived, has been criticized for glamorizing criminality; it has been described dismissively as "a cult of death" and "the essence of patriarchal masculinity" inherited unscrupulously from the Black Power era.[110] Partly due to the ongoing influence of the *Autobiography*, and partly to the in-

creasing incarceration of young black men, the prison narrative became as much a feature of hip-hop music as it had been in African American literature during the late 1960s and the 1970s.[111] Public Enemy's *It Takes a Nation of Millions to Hold Us Back* (1988) featured an image of Chuck D and Flava Flav behind bars on its cover. Ice T's "The Tower," on his *O.G.: Original Gangster* (1991) album, told of the arrival of a prisoner (on a ten-year sentence) at a harrowing state penitentiary. Notorious B.I.G.'s *Ready to Die* (1994) starts with a skit in which the rapper is born, misbehaves as a child, robs a train with a pistol, and is released from prison, in a sort of conversion narrative, with "big plans" to tell his story.[112]

Conservative responses by such as Vice President Dan Quayle to gangsta rap echoed the tone of moral outrage with which Malcolm's pronouncements had been met in his lifetime. In this context, rapper Tupac Shakur emerged as Malcolm's most tragic hip-hop heir, extending Malcolm's late sense of persecution or harried existence to encompass a "paranoid style" all his own. Born to a Black Panther family in 1971, Shakur would become in the 1990s "a symbol of post–civil rights malaise and political frustration"—almost a secular, commercialized version of Malcolm X.[113] On his debut *2Pacalypse Now* (1991), he invoked the inversion of King's dream: "America's nightmare."[114] Like Malcolm, Shakur "explored a range of styles, personas, and forms," including those of outlaw hero and pop prophet. His cultural significance also increased exponentially following his murder in Las Vegas in 1996.[115]

More generally, hip-hop has adopted Malcolm as a kind of patron saint; his words and names have been used as implicit endorsements of numerous acts or albums. Public Enemy's "Bring the Noise" starts with a recorded sample taken from the "Message to the Grass Roots" speech of November 1963, one of Malcolm's last with the Nation of Islam. The repetition of the words "too black, too strong" speaks not only to the updating of a Black Power politics but also to the survival and circulation of Malcolm's speeches on records since the 1960s.[116] Identifying recording as a technology of cultural continuity, the sample positions Malcolm as a protorapper (much as Black Arts theorists regarded him as a proto-poet) and Public Enemy as his anointed heirs. The Brooklyn group X-Clan emerged in 1990 with the politically orientated album *To the East, Blackwards,* whose cover featured a Pan-Africanist collage of prominent black figures (including Malcolm X, Haile Selassie, and Martin Luther

T-shirt stand on 125th Street near Adam Clayton Powell, Jr. Boulevard, Harlem, August 2008. Photograph by Graeme Abernethy.

King), the four original members of the group, and a pink Cadillac as an emblem of American style and success—a linking of nationalism and materialism common enough to hip-hop.[117] Indeed, Gang Starr's *Daily Operation* (1992) displayed Laurence Henry's portrait of a bearded, tweed-jacketed El-Hajj Malik El-Shabazz behind Guru and DJ Premier, at work in a study strewn with books and money.

S. Craig Watkins, among others, has drawn attention to the performative aspect of hip-hop nationalism's reliance on the politics and images of the mid- to late 1960s. Rather than subscribing to the criticism that the new "black militancy" was associated "with revolutionary style rather than revolutionary politics," Watkins argues that hip-hop represents an important part of a cultural shift in modes of expression that subvert rather than reinforce conventional ideology, even while occupying the established avenues of mass media.[118] Other critics have associated hip-hop not with articulate rebellion but with a reinscription of the science of imagery and, indeed, of inhibiting modes of white consumption of images of black exploitation. Adolph Reed, Jr., argued that hip-hop's early

militant practitioners failed to live up to Malcolm X's high standard of social commentary, resorting instead to visual signifiers largely emptied of content: "KRS-One, Public Enemy, X-Clan, and Sister Souljah . . . claim pontifical authority on the basis of identity with the props of their stage and video performances."[119]

South Bronx rapper KRS-One, best known for his 1980s work with DJ Scott La Rock as part of the groundbreaking Boogie Down Productions, was certainly well versed in the deployment of Malcolm X's visual rhetoric, not least as it applied to armed self-defense by African Americans. BDP's second album *By All Means Necessary* (1988) adapted its title from Malcolm's famous phrase; in a swaggering mock-up, the album cover recreated the 1964 rifle pose with several hip-hop embellishments. KRS-One appears, in the photograph by Doug Rowell, in a customized BDP tracksuit, cap, and sunglasses, peering past drapes much like those once parted by Malcolm X. Rather than a replica of Malcolm's now-dated M1 carbine—the U.S. military decommissioned the rifles after the Vietnam War—KRS-One wields in the image a MAC-10 machine pistol popularly associated in the 1980s with the criminal drug trade. Such elements seem initially to place the cover image in a context more evocative of Detroit Red than the later Malcolm X. KRS-One's liner notes for the album, however, contain a critique of hypocritical attitudes toward hip-hop's rhetoric of violence. He suggests that he, like Malcolm, has been willfully miscast as a societal villain. Indeed, after the shooting death of Scott La Rock in 1987, KRS-One became a devoted activist for nonviolence in hip-hop, founding the Stop the Violence Movement in 1989. The cover photograph thus functions, multiply, as an example of hip-hop's blustering style, as a commentary on the cultural presumption of black male criminality, and as an invocation of Malcolm's complex visual testimony.

Public Enemy's 1991 video for the song "Shut 'Em Down" also incorporated images redolent of the militant 1960s, including of the Black Power salute by Tommie Smith and John Carlos at the 1968 Olympics, the Black Panther Party, Muhammad Ali, and Malcolm X. According to Joe Wood, when Chuck D says "*Screw George Washington!* and knocks him from the dollar bill, substituting Malcolm X (and Angela Davis)— this may be an act of defiance, but what's doing the defying and what's being defied are not certain." What Wood calls "the reinscribed dollar" seemingly "promotes the worth of American economic institutions," il-

lustrating what is often regarded as hip-hop's unholy alliance with the materialistic.[120] But such "emphasis on black style politics was as much a critique of whiteness as it was a celebration of blackness"; by inserting themselves in this visual tradition of African American radicalism, Public Enemy reinvigorated a discourse of American racial dualism that rationalized its monetary aspirations.[121] Ostensibly addressing themselves to black listeners, Public Enemy nevertheless discovered the countercultural appeal, especially to a white, middle-class audience, of hip-hop in its more militant and sensational manifestations. In "a familiar scenario that dates back to the fifties: the appropriation of black cool by young white hipsters in search of a rebellious style," these consumers demonstrated the profitability and illicit attraction of the prohibitive, encompassing hip-hop *and* Malcolm.[122]

In the hip-hop of the twenty-first century, Malcolm X quotations and allusions continue to appear. The reconciliation of a 1960s radical aesthetic with a sense of the contemporary urban experience, typically signified by drug and gang cultures, continues to preoccupy such politicized hip-hop groups as Dead Prez, whose 2004 album title, *Revolutionary but Gangsta,* represents something of an ethos for the genre. In other words, *all* Malcolms are embraced in hip-hop, from Detroit Red to El-Shabazz. Ishmael Butler, formerly of Digable Planets, formed the Seattle-based group Shabazz Palaces in 2009, demonstrating the continued currency of Malcolm's several names. Brooklynite Mos Def's *The Ecstatic* (2009) opens with a recording of the closing lines of Malcolm's Oxford Union speech, seemingly announcing a preference for Malcolm not as black nationalist but as revolutionary internationalist; the sample has Malcolm saying, "I for one will join in with anyone, don't care what color you are, as long as you want to change this miserable condition that exists on this earth."[123] Some invocations provide less in the way of edifying political content. Although best known for his cocaine raps, Young Jeezy appeared in a mock-up of Launois's El-Shabazz portrait, complete with backwards baseball cap, on the cover of *Trap or Die II: By Any Means Necessary!* (2010).

Chicago rapper Kanye West, one of contemporary hip-hop's and indeed pop music's biggest (and most self-aggrandizing) stars, has established a pattern of self-consciously aligning himself with Malcolm X. While remote from the mature Malcolm's example in his unabashed association

with sensual and material indulgence, West frequently announces his similarity as an unassimilated voice of rebellion within the mainstream media. Indeed, West does faintly resemble Malcolm in his efforts as a popular controversialist. Like Malcolm in his manipulations of the science of imagery, West has done much to exaggerate his controversial status, including posing as a bloodied Christ in a crown of thorns for the cover of *Rolling Stone* in February 2006, some months after stating, in the wake of a plodding government response to the devastation of Hurricane Katrina, that "George Bush doesn't care about black people!"[124]

It is primarily through his lyrics, however, that West has come to invest his persona with aspects derived from the iconic Malcolm. On the opening track of *Graduation* (2007), he puns on Malcolm's identifying slogan: "I'm like the fly Malcolm X: buy any jeans necessary / Detroit Red cleaned up."[125] Although, on the one hand, this line provides an example of his unrivalled sartorial boasting, West here arguably reduces Malcolm to a mere mask to be donned and discarded at will. Indeed, much more than a statement of political affiliation, the lyric represents West's fluency in signifying within an African American cultural context—one of hip-hop's primary conventions. On his acclaimed 2010 album, *My Beautiful Dark Twisted Fantasy,* West again aligned himself with Malcolm, declaring in a chorus that "no one man should have all that power," an allusion to Malcolm's role in the 1957 Hinton X Johnson protest featured in the *Autobiography* and in Spike Lee's film. West would distance himself from the African American establishment in the song, describing himself, hyperbolically, as the "abomination of Obama's nation."[126] On "Gorgeous," West questioned whether "hip-hop [is] just a euphemism for a new religion" before conflating himself with Malcolm in messianic terms: "Malcolm West had the whole nation standing at attention."[127] A more recent collaboration with Jay-Z and Frank Ocean situated "Sweet Brother Malcolm" within a pantheon of icons reminiscent, in some respects, of the Black Arts Movement's memorializations, including references also to Martin and Coretta Scott King, Betty Shabazz, Jesus, Mary, and Joseph.[128] The chorus lyric—though concluding with the suggestion, very unlike Malcolm X, of African American deliverance in the post-Obama period—nevertheless captures Malcolm in the customary terms of his iconography. Incongruously (again) situated within a Christian frame of reference, Malcolm figures here also in patriarchal and familial terms.

Conclusion

In yet another recent cycling of the science of imagery, Robert L. Haggins's final portrait of Malcolm X, discussed in my first chapter, appeared in ersatz form as a tattoo on the left leg of Chicago Bulls' star point guard Derrick Rose. The image serves as a reminder both of basketball's popular currency as a theater of black style and achievement and of Malcolm's continued relevance to mainstream images of African American celebrity. In recent years, associations with hip-hop style and related anxieties attending the perception of African American rebelliousness have been carefully stage-managed by the National Basketball Association in the interests of appeasing the sport's many white spectators and corporate advertisers. In the broadly representative context of the sport's increasingly monetized culture, Rose's tattoo can be seen to acknowledge the sophisticated visual practice anchoring American racial attitudes. In marking his skin with an image of Malcolm X, Rose arguably disables the interpretation of his own commodification—by the Chicago Bulls; by Adidas—as unsophisticated or racially unconscious in its own right.

Representations of Malcolm X since the 1980s, popular and otherwise, do more than signify on established cultural and historical themes; they act as material barometers of the relationship to blackness of authors, artists, and audiences. As any such notions of race are necessarily contingent, the iconography of Malcolm X continues to evolve. Indeed, its perpetual open-endedness results from the ongoing debate of how and by whom race and cultural politics—in the United States and beyond— should be defined and expressed. The next and final chapter considers a few more of the most recent images of Malcolm X, not least within the context of American electoral politics and the so-called War on Terror.

CONCLUSION

CONTINUING SIGNIFICATION

*Malcolm was extraordinary only because we paid attention to him—
because he was observable.*
James Small, *Malcolm's Echo*

More than any other figure, the iconic Malcolm X
has embodied in his pervasiveness and mutability the competing dis-
courses that have aspired to define or delimit modern black identity. I
have defined icons as visual receptacles of myth; indeed, Malcolm has
become a mythology unto himself, his life and death proving amenable
to narratives invoking a continuum of African American experience, im-
pelled by traditions of resistance and resilience and advancing toward an
idealized destination as yet unattained. His iconography portrays him as
uniting many of African American culture's most prominent modes and
figures, from the oratory of Frederick Douglass, to the black nationalism
of Marcus Garvey, to the artistic and popular culture rebellions of Miles
Davis and Kanye West. Malcolm's evolving representation demonstrates
the inevitability of change and commodification—some would say dim-
inution—in contemporary cultural practice. It also reveals the interde-
pendence of the visual and the linguistic in memorial and historical ex-
pression.

The iconography of Malcolm X reveals to us the pitfalls of inflexi-
ble ideologies of racial opposition or purity; the cumulative record of his
images—and their uses—identifies many of the tyrannies and tensions
inherent in notions of race. He has been cast as a figure of nostalgia and
legitimization, and, especially during his lifetime, of condemnation. For
some interpreters, Malcolm is taken as emblematic of a reconciliation
of the contradictory; for many others, he is aligned with one or other ex-
treme: he can represent equally rage and reason, revolution and ministry,
prison and mosque, street corner and college campus, black nationalism
and internationalism, jazz and hip-hop. He has been regarded as both
victim and vanquisher of racism's psychological devastation. Given the

lack of consensus about his meaning in contemporary culture and politics, it is perhaps unsurprising that Malcolm is a common referent in the disparate rhetoric at either end of the current period's fundamental (or fundamentalist) ideological dispute—that of the so-called War on Terror. Following an account of Malcolm's cultural afterlife on the streets of New York and London, the book closes with a consideration of what recent invocations of Malcolm by American president Barack Obama and by Al-Qaeda's Ayman al-Zawahiri suggest about his continuing significance and signification as we approach the fiftieth anniversary of his death.

Malcolm X in the City

Community activists, civic authorities, artists, and business owners have collaborated in inscribing the iconography of Malcolm X in the urban landscape of numerous cities. In New York, the city most associated with Malcolm, his name and image have been fixed to major thoroughfares, shops, a market, and the former Audubon Ballroom. Sonny Abubadika Carson, once Brooklyn's most prominent black nationalist activist and a founding member of the Republic of New Afrika, was responsible for Reid Avenue in Stuyvesant Heights being renamed Malcolm X Boulevard in 1985. The renaming, echoing Malcolm's own interest in self-appellation, officially acknowledged the prevailing African American character of the neighborhood. Despite this elevation to civic signage, Malcolm retains radical currency; his ideas and the content of his life have not been forgotten in Brooklyn. In April 2005 a stenciled image of Malcolm "began appearing spontaneously throughout the Williamsburg section of Brooklyn," accompanied by the words "Forget Self."[1] Appealing to the political nostalgia for the community activism associated with the 1960s and implicitly critiquing the perceived contemporary ethos of economic self-advancement, these graffiti portraits were also emblematic of grassroots resistance to the gentrification that threatened to displace many of the area's black residents. In East Elmhurst, Queens, plans for a Malcolm X memorial bust to be situated outside the former Shabazz family home on Ninety-seventh Street, renamed Malcolm X Place in 2005, have been under way since 2007, led by city councilman Hiram Monserrate.

Allusions to Malcolm are most abundant in Harlem, the site of his careers as hustler and minister and the traditional center of urban Af-

rican American culture. Lenox Avenue, Harlem's primary roadway, was conamed Malcolm X Boulevard in 1987. Running from 110th Street to 147th, the boulevard identifies Harlem as a distinct cultural space in Manhattan; along its length are found the Masjid Malcolm Shabazz, formerly the Nation of Islam's Mosque Number Seven; a number of businesses bearing Malcolm's name as both a spatial and cultural signifier; a mural depicting Malcolm alongside Martin Luther King, Harriet Tubman, Jesse Jackson, Rosa Parks, and Frederick Douglass; and, finally, the Schomburg Center for Research in Black Culture, which houses numerous archives relevant to the study of Malcolm X. Commercial uses of Malcolm are ubiquitous throughout Harlem. Vendors on 125th Street sell T-shirts featuring photo transfers of many of Malcolm's iconic poses, often pairing him with Martin Luther King or Fidel Castro, whom Malcolm met at the nearby Hotel Theresa in 1960. At the Malcolm Shabazz Harlem Market on 116th Street, West African traders also sell images of Malcolm.[2] In August 2008 one market stall was selling T-shirts with the face of then presidential hopeful Barack Obama superimposed over Malcolm's in the Associated Press photograph of Malcolm and King shaking hands in Washington, D.C. Inviting Harlemites to "Believe," the image evoked a sense of the imminence of African American historical triumph and a vindication of King's faith in American democracy—a political lineage in which Malcolm was shown to figure indirectly, if at all. This surprising erasure of Malcolm in Harlem, though anomalous, raised the question of whether some in the twenty-first century have elected to abandon him as a symbolic leader of African American struggle.

In early 2003 the Schomburg Center announced its repatriation of a cache of Malcolm's writings and personal effects, including speech notes, an address book, a Koran, newspaper clippings, receipts from hotels and the services of photographer Robert L. Haggins, plane and traffic tickets, budgets, business cards, an Egyptian coin, and, perhaps most significantly, the travel diaries from Malcolm's last year. Hoping to publish these diaries, Malcolm included captions for various photographs he wished to insert. The prospect of these diaries being published, with photographs of and by Malcolm, represents an opportunity for scholarly inquiry beyond the parameters established by the *Autobiography*. The collection, now available to the general public on microfilm, was nearly auctioned off to pay a Shabazz family debt in 2002. Marable criticized the

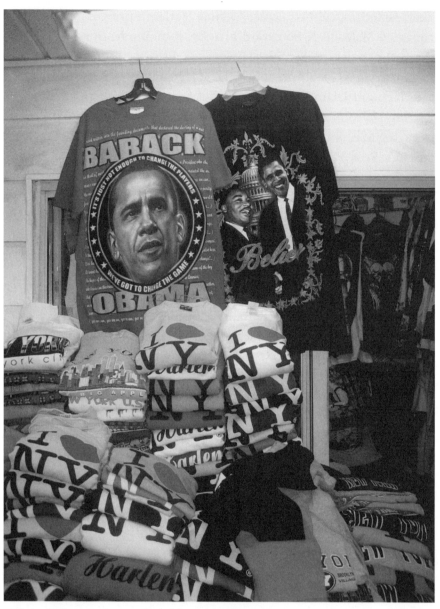

Malcolm Shabazz Harlem Market, 116th Street, August 2008. Photograph by Graeme Abernethy.

Shabazz family for failing to organize Malcolm's papers for the scholarly perusal of "future 'Malcolms' yet to be born." That no Malcolm X archive existed prior to the Schomburg acquisition meant "a tremendous speculative market for his memorabilia [arose] among private collectors"—just another instance of the competition for control of Malcolm's legacy.[3]

On 19 May 2005 a section of the Audubon Ballroom, where Malcolm's "Blood Still Stains the Floor," became the Malcolm X and Dr. Betty Shabazz Memorial and Educational Center.[4] Situated on Broadway between 165th and 166th Streets, the center opened after two decades of uncertainty about the Audubon's fate; Columbia University had purchased the site in 1983 and intended to tear it down to build a biomedical research facility in its place. On 21 February 1990 community activists launched the Malcolm X Save the Audubon Coalition (STAC) to halt the development plans, marching to the former ballroom with Malcolm X placards held aloft. In August 1990 a compromise was reached to preserve part of the building as a memorial. Although the center has been described as "largely an intellectually empty space, without meaningful political content or analysis," it does play host to a number of cultural activities, including plays, music, poetry readings, a youth reading club, and a human rights film festival.[5] In an evocation of Malcolm's final appearance, the center displays in its lobby a bronze life-size sculpture by Gabriel Koren of El-Hajj Malik El-Shabazz speaking into a microphone. The main wall of the upstairs auditorium exhibits a massive mural, *Homage to Malcolm X* (1997), by Daniel Galvez. The mural provides a visual biography in iconic terms, alluding to the central personae of the *Autobiography*: Detroit Red dances the lindy-hop; Malcolm X gives a speech; El-Hajj Malik El-Shabazz visits Africa.

In London, Malcolm has been invoked in the service of evolving diasporic notions of black identity. Indeed, very near the end of his life he addressed an audience of African, Afro-Caribbean, and black British observers in giving the "closing address at the First Congress of the Council of African Organisations, at the Africa Unity House in London."[6] Malcolm's continuing resonance in London, however, speaks as much to the popular currency of American culture as to cultural transmission across the African diaspora.

In 2009 photographer Robin Maddock produced *Our Kids Are Going to Hell*, a book of pictures taken while accompanying the Metropolitan

Police on minor drug raids in Hackney between 2005 and 2008. Depicting nocturnal streetscapes and sparsely furnished interiors, Maddock's portrayals of Hackney's social environment investigate "the condition of lost meaning and toxic poverty of the spirit" permitted to exist in the British capital.[7] In one photograph, a framed picture of El-Shabazz with the legend "By any means necessary" overlooks a table strewn with dominoes; other photos contain images of Marcus Garvey, Prince William, Queen Elizabeth II, Kurt Cobain, the Beatles, and 2Pac, and posters of paintings by Vincent Van Gogh and Gottfried Helnwein. The images that decorate the domestic spaces suggest both the generic signification of popular culture and an investment in iconic or rebellious figures.

Today, black British Londoners, many of Afro-Caribbean descent, celebrate and sell Malcolm's image on books, clothing, photographs, and posters in barbershops, bookshops, and market stalls in Brixton and Shepherd's Bush. The prevalence of such images, however, is no longer as pronounced as in the early 1990s, when areas such as Hackney's "Kingsland High Street, pulsated under the plethora of baseball caps and T-shirts festooned with the grey, silver or white 'X,' on Black (and some white) bodies, in the window displays of clothes shops or the market stalls of Ridley Road Market."[8] In 2013 images of Malcolm have given way in many cases to depictions of Barack Obama that emblematize an adherence to a narrative of progress for visible minorities in the West and a partial relinquishing of Malcolm's call for sustained vigilance. Images of Malcolm X are not confined to London's largely black neighborhoods. In August 2010 the phrase "by any means necessary" appeared in Nike's "Kill the Nil" advertising campaign for its new football at Arsenal's Emirates Stadium—the most plainly commercial reduction of Malcolm to date. In the summer of 2009 an artist on London's much-touristed South Bank was seen painting Malcolm from John Launois's close-up portrait in a mural that placed him alongside the iconic Gandhi and American president Barack Obama.

Barack Obama

Like Malcolm X, Barack Obama has become a cultural symbol of uncertain substance. Susceptible to the often self-serving projections and impositions of a variety of commentators and observers, the politically

chameleonic Obama has been framed as "both a black leader and a post-racial icon."[9] While, for some, Obama's election to the presidency in 2008 was a vindication of the investment of the civil rights movement in the institutions of American democracy, for others, and especially for "a small but robust segment" of Pan-Africanist radicals inspired by such figures as Malcolm X and Stokely Carmichael, "Obama's rise signals a repudiation of their long struggle for racial justice rather than its ultimate affirmation."[10] Such critics view the designation "post-racial" as a cynical marketing ploy designed to empty Obama of racial signification in an effort to appease white voters. Despite his political origins in community organizing on Chicago's largely African American South Side, Obama does represent a departure from the civil rights era—and certainly from the example of Malcolm X—in his approach to the politics of race.

Obama's own marketing of his racial narrative was established in the memoir *Dreams from My Father* (1995), which narrates an intellectual, if not a personal, encounter with the iconic Malcolm. The book was conceived in a spirit of literary aspiration and emotional disclosure that preceded Obama's first electoral candidacy, announced in September 1995. The book did not, however, take shape in a political vacuum. Born in 1961 near the pinnacle of the civil rights era, Obama began contemplating a career in public office in the 1980s; his writing of the memoir was interrupted by his participation in Project Vote, a 1992 voter registration drive aimed at the South Side. The campaign conflated the ballot with Black Power rhetoric, employing the slogan "It's a Power Thing" and the Spike Lee–inflected X as a dual signifier.[11]

Obama recalled grappling with resentment as a teenager in Hawaii after a childhood comparatively unclouded by the contemplation of race. Troubled by a newfound sense that "being black meant only the knowledge of your own powerlessness," the young "Barry" Obama "looked to corroborate this nightmare vision" in the books of Du Bois, Hughes, Wright, Ellison, and Baldwin. Evidently encountering these books with a post–Black Power skepticism, he found them riddled with "a self-contempt that neither irony nor intellect seemed able to deflect." Only *The Autobiography of Malcolm X*, with its redemptive myth of personal renewal, its example of "discipline, forged through sheer force of will," and its "blunt poetry," resolved for Obama the sense of outrage at racial injustice with "some hope of reconciliation . . . in a distant future, in a far-

off land." Like many others, Obama distanced himself from Malcolm's Islamic faith, determining that Malcolm's Nation of Islam–era "talk of blue-eyed devils and apocalypse" was merely "religious baggage that Malcolm himself seemed to have safely abandoned toward the end of his life."[12] The presentation of Malcolm as a potentially conciliatory figure is illustrative of the book's racial politics.

Dreams from My Father shares with the *Autobiography* a degree of anxiety about its subject's blackness relative to his mixed racial ancestry. The book recounts a debate, occurring among a group of African Americans on a basketball court in a university gym, addressing Malcolm's puritanical image:

"You all talking about Malcolm, huh? Malcolm tells it like it is, no doubt about it."

"Yeah," another guy said. "But I tell you what—you won't see me moving to no African jungle anytime soon. Or some goddamned desert somewhere, sitting on a carpet with a bunch of Arabs. No sir. And you won't see me stop eating no ribs."

"Gotta have them ribs."

"And pussy, too. Don't Malcolm talk about no pussy? Now you know that ain't gonna work."

I noticed Ray laughing and looked at him sternly. "What are you laughing at?" I said to him. "You don't even know what he says."

Ray grabbed the basketball out of my hand and headed for the opposite rim. "I don't need no books to tell me how to be black," he shouted over his head.[13]

The scene depicts Barry initially observing from the position of intellectual detachment that largely characterizes his relationship to the phenomenon of blackness in the book. Here, he less than convincingly wields his knowledge of the *Autobiography* as a form of authoritative blackness. The passage presents Obama's view of the path to African American identity as consisting in the negotiation of the dichotomous: the basketball court and the university; the vernacular and the literary; experience and the academic; the black and the white; the group and the

individual—negotiations with which the Malcolm of the *Autobiography* was also fundamentally concerned.[14]

Obama's 2008 presidential campaign deftly managed a politically volatile American racialism, particularly in his conciliatory 18 March speech on race, "A More Perfect Union." Although Obama did not mention Malcolm in the speech, he grappled indirectly with his cultural legacy in distancing himself from the controversial pronouncements made by his pastor, the Reverend Jeremiah Wright. A considerable controversy was stirred in the spring of 2008 when it was revealed that, among other statements deemed by critics to be anti-American, Wright had suggested that "chickens were coming home to roost" in the terrorist attacks of 11 September 2001; Wright's words were a paraphrase of Malcolm's comments on the assassination of John F. Kennedy nearly forty years earlier.[15] Nation of Islam leader Louis Farrakhan also offered a contentious endorsement of Obama's candidacy at the annual Saviour's Day convention in February 2008, which Obama found it politically expedient to denounce. That Obama has seemed reluctant to explicitly align himself with such figures as Malcolm, Wright, and Farrakhan, demonstrating instead a preference for a more moderate American pantheon featuring Abraham Lincoln and Martin Luther King, has strengthened the perception that Obama tacitly disavows meaningful African American leadership. It must be noted, however, that Obama's first presidential campaign was not entirely silent on the subject of Malcolm X.

Obama's campaign rhetoric self-consciously, if less than transparently, echoed that of Malcolm X, or rather Spike Lee's *Malcolm X*. A common refrain, used in reference to both Hillary Clinton and John McCain, was that his rivals sought to "hoodwink" and "bamboozle" voters with their willful misrepresentations.[16] Without acknowledging his source—a speech given by Denzel Washington in his portrayal of Malcolm—Obama delivered the words, with evident relish, as a wink of sorts at his African American supporters.[17] The line also played well with nonblack voters; in constructing (and chiding) his political opponents as enemies held in common with his audience, Obama established an advantage of easy rapport, much as Malcolm had done in his speeches and debates in the 1960s. Finally, on 4 June 2009, in a presidential speech given in Cairo and addressed to the Muslim world, Obama could hardly have avoided thinking of Malcolm when he opened with the traditional greeting "assa-

laamu alaykum" and went on to state that "Islam has always been a part of America's story."[18]

It is perhaps surprising that much of the white or conservative outcry that followed the revelation of Wright's comments about America's history of racism did not attempt to denigrate Obama by fixing upon the familiarly villainous image of Malcolm X. Indeed, it has been argued that the two men resemble each other. To Peniel Joseph, Obama's "long, lanky frame suggests (aesthetically at least) the lean, upright silhouette of both Malcolm X and Stokely Carmichael."[19] Some bloggers have even taken up the notion that Obama is in fact "Malcolm X's biological son and ideological heir."[20] More credibly, anxieties about Obama as a likely target for assassination resound with the cultural memory of Malcolm, King, and Medgar Evers.[21] In spite of such ultimately spurious visual and radical associations and justifiable fears—and in spite of his overt and covert references to Malcolm's influence upon him—Obama would succeed to America's highest office. Have the passage of time, the increasing visibility of African Americans in American culture, and the wider assimilation of the *Autobiography* and Spike Lee's film finally neutralized the knee-jerk paranoia once aroused by Minister Malcolm? More particularly, has Malcolm's perceived threat to the American mainstream been sufficiently defused that Obama will find it expedient to officially acknowledge the fiftieth anniversary of his death in 2015? Could there possibly emerge a monument to Malcolm X in Washington, D.C., a place he once described as "the citadel of world imperialism"?[22]

In some ways, the responses to Obama and his election do represent the absorption of Malcolm X into mainstream American culture or, perhaps, the Americanization of Malcolm X. Obama can be seen to have adapted Malcolm's example of bold, articulate African American leadership and his politics of Pan-Africanist unity to a mainstream American political context, demonstrating the broad relevance of his predecessor's model. It can also be argued that far-right conspiracy theorists who regard Obama as a secret practitioner of Islam are simply modifying irrational views first rehearsed in response to Malcolm X. Despite the obvious differences between the two men and their politics, one must acknowledge Malcolm as pertinent to any understanding of the first African American president. The same will necessarily be said about Obama's political heirs.

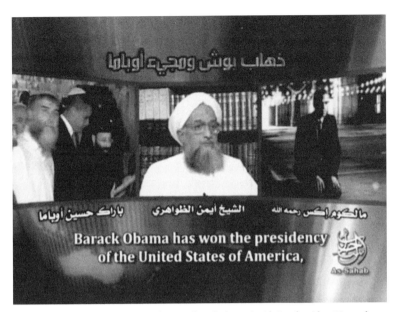

Barack Obama, Ayman al-Zawahiri, and Malcolm X in Al-Qaeda video, November 2008.

Al-Qaeda

In a video released on the Internet in November 2008, Al-Qaeda commander Ayman al-Zawahiri employed the rhetoric and image of Malcolm X in decrying Obama's election. Referring to Obama as a "house negro" protecting the interests of American imperialism, al-Zawahiri's voice appeared with subtitles and was accompanied by photographs juxtaposing Malcolm kneeling in prayer in Cairo and Obama in a yarmulke by the Western Wall in Jerusalem (implicating him in a tradition of American foreign policy support for Israeli interests in the Middle East). Al-Zawahiri also labeled Colin Powell and Condoleeza Rice as "house negroes" in opposition to "honourable black Americans like Malik al-Shabazz, or Malcolm X (may Allah have mercy on him)."[23] The video featured a brief clip of Malcolm speaking about an international revolution against Western imperialism.

Malcolm's Islamic faith has always been among the aspects of his life least embraced and understood by his many American interpreters. As such, the appropriation of Malcolm's legacy by mujahideen represents a nascent, troubling chapter in the unfolding and increasingly unbounded

iconography of Malcolm X. John Walker Lindh, "a suburban hip-hopper from an affluent Californian family who was turned into a Muslim fanatic through over-exposure to the prison-conversion autobiography of Malcolm X," demonstrated Malcolm's utility as a cultural weapon in Al-Qaeda recruitment.[24] Similarly, Londoner Richard Reid pleaded guilty in October 2002 to a botched suicide bombing of an American Airlines plane, claiming to be a follower of Osama bin Laden. Reid's black British father, Robin Reid, had expressly followed Malcolm's lead by converting to Islam in prison; he later encouraged his son to do the same.[25]

Announcing the arrival of Malcolm studies in the 1990s, Joe Wood queried, "*How does Malcolm's icon work? And what does it say?*"[26] Only a dedicated study of Malcolm's campaign of collaborative self-representation across a continually increasing variety of written and visual media provides the answers. While Malcolm found it necessary to engage with the apparatus of mass media, including journalists and photographers, in order to reach a wide audience, he exerted—and continues to exert—a remarkable degree of control over his cultural image. His contributions to journalism, television, photography, literature, film, and visual arts from the 1950s to the present demonstrate his ongoing utility as a symbol of the struggle for social and racial justice in an ever-shifting political and technological landscape.

It has been written that "Malcolm will always be exactly who he is, whether or not we as a society ever succeed in figuring him out. Truth does not change, only our awareness of it."[27] Despite the frequent use of Malcolm X/Detroit Red/El-Hajj Malik El-Shabazz to identify and, at times, exploit the perceived fissures in human society—whether in terms of ideology, nationality, race, or religion—he is not reducible to the "convenient symbol of 'hatred'" that the *Autobiography* foretold. Malcolm's continued resonance emerges from his life's example of the refusal to be "fixed in one position for very long." The *Autobiography*'s final chapter in fact announced Malcolm's ultimate ambition: "I would just like to *study*."[28] In this, we should follow his lead.

NOTES

INTRODUCTION: THE SCIENCE OF IMAGERY

1. Robert E. Terrill, *Malcolm X: Inventing Radical Judgment* (East Lansing: Michigan State University Press, 2004), 12.

2. John Edgar Wideman, "Malcolm X: The Art of Autobiography," in *Malcolm X: In Our Own Image*, ed. Joe Wood (New York: St. Martin's, 1992), 103.

3. Michael Eric Dyson, *Making Malcolm* (Oxford: Oxford University Press, 1995), 152. Peter Goldman, *The Death and Life of Malcolm X*, 2nd ed. (Chicago: University of Illinois Press, 1979), 381.

4. James H. Cone, *Martin and Malcolm and America* (Maryknoll, N.Y.: Orbis, 1991), 41.

5. Malcolm X and Alex Haley, *The Autobiography of Malcolm X* (New York: Ballantine, 1999), 346. All subsequent citations of the *Autobiography* are from this edition unless specified otherwise.

6. Alan Trachtenberg, *Lincoln's Smile and Other Enigmas* (New York: Hill & Wang, 2007), 75–76.

7. James Jennings, "The Meaning of El-Hajj Malik El-Shabazz in the 1980s," in *Malcolm X: Justice Seeker*, ed. James B. Gwynne (New York: Steppingstones, 1993), 33.

8. Malcolm X, "Not Just an American Problem," in *February 1965: The Final Speeches* (New York: Pathfinder, 1992), 152.

9. Sara Blair, *Harlem Crossroads* (Princeton, N.J.: Princeton University Press, 2007), 10.

10. Wilson Jeremiah Moses, *Black Messiahs and Uncle Toms* (London: Pennsylvania State University Press, 1982), 52.

11. Like Manning Marable's much publicized biography, *Malcolm X: A Life of Reinvention* (New York: Viking, 2011), this book demonstrates the importance of a dynamic understanding of Malcolm and his legacy. Providing a more up-to-date—and certainly more comprehensively illustrated—account of Malcolm's cultural afterlife than Dyson's *Making Malcolm*, and a more focused analysis than Robert E. Terrill's edited collection *The Cambridge Companion to Malcolm X* (Cambridge: Cambridge University Press, 2010), this book will also extend Robin D. G. Kelley's discussion, in *Race Rebels: Culture, Politics, and the Black Working Class* (New York: Free Press, 1994), of Malcolm's continuity of consciousness to encompass *all* of his incarnations, from Malcolm Little to El-Hajj Malik El-Shabazz.

12. Gregor Goethals, "Sacred-Secular Icons," in *Icons of America*, ed. Ray B. Browne and Marshall Fishwick (Bowling Green, Ohio: Popular Press, 1978), 25.

13. David Gerald Orr, "The Icon in the Time Tunnel," in Browne and Fishwick, *Icons of America*, 14.

14. Ibid., 14.

15. Erwin Panofsky, *Studies in Iconology* (London: Harper & Row, 1972), 6.

16. Unlike Judaism and Islam, religions associated with nonrepresentational art, Christianity has been uniquely supportive of iconography. Scripture implies that "everything and everybody, God, Christ, people, and nature are in a constant iconic relationship, a *prototype* versus *image* relationship" modeled on Creation and affirmed by the Incarnation. See Ulf Abel, "The Icon-Image of the Divine on the Theology of Icons," in *Five Essays on Icons* (Istanbul: Svenska Forskningsinstitutet, 2005), 12.

17. Claudia Springer, *James Dean Transfigured* (Austin: University of Texas Press, 2007), 10, 18.

18. Wood, "Malcolm X," 5.

19. Robert Hariman and John Louis Lucaites, "Public Identity and Collective Memory in U.S. Iconic Photography: The Image of 'Accidental Napalm,'" *Critical Studies in Media Communication* 20, no. 1 (March 2003): 38.

20. Goethals, "Sacred-Secular Icons," 24.

21. Guy Debord, "The Commodity as Spectacle," in *Media and Cultural Studies*, ed. Meenakshi Gigi Durham and Douglass M. Kellner (Oxford: Blackwell, 2006), 119.

22. Walter Benjamin, "The Work of Art in the Age of Mechanical Reproduction," in *Illuminations* (London: Jonathan Cape, 1970), 223.

23. Hariman and Lucaites, "Public Identity and Collective Memory," 37, 42.

24. Marshall Fishwick, "Icons of America," in Browne and Fishwick, *Icons of America*, 3.

25. Elizabeth A. Castelli, "The Ambivalent Legacy of Violence and Victimhood: Using Early Christian Martyrs to Think With," *Spiritus* 6, no. 1 (Spring 2006): 1.

26. Bent Sørensen, "Sacred and Profane Icon-Work: Jane Fonda and Elvis Presley," in *U.S. Icons and Iconicity*, ed. Walter W. Hölbling, Klaus Rieser, and Susanne Rieser (Vienna: LIT, 2006), 238.

27. Castelli, "Ambivalent Legacy," 1, 2.

28. Robert Hariman and John Louis Lucaites, *No Caption Needed* (London: University of Chicago Press, 2007), 2, 7, 9.

29. Springer, *James Dean Transfigured*, 9, 4.

30. David Kunzle, "Fusion: Christ and Che," *Che Guevara: Revolutionary and Icon*, ed. Trisha Ziff (London: V & A Publications, 2006), 88.

31. Brian Wallis, "Che Lives!" in Ziff, *Che Guevara*, 27.

32. Ibid., 30.

33. Hariman and Lucaites, "Public Identity and Collective Memory," 58.

34. Charles Sanders Peirce, "What Is a Sign?" in *The Essential Peirce: Selected Philosophical Writings, vol. 2 (1893–1913)*, ed. Pierce Edition Project (Bloomington: Indiana University Press, 1998), 10.

35. Gyan Pandey, "Peasant Revolt and Indian Nationalism," in *Selected Subaltern Studies,* ed. Ranajit Guha and Gayatri Chakravorty Spivak (Oxford: Oxford University Press, 1988), 254–255.

36. *Malcolm X,* directed by Arnold Perl (Warner Brothers, 1972).

37. Malcolm's origins in fact represent the increasingly convoluted advancement of the African diaspora: his father, Earl Little, a native of Georgia, met his mother, Louise, born in Grenada, British West Indies, at a meeting of Marcus Garvey's United Negro Improvement Association in Montréal, Canada.

38. William Strickland, *Malcolm X: Make It Plain* (New York: Penguin, 1994), 198.

39. James Baldwin, "Martin and Malcolm," in *Malcolm X: As They Knew Him,* ed. David Gallen (New York: Carroll & Graf, 1992), 266.

40. Manning Marable, "Malcolm X's Life After Death," *American Legacy* 8, no. 3 (Fall 2002): 45.

41. David L. Dudley, *My Father's Shadow* (Philadelphia: University of Pennsylvania Press, 1991), 183.

42. X and Haley, *Autobiography,* 463.

43. Manning Marable, *Living Black History* (New York: Basic Civitas, 2006), 159.

44. Robert F. Sayre, *The Examined Self* (Princeton, N.J.: Princeton University Press, 1964), 16.

45. Paul John Eakin, "Malcolm X and the Limits of Autobiography," *Criticism* 18, no. 3 (Summer 1976): 231.

46. X and Haley, *Autobiography,* 415.

47. Ibid., 135.

48. Baraka wrote of abandoning an interracial family and a life of downtown bohemianism to establish the Black Arts Repertory Theater/School in Harlem within "a few days" of hearing the news of Malcolm's death. See Amira Baraka, *The Autobiography of LeRoi Jones* (New York: Freundlich, 1984), 201.

49. Dudley, *My Father's Shadow,* 183.

50. Marable, "Malcolm X's Life After Death," 46.

51. Adolph Reed, Jr., "The Allure of Malcolm X and the Changing Character of Black Politics," in Wood, *Malcolm X,* 231.

52. Nell Irvin Painter, "Malcolm X Across the Genres," *American Historical Review* 98, no. 2 (April 1993): 433.

53. Marable, *Living Black History,* 132.

54. Fishwick, "Icons of America," 4.

55. Wood, "Malcolm X," 6.

CHAPTER ONE: EARLY IMAGES OF MALCOLM X

1. E. U. Essien-Udom, *Black Nationalism* (Harmondsworth, U.K.: Penguin, 1966), 12.

2. Cone, *Martin and Malcolm*, 162.

3. Goldman, *Death and Life*, 62–63.

4. C. Eric Lincoln, *The Black Muslims in America* (Boston: Beacon, 1961), 208.

5. X and Haley, *Autobiography*, 162.

6. Kenneth B. Clark, ed., *King, Malcolm, Baldwin* (Middletown, Conn.: Wesleyan University Press, 1985), 41.

7. *The Hate that Hate Produced*. WDNT-TV, 13–17 July 1959.

8. Clayborne Carson, *Malcolm X: The FBI File*, ed. David Gallen (New York: Carroll & Graf, 1991), 147–148, 151–152.

9. X and Haley, *Autobiography*, 270.

10. Ibid., 241; Bruce Perry, *Malcolm: The Life of a Man Who Changed Black America* (Barrytown, N.Y.: Station Hill, 1991), 167; A. B. Spellman, "Interview with Malcolm X," *Monthly Review*, May 1964, 16.

11. Richard Hofstadter, "The Paranoid Style in American Politics," *Harper's*, November 1964, 82.

12. Louis Lomax, *The Negro Revolt* (New York: Harper & Row, 1962), 168, 177.

13. Alfred Balk and Alex Haley, "Black Merchants of Hate," *Saturday Evening Post*, 26 January 1963, 68.

14. "Races: The Black Supremacists," *Time*, 10 August 1959, 25.

15. Determined to preserve his journalistic integrity in spite of his "peculiar position" as a mediator of the "black movement" and the "white establishment," in 1963 Parks turned down Elijah Muhammad's offer of $500,000 to make a film about the Nation. See Gordon Parks, *Voices in the Mirror* (New York: Doubleday, 1990), 216, 221.

16. Gordon Parks, "The Black Muslims (May 1963)," in *Born Black* (New York: J. B. Lippincott, 1971), 25–26.

17. Clark, *King, Malcolm, Baldwin*, 33.

18. Benjamin Karim, Peter Skutches, and David Gallen, *Remembering Malcolm* (New York: Carroll & Graf, 1992), 133.

19. X and Haley, *Autobiography*, 390. The *Reader's Digest* article, "Mr. Muhammad Speaks," appeared in March 1960.

20. X and Haley, *Autobiography*, 241.

21. Lincoln, *Black Muslims*, 189, iv.

22. X and Haley, *Autobiography,* 287. Malcolm expressed disdain for Lincoln's motives in a 1963 interview: "Lincoln is just a Christian preacher from Atlanta, Georgia, who wanted to make some money, so he wrote a book and called it *The Black Muslims in America*" (Clark, *King, Malcolm, Baldwin,* 39). The Nation's interest may have been similarly mercenary. According to Elijah Muhammad, the Nation was offered a commission by Beacon Press to sell copies of Lincoln's book. See "Letter to Malcolm X, 23 March 1961," Malcolm X Collection: Papers, 1948–1965, Schomburg Center for Research in Black Culture, New York Public Library (hereafter cited as Malcolm X Papers).

23. Essien-Udom, *Black Nationalism,* 265.

24. Goldman, *Death and Life,* 59.

25. Karim et al., *Remembering Malcolm,* 49–50.

26. Parks, *Voices in the Mirror,* 222.

27. Although, as Eithne Quinn indicates, "the term *underclass* first entered mainstream discourses to describe nonwhite urban communities [only] in the late 1970s," the attendant process of social stigmatization was long-standing. See *Nuthin' but a 'G' Thang* (New York: Columbia University Press, 2004), 210.

28. "Races: The Black Supremacists," 25.

29. Lincoln, *Black Muslims,* 199.

30. Balk and Haley, "Black Merchants," 68.

31. Lincoln, *Black Muslims,* 189, 199.

32. Balk and Haley, "Black Merchants," 72.

33. James Jennings, "The Meaning of El-Hajj Malik El-Shabazz in the 1980s," in *Malcolm X: Justice Seeker,* ed. James B. Gwynne (New York: Steppingstones, 1993), 33.

34. Malcolm X, "The Ballot or the Bullet," *Norton Anthology of African American Literature,* 2nd ed., ed. Henry Louis Gates, Jr., and Nellie Y. McKay (New York: Norton, 2004), 120, 124–125.

35. Malcolm X, "The *Playboy* Interview: Malcolm X speaks with Alex Haley," in Gallen, *Malcolm X,* 116.

36. Lincoln, *Black Muslims,* 192, 195.

37. Malcolm X, "The *Playboy* Interview," 124.

38. Lincoln, *Black Muslims,* 196.

39. Karim et al., *Remembering Malcolm,* 146–161; Carson, *Malcolm X,* 97.

40. Lomax, *Negro Revolt,* 168. In 1968 an FBI memorandum described Malcolm as a "messiah" figure and "the martyr of the movement today"; Elijah Muhammad, unlike such youthful figures as Martin Luther King and Stokely Carmichael, was not considered a significant threat to society "because of his age" (Carson, *Malcolm X,* 17).

41. Lomax, *Negro Revolt*, 164, 170.

42. Wayne Taylor, "Premillennium Tension: Malcolm X and the Eschatology of the Nation of Islam," *Souls* 7 no. 1 (Winter 2005): 55.

43. William Van Deburg, *Black Camelot* (London: University of Chicago Press, 1997), 1–2; Wilson Jeremiah Moses, *Black Messiahs and Uncle Toms* (London: Pennsylvania State University Press, 1982), 2.

44. Essien-Udom, *Black Nationalism*, 120. Michael A. Gomez has challenged the Nation's myth of racial purity, claiming that the "Asiatic" Fard Muhammad "was born Wali Dodd Fard on February 25, 1891 in New Zealand. His father was Zared Fard, an East Indian, and either Zared Fard or his parents came to New Zealand from what is now Pakistan. Fard Muhammad's mother Beatrice was a white Englishwoman living in New Zealand" (*Black Crescent*, 276–278).

45. Moses, *Black Messiahs*, 187.

46. Frantz Fanon, *The Damned* (Paris: Présence Africaine, 1963), 170.

47. Essien-Udom, *Black Nationalism*, 149.

48. Moses, *Black Messiahs*, 95, 70, 208.

49. Booker T. Washington, *Up from Slavery* (New York: Dover, 1995), 35, 84.

50. Ibid., 28; William Van Deburg, *Slavery and Race in American Popular Culture* (Madison: University of Wisconsin Press, 1984), 30.

51. Karim et al., *Remembering Malcolm*, 134; Edward E. Curtis IV, "Islamizing the Black Body: Ritual and Power in Elijah Muhammad's Nation of Islam," *Religion and American Culture* 12, no. 2 (Summer 2002): 175, 174.

52. Gomez, *Black Crescent*, 322; X and Haley, *Autobiography*, 158.

53. Frederick Douglass, "Narrative of the Life of Frederick Douglass, an American Slave, Written by Himself," in Gates and McKay, *Norton Anthology*, 448.

54. Martin Luther King, Jr., "The *Playboy* Interview: Martin Luther King," *Playboy*, January 1965, accessed 29 June 2012, http://www.playboy.com/arts-entertainment/features/mlk/index.html.

55. Malcolm X, "*Playboy* Interview," 119, 130.

56. X and Haley, *Autobiography*, 177.

57. Essien-Udom, *Black Nationalism*, 177.

58. Gomez, *Black Crescent*, 319.

59. Malcolm X, "*Playboy* Interview," 121.

60. Gomez, *Black Crescent*, 299–300.

61. Essien-Udom, *Black Nationalism*, 124; X and Haley, *Autobiography*, 167–170.

62. Essien-Udom, *Black Nationalism*, 211, 127.

63. Cornel West, "Malcolm X and Black Rage," in *Malcolm X: In Our Own Image*, ed. Joe Wood (New York: St. Martin's, 1992), 48–49.

64. Fanon, *The Damned*, 176.

65. Moses, *Black Messiahs,* 209.

66. *The Hate That Hate Produced.*

67. X, "Not Just an American Problem," 152, 156.

68. Jan Carew, *Ghosts in Our Blood* (Chicago: Lawrence Hill, 1994), 118.

69. X and Haley, *Autobiography,* 171.

70. Thulani Davis, "Malcolm X: Image, Myth, Ideas," in *Malcolm X: The Great Photographs,* ed. Howard Chapnick (New York: Stewart, Tabori & Chang, 1993), 24–25.

71. Mel Watkins, *Stepin Fetchit* (New York: Vintage, 2005), 4.

72. Van Deburg, *Slavery and Race,* 38.

73. James Baldwin, *The Devil Finds Work* (London: Corgi, 1976), 64.

74. Larry Neal, "Beware of the Tar Baby," *New York Times,* 3 August 1969, D13.

75. Thomas Cripps, *Slow Fade to Black* (New York: Oxford University Press, 1977), 3, 9–10.

76. X and Haley, *Autobiography,* 278.

77. Essien-Udom, *Black Nationalism,* 92.

78. X and Haley, *Autobiography,* 278.

79. Clark, *King, Malcolm, Baldwin,* 42–43.

80. Kasia Boddy, *Boxing* (London: Reaktion, 2008), 315; Crispin Sartwell, *Act Like You Know* (Chicago: University of Chicago Press, 1998), 21.

81. Miles Davis, "The *Playboy* Interview with Alex Haley," in *Miles Davis and American Culture,* ed. Gerald Early (Saint Louis: Missouri Historical Society, 2001), 200–201.

82. Perry, *Malcolm,* 82.

83. Linda G. Tucker, *Lockstep and Dance* (Jackson: University Press of Mississippi, 2007), 62.

84. X and Haley, *Autobiography,* 277.

85. Malcolm X, "The Ballot or the Bullet," 120.

86. King, "The *Playboy* Interview."

87. X and Haley, *Autobiography,* 286.

88. Ibid., 287.

89. Sasha Torres, *Black, White, and in Color* (Princeton, N.J.: Princeton University Press, 2003), 15, 13.

90. Donald Bogle, *Primetime Blues* (New York: Farrar, Straus & Giroux, 2001), 76–77, 85.

91. Ibid., 6.

92. Torres, *Black, White,* 19.

93. Walter Benjamin, "The Work of Art in the Age of Mechanical Reproduction," in *Illuminations* (London: Jonathan Cape, 1970), 235.

94. Torres, *Black, White,* 90.

95. Ibid., 13.

96. Theodor Adorno, *The Culture Industry* (London: Routledge, 1991), 146.

97. Baldwin, *Devil Finds Work,* 34.

98. Van Deburg, *Black Camelot,* 3.

99. Hariman and Lucaites, "Public Identity and Collective Memory," 58.

100. Thomas Cripps, "The Noble Black Savage: A Problem in the Politics of Television Art," *Journal of Popular Culture* 8, no. 4 (Spring 1975): 690.

101. Essien-Udom, *Black Nationalism,* 76.

102. Malcolm described the documentary as "a kaleidoscope of 'shocker' images" (*Autobiography,* 242).

103. The term "Black Muslims" was coined by C. Eric Lincoln, perhaps following misguidedly from his assessment that "the Muslims prefer to be called 'Black Men'" rather than "Negroes" (*Black Muslims,* 68).

104. *The Hate That Hate Produced.*

105. Karim et al., *Remembering Malcolm,* 107.

106. William Strickland, *Malcolm X: Make It Plain* (New York: Penguin, 1994), 159.

107. X and Haley, *Autobiography,* 313.

108. Ibid., 314.

109. Lincoln, *Black Muslims,* 95.

110. "Malcolm Rejects Racist Doctrine," *Front Page Challenge,* CBC Television, 5 January 1965.

111. bell hooks, *We Real Cool* (London: Routledge, 2004), 93.

112. Strickland, *Malcolm X,* 107.

113. *Malcolm X: Make It Plain,* directed by Orlando Bagwell (Blackside, 1994).

114. Strickland, *Malcolm X,* 97.

115. Carson, *Malcolm X,* 269. Nat Hentoff wrote in 1964 that "Martin Luther King, on his way to a New York civil rights rally a couple of years ago, told a friend, 'I just saw Malcolm X on television. I can't deny it. When he starts talking about all that's been done to us, I get a twinge of hate, of identification with him.'" See *The New Equality* (New York: Viking, 1964), 47–48.

116. Saul Bellow, *Herzog* (Harmondsworth, U.K.: Penguin, 1965), 222.

117. Torres, *Black, White,* 68.

118. Perl, *Malcolm X.*

119. Alex Haley, "Alex Haley Remembers," in Gallen, *Malcolm X,* 245.

120. X and Haley, *Autobiography,* 249.

121. Goldman, *Death and Life,* 16.

122. X and Haley, *Autobiography,* 249.

123. John Eligon, "Malcolm X Trove Hidden during Feud," *New York Times*, 8 February 2011, accessed 29 June 2012, http://www.nytimes.com/2011/02/09/nyregion/09shabazz.html?pagewanted=all.

124. Essien-Udom, *Black Nationalism*, 168.

125. Rosemari Mealy, *Fidel and Malcolm X* (Melbourne: Ocean, 1993), 29.

126. James Tyner, *The Geography of Malcolm X* (New York: Routledge, 2006), 45.

127. Essien-Udom, *Black Nationalism*, 189.

128. Carew, *Ghosts*, 101.

129. Karim et al., *Remembering Malcolm*, 125.

130. Van Deburg, *Black Camelot*, 6.

131. David Gallen and Peter Skutches, "As They Knew Him: Oral Remembrances of Malcolm X," in Gallen, *Malcolm X*, 29, 47, 42.

132. Ibid., 58.

133. Chapnick, *Malcolm X: The Great Photographs*, 61–63, 68–71.

134. The reverse angle of Parks's photograph can be viewed in a shot taken at very nearly the same moment from amongst the crowd of spectators by Robert L. Haggins (Strickland, *Malcolm X*, 141). Parks's camera is visible behind Malcolm to the right of the frame.

135. Henri Cartier-Bresson, *The Decisive Moment* (New York: Simon & Schuster, 1952), n.p.

136. Goldman, *Death and Life*, 6.

137. Mealy, *Fidel and Malcolm X*, 12, 21, 31, 47.

138. Ibid., 43, 44.

139. Ibid..

140. It is no testament to Nesfield's professionalism or good fortune that, eventually, his "negatives were thrown away in the trash by a landlord, including the negative of that famous picture of Fidel and Malcolm" (Mealy, *Fidel and Malcolm X*, 45).

141. Gallen and Skutches, "As They Knew Him," 58.

142. Goldman indicated, however, that profanity was forbidden to members of the Nation: "Malcolm wouldn't even say 'hell' unless powerfully moved" (*Death and Life*, 387–388, 83).

143. Strickland, *Malcolm X*, 146.

144. Roland Barthes, *Camera Lucida* (London: Jonathan Cape, 1982), 115, 4.

145. Ibid., 32, 94–97.

146. Barbie Zelizer, "The Voice of the Visual in Memory," in *Framing Public Memory*, ed. Kendall R. Phillips (Tuscaloosa: University of Alabama Press, 2004), 176, 163, 180.

147. Barthes, *Camera Lucida*, 82.

148. Carol Tulloch, "'My Man, Let Me Pull Your Coat to Something': Malcolm X," in *Fashion Cultures,* ed. Stella Bruzzi and Pamela Church Gibson (London: Routledge, 2000), 299.

149. Claude McKay, *Banjo* (New York: Harcourt Brace Jovanovich, 1957), 324.

150. Karim et al., *Remembering Malcolm,* 168.

151. X and Haley, *Autobiography,* 196.

152. Tulloch, "'My Man,'" 308, 303.

153. *Life* initially refused Arnold's photo essay on the grounds of the Nation of Islam's obscurity at the time. When it was to be published, a photograph "of the wife and daughter of Elijah Muhammad at prayer" clashed uncomfortably with an intended "advertisement for Oreo cookies that read, 'The Greatest Chocolate Cookie of Them All.' The editors removed my embarrassing editorial material. The ad stayed." Eve Arnold, *In Retrospect* (London: Sinclair-Stevenson, 1996), 68–69.

154. Ibid., 62–63.

155. Ibid., 60, 63.

156. Although now typically associated with Malcolm X, the browline eyeglass frame—often mistaken for horn-rims—was exceedingly common in the United States following World War II. Consisting of plastic caps and arms and metal frames, browlines were worn by, among others, the ubiquitous Colonel Sanders of Kentucky Fried Chicken.

157. George Elliot Clarke, "Cool Politics: Styles of Honour in Malcolm X and Miles Davis," *Jouvert* 2, no. 1 (1998), accessed 29 June 2012, http://social.chass. ncsu.edu/jouvert/v2i1/Clarke.htm. According to Amiri Baraka (LeRoi Jones), "to be *cool* was, in its most accessible meaning, to be calm, even unimpressed, by what horror the world might daily propose. . . . In a world that is basically irrational, the most legitimate relationship to it is nonparticipation." See *Blues People* (New York: Morrow Quill, 1963), 213.

158. Clarke, "Cool Politics."

159. Gerald Early, "The Art of the Muscle: Miles Davis as American Knight and American Knave," in Early, *Miles Davis and American Culture,* 7–8, 19.

160. Ibid., 16, 21.

161. Ingrid Monson, "Miles, Politics, and Image," in Early, *Miles Davis and American Culture,* 87. A convincing comparison could also be made of Malcolm X and John Coltrane, whose "spiritualized racial consciousness seemed the romanticized ideal of a counterculture impulse that rebelled against a hypocritical, racist, materialist America. Coltrane, previously a sloppy drunk and drug addict, cleaned himself up and found redemption in the purity of art or the quest for pure artistic expression" (Early, "Art of the Muscle," 14). Like Malcolm, Coltrane died at age 39.

162. Muhammad Ali and Richard Durham, *The Greatest* (Frogmore, U.K.: Mayflower, 1976), 120.

163. Following a speech given 1 December 1963 at the Manhattan Center, Malcolm, responding to a question from the audience about Kennedy's death, stated that it was a case of "the chickens coming home to roost" in an American culture marked by domestic and international violence. R. W. Apple, Jr., "Malcolm X Silenced for Remarks on Assassination of Kennedy," *New York Times*, 5 December 1963, 22.

164. Chapnick, *Malcolm X*, 104–107.

165. Bob Mee, *Liston and Ali* (Edinburgh: Mainstream, 2010), 213.

166. Ali and Durham, *The Greatest*, 120, 123.

167. Perry, *Malcolm*, 249.

168. Baldwin, "Martin and Malcolm," 276.

169. Marshall Frady, "The Children of Malcolm," *New Yorker*, 12 October 1992, 64.

170. "Malcolm Rejects Racist Doctrine."

171. Malcolm X, "Why I Came to Selma: Remarks to the Press, February 4, 1965," in *February 1965: The Final Speeches*, 24; Malcolm X, "The House Negro and the Field Negro: Selma, Alabama, February 4, 1965," in *February 1965: The Final Speeches*, 27.

172. Martin Luther King, Jr., *The Autobiography of Martin Luther King, Jr.* (London: Abacus, 2000), 268.

173. "Obituary: Malcolm X," *New York Times*, 22 February 1965, 20. It can be seen that King moved closer to sympathy with Malcolm's politics following the latter's assassination. King's participation in the Chicago Freedom Movement in the summer of 1966 introduced him to many of the northern urban conditions that molded the lives of Malcolm and his constituency.

174. X and Haley, *Autobiography*, 353.

175. Ibid., 352.

176. In fact, Malcolm used the name Shabazz throughout his tenure with the Nation; as early as 1949, he was signing his prison correspondence with the name "Malachi Shabazz" (Gomez, *Black Crescent*, 367–368).

177. Chapnick, *Malcolm X*, 124–129.

178. X and Haley, *Autobiography*, 346–347; Eldridge Cleaver, *Soul on Ice* (London: Panther Modern Society, 1970), 61.

179. Cleaver, *Soul on Ice*, 60.

180. X and Haley, *Autobiography*, 365.

181. Eugene Majied, "Malcolm X Cartoon," *Muhammad Speaks*, 10 April 1964, 15.

182. Malcolm X, "An Interview by A. B. Spellman," in *By Any Means Necessary,* ed. George Breitman (New York: Pathfinder, 1992), 11; Malcolm X, "The Ballot or the Bullet," 124.

183. Cone, *Martin and Malcolm,* 266; Goldman, *Death and Life,* 155.

184. Goldman, *Death and Life,* 186.

185. X and Haley, *Autobiography,* 145–146, 423, 102.

186. Karim et al., *Remembering Malcolm,* 185; Gomez, *Black Crescent,* 333.

187. Hariman and Lucaites, *No Caption Needed,* 197.

188. Peter Kihss, "Malcolm X Shot to Death at Rally Here," *New York Times,* 22 February 1965, 1, 10.

189. Perl, *Malcolm X.*

190. Parks, "The Death of Malcolm X," 55.

191. Moses, *Black Messiahs,* 48.

192. Zelizer, "The Voice," 166.

193. Hariman and Lucaites, *No Caption Needed,* 149; Frady, "Children of Malcolm," 64.

194. Torres, *Black, White,* 26.

195. Karim et al., *Remembering Malcolm,* 52; Chapnick, *Malcolm X,* 83.

196. Davis, "Malcolm X," 13.

197. Herman Ferguson, "The Price of Freedom," *Souls* 7, no. 1 (Winter 2005): 101.

198. Variations on this image appeared on the 22 February 1965 front pages of the *New York Times* and *Los Angeles Times,* among others.

199. Goldman, *Death and Life,* 291–292.

200. Karim et al., *Remembering Malcolm,* 193.

201. Carew, *Ghosts,* 7.

202. Hariman and Lucaites, *No Caption Needed,* 151; Guy Debord, "The Commodity as Spectacle," in *Media and Cultural Studies,* ed. Meenakshi Gigi Durham and Douglass M. Kellner (Oxford: Blackwell, 2006), 120.

203. Hariman and Lucaites, "Public Identity," 36.

204. Benjamin, "Work of Art," 228.

205. Barthes, *Camera Lucida,* 53.

206. Carew, *Ghosts,* 94.

207. Ibid., 5.

CHAPTER TWO: *THE AUTOBIOGRAPHY OF MALCOLM X*

1. X and Haley, *Autobiography,* 2.

2. Ibid., 459.

3. Strickland, *Malcolm X*, 217.

4. Ibid., 346.

5. Ibid., 339.

6. Malcolm X, "I'm Talking to You, White Man: An Autobiography by Malcolm X," *Saturday Evening Post*, 12 September 1964, 31.

7. Malcolm X, "Letter to M. S. Handler, 22 September 1964," and "Letter to M. S. Handler, 23 September 1964," Alex Haley Papers, 1967–1990, Box 3, Folder 1, Schomburg Center for Research in Black Culture, New York (hereafter cited as Haley Papers).

8. X and Haley, *Autobiography*, 426; "The Lesson of Malcolm X," *Saturday Evening Post*, 12 September 1964, 84.

9. "The Lesson of Malcolm X," 84.

10. Ibid.

11. Balk and Haley, "Black Merchants," 71–72.

12. Essien-Udom, *Black Nationalism*, 96.

13. David Bradley, "Malcolm's Mythmaking," *Transition* 56, no. 2 (November 1992): 35.

14. X, "I'm Talking to You," 31.

15. Ibid.

16. Ibid., 53.

17. Marable, *Living Black History*, 148–149, 152–153.

18. X, "I'm Talking to You," 53.

19. Alex Haley, "RCA telegram to Malik El Shabazz, 8 August 1964," Haley Papers, Box 3, Folder 1.

20. Linda Anderson, *Autobiography* (New York: Routledge, 2001), 3.

21. Tulloch, "'My Man,'" 301, 300.

22. X and Haley, *Autobiography*, 153, my emphasis.

23. Eakin, "Malcolm X," 231–232, 242.

24. X and Haley, *Autobiography*, 415.

25. Marable, *Living Black History*, 149.

26. Eakin, "Malcolm X," 233; Alex Haley, undated letter to Murray Fisher, Haley Papers, Box 1a, Folder 15.

27. Eakin, "Malcolm X," 236.

28. X and Haley, *Autobiography*, 394.

29. Ibid., v.

30. Malcolm X and Alex Haley, "Author/Collaborator Letter of Agreement, 1 June 1963"; Alex Haley, "Letter to Paul R. Reynolds, June 16, 1964," Malcolm X Papers.

31. Eakin, "Malcolm X," 231.

32. X and Haley, *Autobiography*, 396, 399.

33. Alex Haley, "Black History, Oral History, and Genealogy," *Oral History Review* (1973): 8.

34. Dudley, *My Father's Shadow*, 182.

35. X and Haley, *Autobiography*, 421, 426–427.

36. Louis A. DeCaro, Jr., *On the Side of My People* (New York: New York University Press, 1996), 4, 304.

37. Detroit attorney Gregory Reed purchased the original manuscripts "at the sale of the Haley Estate for $100,000" in 1992. Reed is not the only attorney with a hand in the text of the *Autobiography*. Marable's discussion also reveals that "several attorneys retained by Doubleday closely monitored and vetted entire sections of the controversial text in 1964, demanding numerous name changes, the reworking and deletion of blocks of paragraphs, and so forth" (*Living Black History*, 156–158).

38. Ibid., 158.

39. X and Haley, *Autobiography*, 394.

40. Bashir M. El-Beshti, "The Semiotics of Salvation: Malcolm X and the Autobiographical Self," *Journal of Negro History* 82, no. 4 (1997): 361; Dudley, *My Father's Shadow*, 186.

41. Dudley, *My Father's Shadow*, 463.

42. Alex Haley, "Alex Haley Remembers," in Gallen, *Malcolm X*, 249.

43. Marable, *Living Black History*, 155.

44. X and Haley, *Autobiography*, 395, 397–398.

45. Ibid., 22, 411.

46. Bradley, "Malcolm's Mythmaking," 41–42.

47. Strickland, *Malcolm X*, 56.

48. Nell Irvin Painter, "Malcolm X Across the Genres," *American Historical Review* 98, no. 2 (April 1993): 433. Perry claimed that Malcolm's mother, "who confronted the klansmen, according to his autobiography—says the incident never occurred" (*Malcolm*, 3). Marable indicated that the Klan was in fact very active in Nebraska in the 1920s (*Life of Reinvention*, 21–23).

49. Goldman, *Death and Life*, 31.

50. Perry, *Malcolm*, 82–83.

51. Baldwin, "Martin and Malcolm," 266.

52. DeCaro, *On the Side*, 74.

53. Ibid., 82–83, 92.

54. X and Haley, *Autobiography*, 399, 402.

55. Ibid., 423.

56. James Baldwin, "Down at the Cross: Letter from a Region in My Mind," in *The Fire Next Time* (London: Michael Joseph, 1963), 60, 85.

57. Marable, *Living Black History*, 152.

58. X and Haley, *Autobiography*, 212.

59. Lincoln, *Black Muslims*, 195–196.

60. X and Haley, *Autobiography*, 9, 190.

61. Ibid., 192.

62. DeCaro, *On the Side*, 89.

63. Eakin, "Malcolm X," 232.

64. Augustine, *The Confessions of Saint Augustine* (New York: Pocket Books, 1953), 147–148.

65. Acts 26:13, 26:15.

66. X and Haley, *Autobiography*, 158, 167.

67. DeCaro, *On the Side*, 92.

68. X and Haley, *Autobiography*, 377, 194, 188, 307.

69. Ibid., 5, 180, 189.

70. Alex Haley, "MX Extra 17," Haley Papers, Box 1a, Folder 21.

71. El-Beshti, "Semiotics of Salvation," 362, 363.

72. Dwight F. Reynolds, "Introduction," *Interpreting the Self*, ed. Dwight F. Reynolds (Berkeley: University of California Press, 2001), 3.

73. X and Haley, *Autobiography*, 166.

74. Ibid., 215.

75. Dudley, *My Father's Shadow*, 3.

76. Fanon, *The Damned*, 30; Paul Gilroy, *The Black Atlantic* (London: Verso, 1993), 63.

77. X and Haley, *Autobiography*, 25.

78. Boddy, *Boxing*, 281; X and Haley, *Autobiography*, 25.

79. X and Haley, *Autobiography*, 30, 27, 32, 28, 12.

80. Sartwell, *Act Like You Know*, 11.

81. X and Haley, *Autobiography*, 188.

82. Ibid., 185, 1.

83. DeCaro, *On the Side*, 50.

84. X and Haley, *Autobiography*, 174.

85. Ibid., 204.

86. Stephen Butterfield, *Black Autobiography in America* (Amherst: University of Massachusetts Press, 1974), 63, 81.

87. Eakin, "Malcolm X," 239–240.

88. Butterfield, *Black Autobiography*, 285.

89. American editions consistently include Handler's introduction and Davis's coda; British editions do not.

90. See M. S. Handler, "Malcolm X Rejects Racist Doctrine," *New York Times*, 4 October 1964, 59. According to Haley, Malcolm said of Handler, "He's the most genuinely unprejudiced white man I ever met." Haley believed "that Malcolm X would have liked" that "Handler had agreed to write this book's Introduction" (*Autobiography*, 407). Handler's more sympathetic articles were often countered in the *Times* by such inflammatory pieces as "To Arms with Malcolm X" (*New York Times*, 14 March 1964, 22).

91. M. S. Handler, "Introduction," *The Autobiography of Malcolm X* (New York: Ballantine Books, 1999), xxvi–xxix, xxv.

92. Attallah Shabazz, "Foreword," *The Autobiography of Malcolm X* (New York: Ballantine Books, 1999), xi–xii.

93. X and Haley, *Autobiography*, 430, 428.

94. Dyson, *Making Malcolm*, 127; Clarke, "Cool Politics."

95. X and Haley, *Autobiography*, 230.

96. Fanon, *The Damned*, 172.

97. The troubling revelation that Elijah Muhammad fathered six children out of wedlock with three of his secretaries actually came to Malcolm's attention in the spring of 1963—around the time of the commencement of the *Autobiography*. The feelings of shock and betrayal expressed in the book seem slightly exaggerated, as Malcolm confessed to having "heard hints" of Muhammad's adultery as early as 1955 (*Autobiography*, 300–301). Had Malcolm not left the Nation in 1964, it is not likely that Muhammad's affairs would have been mentioned.

98. Ibid., 231, 232, 234–235.

99. Dudley, *My Father's Shadow*, 31.

100. Gilroy, *Black Atlantic*, 83.

101. X and Haley, *Autobiography*, 237.

102. Ibid., 237.

103. Ibid., 345, 297. The reality of Malcolm and Betty's marriage appears to have been more complicated. Marable described a letter from Malcolm X to Elijah Muhammad, made public at an auction in June 2002 and dated 25 March 1959: "The letter stated that Malcolm X had been extremely reluctant to get married" and "detailed the marital and sexual problems Malcolm X was experiencing with his wife of then one year, Betty" (*Living Black History*, 170).

104. X and Haley, *Autobiography*, 311.

105. Eakin, "Malcolm X," 231.

106. Robin D. G. Kelley, *Race Rebels* (New York: Free Press, 1994), 163.

107. X and Haley, *Autobiography*, 45, 80, 99.

108. Ibid., 173.

109. Ibid., 293.

110. Ibid., 41–42.

111. DeCaro, *On the Side*, 67.

112. Dudley, *My Father's Shadow*, 175.

113. Kelley, *Race Rebels*, 162.

114. X and Haley, *Autobiography*, 72.

115. Ibid., 56; Kelley, *Race Rebels*, 166.

116. Douglas Henry Daniels, "Schooling Malcolm: Malcolm Little and Black Culture during the Golden Age of Jazz," in Gwynne, *Malcolm X*, 68.

117. Moses, *Black Messiahs*, 119; X and Haley, *Autobiography*, 60.

118. Essien-Udom, *Black Nationalism*, 97.

119. Ibid., 112–113.

120. X and Haley, *Autobiography*, 398.

121. DeCaro, *On the Side*, 56.

122. X and Haley, *Autobiography*, 113, 29, 36, 51–52.

123. Baraka, *Blues People*, 106.

124. X and Haley, *Autobiography*, 43, 46, 75–76.

125. Baraka, *Blues People*, 176, 106.

126. Claude Brown, *Manchild in the Promised Land* (New York: Touchstone, 1999), 37.

127. X and Haley, *Autobiography*, 41.

128. Tulloch, "'My Man,'" 303–304.

129. X and Haley, *Autobiography*, 108.

130. DeCaro, *On the Side*, 97.

131. X and Haley, *Autobiography*, 82.

132. Strickland, *Malcolm X*, 46.

133. X and Haley, *Autobiography*, 89.

134. Ibid., 89, 139, 141.

135. Ibid., 317–318.

136. Ibid., 203–204.

137. Ibid., 272, 174, 317.

138. Ibid., 319.

139. "A filmed feature" about Malcolm X's trip to Mecca, titled *The Muslim from America*, was made by Ahmed Horyallah and Essid Muhammad for a Tunisian television station (*Autobiography*, 372, 351–352).

140. Ibid., 333.

141. Manthia Diawara, "Black American Cinema: The New Realism," in *Black American Cinema*, ed. Manthia Diawara (London: Routledge, 1993), 3.

142. X and Haley, *Autobiography*, 33.

143. Ibid., 102. The musical *Cabin in the Sky* (1943) featured an all-black cast; *Stormy Weather* (1943) featured performances by Lena Horne, Bill Robinson, Cab Calloway, Fats Waller, and the Nicholas Brothers dance duo.

144. Karim et al., *Remembering Malcolm*, 96–97.

145. Brown, *Manchild*, 316–317. Although Brown would not mention Malcolm by name, he had been minister of New York's Temple Number Seven since June 1954. Brown gave the film's title as *Hannibal the Great*, but the film in question was likely *Jupiter's Darling* (1955), starring Howard Keel as Hannibal.

146. X and Haley, *Autobiography*, 6–7.

147. Ibid., 7.

148. W. E. B. Du Bois, *Dusk of Dawn* (London: Transaction, 1984), 277.

149. Van Deburg, *Black Camelot*, 2.

150. X and Haley, *Autobiography*, 73–74. Malcolm established offices in Suite 128 of the Hotel Theresa following his departure from the Nation of Islam (Goldman, *Death and Life*, 146).

151. The *Autobiography* stated that "the white man's efforts to make my name poison actually succeeded only in making millions of black people regard me like Joe Louis" (*Autobiography*, 357).

152. Ibid., 54.

153. DeCaro, *On the Side*, 61.

154. Holiday, who died in 1959, is presented in the *Autobiography* as a tragically underappreciated figure: "What a shame that proud, fine, black woman never lived where the true greatness of the black race was appreciated!" (*Autobiography*, 131, 132).

155. Ibid., 173, 200, 297.

156. Haley, "Letter to Malcolm X, 25 September 1963."

157. Malcolm X and Alex Haley, *The Autobiography of Malcolm X* (New York: Grove Press, 1965), plate xii.

158. Marable, *Living Black History*, 244, 158.

159. Malcolm X and Alex Haley, *The Autobiography of Malcolm X* (New York: Grove Press, 1966), front cover.

160. DeCaro, *On the Side*, 286.

CHAPTER THREE: MAINSTREAM CULTURE AND
CULTURAL REVOLUTION

1. William L. Van Deburg, *New Day in Babylon* (London: University of Chicago Press, 1992), 2–3. "Black Power," though hardly a new coinage, was circu-

lated as a popular slogan after its use by Stokely Carmichael during a June 1966 march in support of voter registration in Mississippi.

2. Malcolm X, "The Founding Rally of the OAAU," in *By Any Means Necessary* (New York: Pathfinder, 1970), 54.

3. Ted Poston, "Malcolm and the Muslims," *New York Post*, 22 February 1965, 15; "The Violent End of the Man Called Malcolm X," *Life*, 5 March 1965, 26–27.

4. "The Violent End," 26–27; "Races: Death and Transfiguration," *Time*, 5 March 1965, 23.

5. "The Violent End," 26.

6. "Races: Death and Transfiguration," 23.

7. "*Ebony* Photo-Editorial: Violence Versus Non-Violence," *Ebony*, April 1965, 168.

8. "Murder of Malcolm X a Cruel Blow to the Cause of Black Emancipation," *The Militant*, 1 March 1965, 1.

9. "Terrorism Must Go! Serious Struggle Must Begin!" *Bulletin of International Socialism*, 8 March 1965, 1.

10. Jigs Gardner, "The Murder of Malcolm X," *Monthly Review*, April 1965, 804, 802.

11. William F. Warde, "The Life and Death of Malcolm X," *International Socialist Review*, Spring 1965, 36. The *Autobiography* presents the young Malcolm as immediately emboldened, on his first visit to Boston Common, by an unanticipated image of African American revolutionary martyrdom: a statue of Crispus Attucks, "who had been the first man to fall in the Boston Massacre" (X and Haley, *Autobiography*, 43).

12. Warde, "Life and Death," 36.

13. Robert Vernon, "Malcolm X: Voice of the Black Ghetto," *International Socialist Review*, Spring 1965, 37.

14. George Breitman, "The Impact of Malcolm X," *Young Socialist*, March-April 1966, 5.

15. Abby Arthur Johnson and Ronald Maberry Johnson, *Propaganda and Aesthetics* (Amherst: University of Massachusetts Press, 1979), 161.

16. Christopher M. Tinson, "'The Voice of the Black Protest Movement': Notes on the *Liberator* Magazine and Black Radicalism in the Early 1960s," *Black Scholar* 37, no. 4 (Winter 2008): 3.

17. Ossie Sykes, "The Week That Malcolm X Died," *Liberator*, April 1965, 4–7.

18. Revolutionary Action Movement, "Why Malcolm X Died," *Liberator*, April 1965, 10.

19. A. B. Spellman, "The Legacy of Malcolm X," *Liberator*, June 1965, 11–12.

20. Colin MacInnes, "Malcolm, The Lost Hero," *Negro Digest*, May 1967, 5.

21. W. E .B. Du Bois, "The Souls of Black Folk," in Gates and McKay, *Norton Anthology*, 692.

22. Milton R. Henry, "New Glory Visits Malcolm X," *Now!*, March-April 1966, 16; Van Deburg, *New Day in Babylon*, 145.

23. Henry, "New Glory," 18.

24. Marable, *Living Black History*, 136.

25. *Kerner Commission Report* (Washington, D.C.: U.S. Government Printing Office, 1968), 1.

26. William H. Grier and Price M. Cobbs, *Black Rage* (London: Jonathan Cape, 1969), 22, 4.

27. Carlo Rotella, *October Cities* (Berkeley: University of California Press, 1998), 243, 270.

28. Moses, *Black Messiahs*, 211.

29. Marable, *Living Black History*, 134.

30. James A. Emanuel, "Blackness Can: A Quest for Aesthetics," in *The Black Aesthetic*, ed. Addison Gayle, Jr. (New York: Doubleday, 1971), 195.

31. Van Deburg, *New Day in Babylon*, 291.

32. Marable, *Living Black History*, 134–135.

33. Cleaver, *Soul on Ice*, 61, 69.

34. George Jackson, *Soledad Brother* (London: Jonathan Cape, 1971), 258, 260.

35. Jane Rhodes, *Framing the Black Panthers* (London: New Press, 2007), 296.

36. Ibid., 103.

37. Huey P. Newton and J. Herman Blake, *Revolutionary Suicide* (London: Wildwood House, 1974), iii.

38. Rhodes, *Framing the Black Panthers*, 69.

39. *Black Panthers*, directed by Agnes Varda (American Documentary Films, 1968).

40. Jackson, *Soledad Brother*, 264.

41. Angela Davis, *Angela Davis* (London: Hutchinson, 1975), xi , xii.

42. Obi Egbuna wrote a manifesto in prison that told of "Black Power [as] a state of mind" emerging from exemplary figures such as Marcus Garvey, Malcolm X, and Stokely Carmichael. See *Destroy This Temple* (London: MacGibbon & Kee, 1971), 53.

43. Michael Abdul Malik, *From Michael de Freitas to Michael X* (London: Andre Deutsch, 1968), 144.

44. Carew, *Ghosts*, 99.

45. Newton and Blake, *Revolutionary Suicide*, 107, 113, my emphases.

46. Ibid., 71.

47. Chester Himes wrote that Malcolm was the fashion in Paris during the last months of his life: "Some claimed to be his followers and more or less worshiped him, others wanted to know him to become his followers; the black women oldtimers on the Paris scene were all trying to seduce him. There were scores of black men who claimed to be watching Malcolm for the CIA." See *My Life of Absurdity* (New York: Doubleday, 1976), 290–291.

48. Davis, *Angela Davis*, 127.

49. Ibid., 144, 150, 161, 189.

50. Boddy, *Boxing*, 334.

51. Gerald Early, *This Is Where I Came In* (Lincoln: University of Nebraska Press, 2003), 33–34.

52. Jamal's preface states: "There are no tape recordings of any of the lectures by Malcolm X that appear in *From the Dead Level*. I have never seen any transcripts. The words of Malcolm X quoted in this book are from my memory— and his thoughts and ideas are those which most affected me as I was then, an alcoholic and an addict." See *From the Dead Level* (New York: Random House, 1972), 1, 125.

53. Ibid., 12–13, 31–33.

54. Ibid., 152, 195.

55. Ibid., 155, 117, 115.

56. Marable, *Living Black History*, 135.

57. Terrill, *Malcolm X*, viii.

58. Ibid., x.

59. Although Malcolm X "responded favourably to the idea, [he] put off a decision until after he had a chance to consult with the agent handling his forthcoming autobiography." Malcolm's one request was that "the memorandum he had submitted to the Organization of African Unity at its meeting in Cairo in July, 1964" be included in what became *Malcolm X Speaks*, which it was. See George Breitman, *The Last Year of Malcolm X* (New York: Merit, 1967), 1.

60. Essien-Udom, *Black Nationalism*, 228; Bayard Rustin, "Making His Mark: The Autobiography of Malcolm X," *Time on Two Crosses* (San Francisco: Cleis, 2003), 180; Butterfield, *Black Autobiography*, 184.

61. Breitman, *Last Year of Malcolm X*, 69.

62. Michael Eric Dyson, "X Marks the Plots: A Critical Reading of Malcolm's Readers," *Social Text* 35 (Summer 1993): 49. Some of the suspicion of the white authorization of black radicalism may have been justified. In presenting books written by such figures as Frantz Fanon and George Jackson, publishers commonly included prefaces by French intellectuals such as Jean-Paul Sartre and

Jean Genet, a practice redolent of the nineteenth-century rhetoric of white Christian authorities introducing African American slave narratives.

63. Breitman, *Last Year of Malcolm X*, 1.

64. Marable, *Living Black History*, 163; Breitman, *Last Year of Malcolm X*, 1.

65. Dyson, "X Marks the Plots," 26.

66. Tariq Ali, "The Extra-Parliamentary Opposition," in *New Revolutionaries,* ed. Tariq Ali (London: Peter Owen, 1969), 7.

67. Eldridge Cleaver, "Letter from Jail," in Ali, *New Revolutionaries,* 89.

68. Ibid., 83.

69. Ibid.

70. Stokely Carmichael, "Black Power and the Third World," in Ali, *New Revolutionaries,* 92–93.

71. Bayard Rustin, "On Malcolm X," *New America,* 28 February 1965, 1.

72. Ossie Davis, "Our Shining Black Prince," in *Malcolm X: The Man and His Times,* ed. John Henrik Clarke (Trenton, N.J.: Africa World Press, 1990), x–xii.

73. John Henrik Clarke, "Introduction," *Malcolm X: The Man and His Times,* xii, xiv, xviii–xix, xxii, xxiv.

74. Sara Mitchell, *Brother Malcolm* (New York: Malcolm X Memorial Committee, 1965), 6, 3.

75. Balogun Moyenda Adom Jasiri, *Malcolm X Is Found Guilty* (self-published, ca. 1978), 1, 7.

76. Ibid., 8.

77. Brother Imari Abubakari Obadele, *War in America* (Detroit: Malcolm X Society, 1968), front cover, 7.

78. Ibid., 2.

79. Van Deburg, *New Day in Babylon,* 145–147.

80. Obadele, *War in America,* 64, 3.

81. Malcolm X, "The Founding Rally," 54–56, 38, 34.

82. Johnson and Johnson, *Propaganda and Aesthetics,* 164, 169.

83. Ibid., 166–167.

84. Albert B. Cleage and George Breitman, *Myths About Malcolm X* (New York: Merit, 1968), 4.

85. James Edward Smethurst, *The Black Arts Movement* (London: University of North Carolina Press, 2005), 47.

86. Eddie S. Glaude, Jr., "Introduction: Black Power Revisited," in *Is It Nation Time?* ed. Eddie S. Glaude, Jr. (Chicago: University of Chicago Press, 2002), 4.

87. Ibid., 9.

88. Van Deburg, *New Day in Babylon,* 245.

89. The John Henrik Clarke Papers, 1937–1996, Schomburg Center for Research in Black Culture, New York Public Library.

90. Michael D. Harris, "Urban Totems: The Communal Spirit of Black Murals," in *Walls of Heritage, Walls of Pride,* ed. James Prigoff and Robin J. Dunitz (San Francisco: Pomegranate, 2000), 26.

91. Apparently, Elijah Muhammad objected to being depicted in the religion category on a wall featuring an image of Malcolm X. See Margo Natalie Crawford, "Black Light on the *Wall of Respect:* The Chicago Black Arts Movement," in *New Thoughts on the Black Arts Movement,* ed. Lisa Gail Collins and Margo Natalie Crawford (London: Rutgers University Press, 2006), 23, 25–26.

92. Baraka, *Autobiography of LeRoi Jones,* 200.

93. Van Deburg, *New Day in Babylon,* 81.

94. X and Haley, *Autobiography,* 296–297, 6.

95. Sharon F. Patton, *African-American Art* (Oxford: Oxford University Press, 1998), 195.

96. Ibid., 208–209.

97. Peter Selz and Anthony F. Janson, *Barbara Chase-Riboud* (New York: Harry N. Abrams, 1999), 36.

98. Amiri Baraka, "Foreword," in *Black Fire,* ed. Amiri Baraka (LeRoi Jones) and Larry Neal (New York: William Morrow, 1968), xvii. "Weusi Mchoro" is a Swahili phrase equating to "Black Arts."

99. Larry Neal, "An Afterword: And Shine Swam On," in Baraka and Neal, *Black Fire,* 638, 645–646.

100. James Boggs, "Black Power—A Scientific Concept Whose Time Has Come," in Baraka and Neal, *Black Fire,* 106.

101. Addison Gayle, Jr., "Introduction," in Gayle, *Black Aesthetic,* xvi, xxii.

102. Larry Neal, "The Black Arts Movement," in Gayle, *Black Aesthetic,* 272, 290.

103. Julian Mayfield, "You Touch My Black Aesthetic and I'll Touch Yours," in Gayle, *Black Aesthetic,* 30.

104. William Keorapetse Kgositsile, "Paths to the Future," in Gayle, *Black Aesthetic,* 248–260.

105. Abraham Chapman, ed., *New Black Voices* (New York: New American Library, 1972), i.

106. Amiri Baraka, "The Legacy of Malcolm X, and the Coming of the Black Nation," in Chapman, *New Black Voices,* 460.

107. John Oliver Killens, *The Cotillion* (Minneapolis: Coffee House, 2002), 8.

108. Marable, *Living Black History,* 137.

109. Gwendolyn Brooks, "Malcolm X," in *For Malcolm,* ed. Dudley Randall and Margaret G. Burroughs (Detroit: Broadside Press, 1969), 3.

110. Marvin E. Jackmon, "That Old Time Religion," in Baraka and Neal, *Black Fire,* 268.

111. Glaude, "Introduction," 10; Cherise A. Pollard, "Sexual Subversions, Political Inversions: Women's Poetry and the Politics of the Black Arts Movement," in Collins and Crawford, *New Thoughts;* 176; Marable, *Living Black History,* 163.

112. Ishmael Reed, "Introduction," in *The Reed Reader* (New York: Basic, 2000), xiii.

113. Clayton Riley, "On Black Theater," in Gayle, *Black Aesthetic,* 329; Ronald Milner, "Black Theater—Go Home!" in Gayle, *Black Aesthetic,* 311. Amiri Baraka, "The Revolutionary Theatre," in Gates and McKay, *Norton Anthology,* 1960.

114. Neal, "Black Arts Movement," 286; Baraka, "Revolutionary Theatre," 1960.

115. Baraka, "Revolutionary Theatre," 1962.

116. Woodie King and Ron Milner, "Evolution of a People's Theater," in *Black Drama Anthology,* ed. Woodie King and Ron Milner (London: Columbia University Press, 1972), viii.

117. Baraka, "Revolutionary Theatre," 1963; Riley, "On Black Theater," 327.

118. Amiri Baraka, "Experimental Death Unit #1," in *Four Black Revolutionary Plays* (London: Calder & Boyars, 1971), 9–19; Amiri Baraka, *Junkies Are Full of (SHHH . . .),* in King and Milner, *Black Drama Anthology,* 11–23.

119. Neal, "Black Arts Movement," 284.

120. Johnson and Johnson, *Propaganda and Aesthetics,* 177.

121. Amiri Baraka, "A Black Mass," in *Four Black Revolutionary Plays,* 37.

122. Baraka wrote: "I even did a script for a film I figured might not ever be shot. *The Death of Malcolm X.* But what this did was get me interested in making films. I bought a camera, a 16mm Bolex, some editing equipment, including a Moviola for viewing what I shot" (*Autobiography of LeRoi Jones,* 231).

123. Amiri Baraka, "The Death of Malcolm X," in Gwynne, *Malcolm X: Justice Seeker,* 83, 95, 93, 88.

124. Van Deburg, *New Day in Babylon,* 6.

125. James Baldwin, *The Devil Finds Work* (London: Corgi, 1976), 100.

126. Ibid., 99, 50, 25, 105, 101, 103.

127. Elombe Brath, "I Remember Malcolm (a narrative)," in *The Harlem Cultural/Political Movements, 1960–1970: From Malcolm X to "Black is Beautiful,"* ed. Abiola Sinclair (New York: Gumbs & Thomas, 1995), 18.

128. Baldwin, "Martin and Malcolm," 265–266, 268.

129. Baldwin, *Devil Finds Work,* 66–67.

130. Brian Norman, "Reading a 'Closet Screenplay': Hollywood, James Baldwin's Malcolms and the Threat of Historical Irrelevance," *African American Review* 39, no. 1–2 (Spring–Summer 2005): 104.

131. James Baldwin, *One Day, When I Was Lost* (New York: Laurel, 1992), 3.

132. Norman, "Reading a 'Closet Screenplay,'" 103.

133. Ibid., 105.

134. Ibid., 105, 110.

135. James Baldwin, *Another Country* (New York: Dial, 1962), 3.

136. Mother Henry tells Richard, "You're going to make yourself sick with hatred." Richard replies: "No, I'm not. I'm going to make myself well." James Baldwin, *Blues for Mister Charlie* (London: Michael Joseph, 1965), 31.

137. Bradley, "Malcolm's Mythmaking," 34.

138. The Last Poets, "Niggers Are Scared of Revolution," *Malcolm X: Music and Dialogue from the Original Soundtrack of the Motion Picture*, Warner Brothers Records, 9362 45157-2, 1972.

139. Bradley, "Malcolm's Mythmaking," 33.

140. George Lois, *Covering the '60s: George Lois—The Esquire Era* (New York: Monacelli, 1996), 6, 19, 31.

141. "28 People Who Count," *Esquire*, September 1965, 97.

142. Malcolm X, "God's Judgment of White America," *Evergreen*, December 1967, 54–55.

143. E. J. Hobsbawm, *Primitive Rebels* (Manchester: Manchester University Press, 1959), 28.

144. John W. Roberts, *From Trickster to Badman* (Philadelphia: University of Pennsylvania Press, 1989), 182.

145. Lawrence W. Levine, *Black Culture and Black Consciousness* (Oxford: Oxford University Press, 1978), 412–413.

146. Ibid., 415, 417.

147. William L. Van Deburg, *Hoodlums* (London: University of Chicago Press, 2004), 68.

148. Levine, *Black Culture*, 420, 426, 417.

149. Eithne Quinn, "'Pimpin' Ain't Easy': Work, Play, and 'Lifestylization' of the Black Pimp Figure in Early 1970s America," in *Media, Culture, and the Modern African American Freedom Struggle*, ed. Brian Ward (Gainesville: University Press of Florida, 2001), 228.

150. Kelley, *Race Rebels*, 216.

151. Levine, *Black Culture*, 382.

152. Terri Hume Oliver, "Prison, Perversion, and Pimps: The White Temptress in *The Autobiography of Malcolm X* and Iceberg Slim's *Pimp*," in *White Women in*

Racialized Spaces, ed. Samina Najmi and Rajini Srikanth (Albany: State University of New York Press, 2002), 148.

153. Larry Neal, "Brother Pimp," in *Black Boogaloo* (San Francisco: Journal of Black Poetry Press, 1969), 45–46.

154. Lee Bernstein, "Prison Writers and the Black Arts Movement," in Collins and Crawford, *New Thoughts,* 306.

155. The title of Sanchez's poem echoed Madhubuti's description of Detroit Red as a "revolutionary pimp." See Haki Madhubuti (Don L. Lee), "Malcolm Spoke—who listened?" in Randall and Burroughs, *For Malcolm,* 64.

156. Robert Beck (Iceberg Slim), *Pimp* (Los Angeles: Holloway House, 1969), 17, 38.

157. Ibid., 312.

158. In the book's last entry, Beck wrote that "White racist America hated Jack Johnson, Paul Robeson and Malcolm X. What a monstrous crime it is that the black masses did not and were not permitted to love them at least proportionately to the hatred of their white enemies." See *The Naked Soul of Iceberg Slim* (Los Angeles: Holloway House, 1971), 5, 247.

159. Ibid., 17, 171, 154.

160. Van Deburg, *Hoodlums,* 118.

161. Ibid., 119. Cripps, "Noble Black Savage," 692.

162. *The Spook Who Sat by the Door,* directed by Ivan Dixon (United Artists, 1973).

163. Playthell Benjamin, "Malcolm X Revisited," in Sinclair, *Harlem Cultural/Political Movements,* 11.

164. Robert Penn Warren, "Malcolm X: Mission and Meaning," in Gallen, *Malcolm X,* 202.

CHAPTER FOUR: FROM HOLLYWOOD TO HIP-HOP

1. Malcolm's increasingly mythic stature has even found expression in the unlikely medium of opera. Siblings Thulani Davis (libretto) and Anthony Davis (music) collaborated on the opera *X: The Life and Times of Malcolm X,* first performed by the New York City Opera in 1986.

2. Manning Marable, *Race, Reform, and Rebellion,* 3rd ed. (Jackson: University Press of Mississippi, 2007), 152.

3. West, *Race Matters,* 1, 12–13.

4. Quinn, *Nuthin' but a 'G' Thang,* 143, 189, 169.

5. Marable, *Living Black History,* 162.

6. Eugene Victor Wolfenstein, *The Victims of Democracy* (London: Free Association, 1989), 4.

7. Perry, *Malcolm*, x.

8. Amiri Baraka, "Malcolm as Ideology," in Wood, *Malcolm X*, 19.

9. Arnold Rampersad, "The Color of His Eyes," in Wood, *Malcolm X*, 129.

10. John Edgar Wideman, "Malcolm X: The Art of Autobiography," in Wood, *Malcolm X*, 111.

11. Marable, *Life of Reinvention*, 13. A volume of criticism has appeared in response to Marable's biography. *A Lie of Reinvention* includes entries by Amiri Baraka, A. Peter Bailey, Rosemari Mealy, William L. Strickland, and Karl Evanzz. Evanzz, author of *The Judas Factor: The Plot to Kill Malcolm X* (1992), condemns Marable's book as "an abomination": "It is a cavalcade of innuendo and logical fallacy, and is largely 'reinvented' from previous works on the subject." See Evanzz, "Paper Tiger: Manning Marable's Poison Pen," in *A Lie of Reinvention*, ed. Jared A. Ball and Todd Steven Burroughs (Baltimore: Black Classic Press, 2012), 207.

12. James S. Haskins, *The Picture Life of Malcolm X* (New York: Franklin Watts, 1975), 8, 15.

13. Ibid., 43.

14. Abdul Alkalimat, *Malcolm X for Beginners* (New York: Writers and Readers, 1990), 14, 62.

15. Ibid., 62.

16. Wideman, "Malcolm X," 102.

17. Dyson, *Making Malcolm*, 17.

18. Harold Schechter, "Comicons," in *Icons of America*, ed. Ray B. Browne and Marshall Fishwick (Bowling Green: Popular Press, 1978), 268.

19. Manning Marable, "Malcolm X's Life After Death," *American Legacy* 8, no. 3 (Fall 2002): 46.

20. Andrew Helfer and Randy DuBurke, *Malcolm X: A Graphic Biography* (New York: Hill & Wang, 2006), 100, 102.

21. Karim et al., *Remembering Malcolm*, 169, 181, 193, 113.

22. Maya Angelou, *All God's Children Need Traveling Shoes* (Boston: G. K. Hall, 1986), 23, 186, 208.

23. Ibid., 209.

24. Ibid., 187.

25. Parks, *Voices in the Mirror*, 224.

26. Trachtenberg, *Lincoln's Smile*, 87.

27. Parks, *Voices in the Mirror*, 224.

28. Ibid.

29. Yuri Nakahara Kochiyama, *Passing It On* (Los Angeles: UCLA Asian American Studies Center, 2004), 71–72.

30. See Graeme Abernethy, "'Not Just an American Problem': Malcolm X in Britain," *Atlantic Studies* 7, no. 3 (September 2010): 285–307.

31. Tariq Ali, *Street Fighting Years* (London: Verso, 2005), 103; Carew, *Ghosts,* 100.

32. Carew, *Ghosts,* 100; Ali, *Street Fighting Years,* 104.

33. Carew, *Ghosts,* 94, 14–15.

34. Ali, *Street Fighting Years,* 106.

35. Paul D. Nichols, "Preface," in Malcolm Jarvis with Paul D. Nichols, *The Other Malcolm—"Shorty" Jarvis,* ed. Cornel West (Jefferson, N.C.: McFarland, 2001), 2.

36. Jarvis, *The Other Malcolm,* 7–8.

37. Ibid., 136, 139.

38. Ilyasah Shabazz and Kim McLarin, *Growing Up X* (New York: Ballantine, 2002), xv, 11–13, 16–17.

39. Ibid., 36, 9, 24.

40. Kent Smith, *Future X* (Los Angeles: Holloway House, 1990), 50–51.

41. Ibid., 352.

42. Sukhdev Sandhu, *London Calling* (London: HarperCollins, 2003), 376.

43. Paul Beatty, *The White Boy Shuffle* (London: Minerva, 1996), 5, 23, 146, 221.

44. Ted Pelton, *Malcolm and Jack (and Other Famous American Criminals)* (New York: Spuyten Duyvil, 2006), 14, 108, 8.

45. Caryl Phillips, *Higher Ground* (London: Vintage, 2006), 136, 160, 157.

46. X and Haley, *Autobiography,* 205.

47. Spike Lee and Lisa Jones, *Do the Right Thing* (New York: Fireside, 1989), 91.

48. Ibid., 282.

49. Reed, "Allure of Malcolm X," 226.

50. Spike Lee and Ralph Wiley, *By Any Means Necessary* (New York: Hyperion, 1992), 2. While still in preproduction for *Do the Right Thing* in late 1987, Lee wrote of the prospect of adapting the *Autobiography* for Warner Brothers: "I am of the opinion that only a Black man should write and direct *The Autobiography of Malcolm X.* Bottom line." His interest in the project was, from the outset, "contingent on absolute artistic control" (Lee and Jones, *Do the Right Thing,* 38, 32).

51. Lee and Wiley, *By Any Means Necessary,* 3, 21–22.

52. Ibid., 22.

53. Warner Brothers refused to invest more than $28 million in the project. When production costs soared to $33 million, Lee secured contributions from

Bill Cosby, Oprah Winfrey, Michael Jordan, Janet Jackson, Prince, Magic Johnson, Tracy Chapman, and Peggy Cooper-Cafritz (ibid., 165). Lee also agreed to forgo his director's fee.

54. Ibid., 165.

55. Ibid., 86, 111.

56. Lee and Jones, *Do the Right Thing*, 32.

57. Bradley, "Malcolm's Mythmaking," 20.

58. Baraka, "Malcolm as Ideology," 21, 19. Lee's casting of himself as Shorty was, for some, also a step too far in the direction of egotistical wish fulfillment.

59. Ibid., 18.

60. Lee and Wiley, *By Any Means Necessary*, 100.

61. Paul Gilroy, *Postcolonial Melancholia* (New York: Columbia University Press, 2005), 127.

62. Marable, *Living Black History*, 145; Kalbir Shukra, *The Changing Pattern of Black Politics in Britain* (London: Pluto, 1998), 27–28.

63. The term "white devils," for example, appears in the film only twice and never in a confrontational context. Painter argues, further, that "deleting the inane portions of the creed . . . eliminates the mystery of why so intelligent a person as Malcolm X would stay twelve years in such a narrow-minded movement." See Painter, "Malcolm X Across the Genres," 436, 434.

64. Lee and Wiley, *By Any Means Necessary*, 26.

65. Spike Lee reported that "Eddie Murphy had read that particular script and he really wanted to play the Alex Haley character. If Eddie Murphy wanted to do it, it's a wonder that shit wasn't made right on the spot!" (ibid., 26). David Bradley has written revealingly of the pressures exerted on his script by Warner Brothers, including an instance in which an executive objected to the inclusion of accurately quoted statements made by Malcolm about Jews (Bradley, "Malcolm's Mythmaking," 23–24).

66. Lee and Wiley, *By Any Means Necessary*, 66, 89.

67. Rampersad, "Color of His Eyes," 124; X and Haley, *Autobiography*, 2.

68. Sartwell, *Act Like You Know*, 18.

69. Lee and Wiley, *By Any Means Necessary*, 94.

70. Ibid., 90.

71. Ibid., 115.

72. Ibid., 91, 137.

73. Ibid., 101.

74. Ibid., 142.

75. *Malcolm X*, directed by Spike Lee (Warner Brothers, 1992).

76. Ibid. The statement refers, of course, to the FBI wiretap revelation of Martin Luther King's infidelities.

77. Ibid.

78. Torres, *Black, White*, 95.

79. Several names were changed and key figures such as Muhammad Ali and Minister Louis Farrakhan, the Nation's leader, did not feature. Lee was wary of his film causing offense to the Nation of Islam or in any way implicating Farrakhan in the conspiracy to murder Malcolm X; the production actually employed a New York–based Nation of Islam group to provide security on set (*By Any Means Necessary*, 67, 97). According to Mfanya Donald Tryman and Lawrence H. Williams, "Farrakhan has continuously denied any involvement in the actual death of Malcolm X [but] he has admitted on the CBS news program *60 Minutes* broadcast in the spring of 2000 that he contributed to the violent climate that precipitated Malcolm's death." See "Conspiracy Theories of the Assassination of Malcolm X," in *The Malcolm X Encyclopedia*, ed. Robert L. Jenkins and Mfanya Donald Tryman (Westport, Conn.: Greenwood, 2002), 43.

80. See Darryl Pinckney, "Misremembering Martin Luther King," *New York Review of Books*, 15 December 2011, accessed 29 June 2012, http://www.nybooks.com/blogs/nyrblog/2011/dec/15/misremembering-martin-luther-king/.

81. *The Meeting*, directed by Bill Duke (American Playhouse, 1989).

82. Manthia Diawara, "Black American Cinema: The New Realism," in *Black American Cinema*, ed. Manthia Diawara (London: Routledge, 1993), 24.

83. *Panther*, directed by Mario Van Peebles (Gramercy Pictures, 1995).

84. *Ali*, directed by Michael Mann (Columbia Pictures, 2001). It was reported that Malcolm died instantly upon receiving shotgun wounds to the heart.

85. Keith Huff and Matthew Weiner, "The Rejected," *Mad Men*, season 4, episode 4, directed by John Slattery, aired 15 August 2010, AMC.

86. Sue Coe, *X* (New York: New Press, 1986), front cover.

87. Ibid., 35, 33.

88. Steven Heller, "Sue Coe: Eyewitness," *Eye Magazine*, Summer 1996, accessed 29 June 2012, http://www.eyemagazine.co.uk/feature.php?id=28&fid=244.

89. See Graeme Abernethy, "'Studied in his Death': Representations of the Assassination of Malcolm X," in *Envisaging Death: Visual Culture and Dying*, ed. Michele Aaron (Newcastle, U.K.: Cambridge Scholars Publishing, 2013).

90. Heller, "Sue Coe."

91. Leonhard Emmerling, *Jean-Michel Basquiat* (New York: Taschen, 2003), 88.

92. Michele Wallace, *Invisibility Blues* (London: Verso, 1990), 200.

93. Alanna Heiss et al., "David Hammons," in *Casino Fantasma* (New York: Institute for Contemporary Art, 1990), n.p. See also *David Hammons: Rousing the Rubble* (New York: Institute for Contemporary Art, 1991).

94. Michele Wallace, *Black Macho and the Myth of the Superwoman* (London: Verso, 1990), 52–53.

95. Glenn Ligon, *Glenn Ligon: Some Changes* (Toronto: Power Plant, 2005), 181–183.

96. "Dan Starling: Malcolm X / J. D. Salinger," *Richmond Art Gallery,* accessed 29 June 2012, http://www.richmondartgallery.org/archive_2008/starling.php.

97. Dan Starling, *Malcolm X: An Introduction, by J. D. Salinger* (self-published, 2007), 15.

98. Aliyah S. King, "Malcolm Shabazz: Through the Fire," *Giant,* 1 April 2008, accessed 29 June 2012, http://giantmag.com/articles/giant-magazine-staff/malcolm-shabazz-through-the-fire/.

99. Reed, "Allure of Malcolm X," 207–208.

100. Marable, *Living Black History,* 147–148.

101. Abdul Alkalimat, "Malcolm X in Cyberspace," in Jenkins and Tryman, *Malcolm X Encyclopedia,* 50.

102. Abdul Alkalimat, ed., *Malcolm X: A Research Site,* University of Toledo and Twenty-First Century Books, accessed 1 February 2013, http://www.brother malcolm.net; Columbia University Center for Contemporary Black History/Institute for Research in African-American Studies, *The Malcolm X Project at Columbia University,* accessed 1 February 2013, http://www.columbia.edu/cu/ccbh/mxp/index.html; *James Ku—CG Art,* accessed 29 June 2012, http://www.3dartisan.net/~kuman/.

103. James Ku, personal email correspondence, 12 February 2008.

104. Marable, *Race, Reform, and Rebellion,* 146.

105. Strickland, *Malcolm X,* 220.

106. Joe Wood, "Malcolm X and the New Blackness," in Wood, *Malcolm X,* 7.

107. Marable, *Living Black History,* 146.

108. Quinn, *Nuthin' but a 'G' Thang,* 116.

109. Kelley, *Race Rebels,* 180.

110. bell hooks, *We Real Cool* (London: Routledge, 2004), 148, 153, 27.

111. See Loïc Wacquant, *Prisons of Poverty* (Minneapolis: University of Minnesota Press, 2009).

112. Notorious B.I.G. "Intro," *Ready to Die,* Bad Boy, 0249-86280-1, 1994.

113. Eithne Quinn, "'All Eyez on Me': The Paranoid Style of Tupac Shakur," in *Conspiracy Nation,* ed. Peter Knight (New York: New York University Press, 2002), 183–184, 177, 190.

114. 2Pac. "Words of Wisdom," *2Pacalypse Now,* Jive/Interscope/Priority, 91767-2, 1991.

115. Quinn, "'All Eyez on Me,'" 177.

116. Public Enemy. "Bring the Noise," *It Takes a Nation of Millions to Hold Us Back,* Def Jam/Columbia, 527 358-1, 1988.

117. X-Clan. *To the East, Blackwards,* 4th & Broadway/Island/Polygram, 444 019-1, 1990.

118. S. Craig Watkins, "'Black Is Back, and It's Bound to Sell!': Nationalist Desire and the Production of Black Popular Culture," in Glaude, *Is It Nation Time?,* 208.

119. Reed, "Allure of Malcolm X," 228.

120. Wood, "Malcolm X," 7.

121. Watkins, "'Black Is Back,'" 193.

122. Springer, *James Dean Transfigured,* 5.

123. Mos Def, "Supermagic," *The Ecstatic,* Downtown, DWT70055, 2009.

124. Lisa de Moraes, "Kanye West's Torrent of Criticism," *Washington Post,* 3 September 2005, accessed 29 June 2012, http://www.washingtonpost.com/wp-dyn/content/article/2005/09/03/AR2005090300165.html.

125. Kanye West, "Good Morning (Intro)," *Graduation,* Roc-A-Fella/Def Jam, B0009541-02, 2007.

126. Kanye West, "Power," *My Beautiful Dark Twisted Fantasy,* Roc-A-Fella/Def Jam, B0014695-00, 2010.

127. Kanye West, "Gorgeous," *My Beautiful Dark Twisted Fantasy.*

128. Jay-Z and Kanye West, "Made in America (featuring Frank Ocean)," *Watch the Throne,* Roc-A-Fella/Roc Nation/Def Jam, B0015426-02, 2011.

CONCLUSION: CONTINUING SIGNIFICATION

1. Marable, *Living Black History,* 121–122.

2. See Rosemary J. Coombe and Paul Stoller, "X Marks the Spot: The Ambiguities of African Trading in the Commerce of the Black Public Sphere," *Public Culture* 7, no. 1 (Fall 1994): 249–274.

3. Manning Marable, "Selling Malcolm: Black History on the Auction Block," *The Crisis,* September/October 2002, 20–21.

4. Nick Charles, "His Blood Still Stains the Floor," *Emerge,* February 1990, 28.

5. Marable, *Living Black History,* 127, 132.

6. "Washington D.C. Centre of World Imperialism—Malcolm X," *West Indian Gazette and Afro-Asian-Caribbean News,* February 1965, 4.

7. Robin Maddock, *Our Kids Are Going to Hell* (London: Trolley, 2009), n.p.

8. Tulloch, "'My Man,'" 302.

9. Peniel E. Joseph, *Dark Days, Bright Nights* (New York: Basic Civitas, 2010), 204.

10. Ibid., 206.

11. David Remnick, *The Bridge* (London: Picador, 2010), 178, 223.

12. Barack Obama, *Dreams from My Father* (New York: Times, 1995), 79–80.

13. Ibid., 80–81.

14. Although *Dreams from My Father* does not make explicit the reasons for the appellative transition from Barry to Barack, it may have been attributable in part to Obama's embrace of Malcolm's encouragement of pride in African heritage.

15. Kate Phillips, "Wright Defends Church and Blasts Media," *New York Times*, 28 April 2008, accessed 29 June 2012, http://thecaucus.blogs.nytimes. com/2008/04/28/rev-wright-defends-church-blasts-media/?ref=politics.

16. Ibid., 502; Richard Wolffe, *Renegade* (London: Virgin, 2009), 198; Johanna Neuman, "Obama to Clinton: Who's No. 1?" *Los Angeles Times*, 11 March 2008, accessed 29 June 2012, http://articles.latimes.com/2008/mar/11/nation/ na-campaign11.

17. The following words spoken by Denzel Washington are not attributable to any known speech by Malcolm X: "Oh I say it, I say it again, you've been had! You've been took! You've been hoodwinked! Bamboozled! Led astray! Run amok!" (Lee, *Malcolm X*).

18. Paul Reynolds, "Obama Speech: An Analysis," *BBC News*, 4 June 2009, accessed 29 June 2012, http://news.bbc.co.uk/1/hi/world/americas/8082862. stm.

19. Joseph, *Dark Days*, 195.

20. "Is Obama the Secret Son of Malcolm X?" *Israel Insider*, 4 November 2008, accessed 29 June 2012, http://israelinsider.net/profiles/blogs/is-obama-the-secret-son-of.

21. Remnick, *The Bridge*, 462.

22. "Washington D.C. Centre of World Imperialism," 4.

23. Graham Bowley, "Al Qaeda Leader Weighs in on Obama, Insultingly," *New York Times*, 19 November 2008, accessed 29 June 2012, http://thelede.blogs.ny-times.com/2008/11/19/al-qaeda-leader-weighs-in-on-obama-insultingly/; Mark Mazzetti and Scott Shane, "Al Qaeda Coldly Acknowledges Obama Victory," *New York Times*, 19 November 2008, accessed 29 June 2012, http://www.nytimes. com/2008/11/20/world/middleeast/20qaeda.html.

24. Gilroy, *Postcolonial Melancholia*, 128.

25. Ibid., 128–130. Michael Elliot, "The Shoe Bomber's World," *Time*, 16 February 2002, accessed 29 June 2012, http://www.time.com/time/world/article/0,8599,203478,00.html.

26. Wood, "Malcolm X," 3.

27. Attallah Shabazz, "Foreword," *Autobiography of Malcolm X* (1999), xiii.

28. X and Haley, *Autobiography,* 389, 385, 388.

SELECTED BIBLIOGRAPHY

As any perusal of this volume's main text and notes will reveal, the contestation of Malcolm's meaning encompasses a diverse array of disciplines, further confirming his continuing appeal and importance. Contending with the ever-expanding literature and iconography of Malcolm X, however, represents one of the challenges of writing about him. Although many books and articles addressing the study of visual culture and various aspects of African American culture have influenced my analysis and understanding of the matters discussed in these pages, this bibliography includes only those books, magazines, films, albums, and archives most particularly helpful to me in the writing of this book. Given this study's visual orientation, I typically have favored documents making significant contributions to the iconography of Malcolm X.

METHODOLOGY

Barthes, Roland. *Camera Lucida: Reflections on Photography.* Translated by Richard Howard. London: Jonathan Cape, 1982.

Boddy, Kasia. *Boxing: A Cultural History.* London: Reaktion Books, 2008.

Fabre, Genevieve, and Robert O'Meally, eds. *History and Memory in African-American Culture.* Oxford: Oxford University Press, 1994.

Hariman, Robert, and John Louis Lucaites. *No Caption Needed: Iconic Photographs, Public Culture, and Liberal Democracy.* London: University of Chicago Press, 2007.

Panofsky, Erwin. *Studies in Iconology: Humanistic Themes in the Art of the Renaissance.* London: Harper & Row, 1972.

Powell, Richard J. *Cutting a Figure: Fashioning Black Portraiture.* Chicago: University of Chicago Press, 2008.

Rhodes, Jane. *Framing the Black Panthers: The Spectacular Rise of a Black Power Icon.* London: New Press, 2007.

Springer, Claudia. *James Dean Transfigured: The Many Faces of Rebel Iconography.* Austin: University of Texas Press, 2007.

Taschen, Benedikt, and Howard Bingham. *GOAT: A Tribute to Muhammad Ali.* New York: Taschen, 2004.

Torres, Sasha. *Black, White, and in Color: Television and Black Civil Rights.* Princeton, N.J.: Princeton University Press, 2003.

Ziff, Trisha, ed. *Che Guevara: Revolutionary and Icon.* London: V & A Publications, 2006.

ARCHIVES

Abel, O'Neal. O'Neal Abel Photograph Portfolio. Schomburg Center for Research in Black Culture, New York Public Library.

Alkalimat, Abdul, ed. *Malcolm X: A Research Site*. University of Toledo and Twenty-First Century Books. http://www.brothermalcolm.net.

A Black Mass: Photographs. Billy Rose Theater Collection, New York Public Library.

Clarke, John Henrik. The John Henrik Clarke Papers, 1937–1996. Schomburg Center for Research in Black Culture, New York Public Library, box 24.

Columbia University Center for Contemporary Black History/Institute for Research in African-American Studies. *The Malcolm X Project at Columbia University*. http://www.columbia.edu/cu/ccbh/mxp/index.html.

Experimental Death Unit #1: Photographs. Billy Rose Theater Collection, New York Public Library.

Haggins, Robert L. The Robert Haggins Photograph Collection. Schomburg Center for Research in Black Culture, New York Public Library.

Haley, Alex. The Alex Haley Papers, 1967–1990. Schomburg Center for Research in Black Culture, New York Public Library, boxes 1–3.

Henry, Laurence. The Laurence Henry Photograph Collection. Schomburg Center for Research in Black Culture, New York Public Library.

The Malcolm X Portrait Collection. Schomburg Center for Research in Black Culture, New York Public Library.

The Malcolm X Poster Collection. Schomburg Center for Research in Black Culture, New York Public Library.

Mayfield, Julian. The Julian Mayfield Photograph Collection. Schomburg Center for Research in Black Culture, New York Public Library.

Organization of Afro-American Unity (OAAU) Collection, 1963–1965. Schomburg Center for Research in Black Culture, New York Public Library.

Saunders, Richard. The Richard Saunders Photograph Collection. Schomburg Center for Research in Black Culture, New York Public Library, box 3.

Smith, Klytus. The Klytus Smith Photograph Collection. Schomburg Center for Research in Black Culture, New York Public Library.

X, Malcolm. The Malcolm X Collection: Papers, 1948–1965. Schomburg Center for Research in Black Culture, New York Public Library, boxes 1–17 on microfilm.

———. The Malcolm X Collection: Photographs. Schomburg Center for Research in Black Culture, New York Public Library.

BY MALCOLM X AND/OR ALEX HALEY

Balk, Alfred, and Alex Haley. "Black Merchants of Hate." *Saturday Evening Post,*
26 January 1963, 68–75.

Haley, Alex. "Mr. Muhammad Speaks." *Reader's Digest,* March 1960, 100–104.

———. "*Playboy* Interview: Malcolm X." *Playboy,* May 1963, 53–63.

X, Malcolm. *By Any Means Necessary: Speeches, Interviews and a Letter by
Malcolm X.* Edited by George Breitman. New York: Pathfinder Press, 1970.

———. *The End of White World Supremacy: Four Speeches by Malcolm X.* Edited
by Benjamin Karim. New York: Seaver Books, 1971.

———. *February 1965: The Final Speeches.* Edited by Steve Clark. New York:
Pathfinder Press, 1992.

———. "God's Judgment of White America." *Evergreen,* December 1967,
54–57, 98–102.

———. "I'm Talking to You, White Man: An Autobiography by Malcolm X."
Saturday Evening Post, 12 September 1964.

———. *Malcolm X on Afro-American History.* New York: Merit Publishers,
1967.

———. *Malcolm X on Afro-American History.* New York: Pathfinder Press, 1988.

———. *Malcolm X: The Last Speeches.* Edited by Bruce Perry. New York:
Pathfinder Press, 1989.

———. *Malcolm X Speaks: Selected Speeches and Statements.* New York: Merit
Publishers, 1965.

———. *Malcolm X Speaks: Selected Speeches and Statements.* New York: Grove
Press, 1966.

———. *Malcolm X Speaks: Selected Speeches and Statements.* London: Secker &
Warburg, 1966.

———. *Malcolm X Speaks: Selected Speeches and Statements.* New York: Grove
Press, 1990.

———. *Malcolm X Talks to Young People.* New York: Merit Publishers, 1969.

———. *Malcolm X Talks to Young People: Speeches in the U.S., Britain, and
Africa.* Edited by Steve Clark. New York: Pathfinder Press, 1991.

———. *Malcolm X Talks to Young People: Speeches in the United States, Britain,
and Africa.* 2nd ed. Edited by Steve Clark. New York: Pathfinder Press, 2002.

———. *The Speeches of Malcolm X at Harvard.* Edited by Archie Epps. New
York: William Morrow, 1968.

———. *Two Speeches by Malcolm X.* New York: Merit Publishers, 1969.

———. *Yacub's History: The Nation of Islam Speech.* Norfolk, Va.: Universal
Truth, 1994.

X, Malcolm, and Alex Haley. *The Autobiography of Malcolm X.* New York: Grove Press, 1965.

————. *The Autobiography of Malcolm X.* London: Hutchinson, 1966.

————. *The Autobiography of Malcolm X.* New York: Grove Press, 1966.

————. *The Autobiography of Malcolm X.* Harmondsworth, U.K.: Penguin Books, 1968.

————. *The Autobiography of Malcolm X.* New York: Ballantine Books, 1992.

————. *The Autobiography of Malcolm X.* New York: Ballantine Books, 1999.

————. *The Autobiography of Malcolm X.* London: Penguin Books, 2001.

————. *The Autobiography of Malcolm X.* London: Penguin Books, 2007.

————. *The Autobiography of Malcolm X.* London: Penguin Books, 2010.

CRITICAL STUDIES AND BIOGRAPHIES

Abernethy, Graeme. "'Not Just an American Problem': Malcolm X in Britain." *Atlantic Studies* 7, no. 3 (September 2010): 285–307.

————. "'Studied in his death': Representations of the assassination of Malcolm X." In *Envisaging Death: Visual Culture and Dying,* edited by Michele Aaron. Newcastle-upon-Tyne: Cambridge Scholars Publishing, 2013.

Ball, Jared A., and Todd Steven Burroughs, eds. *A Lie of Reinvention: Correcting Manning Marable's Malcolm X.* Baltimore: Black Classic Press, 2012.

Bradley, David. "Malcolm's Mythmaking." *Transition* 56, no. 2 (November 1992): 20–46.

Breitman, George. *The Last Year of Malcolm X: The Evolution of a Revolutionary.* New York: Merit Publishers, 1967.

————. *Malcolm X: The Man and His Ideas.* New York: Merit Publishers, 1967.

Carson, Clayborne. *Malcolm X: The FBI File.* Edited by David Gallen. New York: Carroll & Graf, 1991.

Clarke, John Henrik, ed. *Malcolm X: The Man and His Times.* Trenton, N.J.: Africa World Press, 1990.

Cone, James H. *Martin and Malcolm and America: A Dream or a Nightmare.* Maryknoll, N.Y.: Orbis, 1991.

Conyers, Jr., James L., and Andrew P. Smallwood, eds. *Malcolm X: A Historical Reader.* Durham, N.C.: Carolina Academic Press, 2008.

DeCaro, Jr., Louis A. *On the Side of My People: A Religious Life of Malcolm X.* New York: New York University Press, 1996.

Dyson, Michael Eric. *Making Malcolm: The Myth and Meaning of Malcolm X.* Oxford: Oxford University Press, 1995.

Eakin, Paul John. "Malcolm X and the Limits of Autobiography." *Criticism: A Quarterly of Literature and the Arts* 18, no. 3 (Summer 1976): 230–242.

Essien-Udom, E. U. *Black Nationalism: A Search for an Identity in America.* London: University of Chicago Press, 1962.

Evanzz, Karl. *The Judas Factor: The Plot to Kill Malcolm X.* New York: Thunder's Mouth Press, 1992.

Frady, Marshall. "The Children of Malcolm." *New Yorker,* 12 October 1992, 64–81.

Gallen, David, ed. *Malcolm X: As They Knew Him.* New York: Carroll & Graf, 1992.

Goldman, Peter. *The Death and Life of Malcolm X.* 2nd ed. Chicago: University of Illinois Press, 1979.

Gomez, Michael A. *Black Crescent: The Experience and Legacy of African Muslims in the Americas.* Cambridge: Cambridge University Press, 2005.

Kelley, Robin D. G. *Race Rebels: Culture, Politics, and the Black Working Class.* New York: Free Press, 1994.

Kondo, Zak. *Conspiracys: Unravelling the Assassination of Malcolm X.* Washington, D.C.: Nubia Press, 1993.

Lincoln, C. Eric. *The Black Muslims in America.* Boston: Beacon Press, 1961.

Lomax, Louis. *The Negro Revolt.* New York: Harper & Row, 1962.

———. *When the Word Is Given: A Report on Elijah Muhammad, Malcolm X, and the Black Muslim World.* Cleveland: World Publishing, 1963.

Marable, Manning. *Living Black History: How Reimagining the African-American Past Can Remake America's Racial Future.* New York: Basic Civitas Books, 2006.

———. *Malcolm X: A Life of Reinvention.* New York: Viking, 2011.

Mealy, Rosemari. *Fidel and Malcolm X: Memories of a Meeting.* Melbourne: Ocean, 1993.

Moses, Wilson Jeremiah. *Black Messiahs and Uncle Toms: Social and Literary Manipulations of a Religious Myth.* London: Pennsylvania State University Press, 1982.

Norman, Brian. "'Reading a Closet Screenplay': Hollywood, James Baldwin's Malcolms and the Threat of Historical Irrelevance." *African American Review* 39, nos. 1–2 (Spring–Summer 2005): 103–115.

Ogbar, Jeffrey O. G. *Black Power: Radical Politics and African American Identity.* Baltimore: Johns Hopkins University Press, 2004.

———. *Hip-Hop Revolution: The Culture and Politics of Rap.* Lawrence: University Press of Kansas, 2009.

Painter, Nell Irvin. "Malcolm X across the Genres." *American Historical Review* 98, no. 2 (April 1993): 432–439.

Perry, Bruce. *Malcolm: The Life of a Man Who Changed Black America.* Barrytown, N.Y.: Station Hill, 1991.

Sales, William W. *From Civil Rights to Black Liberation: Malcolm X and the Organization of Afro-American Unity.* Boston: South End Press, 1994.

Sherwood, Marika. *Malcolm X Visits Abroad.* London: Tsehai, 2011.

Sinclair, Abiola, ed. *The Harlem Cultural/Political Movements, 1960–1970: From Malcolm X to "Black Is Beautiful."* New York: Gumbs & Thomas, 1995.

Terrill, Robert E. *Malcolm X: Inventing Radical Judgment.* East Lansing: Michigan State University Press, 2004.

———, ed. *The Cambridge Companion to Malcolm X.* Cambridge: Cambridge University Press, 2010.

Tyner, James. *The Geography of Malcolm X: Black Radicalism and the Remaking of American Space.* New York: Routledge, 2006.

Wolfenstein, Eugene Victor. *The Victims of Democracy: Malcolm X and the Black Revolution.* London: Free Association Books, 1989.

Wood, Joe, ed. *Malcolm X: In Our Own Image.* New York: St. Martin's Press, 1992.

Van Deburg, William L. *New Day in Babylon: The Black Power Movement and American Culture, 1965–1975.* London: University of Chicago Press, 1993.

MEMOIRS

Ali, Tariq. *Street Fighting Years: An Autobiography of the Sixties.* London: Verso, 2005.

Angelou, Maya. *All God's Children Need Traveling Shoes.* Boston: G. K. Hall, 1986.

Arnold, Eve. *In Retrospect.* London: Sinclair-Stevenson, 1996.

Baraka, Amiri (LeRoi Jones). *The Autobiography of LeRoi Jones.* New York: Freundlich, 1984.

Beck, Robert (Iceberg Slim). *The Naked Soul of Iceberg Slim.* Los Angeles: Holloway House, 1971.

Carew, Jan. *Ghosts in Our Blood: With Malcolm X in Africa, England, and the Caribbean.* Chicago: Lawrence Hill Books, 1994.

Cleaver, Eldridge. *Soul on Ice.* London: Panther Modern Society, 1970.

Davis, Angela. *Angela Davis: An Autobiography.* London: Hutchinson, 1975.

Egbuna, Obi. *Destroy This Temple: The Voice of Black Power in Britain.* London: MacGibbon & Kee, 1971.

Jackson, George. *Soledad Brother: The Prison Letters of George Jackson.* London: Jonathan Cape, 1971.

Jamal, Hakim A. *From the Dead Level: Malcolm X and Me*. New York: Random House, 1972.

Jarvis, Malcolm, and Paul D. Nichols. *The Other Malcolm—"Shorty" Jarvis*. Edited by Cornel West. Jefferson, N.C.: McFarland, 2001.

Karim, Benjamin, with Peter Skutches and David Gallen. *Remembering Malcolm*. New York: Carroll & Graf, 1992.

Kochiyama, Yuri Nakahara. *Passing It On: A Memoir*. Los Angeles: UCLA Asian American Studies Center Press, 2004.

Lee, Spike, and Lisa Jones. *Do the Right Thing: A Spike Lee Joint*. New York: Fireside, 1989.

Lee, Spike, and Ralph Wiley. *By Any Means Necessary: The Trials and Tribulations of the Making of Malcolm X*. New York: Hyperion, 1992.

Malik, Michael Abdul. *From Michael de Freitas to Michael X*. London: Andre Deutsch, 1968.

Mitchell, Sara. *Brother Malcolm*. New York: Malcolm X Memorial Committee, 1965.

———. *Shepherd of Black-Sheep: A Commentary on the Life of Malcolm X with an on the Scene Account of His Assassination*. Self-published, 1981.

Newton, Huey P., and Herman J. Blake. *Revolutionary Suicide*. London: Wildwood House, 1974.

Obadele, Brother Imari Abubakari. *War in America: The Malcolm X Doctrine*. Detroit: Malcolm X Society, 1968.

Obama, Barack. *Dreams from My Father: A Story of Race and Inheritance*. New York: Times Books, 1995.

Parks, Gordon. *Voices in the Mirror: An Autobiography*. New York: Doubleday, 1990.

Shabazz, Ilyasah, and Kim McLarin. *Growing Up X*. New York: Ballantine, 2002.

ASSORTED LITERATURE

Ali, Tariq, ed. *New Revolutionaries: Left Opposition*. London: Peter Owen, 1969.

Avedon, Richard, and James Baldwin. *Nothing Personal*. New York: Penguin Books, 1964.

Baldwin, James. "Letter from a Region in My Mind." *New Yorker*, 17 November 1962, 59–144.

———. *One Day When I Was Lost: A Scenario Based on Alex Haley's "The Autobiography of Malcolm X."* New York: Laurel, 1992.

Baraka, Amiri (LeRoi Jones). *Four Black Revolutionary Plays: Experimental Death Unit #1, A Black Mass, Great Goodness of Life, Madheart*. London: Calder & Boyars, 1971.

Baraka, Amiri (LeRoi Jones), and Larry Neal, eds. *Black Fire: An Anthology of Afro-American Writing*. New York: William Morrow, 1968.

Beatty, Paul. *The White Boy Shuffle*. London: Minerva, 1996.

Chapman, Abraham, ed. *Black Voices: An Anthology of Afro-American Literature*. New York: New American Library, 1968.

———, ed. *New Black Voices: An Anthology of Contemporary Afro-American Literature*. New York: New American Library, 1972.

Gayle, Jr., Addison, ed. *The Black Aesthetic*. New York: Doubleday, 1971.

Gwynne, James B., ed. *Malcolm X: Justice Seeker*. New York: Steppingstones Press, 1993.

Jasiri, Balogun Moyenda Adom. *Malcolm X Is Found Guilty*. Self-published, ca. 1978.

Kalu, Peter. *Professor X*. London: The X Press, 1995.

Killens, John Oliver. *The Cotillion, or One Good Bull Is Half the Herd*. Minneapolis: Coffee House Press, 2002.

Oglesby, Carl, ed. *The New Left Reader*. New York: Grove Press, 1969.

Randall, Dudley, and Margaret G. Burroughs, eds. *For Malcolm: Poems on the Life and the Death of Malcolm X*. Detroit: Broadside Press, 1969.

Smith, Kent. *Future X*. Holloway House, 1990.

VISUAL ARTS

"28 People Who Count." *Esquire*, September 1965, front cover, 97.

Chapnick, Howard, ed. *Malcolm X: The Great Photographs*. New York: Stewart, Tabori & Chang, 1993.

Coe, Sue. *X*. New York: New Press, 1992.

"*Ebony* Photo-Editorial: Violence Versus Non-Violence." *Ebony*, April 1965, 168–169.

Hammons, David, et al. *David Hammons: Rousing the Rubble*. New York: Institute for Contemporary Art, 1991.

Helfer, Andrew, and Randy DuBurke. *Malcolm X: A Graphic Biography*. New York: Hill & Wang, 2006.

Kihss, Peter. "Malcolm X Shot to Death at Rally Here." *New York Times*, 22 February 1965, 1, 10.

Liberator, April 1965, entire issue.

Ligon, Glenn. *Coloring: New Work by Glenn Ligon*. Minneapolis: Walker Art Center, 2001.

Maddock, Robin. *Our Kids Are Going to Hell*. London: Trolley Books, 2009.

Prigoff, James, and Robin J. Dunitz, eds. *Walls of Heritage, Walls of Pride: African American Murals*. San Francisco: Pomegranate, 2000.

Starling, Dan. *Malcolm X: An Introduction, by J. D. Salinger.* Self-published, 2007.

Strickland, William. *Malcolm X: Make It Plain.* Edited by Cheryll Y. Greene. New York: Penguin, 1994.

"The Violent End of the Man Called Malcolm X." *Life,* 5 March 1965, 26–27.

"Will Death of Malcolm X Spur More Bloodshed?" *Jet,* 11 March 1965, front cover.

FILM AND TELEVISION

Ali. Directed by Michael Mann. Columbia Pictures, 2001.

The Answer. Directed by Spike Lee. New York University, 1980.

Black Panthers. Directed by Agnes Varda. American Documentary Films, 1968.

The Blues Brothers. Directed by John Landis. Universal Studios, 1980.

Death of a Prophet. Directed by Woodie King, Jr. National Black Touring Circuit Inc., 1981.

Do the Right Thing. Directed by Spike Lee. Universal Pictures, 1989.

Handsworth Songs. Directed by John Akomfrah. Black Audio Film Collective, 1986.

The Hate that Hate Produced. WDNT-TV, 13–17 July 1959.

"Malcolm Rejects Racist Doctrine." *Front Page Challenge.* CBC Television, 5 January 1965.

Malcolm's Echo. Directed by Dami Akinnusi. Darkling Productions, 2007.

Malcolm X. Directed by Arnold Perl. Warner Brothers, 1972.

Malcolm X. Directed by Spike Lee. Warner Brothers, 1992.

Malcolm X: Make It Plain. Directed by Orlando Bagwell. Blackside, 1994.

The Meeting. Directed by Bill Duke. American Playhouse, 1989.

Panther. Directed by Mario Van Peebles. Gramercy Pictures, 1995.

Roots: The Next Generations. ABC, 18–24 February 1979.

Seven Songs for Malcolm X. Directed by John Akomfrah. Black Audio Film Collective, 1993.

She's Gotta Have It. Directed by Spike Lee. Island Pictures, 1986.

The Spook Who Sat by the Door. Directed by Ivan Dixon. United Artists, 1973.

White Men Can't Jump. Directed by Ron Shelton. Twentieth Century Fox, 1992.

Who Needs a Heart. Directed by John Akomfrah. Black Audio Film Collective, 1991.

The Wire. HBO, 2 June 2002–9 March 2008.

MUSIC

2Pac. *2Pacalypse Now*. Jive/Interscope/Priority, 1991.

Amiri Baraka and Sun Ra and the Myth-Science Arkestra. *A Black Mass*. Jihad, 1968.

Boogie Down Productions. *By All Means Necessary*. Jive/RCA Records, 1988.

Brand Nubian. *One for All*. Elektra Records, 1990.

Brown, James. *Say It Loud—I'm Black and I'm Proud (single)*. King, 1968.

Coltrane, John. *Afro-Blue Impressions*. Pablo Records, 1977.

Cornel West and BMWMB (Black Men Who Mean Business). *Never Forget: A Journey of Revelations*. Hidden Beach, 2007.

Davis, Anthony. *X: The Life and Times of Malcolm X*. Gramavision Records, 1992.

Dead Prez. *Let's Get Free*. Loud Records, 2000.

———. *Revolutionary but Gangsta*. Sony, 2004.

Don Cannon and Young Jeezy. *Trap or Die II: By Any Means Necessary!* CTE, 2010.

Gang Starr. *Daily Operation*. Chrysalis/EMI, 1992.

Ice T. *O.G.: Original Gangster*. Sire/Warner Brothers Records, 1991.

Jay-Z and Kanye West. *Watch the Throne*. Roc-A-Fella/Roc Nation/Def Jam, 2011.

The Last Poets. *The Last Poets*. CLD, 1970.

Malcolm X. *The Ballot or the Bullet*. Paul Winley Records, ca. 1975.

———. *Message to the Grass Roots*. Twenty Grand/Afro American Broadcasting & Recording, 1965.

Mos Def. *The Ecstatic*. Downtown, 2009.

Public Enemy. *It Takes a Nation of Millions to Hold Us Back*. Def Jam/Columbia, 1988.

The Roots. *The Tipping Point*. Geffen/Interscope/Universal, 2004.

Scott-Heron, Gil. *Small Talk at 125th and Lenox*. Flying Dutchman/RCA, 1970.

Shabazz Palaces. *Of Light*. Templar Label Group, 2009.

———. *Shabazz Palaces*. Templar Label Group, 2009.

Various artists. *Malcolm X: Music and Dialogue from the Original Soundtrack of the Motion Picture*. Warner Brothers Records, 1972.

West, Kanye. *Graduation*. Roc-a-Fella/Def Jam, 2007.

———. *My Beautiful Dark Twisted Fantasy*. Roc-A-Fella/Def Jam, 2010.

X-Clan. *To the East, Blackwards*. 4th & Broadway/Island/Polygram Records, 1990.

INDEX

cultural afterlife, 1, 13
family, 80, 83, 100, 103, 177
life, 3, 87–89
names, 15
objectification, 1
as orator, 50–51, 98, 110–111, 120,
 138, 141, 148, 176
parents, 38, 86, 91, 98, 113–114,
 178, 231n37
personae, 1–2, 3, 15, 75–76
physical appearance, 33, 99–100,
 191
travel diaries, 219
See also death of Malcolm X; Detroit
 Red; iconography of Malcolm X;
 Little, Malcolm; Shabazz, El-Hajj
 Malik El

X-Clan, 211–212, 213
X Press, 182
X: *The Life and Times of Malcolm X*,
 254n1

Yearwood, Lloyd, 25, 50
Young Jeezy, 214

Zawahiri, Ayman al-, 227, 227 (photo)
Zelizer, Barbie, 58, 71
zoot suits, 105–106, 108–109, 115, 137,
 189